Collection Companion
TOLEDO MUSEUM OF ART

WITH CONTRIBUTIONS BY

Brian P. Kennedy
Tami Landis
Adam Levine
Courtney Macklin
Lawrence W. Nichols
Halona Norton-Westbrook
Paula Reich
Robin Reisenfeld
Diane C. Wright

Toledo Museum of Art
IN ASSOCIATION WITH
Scala Arts Publishers, Inc.

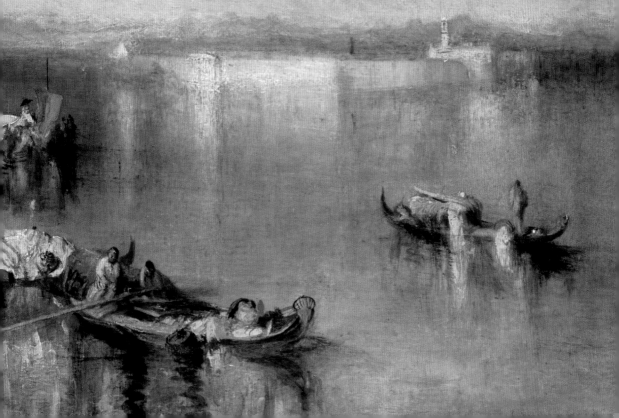

Collection Companion

TOLEDO MUSEUM OF ART

This book was published with the assistance of the Andrew W. Mellon Foundation

Text and photography © 2018 Toledo Museum of Art
Book © 2018 Scala Arts Publishers, Inc.

First published in 2018 by Scala Arts Publishers, Inc.
c/o CohnReznick LLP
1301 Avenue of the Americas, 10th Floor
New York, NY 10019
www.scalapublishers.com
Scala – New York – London

Distributed outside the Toledo Museum of Art in the book trade by
ACC Publishing Group
6 West 18th Street, Suite 4B
New York, NY 10011

ISBN 978-1-78551-178-3

10 9 8 7 6 5 4 3 2 1

Printed and bound in China

Library of Congress Cataloging-in-Publication Data
Names: Toledo Museum of Art, author, issuing body. | Kennedy, Brian P., 1961–
Title: Collection companion / Toledo Museum of Art ; with contributions by Brian P. Kennedy, Tami Landis, Adam Levine, Courtney Macklin, Lawrence W. Nichols, Halona Norton-Westbrook, Paula Reich, Robin Reisenfeld, Diane C. Wright.
Description: New York : Scala Arts Publishers, Inc., 2018. | Includes index.
Identifiers: LCCN 2018033220 | ISBN 9781785511783 (pbk.)
Subjects: LCSH: Art—Ohio—Toledo—Catalogs. | Toledo Museum of Art—Catalogs.
Classification: LCC N820 .A525 2018 | DDC 709.771/13—dc23
LC record available at https://lccn.loc.gov/2018033220

Toledo Museum of Art:
Halona Norton-Westbrook, Director of Curatorial Affairs
Paula Reich, Managing Editor
Tami Landis, Research and Editing Assistant
Julia Hayes, Rights and Reproduction

Edited by Monica S. Rumsey, Essex, New York
Designed by Joan Sommers, Glue + Paper Workshop LLC
Produced by Scala Arts Publishers, Inc.

Cover: Thomas Cole, *The Architect's Dream* (detail, see pp. 190–91)

Title page: Joseph Mallord William Turner, *The Campo Santo, Venice* (detail, see p. 192)

Museum buildings and galleries:
pp. 6–7: The Toledo Museum of Art, Edward B. Green, architect, 1912, 1925, 1933, with Alexander Calder's *Stegosaurus* (1972/73) in the foreground
pp. 8–9: Center for the Visual Arts, University of Toledo, Frank O. Gehry, architect, 1992
pp. 10–11: Toledo Museum of Art Glass Pavilion, SANAA (Sejima and Nishizawa and Associates), architects, 2006
p. 326: The Peristyle, Toledo Museum of Art
p. 327: The Cloister Gallery, Toledo Museum of Art
p. 328: The Great Gallery, Toledo Museum of Art
p. 329: Gallery 2, the Glass Pavilion

Section divider details:
p. 24: Jean-Honoré Fragonard, *Blind-Man's Buff* (see p. 166)
p. 28: A drawing class under the trees at the Toledo Museum of Art, 1923
p. 36: Gandhara, *Seated Buddha* (see p. 38)
p. 37: Toshusai Sharaku, *Onoe Matsusuke as Ashikaga Takauji* (see p. 43)
p. 48: Edo people, Nigeria, *Queen Mother Head* (see p. 52)
p. 49: Fang people, Gabon, *Mask: Ngontang* (see p. 54)
p. 56: Greek, Exekias, *Amphora with Chariot Race* (see p. 63)
p. 57: Roman, *Beaker with Bacchic Imagery* (see p. 82)
p. 86: Seleucid Empire, *Rhyton in the Shape of a Zebu* (see p. 89)
p. 87: Seljuq Dynasty, *Bowl* (see p. 92)
p. 94: Balthasar van der Ast, *Fruit, Flowers, and Shells* (see p. 134)
p. 95: Albrecht Dürer, *Knight, Death, and the Devil* (see p. 109)
p. 156: Raphaelle Peale, *Still Life with Oranges* (see p. 186)
p. 157: Paul Cézanne, *Avenue at Chantilly* (see p. 222)
p. 234: Dominick Labino, *Vitrana* (see p. 297)
p. 235: Lalla Essaydi, *Women of Morocco: The Grand Odalisque* (see p. 312)

Dimensions are in inches (and centimeters); height precedes width for two-dimensional objects. For three-dimensional objects, only the greatest dimension, either height, width, length, or diameter, is given.

Contents

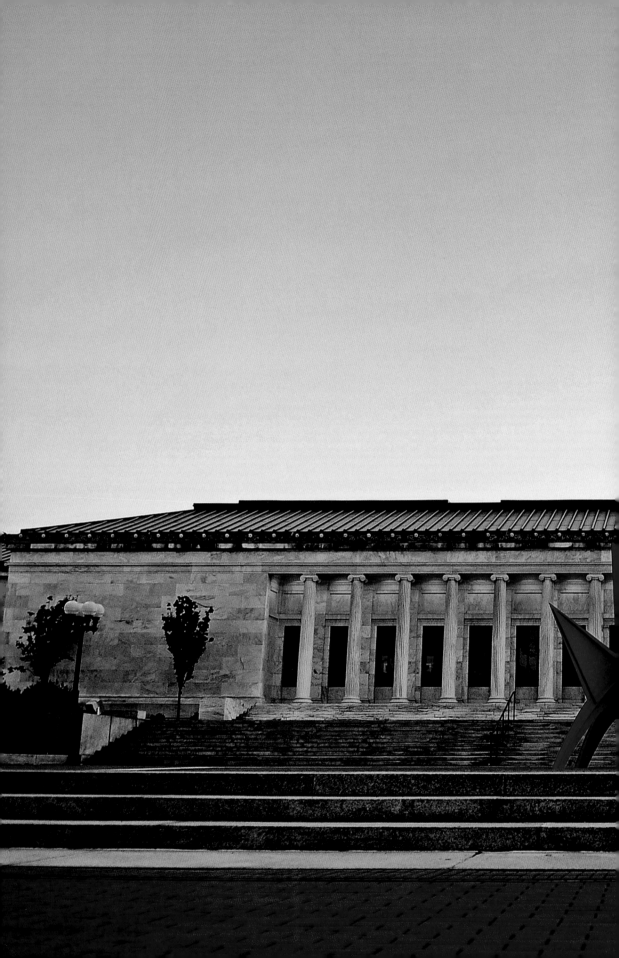

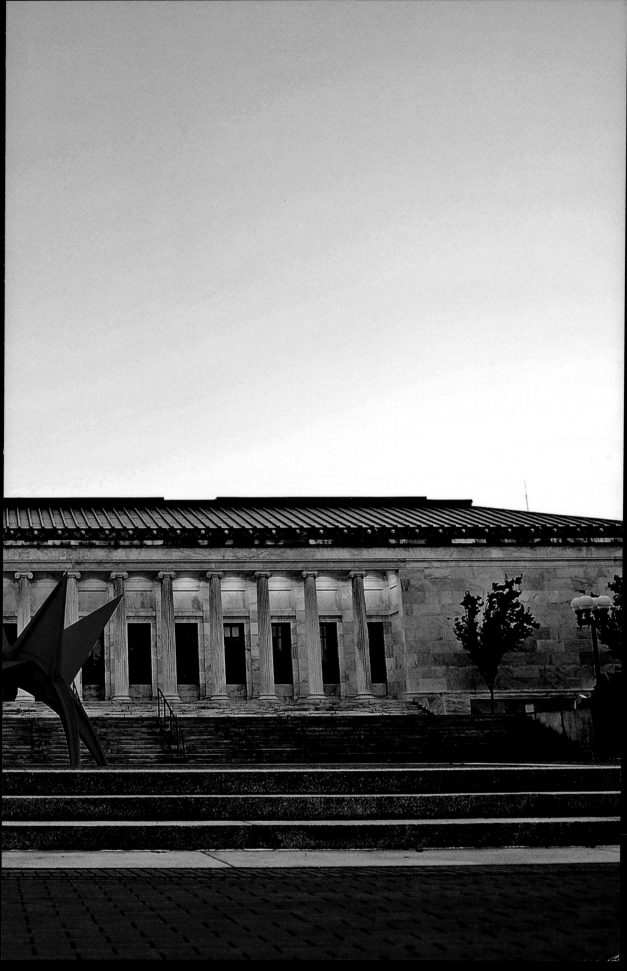

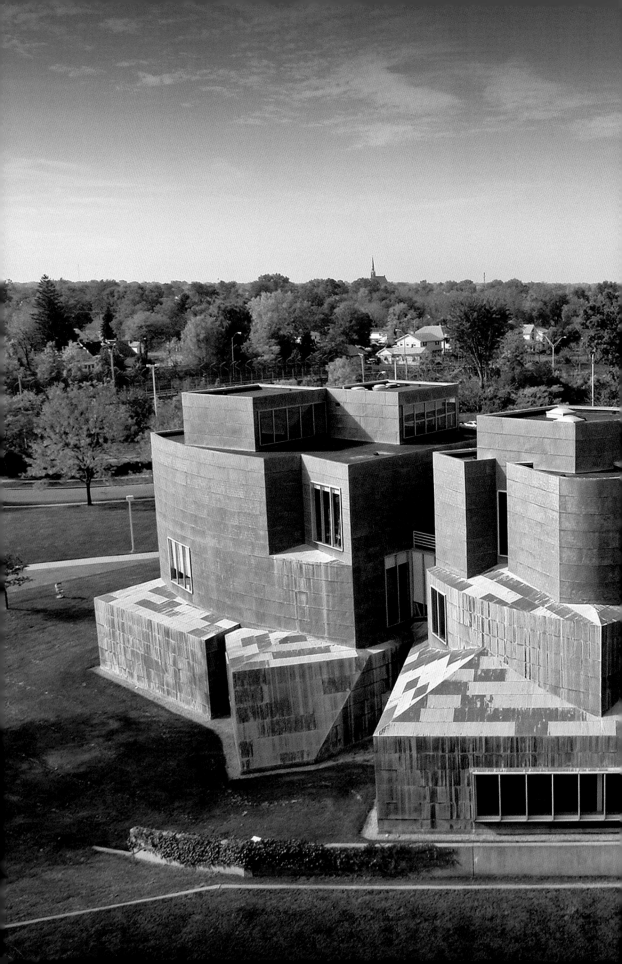

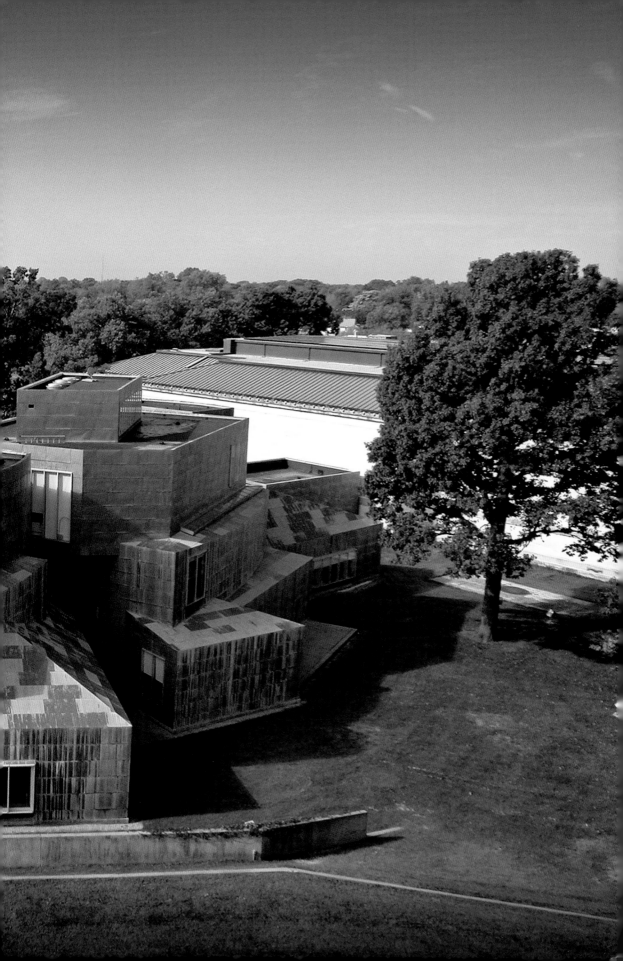

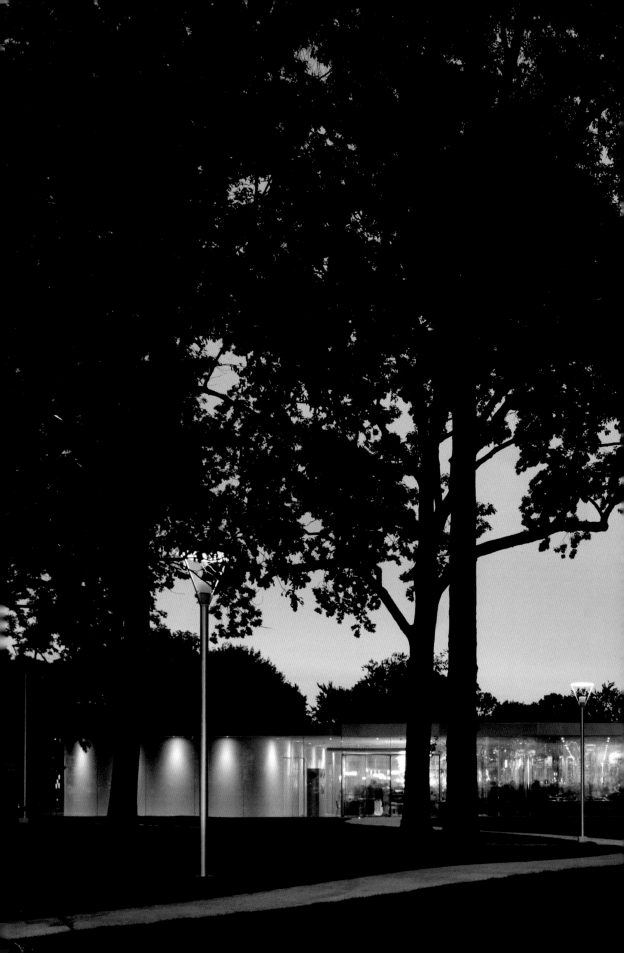

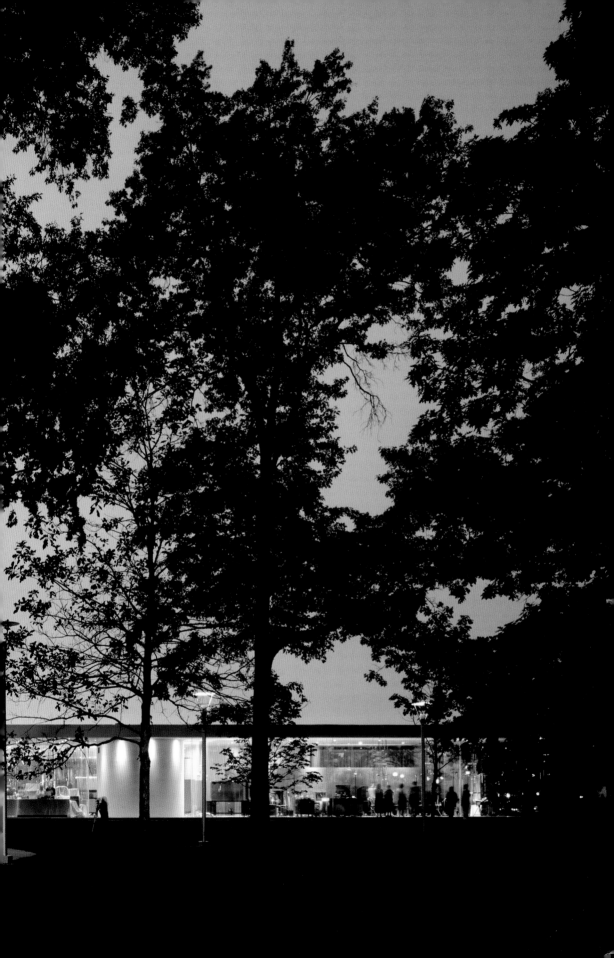

Art of the Highest Quality

*A History of the Toledo Museum
of Art and Its Collection*

At the heart of any art museum is its collection. What it collects, how it presents and interprets its collection, and how visitors interact with the works of art define an art museum and its relationship with its audiences. During more than a century of its existence, the Toledo Museum of Art has been consistently defined by its dedication to art education, community, and works of art of the highest quality. Now, as the twenty-first century has ushered in a new digital age—one in which technology has become integrated into our everyday interactions and the very fabric of our lives—museums have been re-examining assumptions about their audiences, how they approach education, and how to make their collections more relevant to a broader public. As we navigate this expanding world, it has become clear that education, empathy, and understanding are among the most valuable tools available for creating connections. By acquiring these vital skills, we can see, comprehend, and appreciate the world around us—and each other—with greater clarity. The Toledo Museum of Art, devoted to its purpose of art education, is an institution that is especially positioned to engage its visitors through its extraordinary collection of objects from around the world and across history.

Building on a Legacy, Planning for the Future

As the Museum looks forward to its next hundred years, a review of the origins of the collection allows us to better understand the past, consider the present, and plan purposefully for the future. It is important to understand the story of the formation of the Toledo Museum of Art collection, particularly the early development of the Museum's collecting activities, which ultimately laid the foundation for its consistent pursuit of quality and visitor engagement. In the footsteps of those early efforts, the transformative leadership of recent decades has, with curatorial support, taken the collection to new heights and opened up previously unexplored areas of art from around the globe.

Roger Mandle, who was Director from 1977 to 1988, added exceptional works to the Museum's core holdings of Old Master paintings (see, for example, works by Jacopo Bassano, p. 123, and Thomas Gainsborough, p. 171). He also greatly expanded the collection of Modern European art with extraordinary acquisitions by Pablo Picasso (p. 85), Max Beckmann (pp. 262–63), Joan Miró (pp. 274–75), among others. In 1986 Mandle, along with Deputy Director Roger Berkowitz, helped to form The Apollo Society collecting group in partnership with donor and collector Georgia Welles and her husband David. Now renamed The Georgia Welles Apollo Society, the group is responsible for acquisitions spanning from an ancient Greek gold jewelry hoard (p. 69) to a contemporary South African sculpture (see Mary Sibande, pp. 322–23).

Mandle was succeeded by David Steadman in 1988, who served as Director until early 1999. Steadman sought to enrich the visitor experience at the Museum, overseeing major

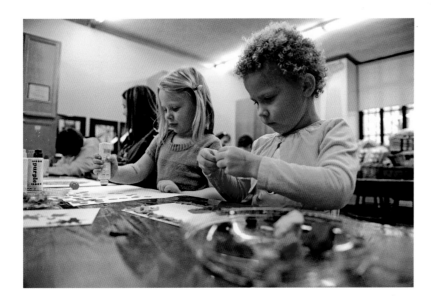

FIG. 2
Children make art in the
Family Center.

FIG. 3
Speaking Visual, a thematic
installation exploring the
Museum's Art of Seeing
Art™ method of teaching
visual literacy.

gallery renovations and the opening of the
Family Center (fig. 2), hosting highly popular
exhibitions of Impressionism and the art of
Peter Paul Rubens, and extending Museum
hours and programming on Friday evenings.
Steadman also oversaw a partnership with
the University of Toledo to build the Center
for the Visual Arts (CVA)—located next to the
Museum building and designed by the eminent
architect Frank O. Gehry—to house the uni-
versity's studio art and art history programs
and the Museum's art reference library. Key
acquisitions made during Steadman's director-
ship include a rare portrait bust of the ancient
Roman Emperor Domitian (p. 76) and works by
Gustave Le Gray (p. 195), Constantin Brancusi
(p. 260), and Anselm Kiefer (pp. 302–303).

Roger Berkowitz, who began working at
the Museum as a curatorial intern, served as
its director from 1999 to 2003. As Curator
of Decorative Arts, Berkowitz had already
made a strong impact on the Museum's col-
lection, seeking out significant examples of
metalwork (Maison Fouquet, p. 257), ceram-
ics (Léonard Limousin, p. 118), and furniture
(Joseph Cremer, pp. 198–99). As Director,
he inaugurated a gallery dedicated to the
Museum's dazzling collection of nineteenth-
and twentieth-century European jewelry
(see pp. 208–209). He also presided over the
Museum's centennial celebration in 2001 and
the opening of the new Georgia and David K.
Welles Sculpture Garden, which continues to
expand (see Jaume Plensa, p. 318). Berkowitz
initiated a capital campaign to raise funds for a
new building to house the Museum's renowned
glass collection.

In 2006 Berkowitz's successor, Don
Bacigalupi, oversaw completion of the
Museum's award-winning Glass Pavilion (see
p. 33), designed by the Japanese architectural
firm SANAA. Serving as Director from 2003
until 2009, Bacigalupi expanded the Museum's
collection of contemporary art, adding many
works by women and artists of color (such
as Elizabeth Catlett, p. 281, Marisol Escobar,
pp. 290–91, and Kehinde Wiley, p. 313).

Brian P. Kennedy became the Museum's
Director in 2010 and was named the Edward
Drummond and Florence Scott Libbey Director
in 2017. Under Kennedy's leadership, the insti-
tution has further cemented its crucial role in
the Toledo community as well as continuing
to grow its reputation on the world stage.

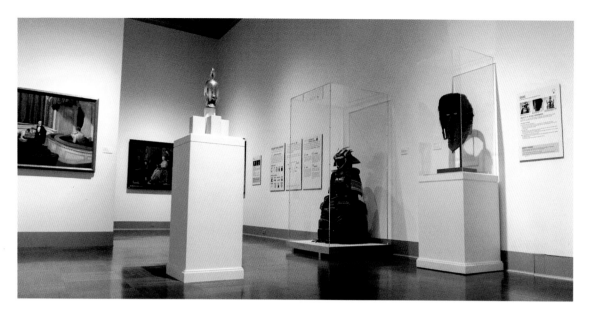

In the past few years, visual literacy—learning to understand what we see—has become an integral focus of TMA's art education curriculum. The Museum has developed a method for teaching visual literacy, The Art of Seeing Art™ (see pp. 25–27), as a means of understanding and interpreting not only works of art, but also the world around us (fig. 3). With Kennedy's encouragement, global contemporary art and the art of indigenous peoples now play a vital role in the Museum's collecting strategy (see a sculpted head by Ravinder Reddy, p. 321; a Cheyenne model tipi, p. 202; and a painting by the Aboriginal Australian artist Tjungkara Ken, p. 320).

Kennedy has also enhanced the Museum's collection of Old Master paintings (see Frans Hals, p. 132, and Luca Giordano, p. 147), while seeking significant works in the category of "new media" (see Nam June Paik, p. 304, and Bill Viola, p. 311). Moving forward in its second century and guided by dedicated and active leaders, the Toledo Museum of Art has developed new galleries and has initiated a Master Plan that includes not only future renovations but also strategies to create deeper ties to the city and its surrounding communities.

The directors, donors, and staff of the past four decades have expanded the collection in new directions, building on the strengths established in the Museum's first several decades. To better understand the Toledo Museum of Art's collection as it exists today, it is worthwhile to reflect on its modest origins and to provide a brief history of its formation and development in the period between the Museum's founding and its maturation under Otto Wittmann, who was Director from 1959 to 1977.

"The Toledo Museum of Art started with nothing but an idea."

The Toledo Museum of Art's origins could hardly have been humbler. When the institution was founded in 1901, it was without a single object, staff member, or dedicated building. However, rather than seeing these circumstances as insurmountable, the Museum's founders and benefactors—glass industrialist Edward Drummond Libbey, his wife, Florence Scott Libbey, and a small but dedicated group of engaged citizens—embraced the concept without hesitation. Indeed, as director Blake-More Godwin told an audience

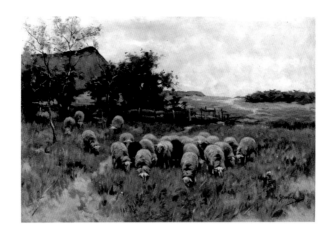

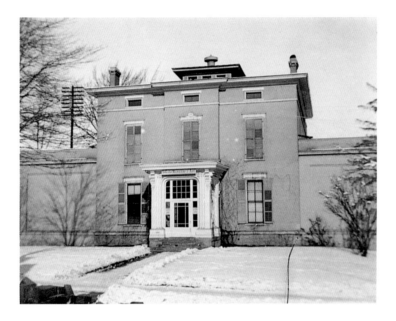

at the National Gallery of Art in 1946, "the Toledo Museum of Art started with nothing but an idea." Yet that idea—that an art museum might be made as useful, as essential, to a community as its libraries or its public schools—sustained the institution and made it grow.

Almost from the very beginning, the Museum was grounded in a deep commitment to art education for all. In 1903 Museum Director George W. Stevens noted, "The first thing we want to do is to remove from the minds of the people the idea that the Toledo Museum of Art is an ultra-exclusive association, or an expensive luxury. It is neither the one nor the other. It has something to give that all the people want, and we want them all with us."[1] Eager to put these declarations into practice, Stevens, with the support of his wife, Nina Stevens, who served as unpaid Assistant Director, set about establishing an ambitious schedule of monthly changing exhibitions and initiated art classes, clubs, and lectures.

Yet while the programs and educational mission of the Museum flourished from the start, the collection was a different matter. When Stevens assumed the directorship on November 1, 1903, the Museum's assets included one desk, six chairs, a little cash, a

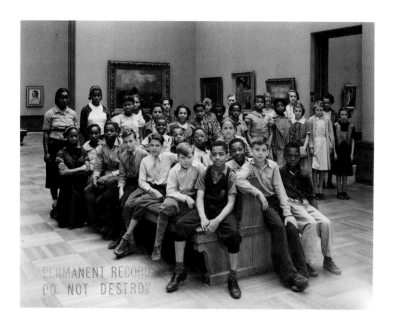

Dutch painting of sheep (fig. 4), and a mummified Egyptian cat. Building the collection became a significant priority for the young institution, and that effort was spearheaded by the Stevenses and the Libbeys.

From the outset, there was a desire to exhibit art that would capture visitors' imagination, that would connect with them and delight them, and that would represent the best examples of artistic expression from around the world. These criteria would guide the acquisition of works of art, but even before the Museum was able to establish a collection, it demonstrated a commitment not only to American and European art, but also to non-Western art. One of the first exhibitions, in 1903, featured Japanese paintings and woodblock prints. In the winter of 1905–1906, the Libbeys made their first trip to Egypt with the intention of acquiring ancient art for the Museum. They returned with 233 objects, including two human mummies, which formed the foundation for the Museum's collection of objects from ancient cultures.

While the collection was beginning to take root, the Museum remained small and modest, housed for several years in a former residential property at the intersection of Madison Avenue and 13th Street in downtown Toledo (fig. 5). Nevertheless, due to the tireless efforts of George and Nina Stevens, the Museum began to hum with activity. The Stevenses were increasingly busy planning and hosting the educational programs, which were growing in popularity. The collection, too, began to develop, though somewhat more slowly. Working with a very limited budget, George Stevens was able to establish a collection of prints, drawings, and books that continues to flourish today.

Founding Figures: Edward Drummond Libbey and Florence Scott Libbey

With donations from the community matched by the generous support from two of the Museum's founders, Edward Drummond and Florence Scott Libbey, the Museum began to draw up plans for a purpose-built structure in 1907, one that could accommodate the growing collection and the immensely popular educational programs (fig. 6). In 1912 a new building for the Museum opened at its current location on Monroe Street. That same year nearly 1,000 works of art were added to the collection. The

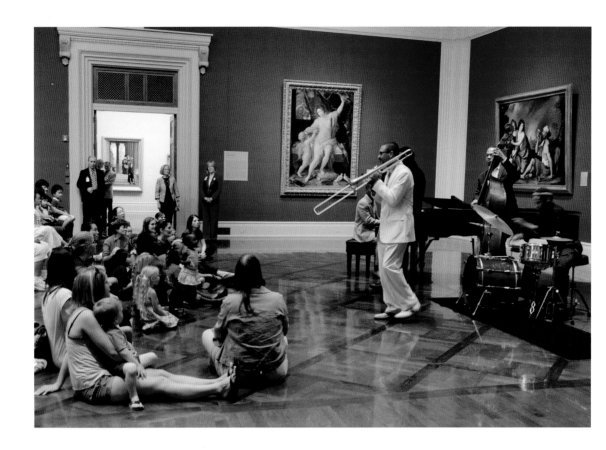

Libbeys' support of the new structure, along with their continual pursuit of objects for the collection, signaled their steadfast devotion to the Museum and its purpose.

In 1913, realizing the importance of connecting the Museum collection to local industry and providing visitors with the best examples of craft and manufacturing, Edward Drummond Libbey—president of the Libbey Glass Company, as well as president of the Museum's Board of Trustees—established the Museum's collection of glass. His goal was to showcase "the complete development of the art [of glass] from antiquity to the present." That year he acquired some eighty pieces of European glass, and in 1917 he purchased the entire collection—almost five hundred objects—formed by the pioneer historian of American glass, Edwin AtLee Barber. Two years later, he bought a vast and nearly encyclopedic collection of

ancient and Islamic glass from Thomas E. H. Curtis. Today, the Toledo Museum of Art has one of the most significant and comprehensive collections of glass in the world, housed in the Glass Pavilion.

As Mr. Libbey's involvement in developing the Museum's collections grew, so too did his sophistication as a collector. During the 1910s, he had begun to pursue in earnest masterworks of European painting for the Museum's collection. Some of those paintings, such as Édouard Manet's *Antonin Proust* (p. 214), were donated during Libbey's lifetime, while others—such as Hans Holbein the Younger's *Portrait of a Lady* (p. 117)—were part of the gift of forty-two paintings that were bequeathed to the Museum after his death in November 1925.

The influence of Florence Scott Libbey was also apparent in the Museum's early decades. With a personal passion for American art, Mrs. Libbey donated funds to establish the Maurice A. Scott Gallery for American Art, named in commemoration of her late father. She was also instrumental in acquiring several key American paintings, including *Indians Simulating Buffalo* by Frederic Remington (p. 247), and works by James Abbott McNeill Whistler and Ralph Albert Blakelock.

After her husband's death, Florence Scott Libbey took on a more significant role in the Museum. Giving up her life interest in her late husband's fortune, she funded two new wings for the Museum and the Peristyle, the Museum's magnificent concert hall, all of which were completed in 1933. Mrs. Libbey had always championed music as an art form on par with painting and sculpture, and her love of music continues to inform the Museum's activities and programming to this day (fig. 7).

The Libbeys clearly shaped the institution through their vision and philanthropy. Under their guidance, the Toledo Museum of Art established a national reputation, anchored itself in a strong commitment to art education

and the community, and actively engaged in the pursuit of works of exceptional quality. The substantial endowment that the Libbeys left to the Museum provides not only for the operation of the building, but also for the continued acquisition of works of art, and—crucially—to provide free admission to the Museum for all visitors.

A World-Class Collection

After the Museum's first Director, George W. Stevens, passed away suddenly in October 1926, Blake-More Godwin was appointed to succeed him, a position he held until 1959. At the time of his promotion, Godwin was already a ten-year veteran of the institution, having joined the small staff as curator in 1916. Soon after he took on his new role, Godwin and his new bride, Molly Ohl—herself a staff member and a key figure in the evolution of the Museum's education department—honeymooned in Europe. There, after seeing the magnificent Romanesque-style cathedral at Arles, France (now the Church of St. Trophime), they were inspired to have a medieval cloister built in the Museum's galleries. The appropriate architectural elements were located and acquired, and the Cloister Gallery became a reality in 1932. To this day it remains one of the Museum's most popular spaces (see pp. 96–97).

As Director, Blake-More Godwin continued to focus on acquiring international art, a hallmark of the Museum since its early years. In 1930 and 1936 Curator J. Arthur MacLean and Assistant Curator Dorothy Blair organized two landmark exhibitions of *shinhanga* (new prints) by contemporary Japanese artists reviving the woodblock print tradition, with the help of pioneering *shin hanga* artist Hiroshi Yoshida. More than three hundred of these remarkable prints by various artists—including nearly a complete set of prints by Yoshida—came to the Museum as a result of

these exhibitions (see pp. 268–69 and fig. 8). Appropriately, the Japanese prints complemented the Museum's growing collection of Asian art, which also included Chinese ceramics, Mamluk glass (p. 93), and Japanese netsuke (pp. 44–45).

The years between 1926 and 1939 proved to be extraordinarily successful for the acquisition of French Impressionist and Post-Impressionist paintings. Among them are works by the acknowledged masters of the styles, including Claude Monet (p. 221), Edgar Degas (pp. 230–31), Paul Gauguin (p. 224), and Vincent van Gogh (p. 223). Godwin also acquired notable works by American artists, such as *Two on the Aisle* by Edward Hopper (p. 271). More American paintings came to the Museum from Arthur J. Secor, the second president of the Museum's Board of Trustees, who donated his collection of European and American paintings (see pp. 213, 228). Significantly, during

this same period, the Museum began collecting works by European Modernists, acquiring superb paintings by Pablo Picasso (p. 245) and Giorgio de Chirico (p. 259).

On an auspicious day in 1946—as Museum legend has it, the same day that *The Agony in the Garden* by El Greco (p. 129) was acquired— a young man named Otto Wittmann came to the Museum to enquire about job prospects. Wittmann, who had trained as part of the renowned program known as the Museum Studies Course at Harvard University, was already a seasoned museum professional. Having begun his career at the Nelson-Atkins Museum of Art in Kansas City, Missouri, Wittmann had most recently been stationed overseas during World War II as a member of the "Monuments Men," a special US Army unit responsible for recovering art looted by the Nazis during the war. Realizing the value of Wittmann's training and experience, the

In 2013 the Museum organized *Fresh Impressions: Early Modern Japanese Prints*, which showcased 343 *shin hanga* prints that were given to the Museum in the 1930s as a result of its landmark exhibitions of the genre during that decade.

The Museum's display of early American art.

Museum hired him as Assistant Director; he ultimately served as Director, from 1959 to 1976.

One of Wittmann's first tasks at the Museum was to articulate a collecting vision and strategy. Embracing this challenge, he devised an approach by which the primary criterion would be the acquisition of art of the highest quality without regard to its culture, material, or an artist's relative fame or obscurity. This principle continues to guide the Toledo Museum of Art's collecting strategy. Employing his arts connoisseurship and an eye trained to recognize unsung masterworks in undervalued areas of the art market, Wittmann spent the next several decades increasing the Museum's holdings by more than two-thirds.

Wittmann's first significant acquisition was *The Crowning of Saint Catherine* (pp. 138–39) by Peter Paul Rubens, a painting often cited as the greatest work by Rubens in an American

collection. Another notable Wittmann acquisition was Thomas Cole's *The Architect's Dream* (pp. 190–91), which Wittmann purchased directly from the artist's granddaughter, Florence H. Cole Vincent, when he traveled to Cole's home on the Hudson River in upstate New York in 1949. The Cole painting, along with others—such as *Blind-Man's Buff* (p. 166) by the French Rococo artist Jean-Honoré Fragonard—illustrate Wittmann's remarkable ability to seek out works that, although from underappreciated time periods or genres when they were acquired, would eventually be recognized as gems of the collection.

Wittmann's keen eye also proved to have a lasting impact on the display of the collection, as he championed what was then an innovative approach: exhibiting painting and sculpture alongside decorative arts and furniture, a display philosophy that the Museum still embraces (fig. 9). Wittmann also expanded the collection into new areas, establishing the African art collection in 1958 (pp. 52 and 54), pursuing photography in the 1960s and '70s (see p. 266), and supporting the experimental glass workshops held on the Museum's grounds in 1962 that would later give birth to the Studio Glass movement (see p. 297 and fig. 10). Strongly committed to education and community, Wittmann established the Museum's volunteer Docent corps and the fund-raising group the Ambassadors (originally the Museum Aides). His efforts are encapsulated by his statement in 1968, "Without art the Museum would be only a school. Without education the Museum might become only a warehouse. Both must be present if the Museum is to continue to play its significant cultural role in our community."[2]

By the end of Wittmann's tenure, the core of what is now recognized as the Toledo Museum of Art's outstanding collection had been established, with the final years of his directorship ushering in a burgeoning focus on collecting contemporary art. The desire to bring the best examples of the world's artistic production to the people of Toledo, Ohio—and to the world—goes back to the first years of the Museum and the energetic efforts of the Stevenses and the Libbeys. Today the Toledo Museum of Art is home to a near-encyclopedic art collection of 23,000 objects of exceptional quality, housed in buildings of architectural significance on a 40-acre campus that marks the gateway to downtown Toledo. The transformation that has occurred since its founding in 1901 has been made possible by the thoughtful stewardship of generations of trustees, directors, staff, volunteers, and community members who have fostered the Museum's development from strength to strength. The result is a museum that enjoys a national and international reputation and regularly receives more than 400,000 visitors a year, more per capita than any other major art museum in the United States, except the National Gallery of Art in Washington, DC. While dynamic programming, dazzling and thought-provoking exhibitions, and robust, inclusive educational offerings have contributed to the Museum's reputation, at the heart of its regard—and at the heart of everything the Toledo Museum of Art does—is its sterling collection, which continues to grow in strength and quality while connecting in essential ways with its audiences.

— Halona Norton-Westbrook
 Director of Curatorial Affairs
 Toledo Museum of Art

1 "The Art Museum Becomes a Center of Life and Activity under the Management of Director George W. Stevens," *Sunday Courier Journal* (Toledo, Ohio), November 8, 1903.

2 Toledo Museum of Art Annual Report, 1968.

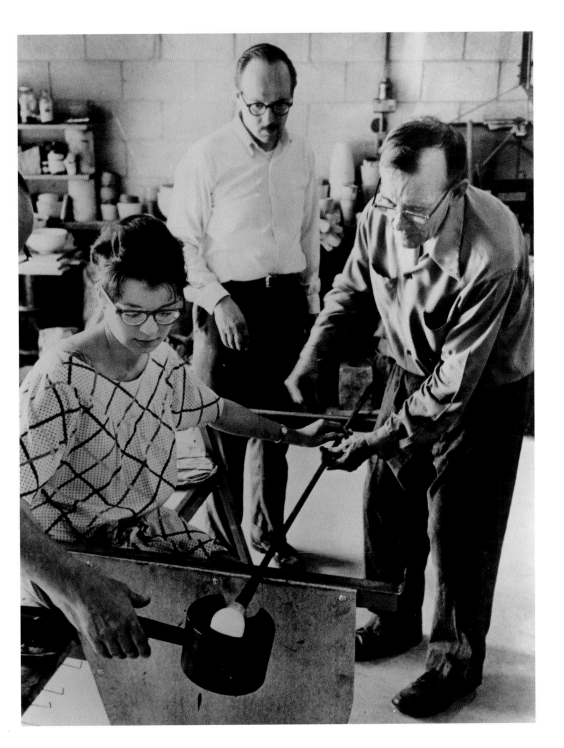

FIG. 10

Rosemary Gulasso, Harvey Littleton, and Harvey Leafgreen at the second experimental Toledo Workshop for studio glassblowing on the Toledo Museum of Art campus, June 1962.

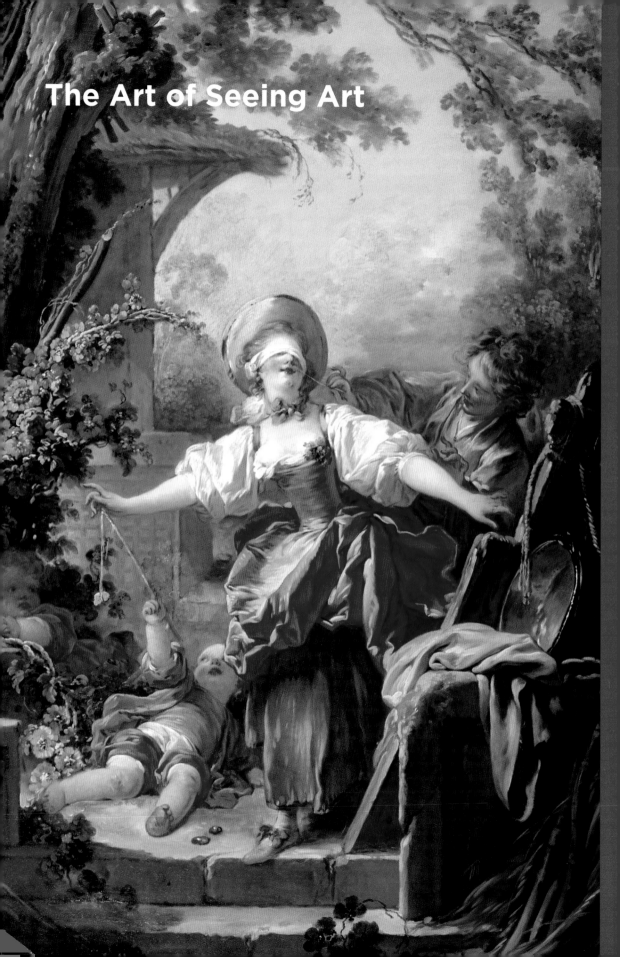

The Art of Seeing Art

THE ART OF SEEING ART™

The average person spends **17 SECONDS** looking at a work of art in a museum. It usually takes less time than that to identify an image. But understanding it? That requires slowing down and taking your time to see the details through thoughtful **CLOSE LOOKING**.

 THE ART OF SEEING ART™ is the Toledo Museum of Art's six-part process for looking carefully and exploring a work of art—or any image encountered in daily life—on a deeper level.

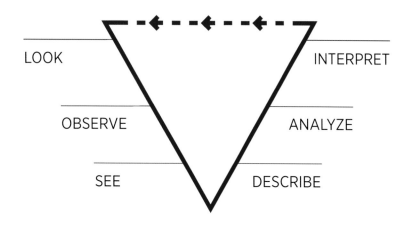

1. LOOK

Take the time to slow down and look carefully.

2. OBSERVE

Observation is an active process, requiring time and attention. With this step you begin to compile a mental catalogue of the image's visual elements.

3. SEE

Looking is a physical act; seeing is a mental process of perception. Seeing involves recognizing or connecting the information your eyes take in with your previous knowledge and experiences to create meaning.

4. DESCRIBE

Describing can help you to identify and organize your thoughts about what you have seen, like taking a careful inventory.

5. ANALYZE

Analysis allows you to consider how the details you identified through description fit together to express meaning or tell a story.

6. INTERPRET

Interpretation combines description and analysis with previous knowledge and any additional information acquired about the image or its maker. Interpretation allows you to draw conclusions about the image.

BUILDING YOUR VOCABULARY

As words build a sentence, the **ELEMENTS OF ART** and the **PRINCIPLES OF DESIGN** build an image. Recognizing the Elements of Art and Principles of Design and understanding how artists use them to create a composition, convey mood, and communicate meaning helps you to see more fully.

ELEMENTS OF ART

COLOR	LINE	SHAPE	SPACE	TEXTURE

PRINCIPLES OF DESIGN

BALANCE	EMPHASIS	HARMONY	MOVEMENT

PROPORTION	RYHTHM	UNITY	VARIETY

UNLOCKING THE MEANING OF IMAGES

Learning to look is the gateway to understanding the visual world. Once you've followed the six-step process of The Art of Seeing Art™ and have absorbed the details of an image, you're ready to read it using these visual languages: **FORM, SYMBOLS, IDEAS,** and **MEANING.** Look for special comparisons throughout this book that use these visual languages to explore diverse works of art.

FORM

Images convey meaning through the Elements of Art and the Principles of Design. Composition is the arrangement of the Elements according to the Principles.

SYMBOLS

Symbols—things that have meaning by association or that stand in for something else—are a powerful part of how we understand the visual world. We recognize symbols by calling on personal knowledge gained through memory and lived experience.

IDEAS

Culture and history influence how and what we see. What was the image-maker trying to convey and how does this relate to the time and place in which the image was created? Similarly, how do the values and beliefs of our own society shape our understanding of an image?

MEANING

Interpretation—making meaning—occurs when we merge together the lenses of Form, Symbols, and Ideas. Being visually literate means that you become aware of these factors and are able to not only understand what you are seeing but also to ask yourself why you see it the way you do.

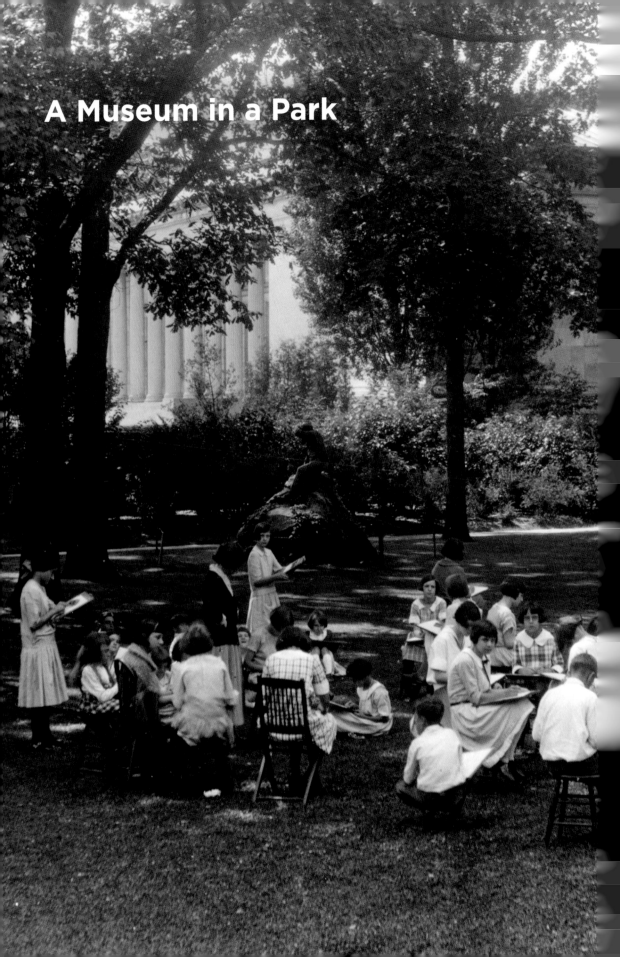

A Museum in a Park

The Toledo Museum of Art is not simply an art museum, it comprises an exceptional assortment of buildings and innovative programs that offer visitors a lively range of experiences. The seven founders of the Museum included an attorney, an architect, an industrialist, a realtor, a journalist, and two artists—each focused on a shared vision of creating an institution that would enhance the city through its art collection, its commitment to art education, and its outreach to the community. From its beginning in 1901, the Museum has held an important position in the life of its home city, a role it has assumed at every turn in its growing and expanding campus. That position was firmly anchored with the opening of its classically inspired building in 1912, set in a leafy neighborhood on a few acres of inviting parkland a mile from downtown Toledo. Today, that setting has expanded to a 40-acre landscaped campus that includes buildings by award-winning architects, an expansive sculpture garden, a formal garden, community vegetable gardens, a playground, and hundreds of trees, some at least a century old (fig. 1).

Like the world-class collection of art inside the Museum and throughout the Sculpture Garden, the campus's green space contributes to the well-being of the community and has become a site of recreation, reflection, and connection. It is a haven for urban wildlife, including migrating birds and pollinating insects. It attracts joggers, dog-walkers, picnickers, and lunch-hour strollers. Indeed, just as the arts do, urban green spaces add to the vitality and character of a city and make it a more welcoming place to live. The campus is an integral part of that goal and the lynchpin of future development plans that will seek to further enrich the adjacent neighborhoods and the city overall, beckoning all to enjoy this "Museum in a Park."

Developing a Campus

When the Museum first opened, it presented temporary exhibitions in a rented building in

FIG. 1

The picturesque grounds surrounding the Museum.

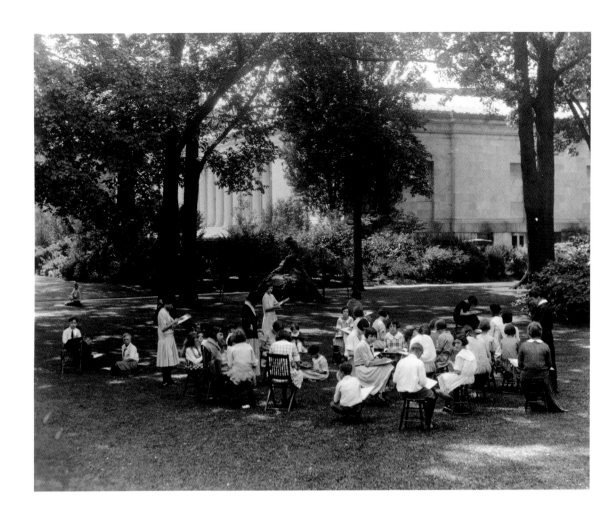

downtown Toledo. In 1908 Edward Drummond Libbey and his wife, Florence Scott Libbey, two of the Museum's co-founders and benefactors, donated the estate of Florence's recently deceased father as the site for a grand new building for the seven-year-old Museum. The Scott estate, along with some additional land purchased by the Libbeys for the Museum, totaled about 4½ acres along Monroe Street in what is now the Old West End historic neighborhood. The Greek revival building that was built on this site in 1912 was designed by Edward B. Green of the Buffalo architectural firm Green & Wicks, assisted by Toledo architect Harry Wachter, who had also designed many of the Victorian homes in the city's Old West End. The Museum building featured a symmetrical design with a sweeping, horizontal, white marble-clad façade, a low copper roof with a cornice of lion's heads and acanthus leaves, and a central row of sixteen fluted Ionic columns. The gleaming marble and copper were set off by the greenery of the setting, with landscaped lawns and mature trees (fig. 2). By 1916, only four years later, the Museum was already outgrowing its new building, and an addition was planned. World War I (1914–18) and a subsequent economic downturn intervened, and so the expansion to the back of the building—which was planned to more than double the Museum's square footage—was not completed until 1926. At that point, the

FIG. 2

A drawing class under the trees at the Toledo Museum of Art, 1923.

FIG. 3

The Peristyle, Toledo Museum of Art, added 1933.

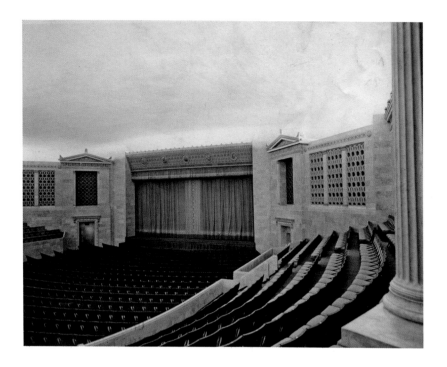

expanded building not only included additional gallery space, but also classrooms, a lecture hall, and an auditorium.

Upon Mr. Libbey's sudden death in 1925, Florence Scott Libbey generously funded the building of two new colonnaded wings with terraces and staircases to match the central block of the building. Mrs. Libbey's altruism allowed the planned construction to be advanced considerably, providing much-needed jobs to 2,500 workers for two years during the height of the Great Depression (1929–39). The Museum's East and West Wings, which opened in 1933, included an addition close to Mrs. Libbey's heart: the Peristyle, a 1,750-seat concert hall (fig. 3). This strikingly beautiful space was modeled after an ancient Greek amphitheater. Besides serving as the location for Museum lectures, performances, and events, the Peristyle is also the main venue for the Toledo Symphony Orchestra.

The Museum expanded its campus again in the 1960s and '70s with the acquisition of additional surrounding land and the construction of the Glass Crafts Building in 1969. This new facility established the Toledo Museum of Art as the first museum in the United States with a studio built specifically for teaching glassworking techniques.

From 1977 to 1992 the Museum embarked on an ambitious renovation program, which included essential modifications to the educational facilities, the creation of a new ground-level public entrance, and the Ward and Mariam Canaday Gallery for special exhibitions. The last phase of this renovation and new construction was funded by the Museum's first public capital campaign, undertaken in cooperation with the University of Toledo, whose art department was, uniquely, located in the Museum. A major goal of the capital campaign was to raise funding for a new building for the University's art department, one that would also house the Museum's Art Reference Library. The capital campaign was successful, and Pritzker Prize laureate Frank O. Gehry was

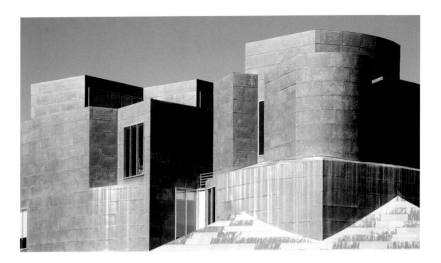

FIG. 4
Center for the Visual Arts, University of Toledo, designed by Frank O. Gehry, and completed in 1992.

FIG. 5
Toledo Museum of Art Glass Pavilion, designed by SANAA (Sejima and Nishizawa and Associates), and completed in 2006.

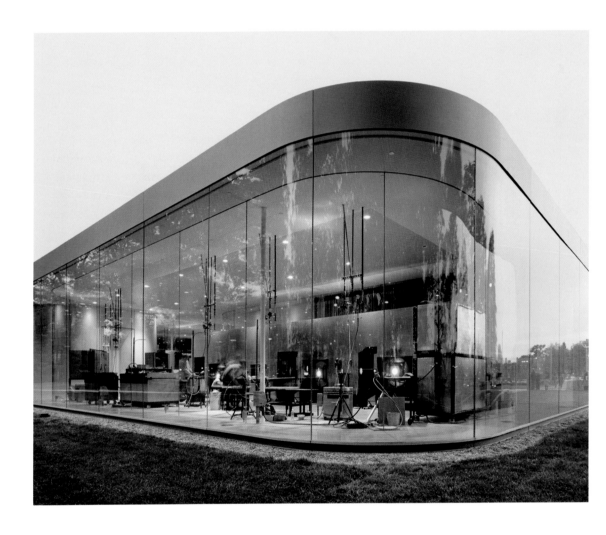

chosen as the architect. Dedicated in December 1992, the four-level structure, dubbed the Center for the Visual Arts (CVA), is located at the east end of the Museum building, creating an integral bond with the Museum's collections (fig. 4). While its sculptural lead-sheathed forms and green glass are striking counterpoints to the Museum's classical-style building, the CVA harmonizes with the older building's height, proportions, and masonry. It also echoes the Museum's central block and wings, though transformed into a V-shaped plan.

In 1995 the Museum initiated a comprehensive landscape-design project, undertaken by the renowned landscape architecture firm Olin Partnership. The project culminated in the opening of the Georgia and David K. Welles Sculpture Garden in 2001, in time to mark the Museum's centennial. By placing twenty-two sculptures in a newly landscaped setting, the visitor experience now extended to the outdoors. Today, the Welles Sculpture Garden includes the Glass Pavilion grounds and features twenty-seven works of art.

The Museum's one-hundredth anniversary was also the occasion for planning a new building to house its extensive and celebrated collection of glass art. Designed by Tokyo-based SANAA, led by Kazuyo Sejima and Ryue Nishizawa, the Glass Pavilion opened in 2006. In addition to galleries, classrooms, and open storage space, the building houses state-of-the-art glassmaking facilities where glass-working demonstrations are held daily. All exterior walls and most interior walls are made entirely of curved glass panels, blurring the boundaries between interior and exterior space (fig. 5). The location of the Glass Pavilion—on an axis across Monroe Street facing the Museum's main building—has served to unify the Museum campus on both sides of Monroe Street and has connected the Museum more strongly with the adjacent neighborhood, the historic Old West

End. The Glass Pavilion's park-like setting, like that of the Museum's main building, features many grand old trees, providing visitors with a shady oasis of greenspace.

The Campus and the Community

One of the earliest examples of the Museum actively contributing to the betterment of Toledo was its involvement in the City Beautiful Campaign of 1914, the goal of which was to plant flower and vegetable gardens throughout the city. This project paralleled the nationwide City Beautiful Movement (1890s–1920s), which sought to align urban planning with social issues. The Museum spearheaded Toledo's beautification campaign, offering lectures on horticulture to 30,000 adults and children and distributing seed packets. At the end of the campaign, the Museum held a flower and vegetable exhibition in its galleries. The Museum revived its connection to environmental sensitivity in 2009 when it formed an agreement with Toledo GROWs (a community-gardening outreach program) and other partners to encourage young gardeners and community members to grow and harvest vegetables, herbs, and flowers on Museum property. Then, in 2016, the Museum opened the Rita B. Kern Garden, a formal garden that includes a glass fountain made in the Glass Pavilion hot shop and a kitchen garden for the Museum Café.

In 1914, alongside the City Beautiful Campaign, the Museum launched its Bird Campaign. After spending the winter learning about birds in classes held at the Museum, children of Toledo built more than 3,000 birdhouses (fig. 6). These were exhibited at the Museum before being placed in public parks. Not surprisingly, the Bird Campaign inspired the Museum's Bird and Tree Club, and by 1921 some 20,000 children were members. The Museum's advocacy for birds and trees

manifests itself today in biennial exhibitions of bird-themed art, recognizing the region's significance for migratory birds, and the cataloguing and labeling of the campus's diverse array of trees in preparation for its planned certification as an arboretum.

In 2014 the Museum inaugurated its annual summer Block Party, a campus-wide event for all ages that attracts more than 7,000 participants. It features outdoor music, dance, and other performances, hands-on art activities, a scavenger hunt, food trucks, and a DJ and dance party (fig. 7). To promote creative play, in 2016 the Museum added a dedicated Play Space to the campus, where children can build structures with oversized foam blocks, play a sidewalk game designed by the Museum's Teen Apprentices with a local artist, and make music with large, outdoor percussion instruments. These activities are part of the Museum's continuing commitment to being a Museum in a Park—a place of respite, of wonder, and of learning for the neighborhood, the wider city of Toledo, and all who visit from across the country and around the world.

Looking Forward

In February 2018 the Toledo Museum of Art unveiled a new comprehensive Master Plan to unify all parts of the growing campus and to increase accessibility and ensure sustainability. The first phase of the plan will further the Museum's efforts to develop the grounds as an urban park within the city of Toledo. Projects include creating new greenspace, unifying the architectural and visitor experience, and enhancing the existing gardens and

FIG. 6

Children with their hand-made bird houses on the front terrace of the Toledo Museum of Art, 1914.

FIG. 7

The Toledo Museum of Art's fourth annual Block Party, 2017.

landscaping. Building on more than a century of community engagement, the Museum's new plan dovetails with the city's goals for the surrounding neighborhood and will weave the Museum and its campus into the broader urban fabric of downtown Toledo. This plan also fulfills Edward Drummond Libbey's vision for the Museum, stated in 1914: "Let us broaden the scope of the Museum. Let its influence enter into the civic improvement of our city, into our parks, our playgrounds, our schools . . . and be a factor and an inspiration for all those things which better civilization and elevate mankind."

— Brian P. Kennedy
 Edward Drummond and Florence Scott Libbey
 Director
 Toledo Museum of Art

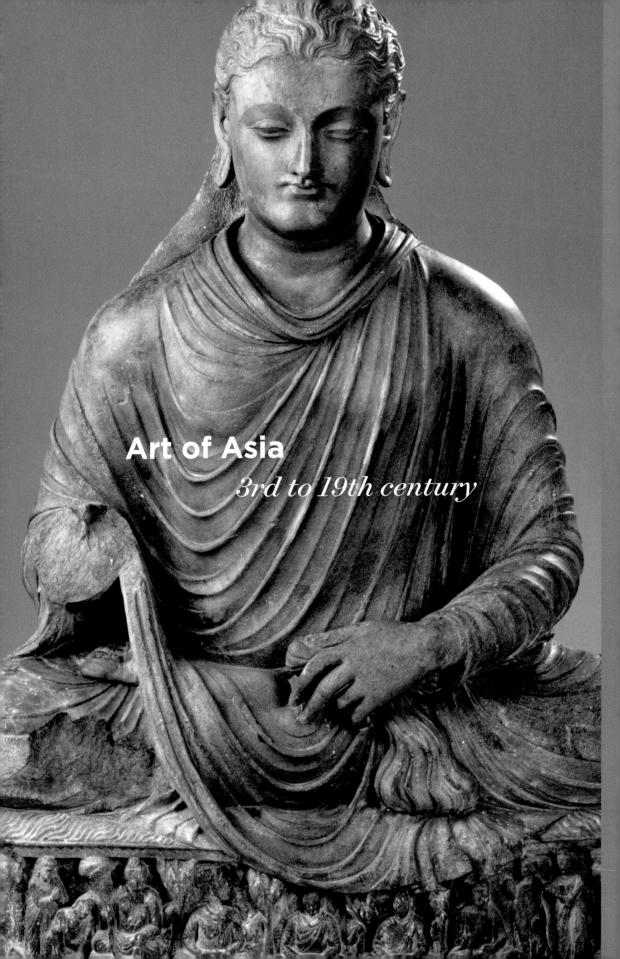

Art of Asia

3rd to 19th century

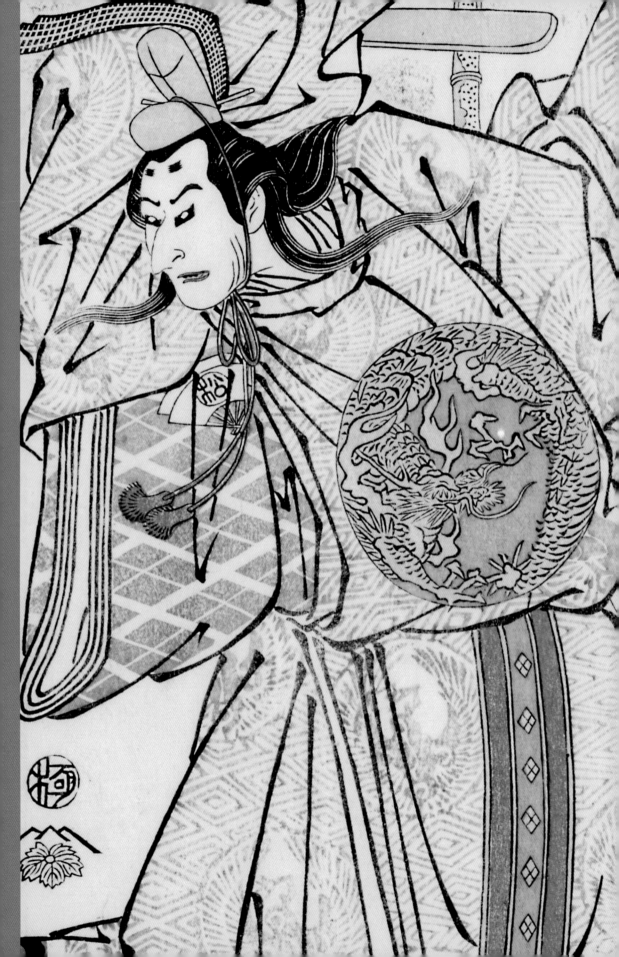

Gandharan, modern-day Pakistan, **Seated Buddha**. Schist, carved, about 250 CE. H. 31½ in. (80 cm). Purchased with funds given by Mr. and Mrs. Preston Levis, 2000.11

Artists first portrayed the Buddha in human form in the first century CE in the region of northwest India called Gandhara (what is now northwestern Pakistan and eastern Afghanistan). Before that time, the Buddha's presence was merely suggested, either by his footprints or by an empty throne. Gandhara was among Alexander the Great's easternmost conquests in 327 BCE and, as a result, artists and artisans in that region were exposed to Greek, and then Roman, culture. The idealized, youthful features and wavy hair of this Buddha were inspired by classical images of the Greco-Roman god Apollo.

This figure displays two distinctive *mudras*, or symbolic hand gestures. The missing right arm would have been raised with palm facing out, assuring the worshipper of Buddha's protection. Buddha's left hand clasps his robe, a gesture symbolizing his intention of answering the devotee's prayer. He sits, lotus-style, on a plinth that represents a *mandala*, or diagram, of the five cosmic Buddhas (the Tathagatas). Flanked by representations of the donors who provided money for the sculpture, they symbolize the four cardinal directions, the center of the cosmos, and the attainment of perfection.

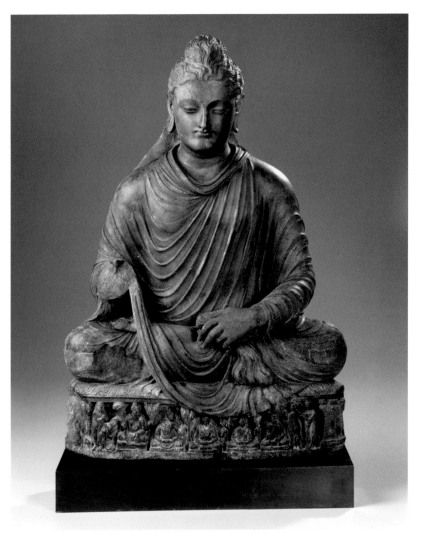

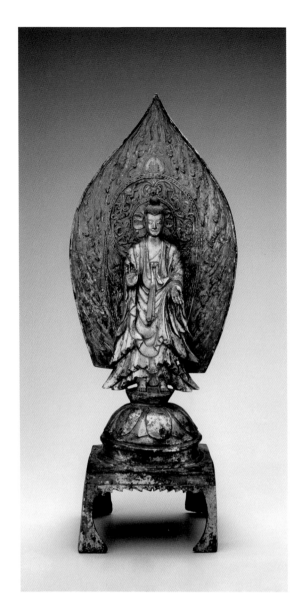

Elegant sculptures such as this were created as offerings to Buddhist temples and monasteries or placed on family altars to solicit sprititual and physical well-being for their donors. According to an inscription on the back of the *mandorla*, or body halo, this gilded bronze Buddha was commissioned and dedicated by members of the Lo family in the sixth century.

Buddhism originated in India in the fifth century BCE; by the first century CE, it had reached China along the trade routes. This sculpture represents Maitreya, a Buddha of the future. He raises his right hand in a gesture of reassurance; his left hand makes a sign of charity. Swirling flames and lotus and honeysuckle flowers enrich the *mandorla* behind him. The swooping rhythms of the garments and the halo's surface and shape establish an upward movement, which would have been intensified by candlelight flickering over the burnished gold surface.

China, Northern Wei Dynasty (386–535 CE), **Standing Buddha**. Gilded bronze, about 530 CE. H. 23 in. (58.4 cm). Purchased with funds from the Florence Scott Libbey Bequest in Memory of her Father, Maurice A. Scott, 1956.55

China, after Guo Xi (Chinese, about 1020–1090), Yuan Dynasty (1279–1368), detail from **Winter Landscape**. Ink and opaque colors on silk. Painting: 21 ¹¹⁄₁₆ x 189 ¼ in. (55 x 480.7 cm), scroll: 22 ³⁄₁₆ x 400 ³⁄₁₆ in. (56.4 x 1016.5 cm). Purchased with funds from the Libbey Endowment, Gift of Edward Drummond Libbey, 1927.151

Like a musical composition, this unusually long handscroll—more than thirty-three feet—flows rhythmically through varied stretches of grand landscapes. The entire scroll was never intended to be seen all at once, however. Instead, it was meant to be unrolled by a seated viewer, one section at a time. Each section would thus nourish and refresh the spirit of the viewer, who would

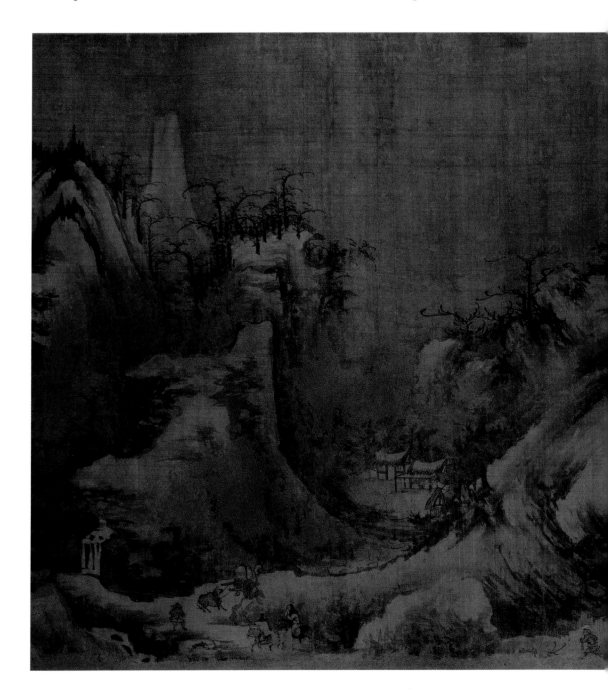

take an imaginary journey, over time, through a panorama representing the whole of nature.

Many scholars believe *Winter Landscape* to be among the oldest known surviving Chinese handscrolls. It reproduces a lost scroll painted more than two centuries earlier by the Northern Song Dynasty painter Guo Xi, who wrote an important treatise on landscape painting. Although the composition is not original, the unknown painter of this scroll was considered no less worthy for imitating an existing work. In fact, styles and forms developed by past masters were so revered at the emperor's court that his artists were expected to study and reproduce them, and in so doing to identify with tradition.

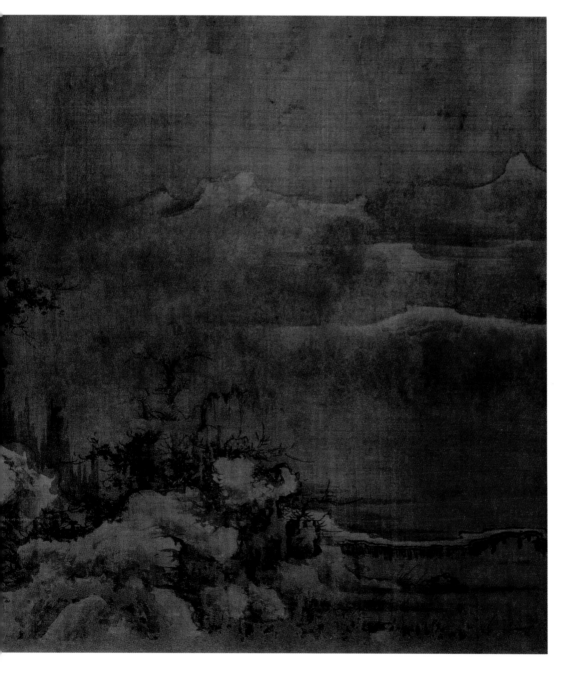

Japan, Kamakura Period (1186–1334), **Bishamonten, Guardian of the North**. Hinoki wood with lacquer paste and traces of gilding, about 1250–1300. H. 75 in. (190.5 cm). Gift of The Georgia Welles Apollo Society, 2008.118

Ferocious Bishamonten is one of the four guardian figures placed at the corners of the main altar in a Buddhist temple. These figures correspond to the four cardinal directions—North, South, East, and West—with Bishamonten representing the North. In addition to protecting the Realm of the North, he is guardian of Buddhist law, god of victory in war, and god of wealth and good fortune.

This life-size figure, carved from a single block of wood, is a fine example of sculpture from Japan's Kamakura period, which is characterized by a strong sense of movement and of realism. Bishamonten stands on a mountaintop with his left hand raised to hold a small pagoda (now missing), symbolic of a treasure house. His raised right fist once held a spear. His billowing sleeves add to the dynamism of the figure, and the demon mask at his waist implies the conquest of evil.

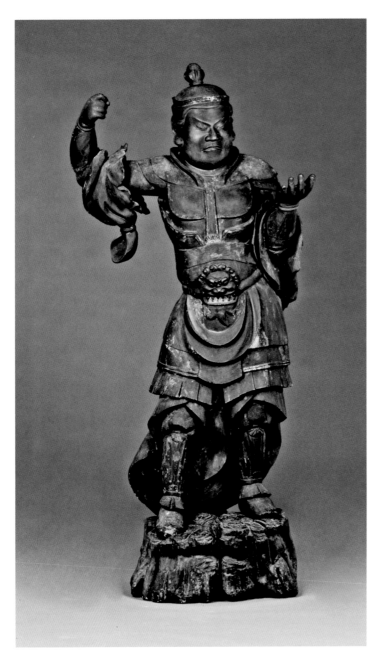

This dynamic image, thought to be the only surviving impression of this print, is one of about 160 woodblock prints produced by artist Toshusai Sharaku. All were completed in a ten-month period between 1794 and 1795, before and after which no artist by that name was producing art. This print depicts the well-known Kabuki actor Onoe Matsusuke (1744–1815) in the role of Ashikaga Takauji, a tyrant who plots against the emperor, in the play *Matsu Wa Misao Onna Kusanoki* (Steadfast as the pine tree is the woman of the Kusanoki clan).

Kabuki actors were revered by the public, and prints of these actors, always shown in their stage roles, were avidly collected. Sharaku created a new form of actor print, often taking into consideration the actor's personality as well as the role he was portraying. Instead of idealizing the actors, Sharaku deliberately exaggerated their personal physical traits, creating a form of caricature not always appreciated by his subjects.

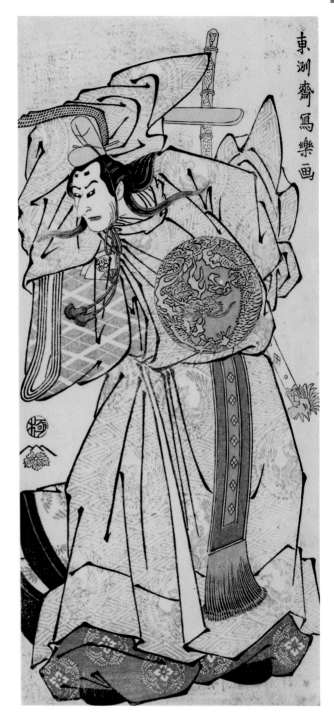

Toshusai Sharaku (Japanese, active 1794–1795), **Onoe Matsusuke as Ashikaga Takauji**, from **Matsu Wa Misao Onna Kusanoki**. Publisher: Tsutaya Juzaburō (Japanese, 1750–1797). Color woodblock print, 1794. Sheet: 12¼ x 5⅝ in. (31.1 x 14.3 cm). Purchased with funds given by Jonathan F. Orser and from the Florence Scott Libbey Bequest in Memory of her Father, Maurice A. Scott, by exchange, 2006.38

Netsuke: Miniature Japanese Sculptures

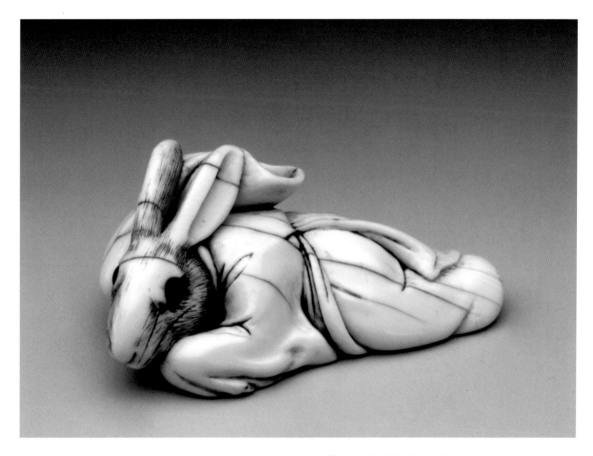

Masanao of Kyoto (Japanese, 18th century), **Netsuke: Reclining Rabbit in a Kimono**. Ivory and amber, late 18th century. L. 2 3/16 in. (5.5 cm). Gift of H. A. Fee, 1950.171

During the Edo Period (1615–1868), Japanese craftsmen created a striking new category of personal adornment in the form of carved toggles made to attach containers for personal belongings to the sashes of men's silk robes. Called *netsuke*, these toggles probably originated as natural objects such as gourds, shells, nuts, or roots, but by the seventeenth century they had developed into a significant art form widely collected by fashionable Japanese gentlemen. The Toledo Museum of Art has a significant collection of these miniature sculptures, numbering more than 500.

The late-eighteenth-century ivory netsuke of a rabbit dressed in monk's robes, by master netsuke carver Masanao of Kyoto, exhibits the skill of the best netsuke carvers and the whimsical nature of many of these small, functional treasures. The wood and antler *Warrior and Helmet* is more imposing with its fierce expression and elaborate, removable headgear. By the nineteenth century, the great centers of Japanese ceramics manufacture began producing exquisite porcelain netsuke, such as the *shishi* lion on a lotus blossom.

Japan, Edo Period (1615–1868), **Netsuke: Warrior and Helmet**. Wood with horn and stag antler inlays, early 19th century. H. 2⅜ in. (6 cm). Gift of Richard R. Silverman in memory of his brother, Irwin Silverman, 2000.44a–b

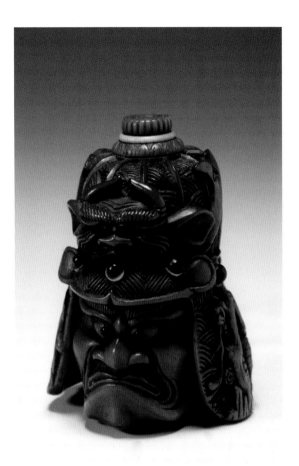

Japan, Edo Period (1615–1868), **Netsuke: Crouching Shishi Lion on a Lotus Pedestal**. Hirado ware: porcelain with clear, blue, brown, and celadon glazes, mid-19th century. H. 1⅝₆ in. (3.4 cm). Gift of Richard R. Silverman, 2009.69

Symbols: Meaning in Material

The choice of material for a work of art can be determined by many factors, including cost, appearance, availability, and, simply, preference. But sometimes the material also carries meaning. Precious metals—especially gold—have long been symbols of status, wealth and power, and indicators of fine craftsmanship. Consider how gold expresses cultural and spiritual beliefs in these diverse examples from fifteenth-century Tibet, the Baule society of Côte d'Ivoire, ancient Greece, and Renaissance Italy.

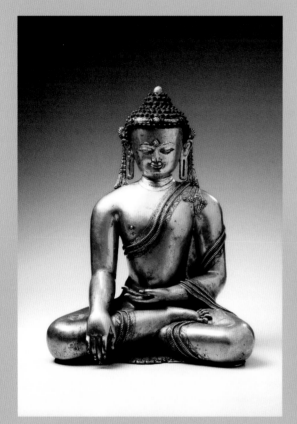

Baule people, Côte d'Ivoire, **Pendant**. Gold, early 20th century. H. 1^{15}⁄$_{16}$ in. (5 cm). Purchased with funds from the Libbey Endowment, Gift of Edward Drummond Libbey, 1977.72

For Baule people, gold is godlike and is considered an heirloom that evokes the presence of the ancestors. In this small pendant, for example, the gold has been cast and tooled into an ancestral likeness.

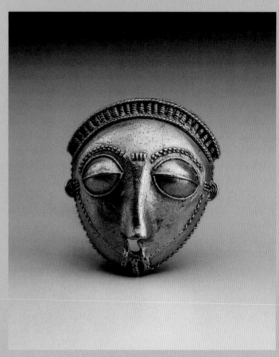

Tibet, **Seated Buddha**. Gilded bronze with lapis lazuli and turquoise, about 1450. H. 14^{13}⁄$_{16}$ in. (37.6 cm). Gift of The Georgia Welles Apollo Society, 1989.4

Gold is the foremost of the five precious substances in Tibetan Buddhist symbolism (gold, pearls, crystal, coral, and turquoise or lapis lazuli). Gold, associated with the sun and fire, has a sacred status in Tibetan Buddhism.

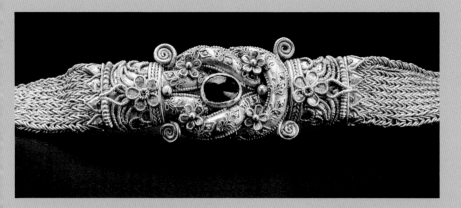

Greek, Hellenistic period (about 323–31 BCE), detail of **Diadem**. Gold, garnet, and blue glass enamel inlay, about 250–200 BCE. L. 14 ½ in. (36.8 cm). Gift of The Georgia Welles Apollo Society, with additional funds from the Libbey Endowment, Gift of Edward Drummond Libbey, 2005.45

The ancient Greeks wore gold to enhance their beauty and status. Surviving jewelry, such as this exquisite gold headband, likely a gift for a bride, has been found mostly in tombs, intended to adorn the deceased in the next world.

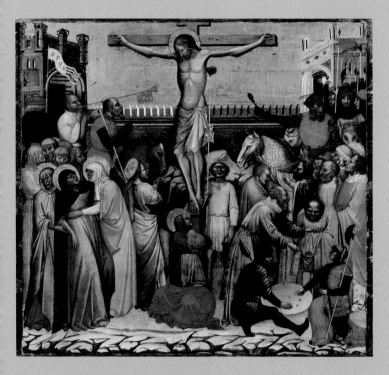

In this painted Christian devotional panel from the early Renaissance, a background of gold leaf, burnished to shining brilliance, symbolizes the light of heaven.

Jacobello del Fiore (Italian, about 1375–1439), **The Crucifixion**. Tempera and gold on wood panel, about 1395–1400. 49 ⅝ x 53 in. (126 x 135 cm). Purchased with funds from the Libbey Endowment, Gift of Edward Drummond Libbey, by exchange, 2008.170

Symbols are a powerful part of how we understand the visual world

Art of Sub-Saharan Africa

16th to 19th century

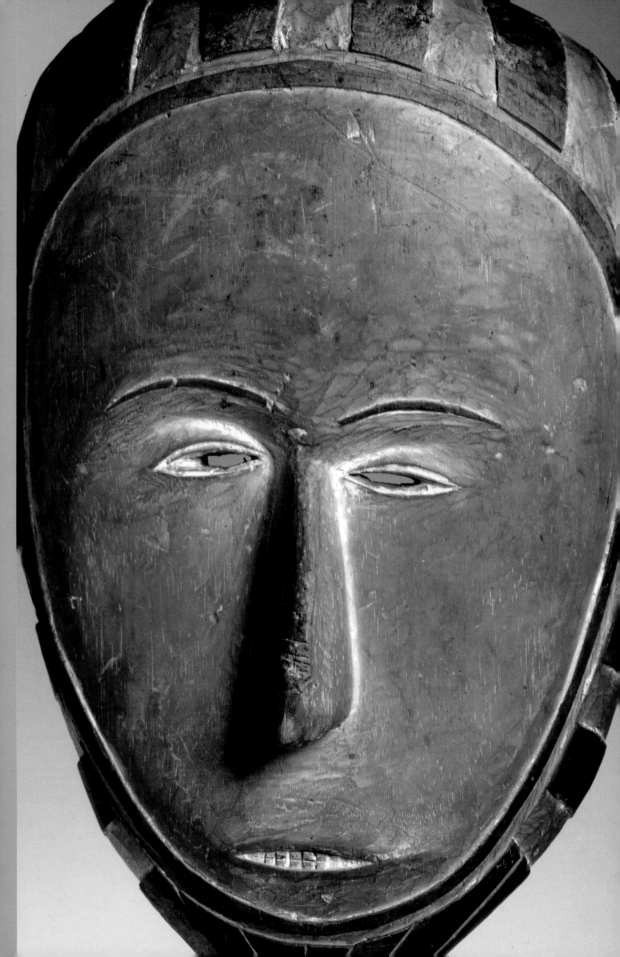

Yoruba people, Owo group, Kingdom of Owo (modern-day Nigeria), **Shrine Figure**. Ivory stained with camwood powder, 16th or 17th century. H. 7 $^{15}/_{16}$ in. (20.1 cm). Purchased with funds from the Libbey Endowment, Gift of Edward Drummond Libbey, 1976.40

In the great Owo Kingdom of the sixteenth to eighteenth centuries, ivory was a prestigious material, reserved for ceremonial objects and royal ornaments. This masterfully carved ivory figure may represent the Owo king (*olowo*) with aspects of both woman and man. The king dressed as a woman for some ceremonies to honor female ancestors and to express the hidden side of his own power. This figure has breasts and wears a full skirt and a braided hair cap. Balancing a pot of sacred water and healing herbs on its head, the figure's nude torso and implied kneeling posture signify humility while praying to the gods.

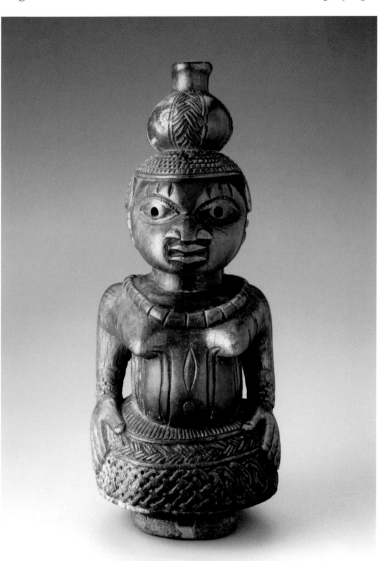

The kingdom of Owo was located between the ancient Yoruba spiritual center of Ile-Ife and Benin City, capital of the powerful Benin Empire. This figure reflects the influence of both Owo culture (large bulging eyes) and Benin culture (cosmetic markings above the eyes and on the torso). The red-brown color and the wear on the beads of the necklace indicate repeated ritual application of camwood powder.

Tabwa people, Ujiji region (modern-day Tanzania), **Figure of a Woman Carrying a Child**. Wood, pigment, fiber, metal, before 1880. H. 20 in. (50.8 cm). Gift of The Georgia Welles Apollo Society, 2011.12

In the Tabwa culture, sculptures of ancestral figures, called *mikisi*, were kept in memorial shrines. The Tabwa people traced their lineage through the mother's family, which in part explains this *mikisi*'s depiction of a woman carrying a child on her back. The features of the female figure encapsulate key elements of Tabwa beauty: short, bent legs; rounded hips; elongated neck and torso; pierced ears; and a short, braided hairstyle. Patterned scarification on the figure's torso, which represent traces of tribal initiation rituals, complement the body's rounded, organic forms.

When Christian missionaries reached the Tabwa villages in the 1870s, they interpreted the reverence for these figures as "idolatrous" and destroyed the vast majority of them. This sculpture, then, is an exceedingly rare example of a maternity figure that may have pre-dated Western contact.

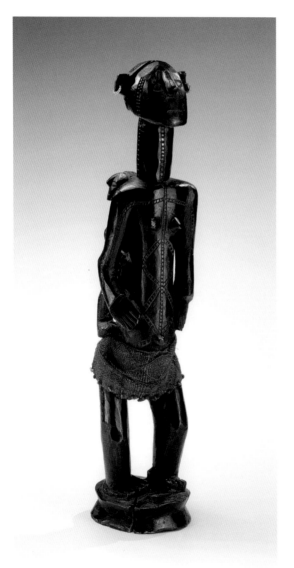
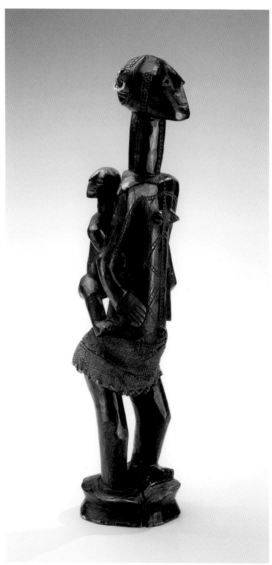

Edo people, Nigeria, Benin City, **Queen Mother Head**. Brass, late 19th century. H. 18½ in. (47 cm). Purchased with funds from the Libbey Endowment, Gift of Edward Drummond Libbey, 1958.4

Benin kings (*obas*) honor their mothers by placing a cast brass commemorative head on an ancestral altar. These sculptures celebrate the special powers of Idia, the venerable mother of the sixteenth-century Oba Esigie. Esigie recognized his mother's importance to his own authority by creating for her both a title (Queen Mother) and her own independent court. The peaked hairstyle, known as the "chicken's beak," is still worn by royal women of the Benin court today. Coral beads, also cast in brass, adorn her hair, and a semicircular opening in the top of the head, behind the peak, once supported a carved-ivory elephant tusk. The forehead bears the raised marks of ritual scarification, and the chin and elongated neck are hidden under rows upon rows of necklaces. The rich brown patina and the state of preservation distinguish this sculpture as a superlative example of its type.

Attributed to Bamgbose (died 1920) or Areogun (about 1880–1954), Yoruba people, Nigeria,
Epa Helmet Mask: Mother of Twins (Iyabeji). Wood, pigment, mid-19th–early 20th
century. H. 49½ in. (125.7 cm). Purchased with funds from the Libbey Endowment, Gift of Edward
Drummond Libbey, 1977.22

Yoruba culture includes rich masquerade traditions that incorporate music, costumes, and helmet masks, such as the annual Epa festival. Epa masks, which commemorate ancestors, are impressive sculptures; their complex forms are carved from a single block of hardwood.

This mask supports seven figures, all focused around the largest, a mother holding her twins. *Ibeji* (twins) are deeply symbolic to the Yoruba, who have the highest twinning rate in the world and believe twins to have superhuman powers that can bring both good and evil.

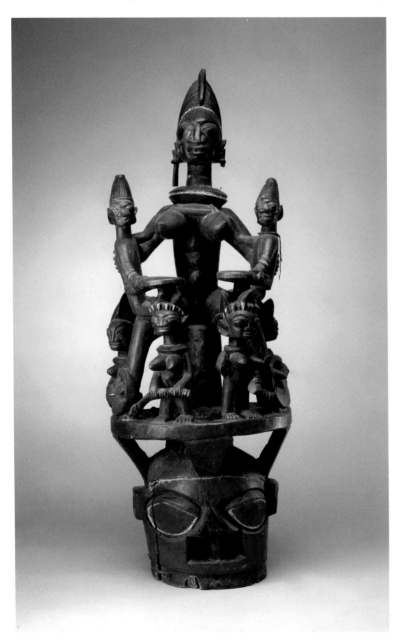

This carved mask celebrates both the *ase* (life-force) and *ewa* (beauty) that the gods bestowed on the woman depicted. The twin boys are supported from below by twin girls; they, in turn, are protected by the boys, who hold cooling fans above the girls' heads. The mother's massive collar is a type worn by devotees of Oshun, goddess of love, beauty, and childbearing. The cosmetic scars on her face, her ear plugs, and the *agogo* (cockscomb) hairstyle signal that she is married. Her well-groomed appearance reveals the outward evidence of her inner virtue.

Fang people, Gabon, **Mask: Ngontang**. Wood, pigment, late 19th century. H. 17 in. (43.2 cm). Purchased with funds from the Libbey Endowment, Gift of Edward Drummond Libbey, 1958.16

The Fang people, who live in Gabon and Cameroon, are known for their refined wood carvings. This carved wood mask is derived from a traditional Fang type known as *ngontang*, once used in ceremonies to celebrate the visitation of spirits upon the living. The white pigment on this mask suggests death, otherworldliness, and states of transition. For the Fang people, white represented the "otherness" of the spirit world.

This mask was probably never used in a Fang ritual, but was instead made some time before 1900 as part of a group of souvenir masks sold to foreigners. Ownership records reveal that this mask made its way to Paris and once belonged to two early Modernist artists, Maurice de Vlaminck (1876–1958) and André Derain (1880–1954). Like so many other European artists active during the late nineteenth and early twentieth centuries, the abstract and formal qualities of African sculpture influenced their work.

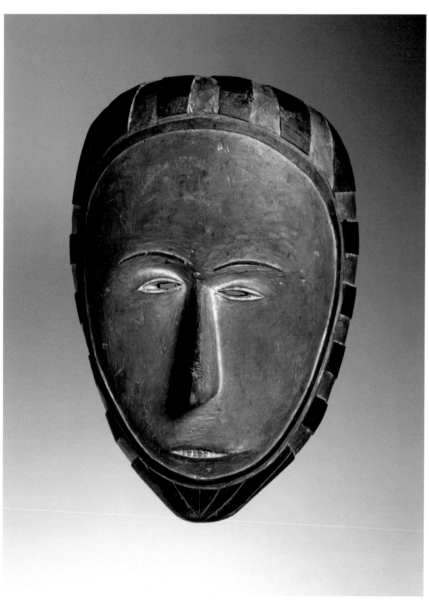

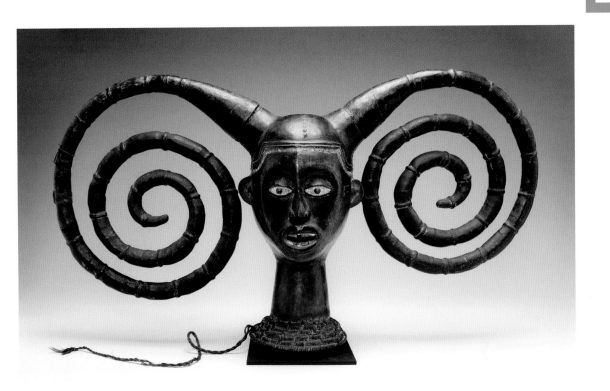

Ejagham people, Nigeria / Cameroon, **Crest Helmet**. Wood, antelope (duiker) skin, palm fiber, bamboo, metal studs, kaolin, pigment, early 20th century. H. 19 ¼ in. (48.9 cm). Purchased with funds given by Dorothy Mackenzie Price, 2005.321

Skin-covered Ejagham crest masks—made of fresh antelope hide stretched and shrunk over a carved wooden form—can have one, two, or occasionally three faces. Such masks represent portraits of ancestors, both men and women. This headdress shows two heads, a man and a woman, back to back. The dark-brown face (shown here) represents a man; the yellow-brown face on the opposite side represents a woman. Famous Ejagham men were almost always heroic warriors, so the man is shown with aggressively bared teeth. The woman may represent his equally strong wife. The spiral "horns" are the braids of an elaborate woman's hairstyle that was worn during festivities for the initiation and education of girls who had completed their seclusion ritual. The dark marks at the temples represent tattoos cut into the skin. These marks are *nsibidi* symbols, part of the ancient writing system of the Ejagham people that was taught by secret societies. The rectangles on the man's head signify high rank, while the concentric circles on the woman's head symbolize love.

Art of the Ancient Mediterranean
13th century BCE to 4th century CE

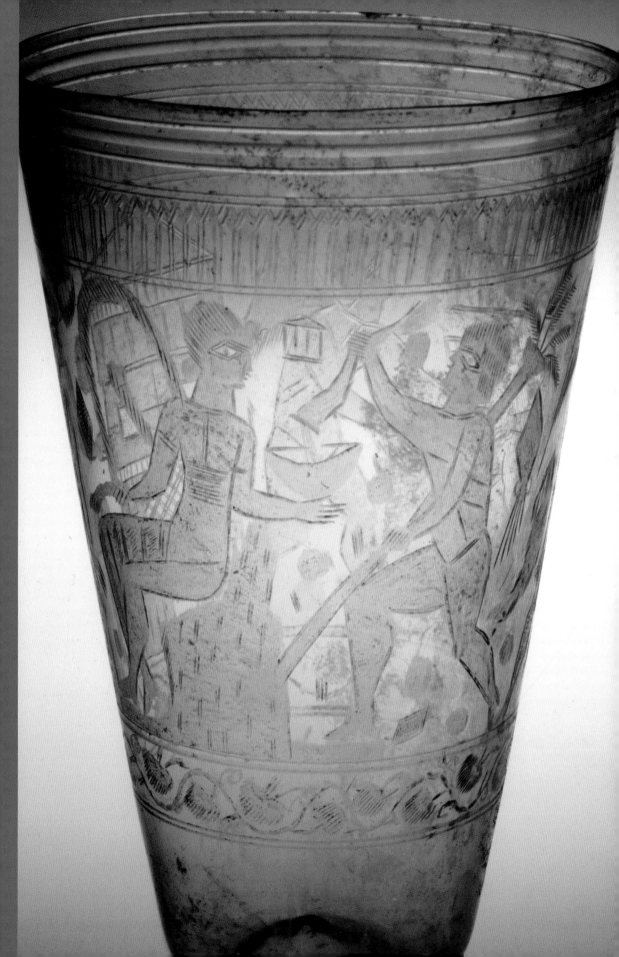

Egyptian, New Kingdom, 18th Dynasty (about 1550–1295 BCE), **Cosmetic Jar**, about 1400–1225 BCE; **Footed Jar**, about 1400–1350 BCE; **Kohl Tube**, about 1400–1225 BCE. Glass, core-forming technique. From left to right: H. 4¾ in. (12.1 cm); H. 3¼ (8.2 cm); H. 4⅜ in. (11.2 cm). Purchased with funds from the Libbey Endowment, Gift of Edward Drummond Libbey, 1951.405, 1948.16, and 1966.114

The secret of making glass was discovered about 2200 BCE, probably in Mesopotamia, an area of southwestern Asia between the Tigris and Euphrates Rivers extending from Asia Minor to the Persian Gulf. Early glassworkers cast the raw materials into small, colorful objects—beads, amulets, cylinder seals, and inlays—that were prized as substitutes for costly imported gemstones. Almost 500 years later, small vessels began to be fabricated using a core-forming technique, first in northern Mesopotamia and later in Egypt. These core-formed cosmetics vessels were probably preserved as grave goods buried with members of the ancient Egyptian nobility, to provide the owner with their fragrant contents in death as they did in life.

The striking colors of these objects imitate highly prized semiprecious stones, such as lapis lazuli and turquoise. Their diminutive forms are based on the traditional shapes of carved stone vessels. The bottle and jar held perfumed oils and were closed with linen-and-wax stoppers, while the palm-tree-shaped vessel once held kohl, a powdered mineral used as eye liner.

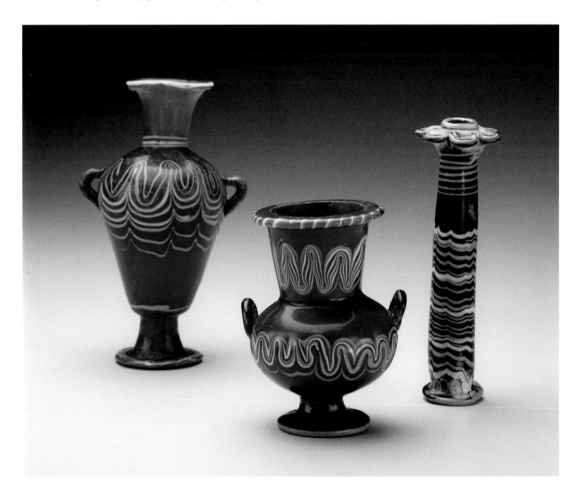

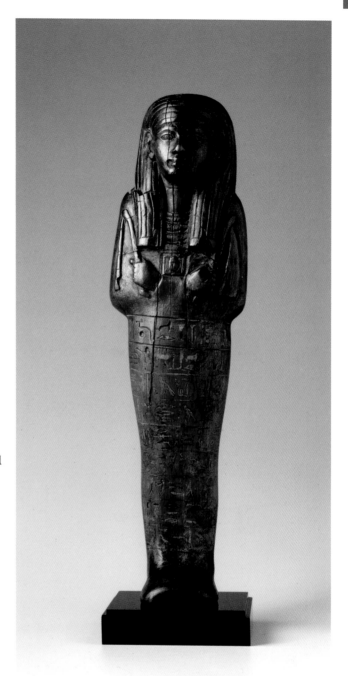

Elegantly carved out of dark wood from central Africa, this particularly large *shabti* (servant figure) was made for the tomb of Henut-wedjebu, "the lady of the river banks, the singer of Amun." Her titles indicate that she was an upper-class woman. Like most Egyptians, Henut-wedjebu wanted to be sure that her afterlife would be as comfortable as possible. To this end, she had *shabtis* buried with her to perform menial tasks for her in the afterlife and to harvest grain in the fields of Osiris, god of the dead.

This *shabti* is inscribed with a standard text to summon the servant figure that has been inlaid with so-called Egyptian blue, a copper-based compound that the Egyptians developed as the first synthetic pigment. The inscription reads, in part:

O shabti, allotted to me, if I be summoned . . . to do any work which has to be done in the realm of the dead. "Here am I," you shall say.

Egyptian, New Kingdom, 18th Dynasty (about 1550–1295 BCE), ***Shabti* of Henut-wedjebu.** Hardwood with Egyptian blue inlay and black pigment, about 1387–1350 BCE. H. 10 $^{15}/_{16}$ in. (27.8 cm). Gift of The Georgia Welles Apollo Society, 1993.52

Egyptian, from Jebel Barkal, Kush (modern-day Karima, Sudan), New Kingdom, 25th Dynasty (about 712–664 BCE), **Statue of Pharaoh Tanwet-amani**. Granodiorite, about 664–653 BCE. H. 79½ in. (202 cm). Purchased with funds from the Libbey Endowment, Gift of Edward Drummond Libbey, 1949.105

Erected as a monument to King Tanwet-amani (ruled 664–653 BCE), also called Tantamani or Tanutamani, this larger than life-size sculpture follows traditions for Egyptian royal statues that continued for almost three thousand years: left foot striding forward, arms straight and hands clenched, nude except for kilt and jewelry. The roughened surfaces on the sandals, bracelets, and shoulder and chest ornaments were once covered with gleaming gold. This figure is among the finest surviving examples of sculpture from Egypt's Late Period and one of only a handful of statues representing Tanwet-amani.

Tanwet-amani was the last pharaoh of 25th Dynasty, a family of kings from Kush (also called Nubia) who ruled Egypt from 750 to 653 BCE. Rows of colossal statues honoring the rulers of 25th Dynasty, including this one, once lined the roads leading to the Great Temple of Amun at Jebel Barkal (on the edge of Karima in northern Sudan). In 593 BCE the statues were pulled down and buried by the invading army of the Egyptian King Psamtik II.

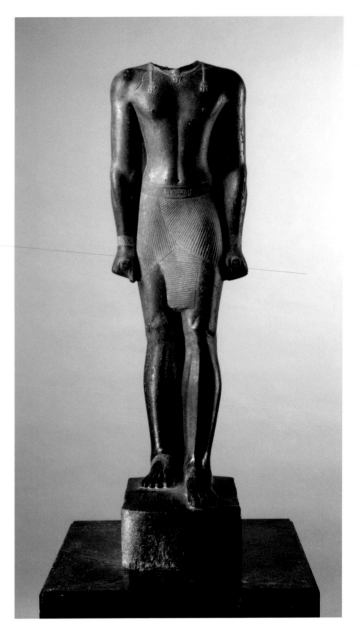

Egyptian, from Thebes (modern-day Luxor), New Kingdom, 18th Dynasty (about 1550–1295 BCE), **Statue of Sakhmet**. Granodiorite, about 1350 BCE. H. 47½ in. (120.7 cm). Gift of Miss Edith Morgan, 1927.154

Sakhmet was a powerful goddess of war, vengeance, and protection for the ancient Egyptians. She was usually depicted with the body of a woman, the head of a lioness, and wearing a wig denoting royalty. The original location of this carved stone figure is not certain, but it probably stood on a processional axis leading to one of the great New Kingdom temples at Thebes. These include two temples dedicated to Amun-Re, high god of the sun: one stood at Luxor and the other was at nearby Karnak. Stone sentries were made to stand guard along the axes of both temples. Sphinxes stood at Luxor and lions with wigged rams' heads stood at Karnak.

These imposing depictions of Sakhmet probably served a similar function at Karnak's Temple of Mut ("mother," the goddess-wife of Amun-Re). In Lower Egypt, along the Nile River delta and closer to the Mediterranean Sea, Sakhmet represented Mut. The two large courtyards of Mut's temple at Karnak were once filled with more than 600 statues of this fierce goddess. Many of these sculptures still stand at the temple today.

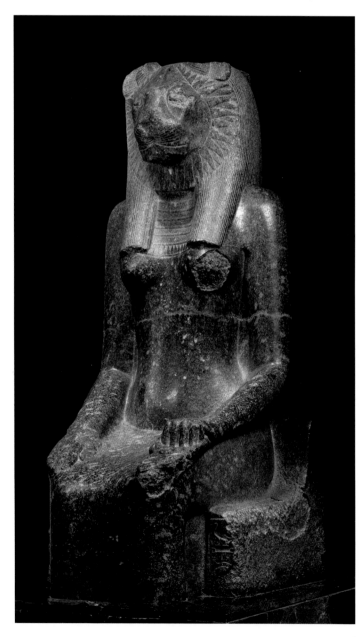

Greek, from Corinth, attributed to a painter in the Gorgoneion Group, **Column Krater with Boar Hunt and Wedding Procession**. Earthenware with incised details, slip-decorated, about 560 BCE. H. 13 13⁄16 in. (35.1 cm). Purchased with funds from the Libbey Endowment, Gift of Edward Drummond Libbey, 1970.2

In the ancient world, wine was fermented to be much stronger than it is now, so it was usually diluted with water before drinking. At a *symposium*, a men's formal banquet, one guest would be put in charge of the mixing, instructing servers to add more wine if conversation lagged or more water if guests began to fall asleep or became rowdy. This mixing was done in a *krater*, a large bowl with handles. Archaeologists call this a column krater because the way the handles are attached to the wide rim, they resemble two vertical columns supporting a platform.

During the seventh and early sixth centuries BCE, when this krater was made, Corinth was the most important city-state in Greece. Corinthian merchants shipped goods to ports all around the Mediterranean Sea. This large krater is said to have been found in Etruria, a region in central Italy settled by the Etruscans. On this krater's upper frieze, the black-figure painter illustrated two scenes: a bloody boar hunt on one side and a stately wedding procession on the other. In so doing the artist juxtaposed the dangers of wild nature and the blessings of peace and civilization.

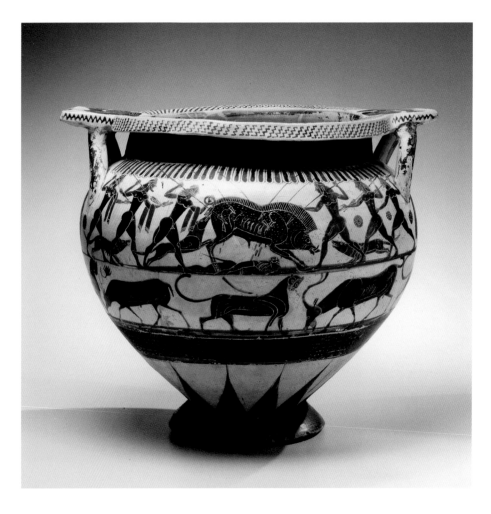

Greek, from Athens, Exekias (potter and possibly painter), **Amphora with Chariot Race**. Earthenware with incised details, slip-decorated, about 550–530 BCE. H. 18⅛ in. (46.2 cm). Purchased with funds from the Libbey Endowment, Gift of Edward Drummond Libbey, 1980.1022a–b

The scenes on this amphora—a vessel for storing wine, oil, or grain—reflect a focus on the human figure that was unprecedented in earlier Greek vase painting. This innovation has been traced to a group of Athenian black-figure vase painters known as "Group E" for the one among them whose name has been recorded, the celebrated Exekias, who signed Toledo's vase as its potter. He also may be the painter of the vase.

Each side shows a *quadriga* (four-horse chariot) competing in a race. The purse-lipped drivers whistle to their teams, and an armor-clad foot soldier stands in each chariot. The scenes on each side look identical at first glance, but the painter has carefully differentiated many details to reveal which helmeted man is the winner and which is the loser. He also includes descriptions, allowing us to deduce that Stesias is victorious over Anchippos. Both men must have been well-known, for their names appear on other vases from this period. The names of two of Stesias's horses are also inscribed on the vase: Kalliphora (a horse with a beautiful mane and tail) and Pyrichos (a fiery, red-brown horse).

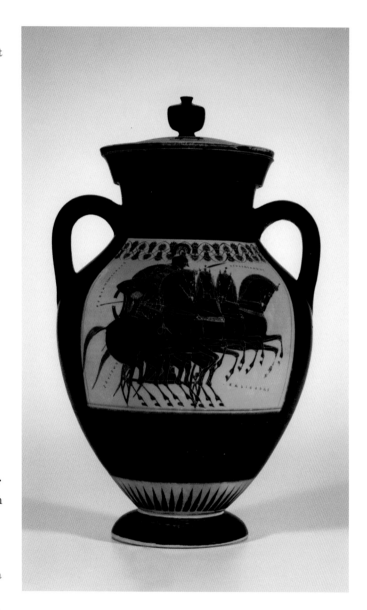

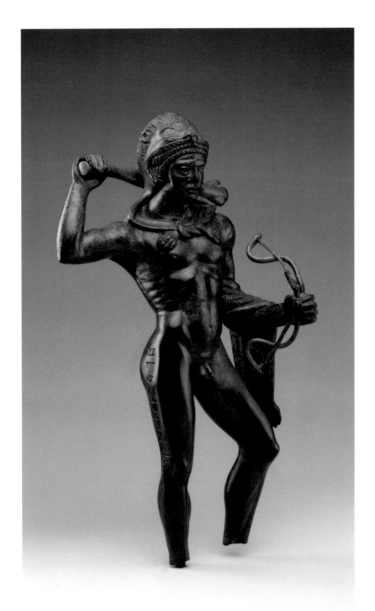

The heroic physique, knotty olive-wood club, bow and arrow, and lion-skin tied over the shoulders identify this figure as the Greek hero Herakles (called Hercules by the ancient Romans). To the Etruscans who settled in central Italy, he was the god Hercle, revered as a protector of men as well as of mountains, streams, and gateways. His bent elbows, the angle of his club, and the flex of his left knee, echoed by the outward thrust of the lion skin, suggest forceful action. His solemn expression—furrowed brow, resolute stare, and firmly set mouth—recalls Greek sculpture of the fifth century BCE.

The Etruscan inscription chiseled into the statue's right leg translates as: "I belong to Hercle," indicating that this statuette may have once been placed in a sanctuary devoted to that same god. Three Etruscan cities had important water sanctuaries dedicated to Hercle: Caere, Veii, and Vulci. This figure probably came from Caere (modern-day Ceverteri in Tuscany).

Etruscan, probably from Caere (modern-day Cerveteri), **Statuette of Hercle**. Bronze, about 425–350 BCE. H. 9½ in. (24.2 cm). Purchased with funds from the Libbey Endowment, Gift of Edward Drummond Libbey, 1978.22

Greek, from Athens, attributed to the Rycroft Painter. **Amphora with the Ransom of the Body of Hector**. Earthenware with incised details, slip-decorated, about 520–510 BCE. H. 27 in. (68.6 cm). Purchased with funds from the Libbey Endowment, Gift of Edward Drummond Libbey, 1972.54

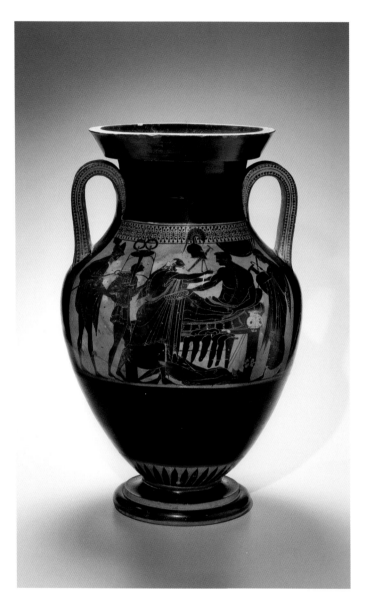

The scene painted on this storage vessel illustrates an episode in Homer's epic poem *The Iliad*. The aged King Priam of Troy visits the enemy Greek camp to beg the warrior Achilles for the body of his son, Hector, whom Achilles had killed in battle. Several vases with variations on this scene exist, but Toledo's amphora is famous for its strong composition and intense emotion.

The artist condensed two hundred lines of narrative into a powerfully iconic image, framed by the blood-spattered corpse of Hector at the bottom and the bristling helmet of Achilles at the top. White-haired Priam lurches forward to plead with Achilles, who heartlessly drinks over Hector's body. From the right, a serving girl brings more wine—representing both the Greek army's tribute to its hero and the stoking of Achilles' drunken wrath. From the left, the god Hermes escorts a servant carrying a ransom of gold vessels, symbolizing how the gods intervened to end Achilles' madness.

Greek, from Athens, attributed to Makron (painter) and to Heiron (potter), **Kylix with Woman Sacrificing**. Earthenware with incised details, slip-decorated, about 490–480 BCE. Diam. across handles 14 ³⁄₁₆ in. (36 cm). Purchased with funds from the Libbey Endowment, Gift of Edward Drummond Libbey, 1972.55

This wide, shallow cup, called a *kylix*, was often used at *symposia*, men's formal drinking parties, where guests would recline while eating and drinking. The kylix shape typically had both a foot and two handles. Scenes painted on the underside could be enjoyed by fellow diners, but the inside decoration was seen by the drinker alone as he drained his diluted red wine.

The interior of this *kylix* shows a scene of libation, the ritual pouring of a drink as an offering to a god. Here, a well-dressed young woman pours wine from a jug over a fire burning on an altar. In her left arm she holds a ritual basket containing the knife used to kill a sacrificial animal. The scene on the outside of this cup, by contrast, depicts men courting *hetairai* (entertainers or courtesans, literally "companions") with gifts of flowers, ribbons, and money bags. By showing women of two very different worlds—sex workers and a reverent maiden—this cup must have provided ample fodder for conversation at a *symposium*.

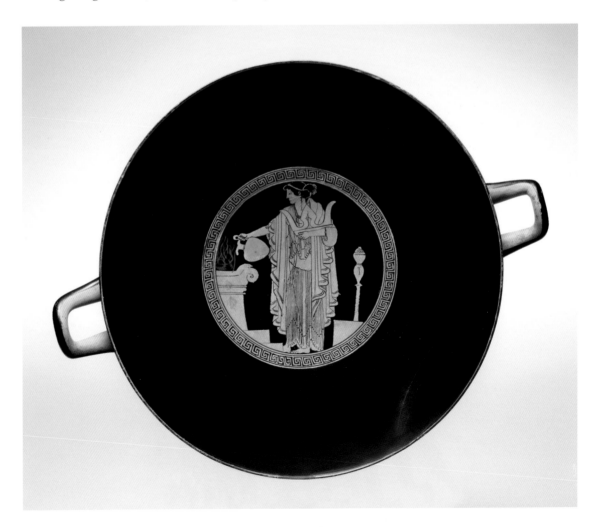

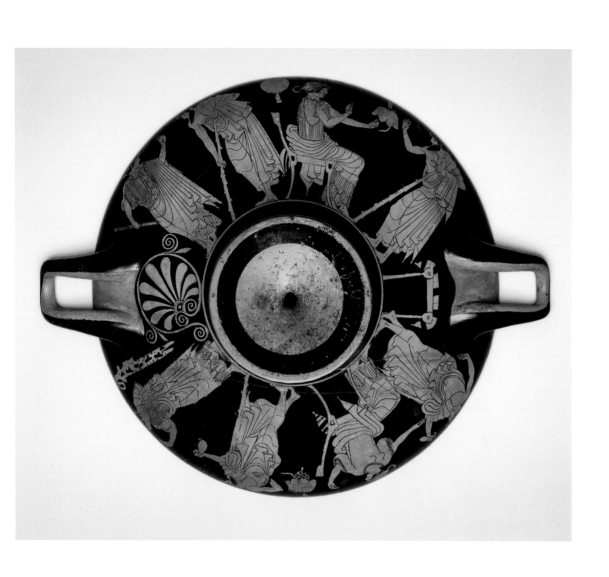

Greek, Hellenistic period (about 323–31 BCE), from the eastern Mediterranean, probably Egypt, **Krater**. Glass, cast, about 250–175 BCE. Diam. (rim) 18⅝ in. (21.9 cm). Purchased with funds from the Libbey Endowment, Gift of Edward Drummond Libbey, 1980.1000

The glassmaking industry flourished in Alexandria, Egypt, in the third century BCE, where Toledo's footed bowl was probably made. Large vessels like this *krater* (mixing bowl) were the earliest in a series of glass tableware produced for a luxury market and represented a new concept in glassware, a complete set for serving and consuming food and drink.

Cast in three parts, this vessel would have been lathe-cut with simple decorative grooves and polished to give it a finished elegance. The astonishingly thin wall of the bowl is a testament to the skill of the glassmaker, who risked breaking or chipping the glass during the laborious processes of cutting and polishing. The bowl's shape and size would have commanded attention

in this era when glass production had been dominated by comparatively small core-formed vessels. As one of the earliest examples of large-scale Hellenistic cast glass, its form bears a strong resemblance to containers of more costly materials, such as silver and gilded silver.

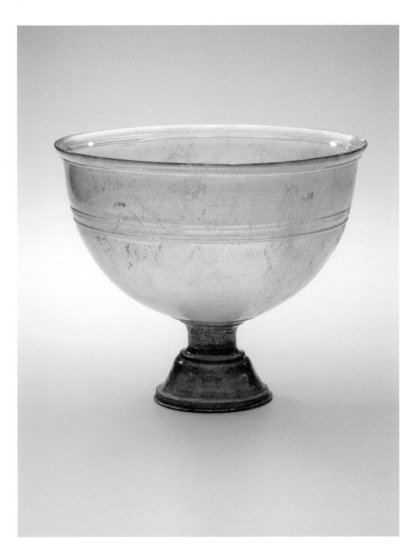

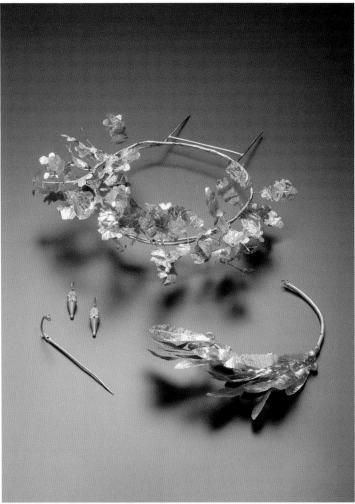

This lavish array of gold jewelry probably was made during the reign of Philip II (Philip of Macedon, ruled 359–336 BCE), father of Alexander the Great. Together, this group reflects the wealth that poured into the court of Macedon as a result of the king's conquests and the opening of new gold mines. These luxurious personal ornaments of pure beaten gold probably belonged to a wealthy aristocrat and his wife, who would have worn them to banquets and festivals. Precious objects like these have survived because they were buried as a source of wealth for their owners, or, upon their deaths, interred with them as grave goods.

The oak wreath, whose tissue-thin leaves tremble with the slightest vibration, refers to Zeus, king of the gods, to whom the oak tree was sacred. The olive was sacred to the goddess Athena, and the olive-branch wreath would have been worn to honor her. The earrings must have been very stylish, because others like them can be seen in many carved stone portraits and paintings of women from about 350 BCE. While the wreaths and earrings are quintessentially Greek in style, the motif of the panther's head adorning the *fibula* (cloak pin or brooch) is adapted from Persian designs.

Greek, from Asia Minor (modern-day Turkey), **Jewelry Hoard: Oak Wreath, Half Olive Wreath, Pair of Earrings, and Fragment of a Cloak Pin with Panther's Head.** Gold, about 375–325 BCE. Oak wreath: W. 12 ¼ in. (31.1 cm); olive wreath: L. 8 ¼ in.(20.9 cm); earrings (each): H. 1 ⅞ in. (4.8 cm); cloak pin: L. 4 ¾ in. (12.1 cm). Gift of The Georgia Welles Apollo Society, 1987.3a–f, 1987.4, 1987.5a–b, 1987.6

Greek, from southern Italy, Apulia, probably Tarentum, attributed to The Darius Painter, **Volute Krater with Dionysos Visiting Hades and Persephone**. Earthenware with incised inscriptions, slip-decorated, about 330 BCE. H. 36 5/16 in. (92.2 cm). Gift of Edward Drummond Libbey, Florence Scott Libbey, and the Egypt Exploration Society, by exchange, 1994.19

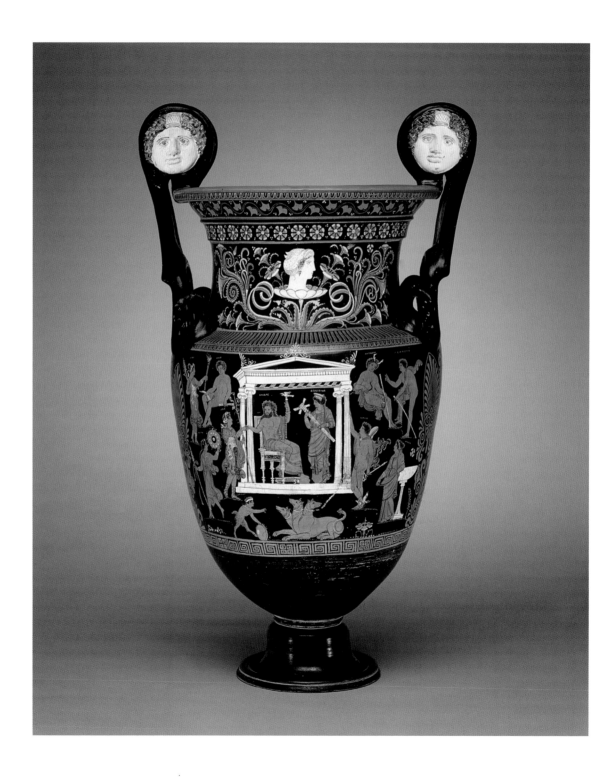

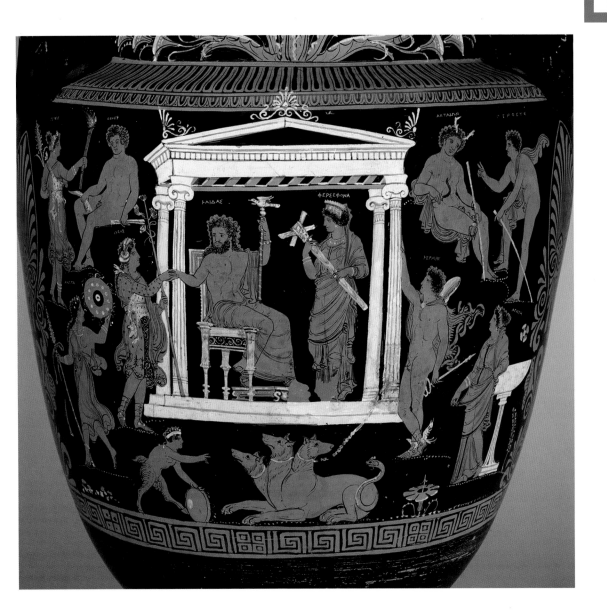

On this large vase, Dionysos, the Greek god of wine and theater, solemnly shakes hands with Hades, god of the Underworld. Hades' wife, Persephone, stands next to him in their marble palace. Hermes, messenger god and guide of the dead, leans on a column. Dionysos is accompanied by a tipsy retinue of satyrs and *maenads* (the god's female followers). Other figures, labeled by the painter, include the antlered Aktaion who was turned into a stag, and Kerberos, the three-headed guard dog of the Underworld.

The shape of this vase is a variation on the form known as a *krater* with volute (scroll-shaped) handles. It was made to decorate the tomb of a young man, who is represented on the back as a marble statue.

Greek, Hellenistic period (about 323–31 BCE), **Statuette of an African**. Bronze, about 150–50 BCE. H. 10¼ in. (26 cm). Purchased with funds given by Nancy and Gene Phlegar, Barbara J. Baker, and the Popplestone Family, and with funds from the Libbey Endowment, Gift of Edward Drummond Libbey, 2010.5

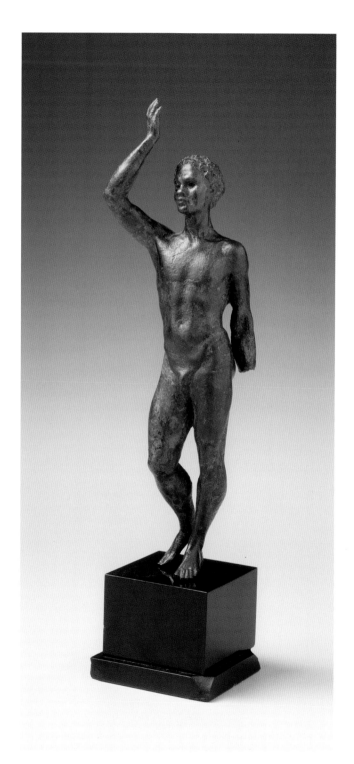

The Greeks established trading centers in Africa beginning in the eighth century BCE, and there is evidence that Africans were living in Greek cities. Many Greek images of Egyptians, Nubians, Ethiopians, Libyans, Berbers, and other ethnic groups from the African continent are represented in Greek art as conquered enemies, as slaves, or as entertainers. This commanding figure, however, more likely represents a man of some prominence in Greek society.

Surviving examples of African imagery from the Greek world tend to be preserved in scenes on painted ceramics. Examples of bronze sculptures of Africans, such as this one, are far less common. This figure's upwardly extended right arm and nudity suggest heroism, while the relaxed pose (a stance known as *contrapposto* that emphasizes a gentle sway of the torso) accentuates the figure's musculature and suggests movement. The sculpture's grandeur, however, contrasts with its relatively small size, implying that it was meant to be decorative, perhaps even for a domestic setting.

Roman, probably from Italy, **Bowl**. Polychrome glass, mosaic (ribbon) glass technique, late 1st century BCE–early 1st century CE. Diam. 3⅜ in. (8.4 cm). Purchased with funds from the Libbey Endowment, Gift of Edward Drummond Libbey, 1968.87

The brilliant blues, reds, and greens that make up this striped bowl imitate the colors of semiprecious stones such as lapis lazuli, carnelian, and emerald. The use of these intense colors and the production method—cast by slumping fused glass canes over a hemispherical mold—are a tribute to the technology of the early Roman glassmakers. Simple yet elegant forms like this bowl with its ribbons of color could have been distributed throughout the Roman Empire, but seem to have been a favorite product of the workshops around the city of Rome.

Manufacturing a glass vessel with this technique was time-consuming and required considerable finishing work, making it a costly object that would have graced a luxurious Roman dining table replete with other colorful glassware. It was created during a transitional period that witnessed the invention and spread of glassblowing, a new technology that revolutionized the glass industry, speeding production and making glassware more affordable for daily use.

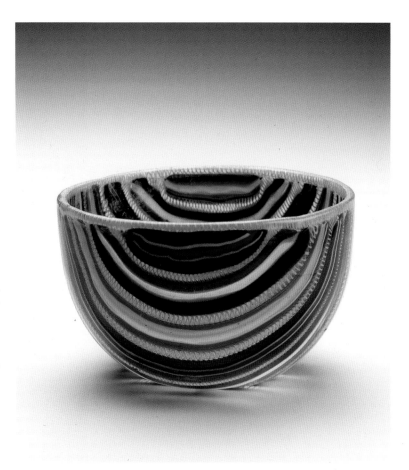

A lusty satyr seizes a nymph around the waist while she forcefully tries to push him away. They wrestle in a secluded flower-strewn grove beneath a tree where the nymph has hung her clothes as she prepares to bathe at the fountain. A silversmith created this scene by hammering out the high-relief forms, called *repoussé*, from the back of a sheet of silver and then punching details into it from the front (a technique called chasing). The resulting figurative representation, or emblemata, was set into a separately cast silver frame decorated with acanthus, lily, ivy, and grapes and an outer rim decorated with an egg-and-dart motif.

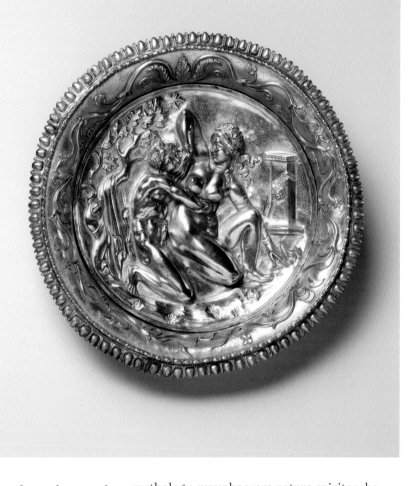

The scene on this emblem dish represents a much-copied ancient sculptural group. The nymph's pose is based on a popular cult statue from the mid-third century BCE showing the goddess Aphrodite kneeling to bathe. In Greek mythology, nymphs were nature spirits who took the form of beautiful young women. They were often associated with springs, forests, and other outdoor settings. Satyrs were the semi-bestial male companions of the wine god Dionysos, who roamed the forests and mountains.

Greek, probably from Asia Minor (modern-day Turkey), Hellenistic Period (about 323–31 BCE), **Emblem Dish with Nymph and Satyr**. Gilded silver, about 150–100 BCE. Diam. 6⅛ in. (15.6 cm). Purchased with funds from the Libbey Endowment, Gift of Edward Drummond Libbey, 1984.67

Roman, **Shield Portrait of Emperor Augustus**. Gilded silver, about 15–30 CE. Diam. 6⅜ in. (16.2 cm). Purchased with funds from the Libbey Endowment, Gift of Edward Drummond Libbey, 2007.11

Much more than visual records of their subjects, portraits of Roman emperors were also used to advertise the power and majesty of the Empire and its leaders and to unify people in Rome's diverse and far-flung provinces. Emperors' portraits were issued on coins, as guarantees of peace and prosperity. Millions more were made in every medium—metal, stone, ceramic, textile—and in all sizes, from the miniscule to the colossal.

This gilded silver shield portrait (*imago clipeata*) shows Emperor Augustus (Gaius Julius Caesar Octavianus), the first Roman Emperor, who ruled 27 BCE to 14 CE. The acanthus foliage under the bust symbolizes that Augustus was dead and deified when this portrait was made. In the stippled background three dogs

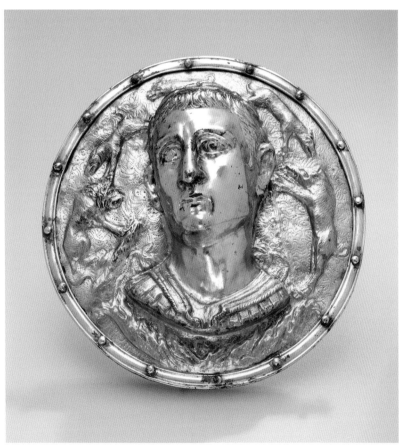

hunt a lion and a boar, two of the most powerful predators. In classical Greek and Roman art, animal-hunt iconography symbolized courage and the fundamental protection of villages, fields, and herds from wild animals and lawless men. The message of power is further underlined by Augustus's armor and laurel wreath, symbols of *imperium* (military authority) and victory.

Although Emperor Domitian (Titus Flavius Domitianus, ruled 81–96 CE) was praised as a benevolent ruler early in his reign, historical accounts of his later years are filled with acts of greed, debauchery, and cruelty. Domitian was so hated by the time of his assassination in 96 CE that the Roman senate officially damned his memory, decreeing that all public statues and inscriptions bearing his name be destroyed. Consequently, only a handful of portraits of Domitian are known; of those that survived, this is the best-preserved example in stone.

Known to be a vain man, he had written a treatise on hair care. Ironically, the hair of this portrait represents a wig that concealed his baldness in later life. The highly polished modeling of the skin, contrasting with the matte drapery and locks of hair, reveals the hand of a master sculptor.

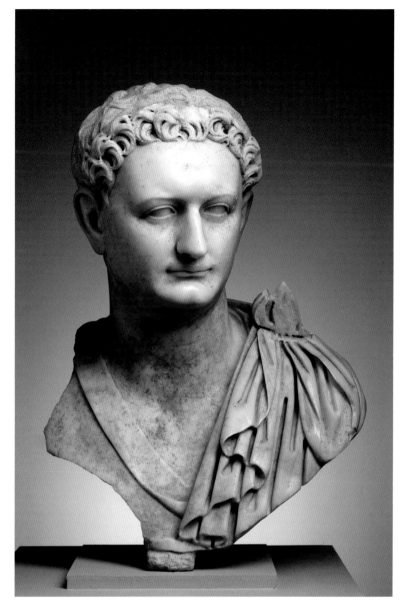

Roman, **Portrait Bust of Emperor Domitian**. Parian marble, about 90 CE. H. 23 7/16 in. (59.5 cm). Purchased with funds from the Libbey Endowment, Gift of Edward Drummond Libbey, and with funds from the Florence Scott Libbey Bequest in Memory of her Father, Maurice A. Scott, 1990.30

Roman, from Egypt, Fayum (modern-day Medìnet-al-Faiyum, **Portrait of a Woman**. Tempera on linden wood panel, about 50 CE. 13⅛ x 8½ in. (33.3 x 21.6 cm). Purchased with funds from the Libbey Endowment; Gift of Edward Drummond Libbey, 1971.130

Painting—on walls, linen hangings, and wood panels—was a prized art form in ancient Greece and Rome, but few examples survive. In Egypt, however, paintings have sometimes been preserved in dry desert tombs, such as this naturalistic portrait of a round-faced, richly attired woman. The strikingly realistic features of the woman's face, such as the rounded nose, cupid's-bow lips, and candid gaze suggest that her portrait was painted from life.

The textured lower edge may indicate where a frame was removed after the woman's death, in order to attach this family portrait over the face of her linen-wrapped mummy. Greeks and Romans who lived in Egypt after it became a Roman province in 30 BCE adapted the ancient Egyptian custom of mummy portraits. The combination of painted portrait and mummified remains dates solely to the period of Roman rule in Egypt and reflects the fusion of funerary customs from both cultures.

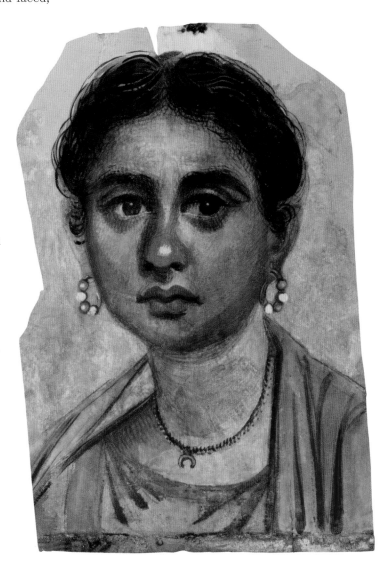

Roman, probably from the province of Africa (modern-day Tunisia), **Mosaic with Portrait of Bacchus**. Limestone, polychrome marble, and glass tesserae, 140–160 CE. 118⅜ x 117½ in. (300.7 x 298.5 cm). Purchased with funds from the Libbey Endowment, Gift of Edward Drummond Libbey, 1990.73

In the round shield portrait (*imago clipeata*) at the center of this floor mosaic is the Roman god Bacchus, known as Dionysos to the Greeks. God of wine, poetry, theater, and rebirth, here he is shown as a beardless youth wearing a leopard skin over one shoulder and a wreath of vine leaves and fruit atop his long, curling hair. He holds a staff (*thyrsos*) of giant wild fennel topped with a pinecone and decorated with ivy. Around Bacchus, grapevines climb from four golden *kantharoi* (wine cups), symbolizing wine, his gift to humankind. In the side panels doves, symbolic of fertility, call to each other among acanthus leaves and tendrils. In the corners are mask-like heads of *maenads*, the female followers of Bacchus.

The individual pieces (tesserae) of this mosaic are made of colored marble, limestone, and glass (the blue-green tiles in the foliage). The size of the mosaic suggests that it was part of the floor of a bedroom or private room *(cubiculum)*. It resembles mosaics found at ancient Thysdrus (modern-day El Djem, Tunisia).

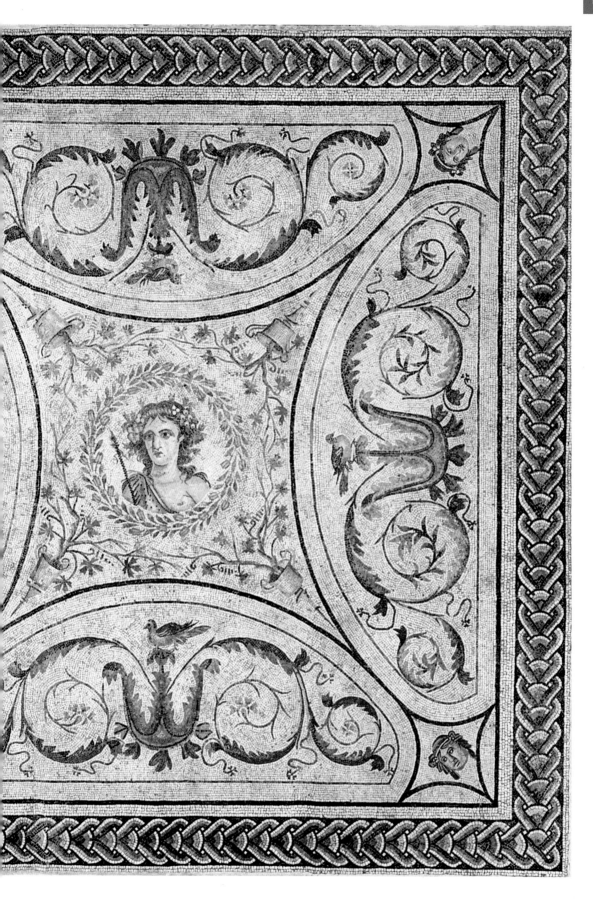

Roman, probably from Asia Minor (modern-day Turkey), **Statue of a Youth**. Bronze, about 140 CE. H. 56⅛ in. (142.6 cm). Purchased with funds from the Libbey Endowment, Gift of Edward Drummond Libbey, 1966.126

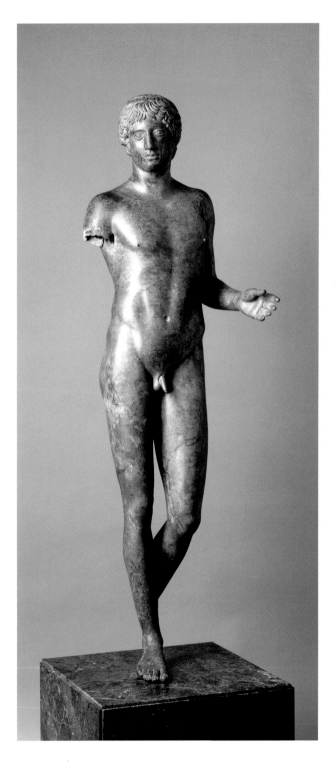

When this life-size bronze sculpture of a handsome adolescent was cast, thousands of statues—many based on admired Greek originals—could be seen in public spaces and private residences across the Roman Empire. Though bronze would have been somewhat more expensive than marble, it was stronger and less fragile, and for that reason allowed the limbs of a statue to extend from the body without support. The process of bronze casting was also more efficient, because head, torso, legs, and arms could be cast separately and then soldered together, which was done in the making of this figure.

The youth's elegant pose and intricately curled hair copy those of a famous statue of an athlete, the *Doryphoros* (Spear-Bearer) by the fifth-century-BCE Greek sculptor Polykleitos. In this case, the original subject was adapted to one almost as popular, that of a pubescent boy. The Romans often made their statues functional as well as decorative, so this sculpture, now missing its right arm, may have originally held up a lamp to light a garden or a dining room.

This hollow-cast statuette is one of the largest silver devotional objects to survive from ancient times. Unfortunately, the figure lacks attributes to securely identify which goddess she represents. Her head is turned toward her right hand, which may have once held a fruit or a cup. She is fully clothed in traditional tunic and cloak (*chiton* and *himation*), with sandals on her feet. The diadem she wears on her head suggests she may represent a major goddess—Hera, Aphrodite, or Fortuna.

Small statuettes—either in terracotta, bronze, marble, or silver—have been excavated in the ruins of ancient Greek and Roman private houses. Ancient authors have described that such figures, as costly as a household could afford, were venerated in shrines at home, where family members and individuals prayed to them and left offerings of wine, food, and incense. The necklace and bracelets of gold placed on this statuette hint that the owner was happy for the goddess's help and rewarded her with offerings of gratitude.

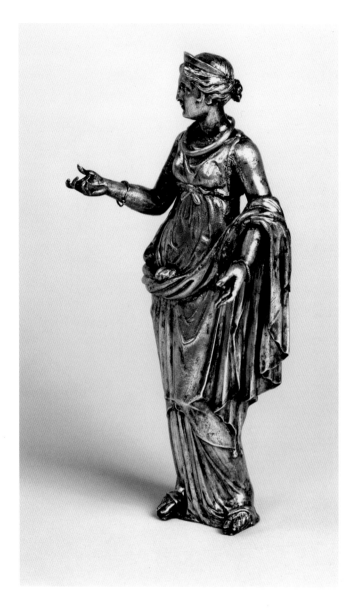

Roman, from Lebanon or Syria, **Statuette of a Goddess**. Silver with gold necklace and bracelets, late 2nd to early 3rd century. H. 9⅝ in. (24.4 cm). Purchased with funds from the Libbey Endowment, Gift of Edward Drummond Libbey, 1971.131

Roman, said to be from Germany, Worringen, Cologne, **Beaker with Bacchic Imagery**. Glass, late 3rd to mid-4th century. H. 8 in. (20.2 cm). Purchased with funds from the Libbey Endowment, Gift of Edward Drummond Libbey, 1930.6

This remarkably large and well-preserved blown-glass drinking cup belongs to a sizable group of bowls, bottles, and drinking vessels engraved with religious figural scenes, a type of glassware that became popular in the Western provinces of the Roman Empire in the third and fourth centuries. This cup is known as "The Worringen Beaker" because it was reported to have come from the Worringen section of Cologne, Germany, which was founded by the Romans in 50 CE.

This beaker's imagery is enigmatic. The central action shows a man pouring a liquid, probably wine, from a rhyton (drinking horn) into a cup held by a seated woman. The most straightforward explanation for the scene is that the man is Bacchus, Roman god of wine, drama, and religious mysteries, though a more complete explanation of the figures has not yet been determined. The cup's

superb condition and its religious imagery suggest that it may have been made for burial with the deceased, or was placed as a tomb offering after its use at a funeral feast.

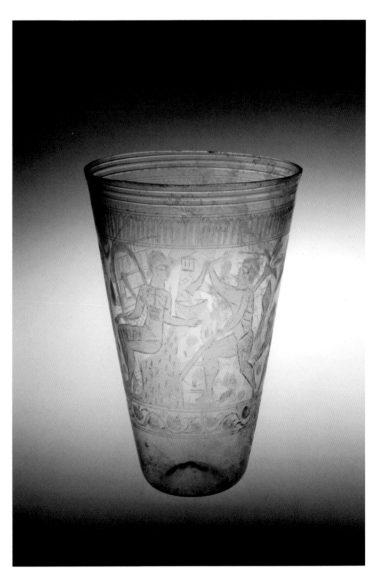

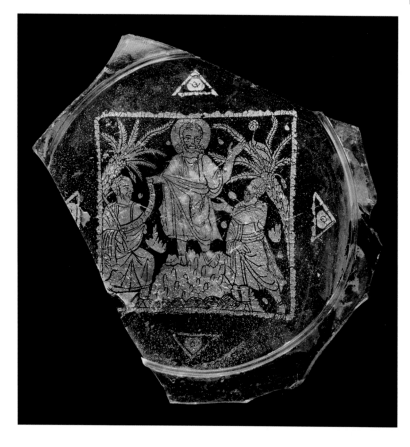

The central figure on this fragment of a gold-glass bowl is a youthful Christ, shown with a beard and short, cropped hair and dressed in a Greek *chiton* and *himation* (tunic and cloak). He stands on a rocky outcrop at the base of which swells rippling water representing the four rivers of Paradise. Christ is flanked by his disciples Peter and Paul, to whom he offers an unfurled scroll, which reads DOMINVS LEGE[M] DAT: "the Lord giving the law."

Gold glass roundels would have adorned the bottoms of cups and bowls that were probably used in ancient Roman funerary rituals. To make these roundels, an area of gold leaf was attached to the top or inside of the wall of a blown-glass vessels. The design was incised, scratched, or scraped into the gold to reveal the clear glass background. To firmly secure the gold leaf to the glass, and to protect it during use, the bowl or cup would first be reheated, and then a bubble of glass would be inflated over the gold design, to fuse it with the glass beneath. Decorated glass fragments such as this one were often re-used, embedded in the walls of catacombs (underground cemeteries) by both pagans and Christians.

Roman, from Italy, probably Rome, **Fragment of a Bowl: Christ Giving the Law to Saints Peter and Paul**. Glass, gold leaf, mid- to late 4th century. Diam. 4⅞ in. (12.4 cm). Purchased with funds from the Libbey Endowment, Gift of Edward Drummond Libbey, 1967.12

Form: The Human Body

Artists have studied and represented the human form in their art since prehistoric times. But how an artist applies the formal qualities of art—color, line, and shape, for example—to construct the human form can create drastically different moods and meanings. From highly naturalistic to almost unrecognizably abstract, the artist's own style of representation communicates as much as the subject itself.

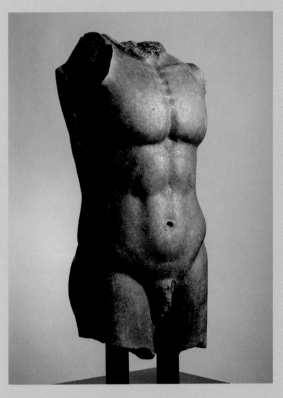

Indian, from Tamil Nadu, Chola Dynasty (about 860–1279), **Parvati.** Bronze, about 1150–1200. H. 32 in. (81.3 cm). Purchased with funds from the Libbey Endowment, Gift of Edward Drummond Libbey, 1969.345

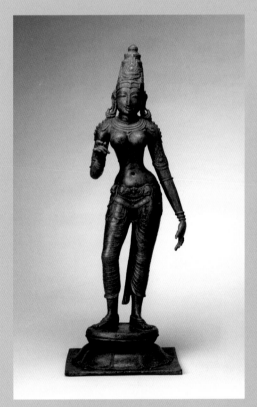

Roman, Eastern Empire, **Male Torso.** Basalt, 2nd century CE. H. 37 13⁄16 in. (96 cm). Gift of Edward Drummond Libbey, Henry W. Wilhelm, Madame Georges Henri Rivière, Thomas Whittemore, and the American Institute for Persian Art and Archaeology, by exchange, 2017.25

This well-muscled nude—an idealized embodiment of strength and physical perfection— likely portrayed an athlete. The use of basalt, a volcanic stone that is naturally dark in color, may suggest that the model was an individual of African descent.

Every detail of this elegant figure of the Hindu deity Parvati, consort of Shiva—from her slender ankles, to the position of each finger, to the sway of her pose—is prescribed by strict canons of iconography and proportion that Indian craftsmen were required to follow to give tangible form to sacred concepts.

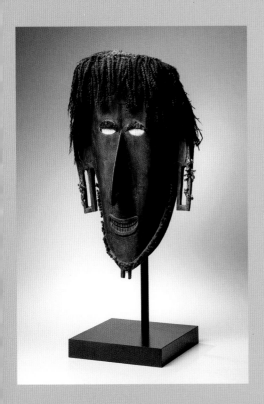

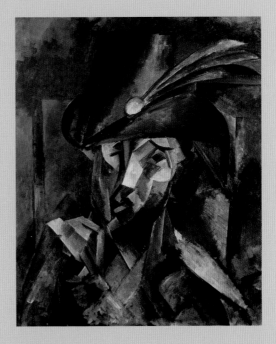

Pablo Picasso (Spanish, 1881–1973), **Woman in a Black Hat.** Oil on canvas, 1909. 28¾ x 23¾ in. (73 x 60.3 cm). Purchased with funds from the Libbey Endowment, Gift of Edward Drummond Libbey, and with funds from the Florence Scott Libbey Bequest in Memory of her Father, Maurice A. Scott, 1984.15

Torres Strait Islanders, Saibai Island, Torres Strait, Australia, **Mask.** Wood, human hair, shell, seedpod, fiber, pigment, melo shell, and coix seeds, late 19th century. H. 28⅜ inches (72 cm). Gift of C. O. Miniger and purchased with funds from the Libbey Endowment, Gift of Edward Drummond Libbey, by exchange, 2015.55

This mask is one of only a handful known from Saibai Island. All were carved of wood, have a scooped, crescent profile, and were completed with human hair and shells for eyes. Such masks, likely worn above the head during rituals, are believed to be stylized, larger-than-life representations of mythical heroes.

In Picasso's early Cubist explorations, like this image of his mistress Fernande Olivier (1881–1966), the artist questioned the means and meaning of visual representation; in this case by overlapping geometric planes and including multiple points of view.

Images convey meaning through their formal qualities

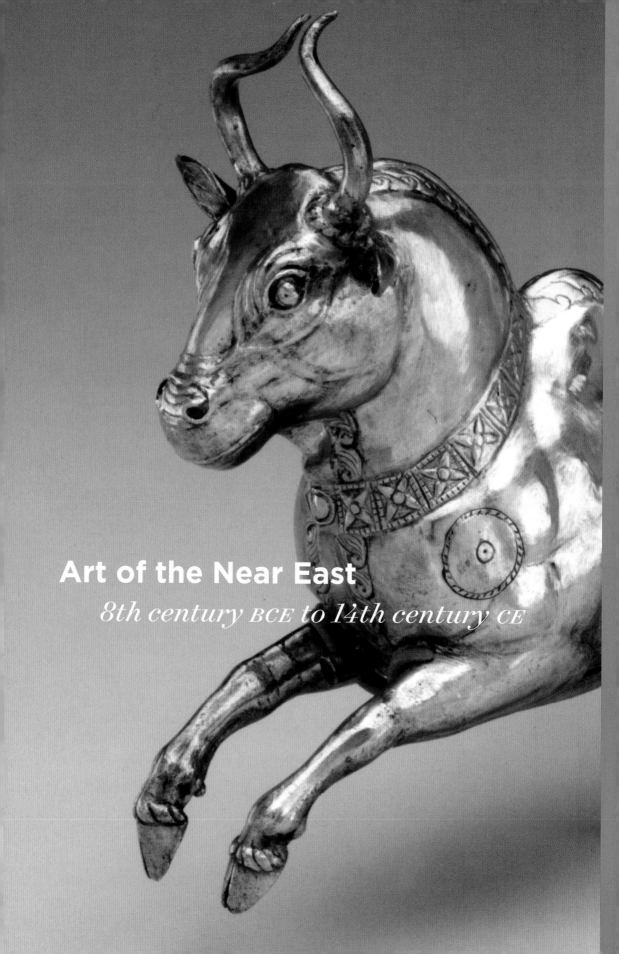

Art of the Near East

8th century BCE to 14th century CE

Neo-Assyrian Empire (about 911–612 BCE), from Kalhu (modern-day Nimrud, Iraq), **Fragment of a Winged God**. Alabaster (gypsum) with traces of pigment, about 880 BCE. W. 52 ⁵⁄₁₆ in. (132.9 cm). Purchased with funds from the Libbey Endowment, Gift of Edward Drummond Libbey, 1966.118

This winged deity, once painted in bright colors, comes from the royal palace at Kalhu (modern-day Nimrud, Iraq). The palace was built for King Ashurnasirpal II (ruled 883–859 BCE), who was notorious for his bloody conquests of Mesopotamia, Lebanon, Syria, and Palestine. This god and many others protected a chamber next to the throne room believed to have served for ritual bathing. This deity's elaborate jewelry and curled hair and beard reflect Assyrian court fashions, while the three horns on his helmet indicate his divinity. In his raised right hand he holds a date palm flower cluster, and his lowered left hand would have held a bucket. He is fertilizing a palm tree, a symbol of fertility and abundance.

From around 911 to 612 BCE, the Assyrians controlled a broad empire that included most of the Middle East and parts of Egypt. According to tradition, each king built his own huge stone palace in the ancient cities of Kalhu, Nineveh, and Dur-Sharrukin, and decorated the walls with finely carved and painted scenes of the king, the Assyrian gods, and the empire's conquering armies.

Seleucid Empire (323–64 BCE), from Persia (modern-day Iran), **Rhyton in the Shape of a Zebu**. Silver with foil gilding, 200–100 BCE. L. 16⅞ in. (42.8 cm). Purchased with funds from the Libbey Endowment, Gift of Edward Drummond Libbey, 1988.23

At Persian and Greek banquets from the sixth through the first centuries BCE, horn-shaped cups called rhyton—made of clay, ivory, silver, and even gold—were popular as drinking vessels. A servant would fill the horn with wine through the open top, then each guest would take a drink from the small spout at the front (located between the animal's forelegs on this example). A rhyton without a base, such as this one, had to be passed by hand from one guest to the next until it was empty.

This rhyton was made in two parts: the horn and the hollow forequarters of a zebu, a hump-backed bull. Both were formed by hammering cast silver cylinders over molds. A gilded ring conceals the join. The bull's solid horns, ears, and forelegs were cast separately and attached with solder. This rhyton is unusual because it has sheet gilding: thick gold foil has been rubbed onto the silver, adhering it solely by the heat of friction. Because less expensive amalgam gilding replaced sheet gilding during the second century BCE, the rhyton can be dated quite accurately.

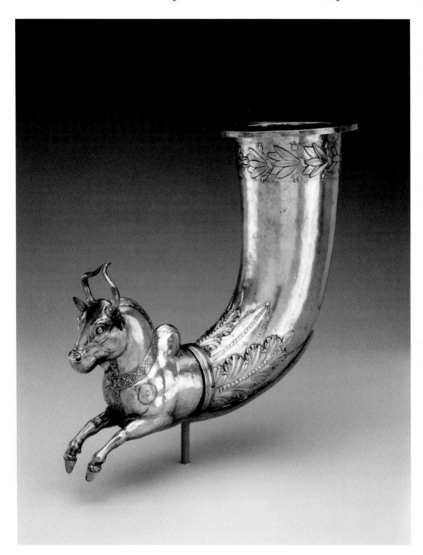

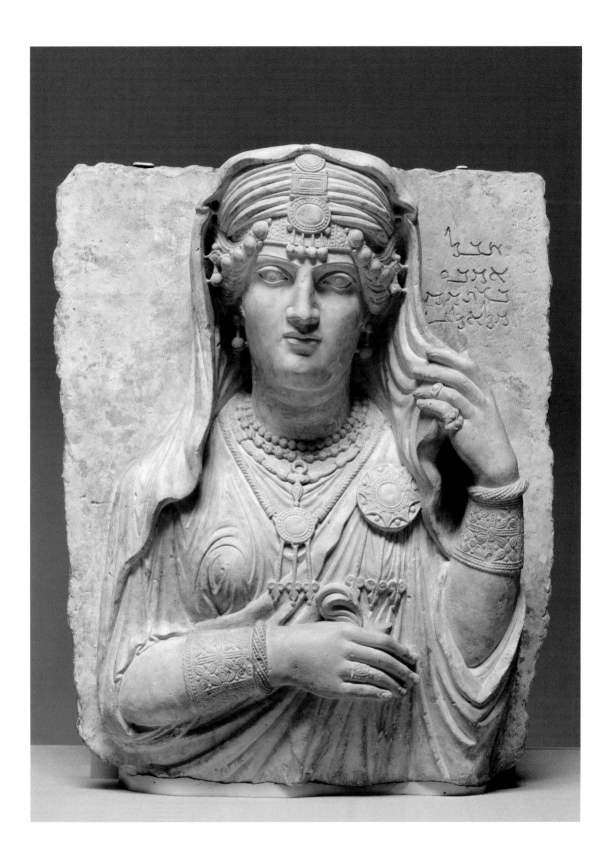

Palmyrene, from Palmyra (modern-day Tadmor, Syria), **Funerary Monument of Umm'abi**. Limestone, with traces of pigment, about 200 CE. H. 23 in. (58.4 cm). Purchased with funds from the Libbey Endowment, Gift of Edward Drummond Libbey, 1962.18

The strong frontal pose creates a sense of timelessness and serenity in this bust-length portrait of a richly adorned citizen of Palmyra. Her home was in the great caravan city of south-central Syria that dominated overland trade in silks and spices—from China and the East Indies to the Euphrates River, and on to the Mediterranean Sea—for more than three hundred years. This portrait, carved in high relief, is from a series of limestone slabs that were used to seal individual graves in the tomb towers of wealthy families that lined the roads into Palmyra.

These funerary portraits of Palmyrene women are so similar in style that they were likely mass-produced, with names added only after purchase. The inscription on this relief identifies the deceased as "Umm'abi, daughter of Maggi, [son of] Malé, [son of] La'ad." Traces of dark red in the inscriptions, dark pigment on the eyes, and red, blue, green, and yellow pigment on some of the jewelry prove that this portrait relief was once vibrantly colored.

Seljuq Dynasty (about 1040–1157), probably from Kashan (Isfahan province, modern-day Iran), **Bowl**. Mina'i ware: polychrome earthenware with overglaze on an opaque white (tin) glaze, late 12th to early 13th century. Diam. 8 3/16 in. (20.8 cm). Purchased with funds from the Libbey Endowment, Gift of Edward Drummond Libbey, 1941.17

A prince sits on a low throne flanked by two kneeling courtiers in the figurative scene on this *mina'i* (enamel) ware bowl. All three figures in the foreground wear colorful, sumptuous garments and the prince clasps a scepter symbolizing his authority. The haloes around their heads are a standard form of emphasis, rather than indications of holiness. A canopy decorated with clouds and scrollwork shelters the men. The fish pond in the foreground and two flying birds place the scene in a garden, both a lavish retreat and a symbol of the garden of heaven.

After the Seljuq Turks (1038–1194) became the rulers of Iran, Iraq, and most of Anatolia (modern-day Turkey), trade and political contact revived interest in luxury porcelains from China. Mina'i pottery, which adapts Chinese techniques, shapes, and imagery, has been identified with the city of Kashan, the center of Persian ceramics in modern-day Iran. Bowls from Kashan typically depict hunters, musicians, and princes in gardens—images of courtly life that appealed to wealthy customers.

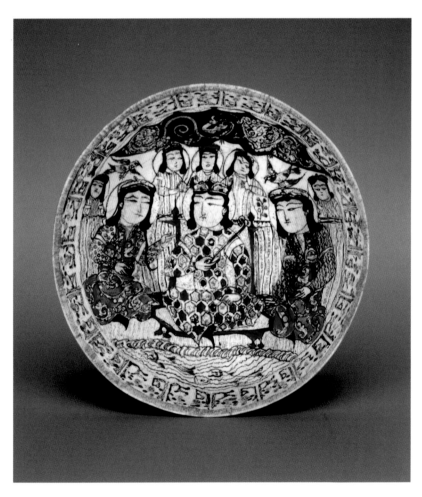

Mamluk Sultanate (1250–1517), probably from Egypt, **Footed Bowl with Lid**. Glass with gilding and enameling, mid-14th century. H. (with lid) 10 in. (25.4 cm). Purchased with funds from the Libbey Endowment, Gift of Edward Drummond Libbey, 1970.56 a–b

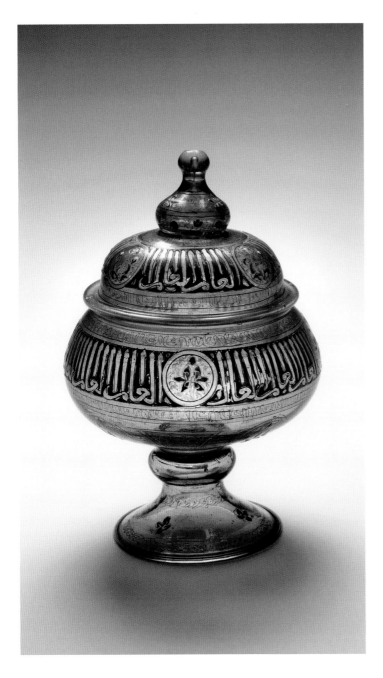

Large, lavishly decorated enameled and gilded glass vessels made in Egypt and Syria in the thirteenth and fourteenth centuries represent a tour de force of glass production. These vessels were highly prized not only in the Mamluk Sultanate, where they were made, but also in other Islamic countries, in Europe, and even in China. This lidded bowl, probably used for serving candied fruits and nuts is an example of a form produced not only in glass but also in metalwork.

The Mamluk Sultanate, based in Syria and Egypt from 1250 to 1517, is considered not only the height of Islamic metalwork and manuscript illumination, but also the golden age of Islamic glassmaking. The technically challenging and innovative use of enamels consisted of painting various colors of powdered glass, suspended in an oily substance, onto a vessel.

The primary decoration on this bowl is a gilded calligraphic inscription and begins, "the sultan, the king" and repeats, "the learned" over and over. The use of decorative script in Islamic art originates with the reverence for writing as the only art form appropriate for expressing the word of God.

Art of Europe

10th to 17th century

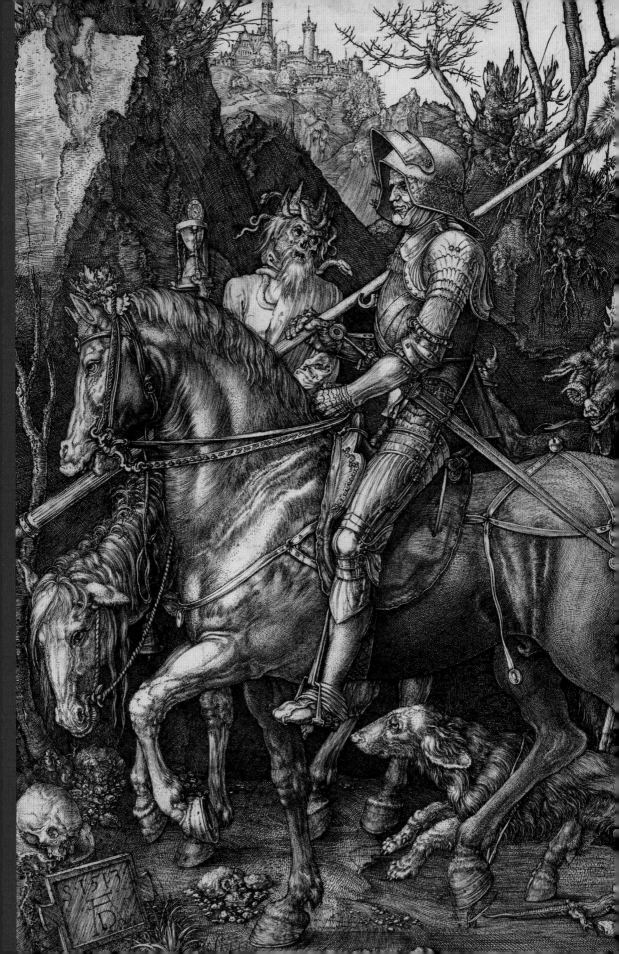

French, **Sculpted Arcade from the Monastery of Saint-Pons-de-Thomières**.
Marble, about 1150 to early 13th century. H. (plinth to keystone) 112 ⅝ in. (286.1 cm). Purchased
with funds from the Libbey Endowment, Gift of Edward Drummond Libbey, 1929.203–208

Part of the Museum's Cloister Gallery, this finely proportioned arcade comes from the Benedictine monastery of Saint-Pons-de-Thomières in Occitanie region, southern France. Saint-Pons-de-Thomières was once a vital center of Romanesque art and architecture. In this arcade, on the capitals atop the slender pairs of spiral columns, stonemasons carved scenes from the Bible and from the life of the monastery's patron. Saint Pontius of Cimiez founded a church in the Roman province of Gallia Narbonensis (today part of southern France), and was martyred in 257. Perhaps the most dramatic and compelling scene vividly depicts the Last Judgment, the separation of the saved and the damned at the end of time. Demons with pitchforks and tongs fling sinners into the fiery mouth of hell—represented as the gaping jaws of a giant dragon-like animal. Such terrifying imagery was a powerful reminder to the monks of the punishment for sin.

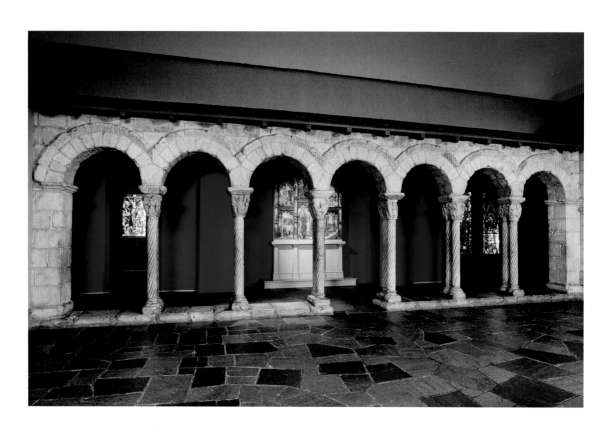

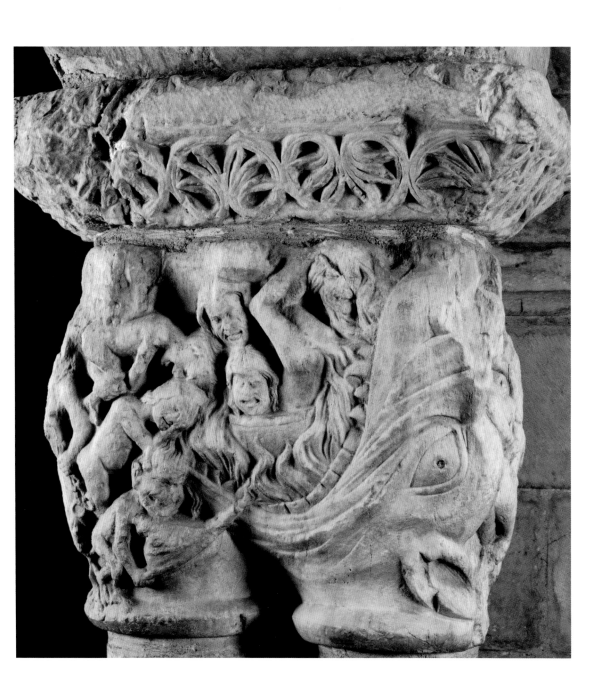

French, from Limoges, **Book Cover with the Crucifixion**. Gilded copper on wood panel with champlevé enamel, early 13th century. H. 12 $^{11}/_{16}$ in. (32.3 cm). Purchased with funds from the Libbey Endowment, Gift of Edward Drummond Libbey, 1950.254

The opulent use of gold and richly colored enamels on this splendid book cover indicate its expense. For most Catholic clergy living in the Middle Ages, the desire to honor God and to evoke a compelling sense of the grandeur of heaven prompted them to use costly materials for their religious books, robes, and altar linens.

Judging from the images surrounding the central figure of the crucified Christ—a scene often used in medieval Christian religious art—the book probably featured the New Testament gospels of Matthew, Mark, Luke, and John. Here, the figure of Christ is flanked on his left by the Apostle John and on his right by the Virgin Mary, while angels hover above. Adam, the first man, rises from his grave at the foot of the cross, making clear an essential Christian belief: Christ's death redeemed Adam and, by extension, all people from their earthly sins and offered them eternal salvation.

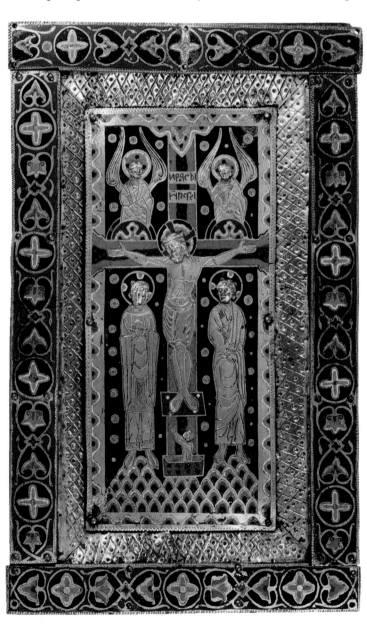

French or Flemish, **Box with Scenes from a Romance**. Ivory with gilded copper mounts, about 1350–75. W. 6½ in. (16.5 cm). Purchased with funds from the Libbey Endowment, Gift of Edward Drummond Libbey, 1950.302

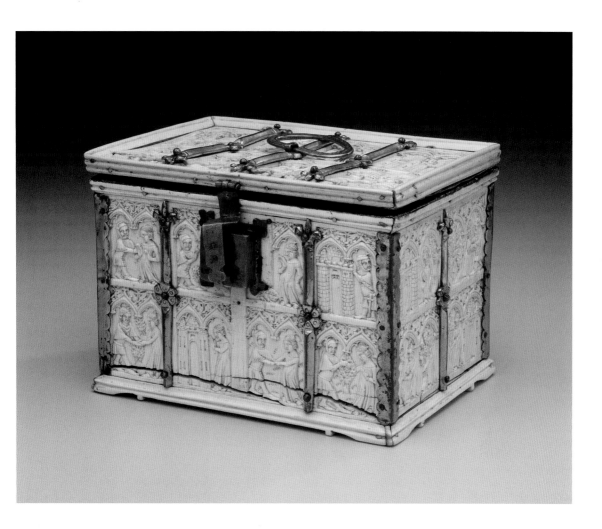

With imagery devoted to a tale of romantic intrigue, this luxurious carved ivory box would have made a perfect gift for a lover. The box, made in the late medieval period, comprises six rectangular panels of ivory held together at the corners with decorative strips of gilded copper and copper nails, and secured with a metal lock. Elaborate and delicately carved scenes on the lid and sides—thirty-one in all—depict episodes from a story of two aristocratic lovers.

The images are probably derived from popular romance literature of the day, replete with tales of chivalry, secret lovers, epic adventures, and betrayals.

Several scenes on this box depict tall, rounded towers on either side of the entrance to a fortified castle or a city gate. The towers suggest that the action takes place outside the bounds of the community, where a secret would be hard to keep.

Made with expensive materials such as gold leaf and deep blue lapis lazuli pigment, this sumptuous image of the Virgin Mary and the Christ Child was originally the center panel of a ten-part altarpiece (called a polyptych). The Virgin, as Queen of Heaven, is shown seated on a marble throne holding the infant Jesus on her lap. The throne is decorated with mosaic inlay and Gothic pinnacles, which were symbols of the Church itself. In his left hand the child grasps a bird, a goldfinch—a symbol of the Resurrection—and with his right hand makes a sign of blessing. The tilt of the Virgin's head suggests humility and approachability, and the way she holds her baby suggests the tender relationship between mother and child. Although some of the gold-leaf background has worn away, revealing its base of red clay (bole), the virtuoso tooling of the thin sheets of gold is still evident in the intricate rose-wreath design of the Virgin's halo.

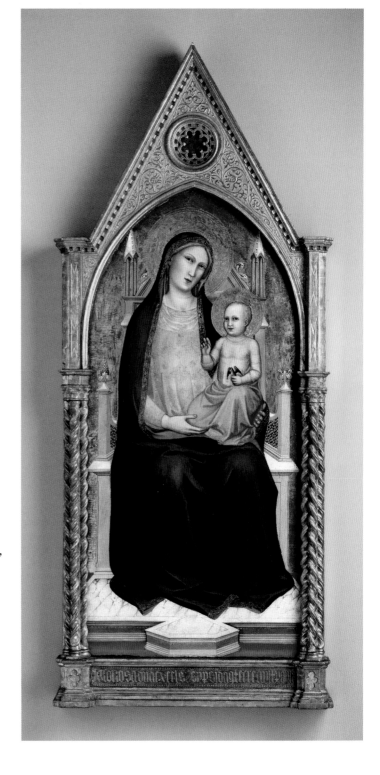

Lorenzo Monaco (Italian, about 1375–1423/24), **Madonna Enthroned**. Tempera and gold on wood panel, about 1390–1400. 48 $^{11}/_{16}$ x 24 in. (123.7 x 61 cm). Purchased with funds from the Libbey Endowment, Gift of Edward Drummond Libbey, 1976.22

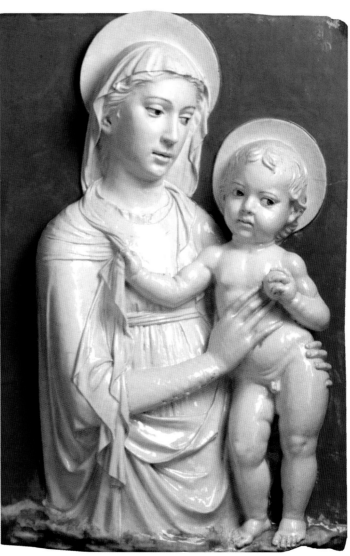

Luca della Robbia (Italian, 1399/1400–1482) OR Andrea della Robbia (Italian, 1435–1525), **Madonna and Child**. Tin-glazed terracotta, about 1465–70. H. 29 in. (73.7 cm). Purchased with funds from the Libbey Endowment, Gift of Edward Drummond Libbey, 1938.123

In this elegant relief, the Virgin Mary tenderly supports the Christ Child, who holds an apple in his right hand and clutches his mother's robes with his left. The deeply modeled figures project out from a flat blue background, symbolizing heaven.

Half-length reliefs of the Madonna and Child were in great demand for private devotional use in fifteenth-century Florence, and the della Robbia family, among others, filled that need. The della Robbia dynasty of Italian Renaissance sculptors, founded by Luca della Robbia, became renowned for a special type of glazed terracotta relief. In a recipe that remains a family secret to this day, Luca invented a ceramic glaze made opaque by the addition of tin oxide. Scholars disagree over whether this sculpture is the work of Luca or of his heir and most talented pupil, his nephew Andrea. This sculpture's intimate scale, sense of humanity, and serene charm are hallmarks of the finest della Robbia sculptures.

French, **Saint George and the Dragon**. Oil on wood panel, about 1480–90. 19 ½ x 14 ¼ in. (49.5 x 36.2 cm). Purchased with funds from the Libbey Endowment, Gift of Edward Drummond Libbey, 1943.30

The hero of this painting is the legendary Saint George, an early Christian martyr from the ancient Roman Empire. A warrior saint, he was popular in the Middle Ages and the Renaissance for his defense of the Christian faith and of the weak or helpless. According to legend, the townspeople of Silene in Libya were being terrorized by a dragon. They had been appeasing the monster by feeding it sheep. When that no longer satisfied it, they began feeding it their youths, chosen by lot. Arriving in Silene just in time, George rushed in to save the beast's next victim, the king's daughter. He made the sign of the cross, killed the dragon, and delivered the city from its terror. Awed by the saint's prowess and faith, the people of Silene converted to Christianity.

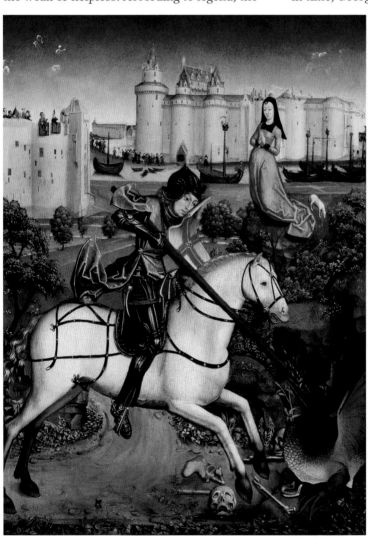

The unknown French artist who painted this panel took inspiration from the great French miniaturists who were masters of illuminated manuscripts, from Flemish panel painters, and probably also from the work of contemporary German printmakers. Here, he has translated the setting from Libya to the township of Tarascon, in the region of Provence-Alpes-Côte-d'Azur. The imposing fortress on the right is based on the castle at Tarascon, while the castle on the left is based on Beauclaire, which lies across the Rhône River from Tarascon.

Inspired by China's porcelain wares, which they saw when Silk Road traders brought back samples from the Far East, Venetian glassblowers developed a white glass they called *lattimo* (milk glass) as early as 1359. The white, slightly translucent glass was produced by adding tin oxide, or lead and arsenic, to a batch of molten glass. When it was also decorated with enamel and gold, it became known as *porcellana contrafacta* (counterfeit porcelain). The production of *lattimo* grew steadily between 1490 and 1512, when this colorful example was made.

This glass jug is illustrated with a triumphal procession of sea gods around its body. During the Italian Renaissance (1500s to 1600s), artists found new interest in depicting the pagan gods of antiquity. Ancient subjects were revived in many art forms, especially in prints, which may have inspired the decoration on this jug. Sea gods represented water's untamed nature, which could either cause disastrous floods or ensure a safe and speedy journey—appropriate imagery for a vase made in a city that depended on marine travel for commercial and political success.

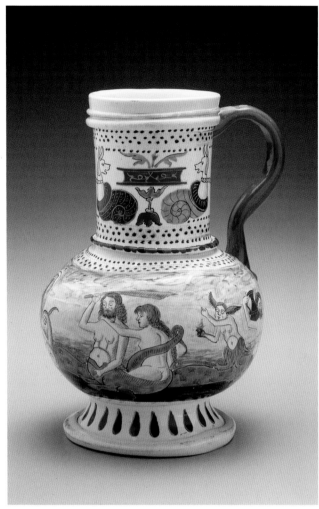

Italian, from Venice, **Lattimo Glass Jug**. Glass with gilding and enameling, about 1480–1525. H. 8 in. (20.3 cm). Purchased with funds from the Libbey Endowment, Gift of Edward Drummond Libbey, 1969.287

Anton Koberger (German, 1445–1513, printer/publisher), Hartmann Schedel (German, 1440–1514, author), Michael Wolgemut (German, about 1434–1519, artist), Wilhelm Pleydenwurff (German, 1458/60–1494, artist), **Liber Chronicarum (The Nuremberg Chronicle).** Book with woodcut illustrations, 1493. Page: 16 ½ x 12 ¼ in. (41.9 x 31.1 cm). Museum Purchase, 1920.542

The *Liber Chronicarum* (Book of Chronicles), commonly called the Nuremberg Chronicle, is one of the most important and spectacular printed books of the fifteenth century. It is the first lavishly illustrated history and geography of the world, tracing events from the biblical Creation up to the book's year of publication, 1493, with a section on the imagined End of the World. The subjects include biblical scenes, imaginary portraits, genealogies, and many remarkably accurate views of contemporary cities, such as Nuremburg itself (shown here).

Anton Koberger, the book's publisher, was originally trained as a goldsmith, but later established a printing press in Nuremberg in 1470/71. At the peak of its success, the Koberger print shop had twenty-four presses and a staff of one hundred.

Nuremberg artist Michael Wolgemut and his stepson Wilhelm Pleydenwurff provided the illustrations. In 1486 Koberger's godson, Albrecht Dürer (1471–1528), began a three-year apprenticeship with Wolgemut and later became one of the most influential graphic artists of his day. It is believed that Dürer may have contributed to the design of some of the 1,809 woodcut illustrations for which this book is famous.

This presentation cup, in the form of the trunk of a stylized oak tree, has as its finial a figure of Saint Sebastian, who was martyred about 288. According to legend, Sebastian served as a captain under the Roman emperor Diocletian, but when it was discovered that he had been converting other soldiers to Christianity, he was sentenced to death by being shot with arrows. Though he survived the arrows, he finally succumbed after being beaten to death, and became known as the patron saint of archers and soldiers. His inclusion on this cup suggests it may have been made for the marksmen's confraternity from the city of Ingolstadt. Other clues lie in the enameled shields on the base which include the coat-of-arms (a rampant panther) of Ingolstadt, a wheel-lock rifle, and a crossbow. Medieval confraternities were volunteer organizations that were often involved in charitable works in cooperation with the Catholic Church.

Cups such as this one were usually reserved for special ceremonies, where they would have been used to serve wine. Hans Greiff was the leading goldsmith in Ingolstadt and produced many elaborate beakers for guilds, civic groups, and town officials.

Attributed to Hans Greiff (German, active about 1470–died 1516), **Footed Beaker with Figure of Saint Sebastian**. Silver with parcel gilding and applied enamel plaques, about 1470–90. H. 12⅜ in. (31.4 cm). Purchased with funds from the Florence Scott Libbey Bequest in Memory of her Father, Maurice A. Scott, 1961.13

Piero di Cosimo (Italian, 1462–1521), **The Adoration of the Child**. Oil on wood panel, about 1495–1500. Diam. 63 in. (160 cm). Purchased with funds from the Libbey Endowment, Gift of Edward Drummond Libbey, 1937.1

Closely observed details of nature carry symbolic meaning in this painting of the Virgin Mary worshiping the Christ Child. The carpet of plants, for example, with such flowers as lilies, daisies, and lady's bedstraw, symbolizes Mary's purity. The tree stump, the sleeping child's pose, and the tomb-like rock formation allude to Christ's death, while the stream trickling from the barren rock suggests resurrection (life from death). Even the bird perched near the child and the tadpoles in the little pool are associated with Christ's resurrection: the bird symbolizes the soul and the tadpoles represent both new life and transformation ("fish" into frog).

The subject of this painting is based on the visions of Saint Bridget of Sweden, a fourteenth-century mystic. In her account, she describes "seeing" the Virgin Mary give painless birth to the Christ Child while kneeling on the ground, then immediately worshiping him while her husband Joseph slept nearby.

Piero di Cosimo—who was a contemporary of fellow Florentine masters Leonardo da Vinci, Sandro Botticelli, and Michelangelo Buonarotti—painted many *tondo* (round) paintings. Used almost exclusively for the home, *tondi* were usually displayed in bedchambers and frequently showed the Virgin and Child as role models for pious domestic behavior.

Albrecht Dürer (German, 1471–1528), **The Lamentation of Christ, from The Large Passion**. Woodcut, hand-colored, with Latin text on verso, about 1498–99; published 1511. 15 ⁹⁄₁₆ x 11¼ in. (39.5 x 28.6 cm). Museum Purchase, 1923.56

Albrecht Dürer's *Lamentation* woodcut derives its expressive power from both its technical complexity and its narrative detail. The solemnity of the image, underscored by the dramatic lighting and the poses of the grief-stricken figures, sets it apart from the other

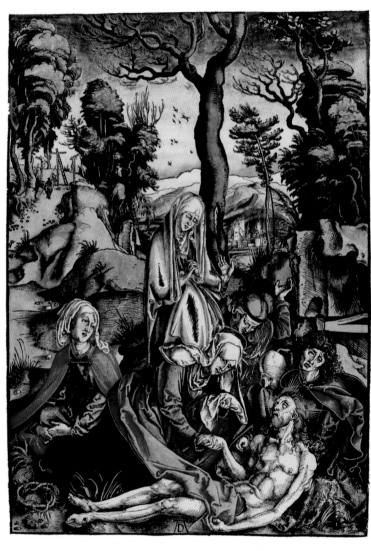

eleven woodcut images in the Large Passion series. Among the pyramidal grouping of mourners surrounding the dead Christ are Saint John (lower right), who gently raises Christ's shoulders; and Christ's mother, the Virgin Mary (center), who tenderly lifts his bleeding hand. Dürer has applied the Renaissance principles of perspective to connect the strongly emotional figures in the foreground to the site of Christ's crucifixion on the distant hillside.

This remarkable woodcut also stands out for its hand-coloring. Though the pigments were not painted onto the print by the artist himself, they may have been done according to his instructions for customers who requested hand-colored impressions. The distinctive luminous palette on this example, with powdered gold and silver highlights (now oxidized to gray), adds to its emotive and mystical effect.

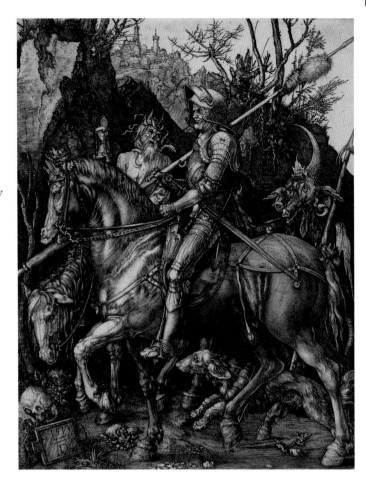

In this detailed and symbolically complex image, the Northern Renaissance artist Albrecht Dürer fuses German and Italian art traditions with Christian ideals to display his technical mastery of engraving. In this print, a Gothic knight rides through a northern European forest on a magnificent horse as his hunting dog runs alongside him. Dürer is known to have made several trips to Italy, and scholars believe that this image of a mounted horse in profile was styled after Italian Renaissance equestrian monuments, a tradition that dates to Imperial Rome. Strengthened by the power of Christian belief, the knight is undaunted by the dangers of the physical world as he makes his way along a narrow, rocky path. With faith as his chief weapon, he confronts Death—a rotting, snake-crowned corpse that rides beside him—who holds an hourglass, a symbol of life's brevity. Temptation to evil, represented by a hideous Devil, walks behind.

Knight, Death, and the Devil belongs to Dürer's three "master engravings," along with *Saint Jerome in His Study* (1514) and *Melencolia I* (1514). Though Dürer created each print independently, collectively they represent the three modes of virtuous living: active (the knight), contemplative (Saint Jerome), and intellectual (*Melencolia*). The Museum owns impressions of all three of these master engravings.

Albrecht Dürer (German, 1471–1528), **Knight, Death, and the Devil**. Engraving, 1513. 9 ⅝ x 7 ⁷⁄₁₆ in. (24.4 x 18.8 cm). Grace J. Hitchcock Collection, 1981.204

Flemish, probably woven in Tournai, possibly in the Poissonier Workshops, **Tapestry with Wild Woman Riding a Unicorn**. Wool and silk tapestry, about 1504–25. 111 x 150 in. (281.9 x 381 cm). Purchased with funds from the Libbey Endowment, Gift of Edward Drummond Libbey, 1947.7

Against a dense background known as *mille fleurs* (French for "a thousand flowers"), birds and animals hide in the foliage of this tapestry while a young woman, riding a camel-like unicorn, faces a fierce lion. The maiden is as extraordinary as the fantastic beast she rides: covered in long body hair, she wears a sheer tunic and a helmet made of two animal jaw-bones tied together. Her appearance matches medieval legends about wondrous tribes from the unknown East and tales of wild men and women living in harmony with nature. The unicorn, too, shares its origins in medieval mythology: as an elusive, dangerous creature from India or Persia, legend claims that it could only be tamed by a virgin.

Europeans' interest in exotic people and creatures was fueled by fanciful accounts by ancient Greek and Roman authors of strange peoples in foreign lands. The obsession reached new heights after Vasco da Gama's voyages to India in 1497 and 1502, inspiring such tapestry series as The Voyage to Calicut (1504) and History of the People and Wild Beasts in the Manner of Calicut (1510), to which this tapestry is related.

Master of the Morrison Triptych (Flemish, active about 1500–1525), **The Morrison Triptych**. Oil on wood panels, about 1500–10. Left and right wings: 43 ⅝ x 14 ⅝ in. (110.8 x 37.2 cm); center panel: 38 ⅜ x 23 ¾ in. (97.5 x 60.4 cm). Purchased with funds from the Libbey Endowment, Gift of Edward Drummond Libbey, 1954.5a-c

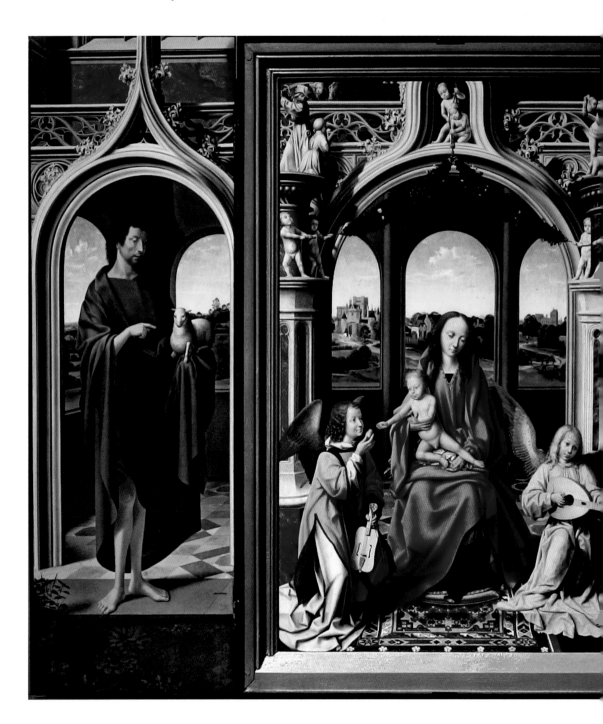

Based on a similar three-part painting, *Triptych with the Virgin and Child Enthroned* (now in Vienna) by the Flemish painter Hans Memling (1430/40–1494), the central image of this triptych depicts the Virgin Mary sitting on a

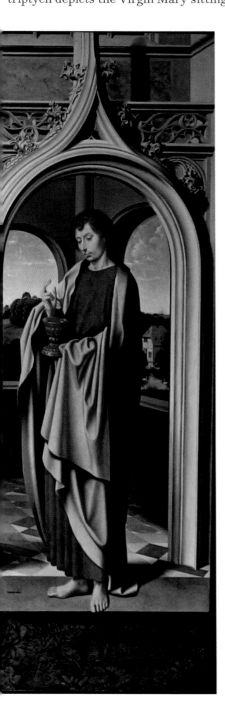

low throne and flanked by two angels playing music, with the Christ Child seated on her lap. The left-hand panel shows Saint John the Baptist, the cousin of Jesus and the last biblical prophet. Saint John the Evangelist is on the right-hand panel. The two outer panels (wings) are hinged to close over the center panel. With the wings closed, worshipers would see realistic paintings of Adam and Eve, the first sinners, standing on pedestals like living statues emerging from the shadows into bright light. When open, the altarpiece revealed its brightly colored interior and the Christian believer could see the possibility of redemption, as represented by the Christ Child and the Virgin Mary—the new, sinless Adam and Eve.

 The Morrison Triptych and its unknown artist are named after its former owner, the British collector Alfred Morrison (1821–1897).

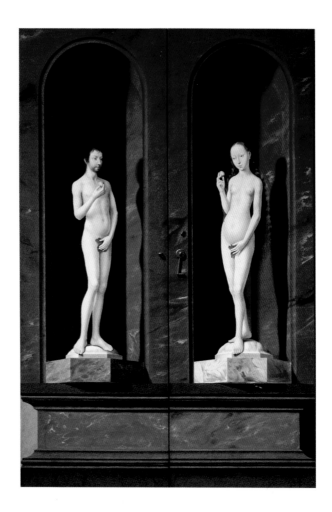

Jan Gossart, also called Mabuse (Flemish, about 1478–1532), **Two Wings from the so-called Salamanca Triptych**. Oil on wood panel, 1521. Each panel: 47¼ x 18½ in. (120 x 47 cm). Purchased with funds from the Libbey Endowment, Gift of Edward Drummond Libbey, 1952.85 a–b

Flemish artist Jan Gossart visited Rome in 1508–09, part of a tradition of Northern European artists traveling to Italy to study both Renaissance and ancient art. In these two panel paintings, Gossart combined these Italian influences with Northern European realism.

These paintings are from a triptych, a three-part altarpiece. The central image—either a painting or a relief sculpture—that the wings would have flanked has not been identified. According to a seventeenth-century account, the wings were located at that time

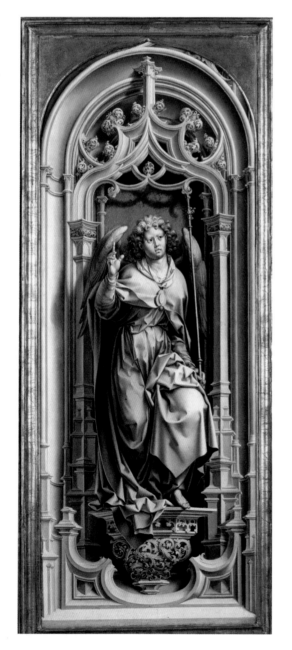

in the chapel of the Spanish merchant Pedro de Salamanca in the Augustinian Church in Bruges.

When the hinged wings, painted on both sides, were closed over the now-missing central component, they showed the angel Gabriel announcing to the Virgin Mary that she will bear the Son of God. The figures stand in elaborate Gothic niches and are painted in tones of gray (grisaille) to mimic stone sculpture. The images on the inside of these panels, visible when the altarpiece was open, also display full-length figures in an architectural setting. But here the fantastic architecture is Italian Renaissance in character. Saint John the Baptist on the left and Saint Peter on the right are painted in strong colors. The effect is one of sculpture come to life.

Lucas Cranach the Younger (German, 1515–1586), **Martin Luther and the Wittenberg Reformers**. Oil on wood panel, about 1543. 27⅝ x 15⅝ in. (70.2 x 39.7 cm). Gift of Edward Drummond Libbey, 1926.55

In 1517, in Wittenberg, Saxony, the religious reformer Martin Luther (1483–1546) posted his *Ninety-five Theses*, in which he argued against corrupt practices in the Roman Catholic Church. Printed copies of his list were circulated widely, sparking the Protestant Reformation. Painted some twenty-five years later, this panel depicts Luther and his fellow reformers.

At the center stands John Frederick the Magnanimous, Elector of Saxony (ruled 1532–47), who protected the Wittenberg reformers from the ire of the Catholic Church and the Holy Roman Emperor. Martin Luther (far left) stands behind him. To the far right, holding a scroll and pointing upward, is Luther's chief associate, the humanist scholar Philipp Melanchthon (1497–1560). Behind the Elector's left shoulder is probably Saxon Chancellor Gregor Brück (1485–1557). The young man in red next to Luther has been identified as Georg Spalatin (1484–1545), a writer and Reformation advocate. The partial, unidentified coat of arms held by the winged cherub was probably that of the patron of the painting.

Numbers painted on some of the figures (for example, on Spalatin's red tunic) were added early in the painting's existence and once corresponded to a list of names on the back of the panel.

Hans Holbein the Younger (German, 1497/98–1543), **Portrait of a Lady, probably a Member of the Cromwell Family**. Oil on wood panel, about 1535–40. 28⅜ x 19½ in. (72 x 49.5 cm). Gift of Edward Drummond Libbey, 1926.57

Impartial observation and meticulous detail are the hallmarks of portraits by Hans Holbein the Younger. Though his likenesses tend to appear unemotional and analytically objective, they have a lifelike quality that still astonishes. German-born Holbein settled in England in 1532, and only a few years later was made court painter to the Tudor King Henry VIII (ruled 1509–47), where his chief job was to paint portraits of members of the royal court, including the king himself.

This woman's identity has not been determined, though her age is inscribed on the painting "ETATIS SVA 21" (21st year of her age). Because the painting belonged to the Cromwells for centuries, it is likely that she was a member of that prominent family. She may be Elizabeth Seymour (1513?–1563), daughter-in-law of Henry's powerful government minister Thomas

Cromwell and sister of Henry's third wife, Jane Seymour. Elizabeth Seymour was a lady's maid to Queen Anne Boleyn and lady-in-waiting to four of Henry's later wives, including her sister Jane.

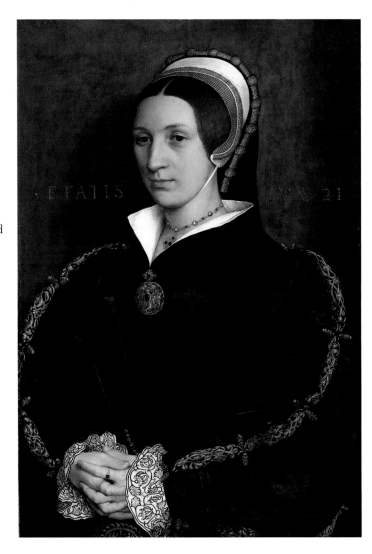

Made by painter and enameler Léonard
Limousin, who worked in the
Fontainebleau court of Francis I (ruled
1515–47), this luxurious footed bowl (tazza)
is a rare masterwork that even retains its
original fitted leather case. Signed "LL"
eleven times by Limousin, the tazza makes
extensive use of the white opaque back-
ground with blue shading that Limousin
himself introduced to enameling. The
interior depicts an allegory of Fortune
(lady luck). "Reason overcomes Fortune's
Changes" is inscribed on the interior in
the medieval dialect of Limoges. Fortune
balances by one foot on an orb and grasps a
billowing sail—symbols of Fortune's unpre-
dictable changes—while riding on a pair
of fish-tailed horses (hippocamps) guided
by Cupid.

The enigmatic imagery on the lid
includes four roundels with double profile
busts combining younger and older por-
traits of Helen of Troy, the Roman Emperor
Nero, Hercules, and a profile bust of the
wife of Hercules, Deianeira.

Léonard Limousin (French, about 1506–1575/77), **Covered Tazza with an Allegory of
Fortune**. Painted enamel on copper, about 1536–48. Diam. 7⅛ in. (18.1 cm). Purchased with funds
from the Florence Scott Libbey Bequest in Memory of her Father, Maurice A. Scott, 1980.1018a–b

Northern Italian, **Book of Hours: Officium Beatae Mariae Virginis**. Book with ink and gold leaf on vellum, about 1513–21. Page: 5 ⅞ x 3 ¾ in. (13.8 x 9.5 cm). Museum Purchase, 1957.23

This exquisite book of hours—cycles of Christian prayers for an individual to recite at certain hours of the day—was sumptuously inscribed and illustrated for Pope Leo X. Born Giovanni di Lorenzo de' Medici (1475–1521), Pope Leo X came from the most renowned family of Renaissance Italy and was a notable collector and patron of the arts.

This small, handheld volume includes six elaborate double-page spreads in which a narrative illustration faces a page with the first words of a prescribed set of prayers. On the left-hand page, set in a verdant landscape, Christ bears the cross to his crucifixion at Golgotha. His mother, Mary, follows him while Simon of Cyrene helps carry the cross. Below, in a decorative floral border, a laurel wreath encircles a cross, representing Christ's victory over death. On the facing page, in Latin, is the introduction to the prayers for this hour: "Here begins the office of the most holy cross." Inside the initial P on a field of gold leaf is a painting of the sinner Mary Magdalene praying before the cross, meant to inspire the reader to repent.

Francesco Primaticcio (Italian, 1504–1570), **Ulysses and Penelope**. Oil on canvas, about 1560. 44 ¾ x 48 ¾ in. (113.6 x 123.8 cm). Purchased with funds from the Libbey Endowment, Gift of Edward Drummond Libbey, 1964.60

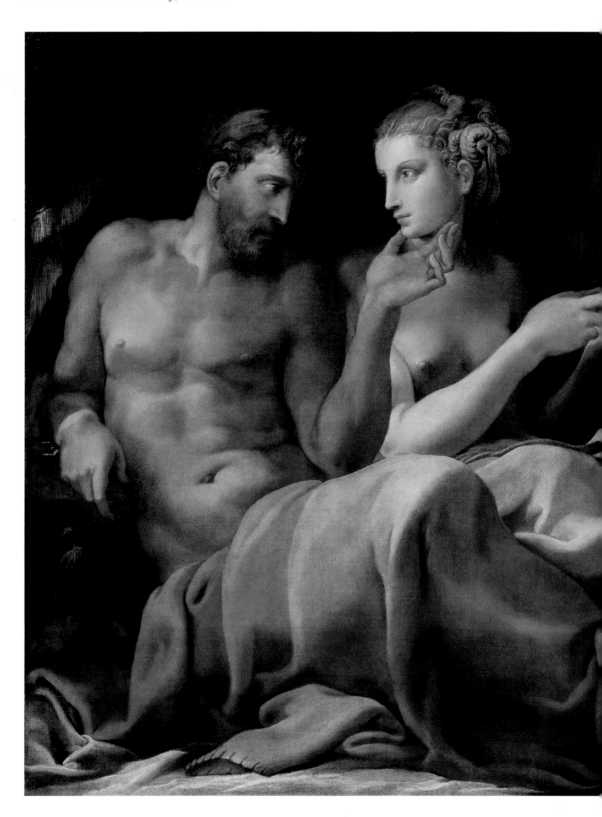

Near the end of the Greek epic *The Odyssey* by Homer, the hero Odysseus (Ulysses to the Romans) returns to the arms of his wife, Penelope, after years of separation and challenges. The two talk deep into the night about all that had happened to them during that time. This striking depiction of their reunion and the tender gesture of Ulysses cradling his wife's face—remarkable for its touching intimacy—is expressed in the elegant style of the French palace at Fontainebleau. There, King Francis I and his successors promoted a setting that became the cultural center of sixteenth-century France. Its architectural magnificence, glamor, and intellectual liveliness made this court the envy of late Renaissance Europe.

In the "universal workshop" at Fontainebleau, the painter, architect, and sculptor Francesco Primaticcio became the dominant artistic personality. There, he adapted his Italian Mannerist style to French taste; his graceful, refined designs defined the official court style. Primaticcio's masterpiece was the palace's 500-foot-long Gallery of Ulysses (about 1556–59), demolished in 1738 due to structural problems. Following Primaticcio's drawings, Niccolò dell'Abate (about 1509/12–1571) painted its walls with fifty-eight scenes from *The Odyssey*. This canvas—one of the few confidently attributed to Primaticcio himself—is based on one of the frescoes, as confirmed by a later engraving.

Francesco Salviati (Italian, 1510–1563), **The Holy Family with Saint John the Baptist**. Oil on wood panel, about 1540. 51¼ x 31½ in. (130.2 x 80 cm). Purchased with funds from the Libbey Endowment, Gift of Edward Drummond Libbey, 1975.83

Languorously elegant, a youthful Madonna gently supports a robust, twisting Christ Child on her lap in this panel painting by Francesco Salviati. The infant John the Baptist leans against her left shoulder as he gazes adoringly at his young cousin, Jesus. In the shadowy background, Saint Joseph looks on in contemplation. The figures emerge from a velvety darkness, the Virgin's robes almost glowing. The play of light on the fabric—represented by slight shifts in color rather than changes in value—gives her garment an iridescent quality. The elongated proportions, serpentine poses, shallow space, and vibrant tones express the taste for the graceful, studied artifice of *la bella maniera*, or Mannerism, of sixteenth-century Italy.

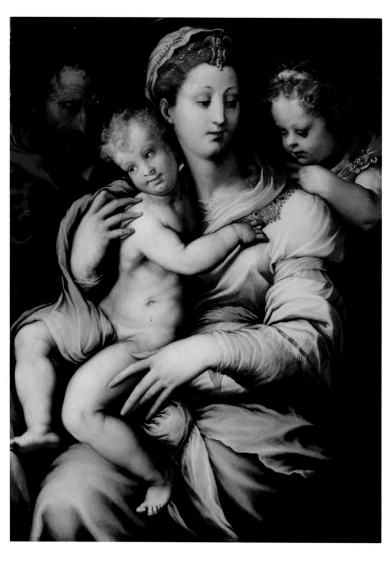

After serving several apprenticeships in Florence, including with the painter and biographer Giorgio Vasari (1511–1574), Salviati left for Rome in 1530, where he made his name as a fresco painter. From 1539 to 1541 he was working primarily in Florence and Venice, and it is likely that he executed the painting during this sojourn.

Jacopo Bassano (Italian, about 1515–1592), **The Flight into Egypt**. Oil on canvas, 1540–45. 62 x 80 in. (157.5 x 203.2 cm). Purchased with funds from the Libbey Endowment, Gift of Edward Drummond Libbey, 1977.41

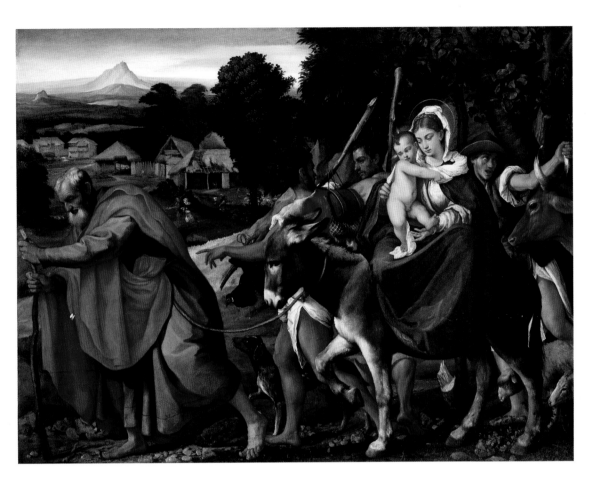

In the New Testament, the Gospel of Matthew tells of an angel warning Joseph to take his wife Mary and the infant Jesus to Egypt, to flee the murderous intentions of King Herod. Jacopo dal Ponte—called Bassano after his home town—places this version of the scene in the realm of everyday life, encouraging empathy for the trials and sufferings of the Christian religion's Holy Family. Key details include Joseph's determined features, the thoughtful young Mary, the expressive faces of the shepherds, and the contemporary landscape inspired by the surroundings of Bassano del Grappa.

The frieze-like composition highlights Bassano's ability to orchestrate a complex figural arrangement while integrating his group into a rustic landscape. The steadfast Joseph leading the ass bearing the haloed Virgin and Child, the three shepherds (possibly Joseph's sons), along with a dog, chickens, sheep, and an ox, are all painted with great sensitivity and naturalism. Bassano's exquisite use of color reflects his training in Venice and his contacts with other Venetian Mannerist painters, who were renowned as sumptuous colorists.

Giorgio Ghisi (Italian, Mantua, about 1520–1582), **Allegory of Life**. Engraving, 1561. 14 ⅞ x 21¼ in. (38.2 x 54.1 cm.). Purchased with funds from the Libbey Endowment, Gift of Edward Drummond Libbey, 1982.90

Filled with monstrous creatures, allegorical figures, and incongruous details, this fascinating image by Italian Mannerist printmaker Giorgio Ghisi has yet to be fully deciphered. A bearded old man and a young, crowned woman wearing classical garb and carrying an oversized arrow are separated by a roiling river that tosses a broken boat. Besides the obvious contrasts of age and gender, the man is resting against a dead tree, while the woman strides powerfully forward, her hand touching a flourishing date palm. Though the details of the print do not correspond to any scenes in Virgil's epic poem *The Aeneid*, the Latin inscriptions below the two figures are quotations from

Book 6, in which Aeneas descends to the Underworld and encounters the spirit of his father. The tablet beneath the old man reads, "The unhappy one sits and will sit forever;" the one beneath the woman reads, "Do not yield to adversaries, but go out and meet them bravely." Another inscription at the bottom attributes the design to the revered Renaissance artist Raphael (1483–1520), though the dense image, with its profusion of detail, does not resemble Raphael's more orderly style. Ghisi engraved designs made by other artists and often embellished those compositions with his own inventive motifs.

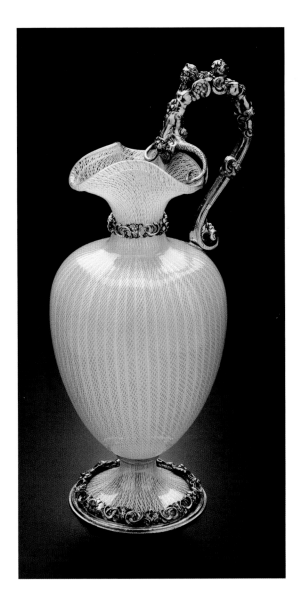

***Vetro a filigrana*, or filigree glass,** was a staple of the Venetian glassmaking repertory in the early sixteenth century and remained so for more than two hundred years. However, this was not a new technique. Filigree glass was already known in Rome by the late first century BCE, when glass canes of twisted opaque white "threads" were embedded in colorless glass. In ancient times, this process was used in making cast and slumped mosaic-glass bowls and plates. What is not known, however, is whether Venetian Renaissance glassmakers, working far north of Rome and some 1500 years later, knew of ancient glassware made by this method.

According to an inventory of 1527, the Venetian glassmaker Francesco Zeno invented a type of blown glass vessel called *vetro a retorti* (glass with twists). By the late 1500s, filigree glass became the most important Venetian luxury glass export. This filigree ewer was exported to Germany, where, in Nuremberg, probably at the workshop of Heinrich Straub, gilded silver mounts were added at the neck and base, and its original glass handle was replaced with an elaborately chased and gilded handle in the form of curved and scrolled male and female figures.

Italian, from Venice, mounts: probably Heinrich Straub (German, Nuremberg, active 1608–36), **Ewer**. Filigree glass; gilded silver mounts with gems, enamel, about 1550–1600. H. 11 $^{11}/_{16}$ in. (29.5 cm). Purchased with funds from the Libbey Endowment, Gift of Edward Drummond Libbey, 1960.36

Danese Cattaneo (Italian, about 1510–1572), **Portrait Bust of a Venetian Gentleman**. Bronze, about 1547–60. H. 22⅛ in. (56.2 cm). Purchased with funds from the Libbey Endowment, Gift of Edward Drummond Libbey, 1995.11

Sixteenth-century artist and biographer Giorgio Vasari wrote of the Venetian High Renaissance sculptor Danese Cattaneo that he is "not only an excellent sculptor, but also a good and much extolled poet as his works clearly demonstrate, on which account he has always had association and sound friendship with the greatest men and choicest spirits of our age."

Cattaneo's reputation as a portrait sculptor is apparent in this life-size bronze bust.

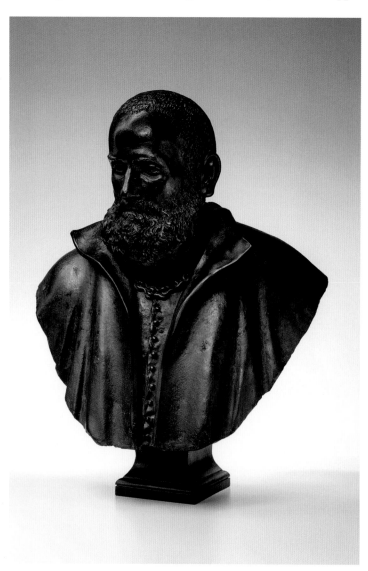

Inspired by examples from classical antiquity and developments in contemporary Venetian painting, Cattaneo brought out a subjective naturalism in his likenesses, a style that captured the individuality of his sitters.

The identity of the gentleman who sat for this sculpture is unknown. Perhaps a scholar, he is rendered frontally with his head turned slightly to his right. Dressed in a cloak with an upturned collar over a buttoned tunic and a heavy chain, the middle-aged man has cropped hair, a mustache, and a full beard. His downward glance marks him as a forceful, intelligent personality rendered in a moment of profound introspection. It may be that this bust was meant to serve as part of a funereal monument, and perhaps was placed in a niche above the tomb of the subject portrayed.

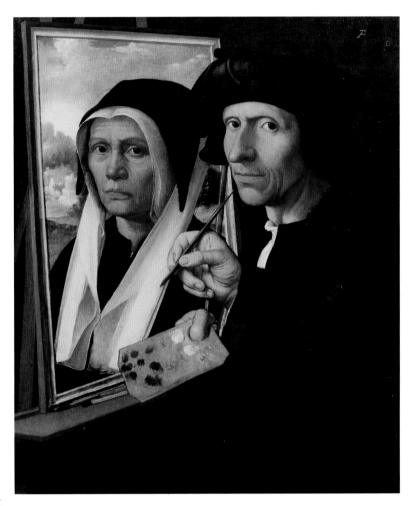

Dirck Jacobsz (Dutch, about 1497–1567), **Jacob Cornelisz van Oostsanen Painting a Portrait of His Wife**. Oil on wood panel, about 1550. 24 ⁷⁄₁₆ x 19 ⁷⁄₁₆ in. (62.1 x 49.4 cm). Purchased with funds from the Libbey Endowment, Gift of Edward Drummond Libbey, 1960.7

Remarkably inventive, this unusual double portrait plays with sophisticated concepts of absence and presence. Here, Dirck Jacobsz shows his artist father, Jacob Cornelisz van Oostsanen, painting a portrait of his wife, Dirck's mother, Anna. Jacobsz based the head and costume of his father on a self-portrait the older artist had painted about twenty years earlier. Though Oostsanen died in 1533, Anna lived until about 1550, around the same time this panel was painted.

Traditionally, portraits have been considered a way of making the absent present, if only in effigy. Because Dirck Jacobsz's mother is depicted as a portrait within a portrait, a traditional way of representing a deceased family member, it seems likely the image was painted soon after her death. Poignantly, in this composition she is made present—symbolically brought to life—simultaneously by her painter husband and her painter son. The artist's father is also "present" through his likeness preserved in paint. This double portrait was probably painted as a memorial, to be installed in a church above the couples' tomb.

Joos de Momper the Younger (Flemish, 1564–1635) and Jan Brueghel the Elder (Flemish, 1568–1625), **A Summer Landscape with Harvesters**. Oil on canvas, about 1610. 65½ x 98⅞ in. (166.4 x 251.1 cm). Purchased with funds from the Florence Scott Libbey Bequest in Memory of her Father, Maurice A. Scott, 2003.16

Prominent Flemish landscape painter Joos de Momper the Younger places *A Summer Landscape with Harvesters* in a vast, all-encompassing panorama of rolling fields giving way to a distant valley and the faraway sea. Using a mutually reinforcing geometry of diagonals that intersect with three distinct color bands (yellow, green, and blue), the composition convincingly leads the eye deep into the picture.

The largest and most spectacular of de Momper's many harvest scenes, this canvas may have been part of a series of paintings of the seasons or labors of the months. The scene includes more than seventy figures (painted by Jan Brueghel the Elder) engaged in different activities, all of which coalesce into a vivid and coherent narrative of the various tasks involved in reaping a crop of wheat. In the heat of the day, laborers cut the grain in the fields and others bundle it into sheaves, while horse-drawn wagons transport the harvest to market and possibly on to overseas destinations, as suggested by the ships in the distant harbor.

Doménikos Theotokópoulos, called El Greco (Spanish, 1541–1614), **The Agony in the Garden**. Oil on canvas, about 1590–95. 40¼ x 44¾ in. (102.2 x 113.7 cm). Purchased with funds from the Libbey Endowment, Gift of Edward Drummond Libbey, 1946.5

This dramatic scene depicts Christ's moment of spiritual struggle as he prays in the Garden of Gethsemane, just before being arrested and later crucified for his teachings. The angel hovering before him holds a cup that refers to Christ's words: "Oh my Father, if this cup may not pass away from me, except I drink it, thy will be done" (Matthew 26:42). Engulfed by the same cloud on which the angel kneels, the disciples Peter, James, and John sleep, oblivious to Christ's vision and his impending ordeal. To the right, soldiers approach from behind, under a full moon.

Greek-born but working in Spain, Doménikos Theotokópoulos, known as El Greco (the Greek), heightened the emotional and spiritual impact of his paintings by elongating proportions, using a palette of intense colors, and exaggerating differences in scale, lighting, and spatial relationships. Here, figures and landscape are isolated in pockets of ambiguous, shallow space. The beam of divine light striking Jesus creates unusual light-dark contrasts, especially on his garment, which hangs heavily in sharp folds. Even the rocks and the clouds seem to be made of the same material.

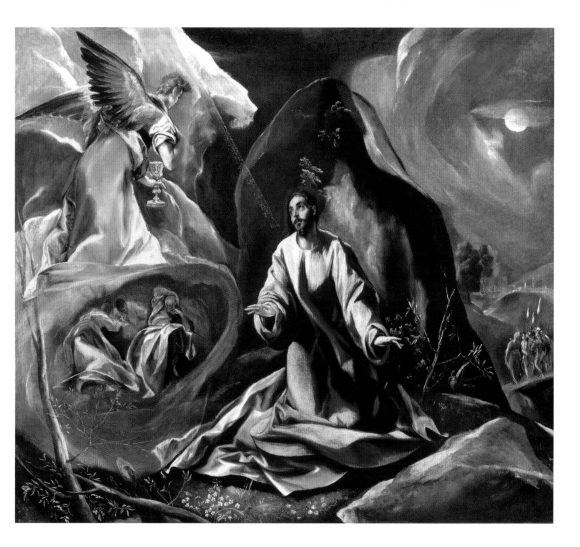

Hendrick Avercamp (Dutch, 1585–1634), **Winter Scene on a Canal**. Oil on wood panel, about 1615. 18 ⅞ x 37 ⅝ in. (47.6 x 95.5 cm). Purchased with funds from the Libbey Endowment, Gift of Edward Drummond Libbey, 1951.402

A canal has frozen over in a Dutch village, trapping boats and inviting people of different social backgrounds to mingle on the ice. Well-dressed gentlemen and ladies greet one another, ride a horse-drawn sleigh, and rent skates alongside humbler villagers. A group of merchant-class men in the center foreground play *kolf*, a game related to golf, while three industrious peasants in the right foreground prepare to fish for eel through the ice.

Hendrick Avercamp, whose work was quite popular in his day, was best known for his winter landscapes and marine paintings. Perhaps his keen observational skills were enhanced by the fact that he was hearing-impaired. Into this scene he packs a wealth of small but telling details, from the man relieving himself behind a tree to the wading boots stuck on fence posts. He also included mininarratives: distant skaters who have fallen on the ice, the dog barking at the closed barn door, and the lone figure in the left foreground walking away from the busy spectacle. The scene stretches into the distance, where the frozen waterway meets heavy skies, emphasizing the flatness of the Dutch landscape.

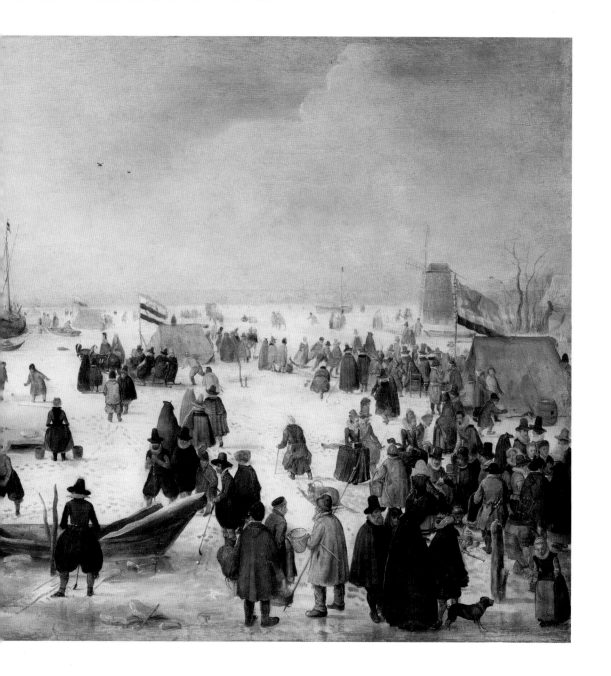

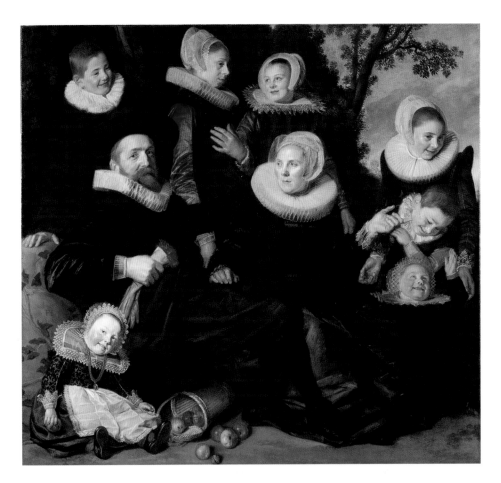

Frans Hals (Dutch, 1582/83–1666), **Van Campen Family Portrait in a Landscape**. Oil on canvas, about 1623–25. 60 x 64¾ in. (151 x 163.6 cm). Purchased with funds from the Florence Scott Libbey Bequest in Memory of her Father, Maurice A. Scott, the Libbey Endowment, Gift of Edward Drummond Libbey, Bequest of Jill Ford Murray, and and Gift of Mrs. Samuel A. Peck, Mrs. C. Lockhart McKelvy, and Mr. and Mrs. Frederick S. Ford, by exchange, 2011.80

Frans Hals is considered one of the premier portraitists in the history of Western art. His genius is evident in his mastery of compositional structure, his ability to capture a natural sense of vitality, and especially in his seemingly spontaneous, bravura brushwork. This painting, the earliest of only four family portraits he painted, is a fragment of a larger composition that showed the fashionably dressed Haarlem cloth merchant Gijsbert Claesz van Campen and his wife, Maria Jorisdr, with their thirteen children. In this fragment the family members interact affectionately through glance and gesture. At some time before 1800, for unknown reasons, a portion of the right side of the canvas was cut away. One segment, showing four children with a goat cart, is in Brussels at the Royal Museums of Fine Arts of Belgium. Another fragment, with the head of a boy, survives in a private collection. The remaining segments have not been found.

A few years after this painting was completed, a fourteenth child was born to the Van Campens. In 1628 the Haarlem painter Salomon de Bray (1597–1664) painted the figure of this infant girl at the lower left, in a style noticeably different from that of Hals.

Thomas de Keyser (Dutch, about 1596–1667), **The Syndics of the Amsterdam Goldsmiths Guild**. Oil on canvas, 1627. 50 ⅛ x 60 in. (127.2 x 152.4 cm). Museum Purchase, 1960.11

Psychological unity and compositional structure are tightly integrated in this group portrait. Thomas de Keyser, the leading Amsterdam portrait painter until Rembrandt van Rijn arrived there in 1631, places four men around a small table. Each looks directly out, as though to establish a strong interaction with the viewer. These men were the syndics, or officers, of the Amsterdam association of goldsmiths. It was their responsibility to ensure quality in both the raw materials and the finished products of the guild community. For this reason, they are shown holding the tools that measure the purity of the gold or silver and some of the luxury objects made by guild members.

Governing boards of a guild would commission artists to paint their collective portraits whenever the officers changed. Displayed in the guild's chamber, these portraits symbolically conveyed both the authority of the officers and the quality of the guild's workmanship. De Keyser conveys this message with the seated man at the right, who makes an eloquent gesture with his hand, as if to say, "Trust us."

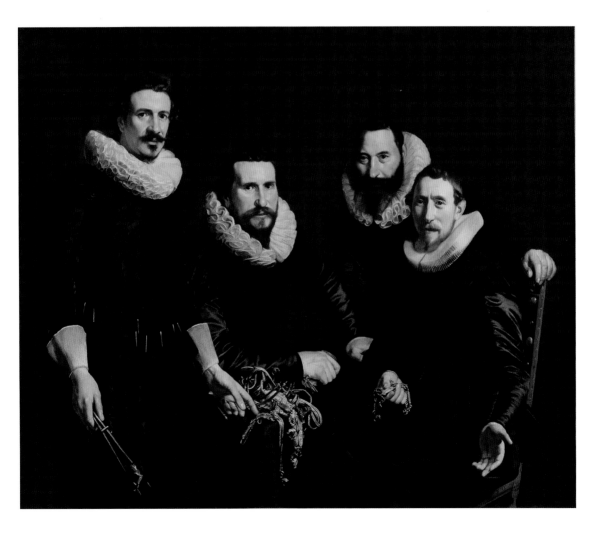

Balthasar van der Ast (Dutch, 1593/94–1657), **Fruit, Flowers, and Shells**. Oil on wood panel, 1620s. 21¾ x 35⅛ in. (55.2 x 89.2 cm). Purchased with funds from the Libbey Endowment, Gift of Edward Drummond Libbey, 1951.381

A profusion of flowers, shells, fruit, and living creatures fills a ledge in Balthasar van der Ast's carefully composed still life. Dutch and Flemish artists of the sixteenth and seventeenth centuries were especially admired for their realistic renderings of the colors, textures, and shapes of both animate and inanimate objects. In this painting Van der Ast places most of the elements in distinct spaces, so that each one can be examined more carefully.

The array of objects creates a feast for the eyes, but also reflects the scientific revolution that had taken place in natural history and other sciences from the 1400s to the 1600s. Amateur naturalists and collectors of curiosities cherished shells from the South Pacific and the Indian Ocean; coveted rare tulips, introduced to Europe from Turkey around 1550; and even kept such exotic creatures as parrots, lizards, and crickets as pets. Trade with the East also brought examples of Asian art and craft to the Netherlands, such as the Chinese blue-and-white Wan-li porcelain vase seen here (enhanced with a gilded base that would have been made by a European goldsmith).

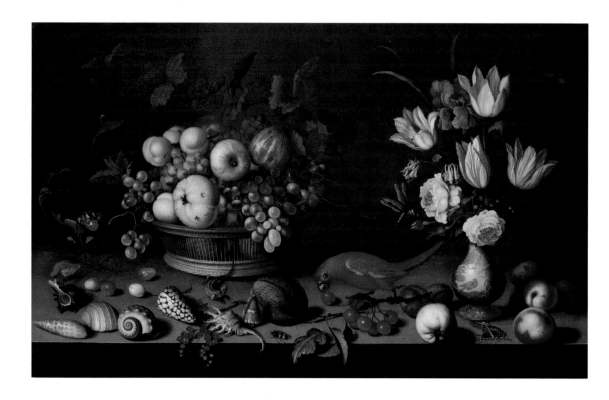

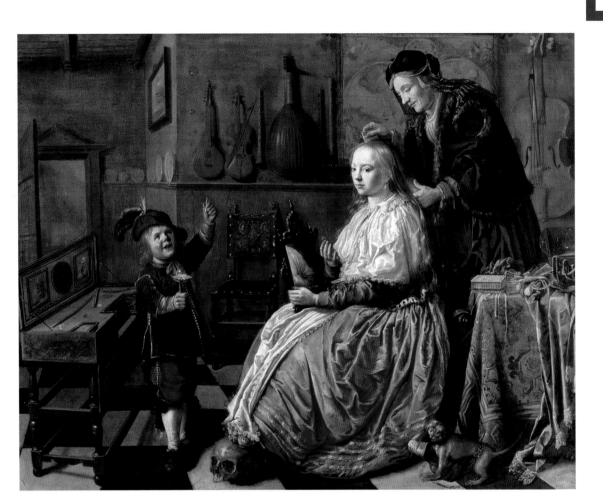

Jan Miense Molenaer (Dutch, about 1610–1668), **Allegory of Vanity**. Oil on canvas, 1633. 40¼ x 50 in. (102 x 127 cm). Purchased with funds from the Libbey Endowment, Gift of Edward Drummond Libbey, 1975.21

Demonstrating both inventiveness and sly wit, Jan Miense Molenaer has painted a tableau of a wealthy Dutch home that is more than just a scene from everyday life. Nearly every detail represents a moral message, namely the inevitability of death and the emptiness of worldly pleasures (*vanitas*). The luxurious array of jewelry, fine clothing, and musical instruments suggests the owners' love of material comforts. The musical elements illustrate a centuries-old connection between music and the senses, specifically love and sensuality. A chained pet monkey was a popular symbol of humankind's captivity to sin. Even the child blowing bubbles suggests the ancient Latin proverb "Man is like a bubble" (*homo bulla*), meaning life is fragile and brief.

The focal point of this painting is the young woman, her long blonde hair being combed by her well-dressed attendant. She holds a mirror, a traditional symbol of vanity and false appearances. Her foot rests on a skull, the universal symbol of the brevity of life and earthly existence.

Valentin de Boulogne (French, 1591–1632), **Fortune-Teller with Soldiers**. Oil on canvas, about 1620. 58⅞ x 93⅞ in. (149.5 x 238.4 cm). Purchased with funds from the Libbey Endowment, Gift of Edward Drummond Libbey, 1981.53

A dark tavern filled with a motley assortment of characters provides the setting for this scene of deceit and bad fortune. A group of drinkers seems caught up in the dramatic tension as a gypsy fortune-teller reads the palm of a naïve young soldier, who appears anxious to hear his fate. To the far right an older soldier raises his wine glass and looks out at the viewer, as if to invite us to join them. On the left, a round robin of thievery takes place: the fortune teller has just taken a coin from the soldier in exchange for her questionable services, while a man in a red hat and cloak gestures to the viewer to keep silent as he steals a rooster from her. He fails to notice that a child, in turn, is picking his pocket.

While working in Rome under the patronage of the noble Barberini family, Valentin de Boulogne mastered the style introduced by Michelangelo Merisi da Caravaggio (1571–1610). This painting is an excellent example of Boulogne's adaptation of Caravaggio's dramatic lighting, tabletop groupings, and unflinching attention to realistic detail.

Peter Paul Rubens (Flemish, 1577–1640), **The Crowning of Saint Catherine**. Oil on canvas, 1631 (1633?). 104 ⅝ x 84 ⅜ in. (265.8 x 214.3 cm). Purchased with funds from the Libbey Endowment, Gift of Edward Drummond Libbey, 1950.272

Widely considered the most beautiful religious painting by Rubens now in the United States, *The Crowning of Saint Catherine* was commissioned as an altarpiece for the church of the Augustinian monks in Mechelen (Malines), near Antwerp. Seated on a leafy throne, the Virgin Mary gently holds the Christ Child on her lap. He places a laurel wreath, signifying victory, on the head of the kneeling virgin saint, Catherine of Alexandria, who holds a palm branch, a symbol of martyrdom. Flanking the scene are two other virgin martyrs, Saint Apollonia (left) and Saint Margaret (right).

Rubens's visionary scene departs from the traditional imagery of Saint Catherine.

According to the *Golden Legend* (about 1275, by Jacobus de Voragine), when the well-educated young Egyptian queen converted to Christianity in about 300, she experienced a mystical vision in which the Christ Child symbolically married her, placing a ring on her finger. Rubens's version of the legend, in which Saint Catherine receives a crown rather than a wedding ring, instead emphasizes her martyrdom, a saintly attribute often celebrated in the renewal of Catholic faith during the Counter Reformation, which arose in response to the Protestant Reformation of the early 1500s.

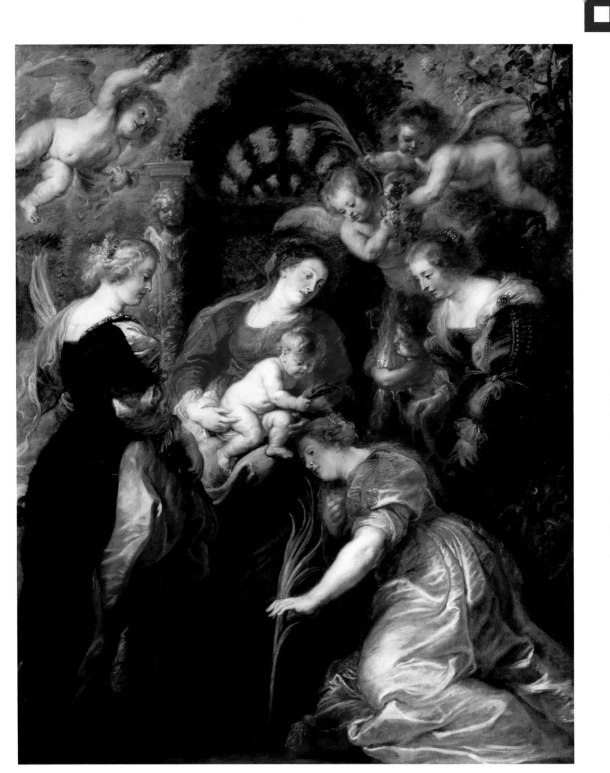

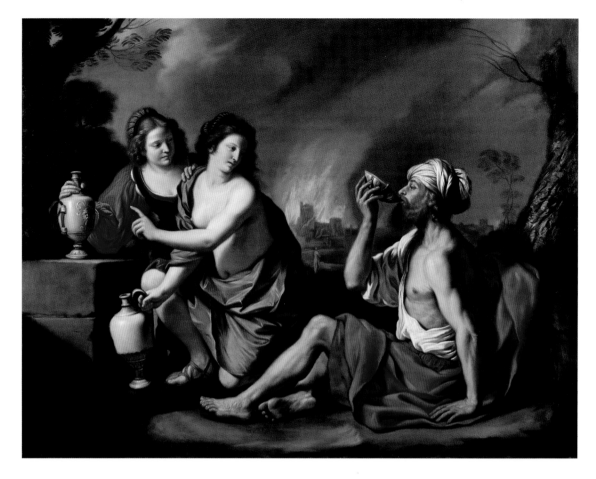

Giovanni Francesco Barbieri, called Guercino (Italian, 1591–1666), **Lot and His Daughters**. Oil on canvas, about 1651–52. 69 $\frac{5}{16}$ x 90 $\frac{15}{16}$ in. (176 x 231 cm). Purchased with funds from the Libbey Endowment, Gift of Edward Drummond Libbey, 2009.345

While a raging inferno consumes a city in the background, two young women—one provocatively only partially robed—hold wine jugs and observe an older man raising a bowl to his lips. The drama depicted is the Old Testament story of Lot and his daughters (Genesis 19). According to the text, when angered by the immorality of those who lived in Sodom and Gomorrah, God decided to destroy the cities. Angels were sent ahead to warn the pious Lot to escape with his wife and daughters to the mountains. They are told not to look back, but Lot's wife disobeys and is turned into a pillar of salt (conspicuously visible in the background).

Believing that they and their father were now the sole survivors on Earth, Lot's daughters decide to ply him with wine and "lie with him, that we may preserve the seed of our father" (Genesis 19:32).

Giovanni Francesco Barbieri, known as Guercino (squinter), had a supreme talent for staging a narrative and conveying his protagonists' actions and emotional struggles. Guercino effectively communicates the conspiratorial intent of Lot's daughters through subtle facial expressions and hand gestures and the placement of the figures.

Artemisia Gentileschi (Italian, 1593–1652/53), **Lot and His Daughters**. Oil on canvas, about 1636–38. 90 ¾ x 72 in. (230.5 x 182.9 cm). Clarence Brown Fund, 1983.107

Artemisia Gentileschi's depiction of the seduction of Lot by his daughters, following the destruction of Sodom, shows Lot holding a glass of wine and leaning toward the daughter on the right as he moves to embrace her. His drunkenness is suggested by his indecorous exposed leg and bare foot. Gentileschi subtly highlights the plot by connecting him to his daughter not only through physical contact, but also by their parallel poses. Artists often treated the subject as a lusty scene of seduction, but in her version, Gentileschi restrained the overt sexuality of the story, giving the figures subtle dignity and deeper psychological interactions.

Gentileschi was trained by her father, the painter Orazio Gentileschi (1563–1639). Having worked in Rome, Florence, and Venice, she headed her own workshop in Naples, executing commissions for patrons throughout Europe and achieving a level of success unprecedented for a female artist at the time.

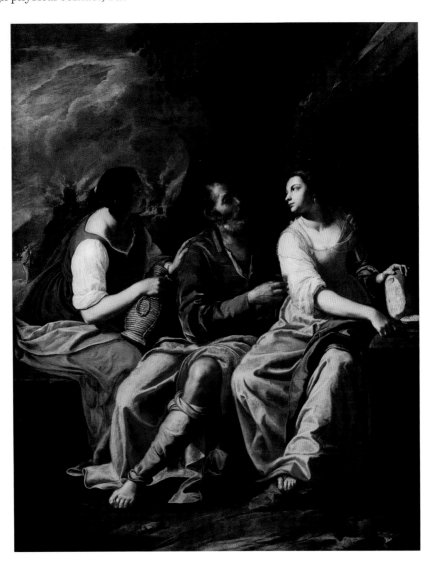

Claude Lorrain (French, 1604–1682), **Landscape with Nymph and Satyr Dancing**. Oil on canvas, 1641. 39 ¼ x 52 ⅜ in. (99.6 x 133 cm). Purchased with funds from the Libbey Endowment, Gift of Edward Drummond Libbey, 1949.170

Near the ruins of a majestic Roman temple, a flute-playing shepherd and his man-beast companion, a satyr, make music with a trio of nymphs. One nymph beats a tambourine while the other dances with the satyr—somewhat warily, in view of his lustful nature. Sunlight streams through the columns, brightening the foreground and separating this enchanted glade from the bright horizon across the river behind them. Beyond, where water, land, and sky blend into infinite distance, the light grows radiant. It is the clarity of this light and its unifying effect that defines the aesthetic beauty of Claude Lorrain's paintings.

Originally named Claude Gellée, born in Lorraine, France, the artist apprenticed with painters in Rome and Naples, specializing in landscape when it first became recognized as an independent pictorial subject. By the 1630s he was the leading landscapist in Italy, with commissions from the pope and the king of Spain, and he remained a sought-after artist for the rest of his life.

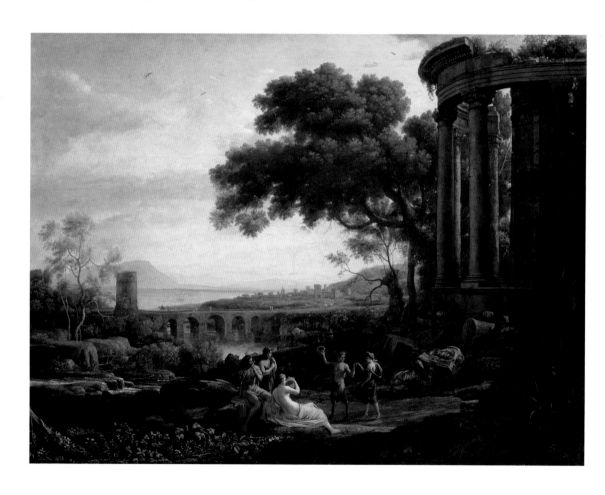

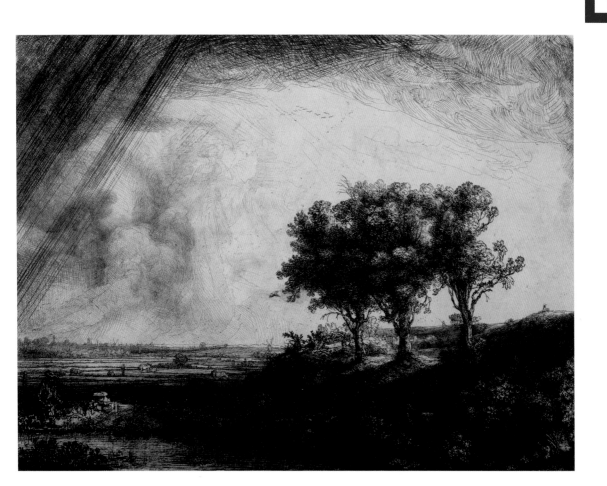

Rembrandt van Rijn (Dutch, 1606–1669), **The Three Trees**. Etching, drypoint and engraving, 1643. 8 5/16 x 10 7/8 in. (21.1 x 27.7 cm). Grace J. Hitchcock Collection, 1981.171

The Three Trees, Rembrandt's largest and most famous landscape etching, captures the sweeping grandeur and vitality of the Dutch countryside. His expansive view of farmland and a distant town, anchored by the title's majestic trees, includes a dramatic sky of wind-blown rain clouds illuminated against a sunlit horizon. Meanwhile, he has inserted figures throughout the scene who, undaunted by the changing weather, continue to engage in leisure pursuits and labor. Just as the activities of these figures suggest the pleasures and virtues of country life, the three sturdy trees that tower over the countryside are often interpreted as a reference to Biblical accounts of Christ crucified and the three crosses. In this interpretation, Rembrandt's landscape becomes a vehicle to express the spiritual message of divine order in nature.

Only in 1640, after making many prints that featured portraits and religious themes, did Rembrandt begin to make landscape etchings. Here his virtuosity is displayed in his combination of three intaglio techniques— etching, engraving, and drypoint—to achieve painterly effects. Renowned as a painter and as one of the finest *peintre-graveurs* (a painter who also creates original prints), Rembrandt set new technical and aesthetic standards for etching in the nearly 300 prints he made during his career.

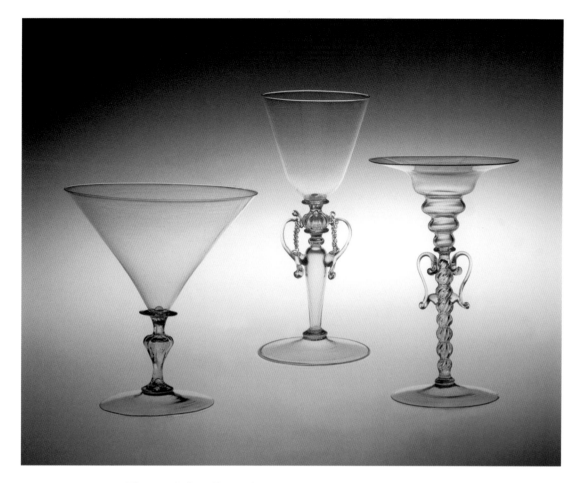

Italy, from Venice, **Three Cristallo Wine Glasses**. Glass, about 1650. From left to right: H. 5 5/16 in. (13.4 cm); H. 7 1/4 in. (18.5 cm); H. 5 7/8 in. (14.9 cm). Gift of Edward Drummond Libbey, 1913.425, 1913.427, 1913.428

Drinking glasses, to be held in the hand rather than admired on a sideboard, were valued for their inherent beauty, their unsurpassed craftsmanship, and the expressive forms that were not achievable in other materials. Affluent Europeans—including merchants, innkeepers, and landowners—had the means and access to the most fashionable and elaborate Venetian glassware. Vessels made from Venetian *cristallo* glass, so named for its resemblance to vessels carved of clear quartz, or rock crystal, were exceptional, highly valued commodities from the mid-sixteenth until the late seventeenth century.

European nobles who shared a taste and desire for luxury tableware eagerly ordered Venetian glass through their respective ambassadors and envoys. Archduke Ferdinand II of Austria (ruled 1564–95), for example, was an avid connoisseur and collector of fine glassware. One of his commissions included forty-four glasses from a Venetian factory, ordered undecorated, perfectly transparent, and only as thick as a knife's edge—a perfect description of the most elegant *cristallo* ware, as seen in these examples.

Francesco Mochi (Italian, 1580–1654), **Cardinal Antonio Barberini the Younger**. Marble, about 1629. H. (with base) 39¼ in. (99.7 cm). Purchased with funds from the Libbey Endowment, Gift of Edward Drummond Libbey, 1965.176

The mood of this Baroque portrait bust is quiet. The eyes are incised to appear to be looking upward, giving Cardinal Antonio Barberini the Younger (1607–1671) an introspective air. His image is enlivened by the turn of his head and resting gaze, further animated by the silky folds of the cardinal's cloak, his thick, curly hair, and upturned mustache. Sculptor Francesco Mochi clearly understood the importance of light in bringing his subject "to life," chiseling both shallow and deep to create highlights and shadows that animate this marble portrait bust.

Cardinal Antonio Barberini's uncle, Maffeo Barberini (1568–1644), was elected Pope Urban VIII in 1623. Because of his aristocratic family connections, Antonio was made a cardinal in 1628, at age twenty-one. This bust was likely commissioned to celebrate Antonio's new position.

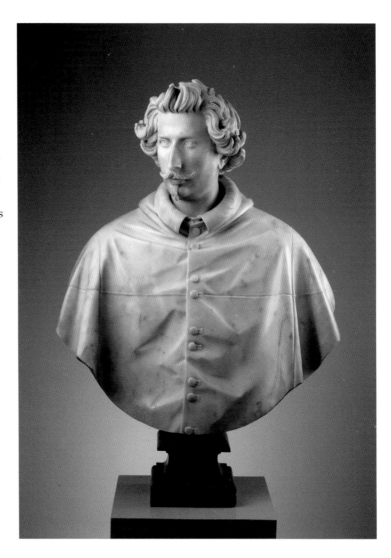

Bartolomé Esteban Murillo (Spanish, 1617–1682), **The Adoration of the Magi**. Oil on canvas, about 1655–60. 75⅛ x 57½ in. (190.7 x 146 cm). Purchased with funds from the Libbey Endowment, Gift of Edward Drummond Libbey, 1975.84

In this, the only known depiction of the Adoration of the Magi by Bartolomé Esteban Murillo, the great Spanish Baroque artist treats the subject in an appealingly human way. Instead of concentrating on the splendor of the three kings and their entourage, he instead emphasizes their reaction to the infant Jesus, convincingly expressing their joy, solemn contemplation, and humble devotion as the young Virgin Mary tenderly presents the child to them. The kneeling king, seen from the back, makes a particularly effective emotional impact and draws the viewer into the scene.

Though the biblical account of the Magi following a star in search of the Christ Child is brief, later Church tradition expanded the story, providing names and other details as the Magi came to represent the kings of the world and the idea of the universality of Christianity. Here Murillo follows the tradition of representing them as the three ages of man (youth, maturity, and old age) and as the continents of Africa, Asia, and Europe.

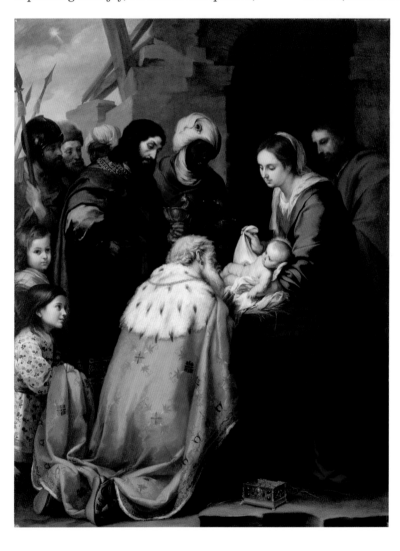

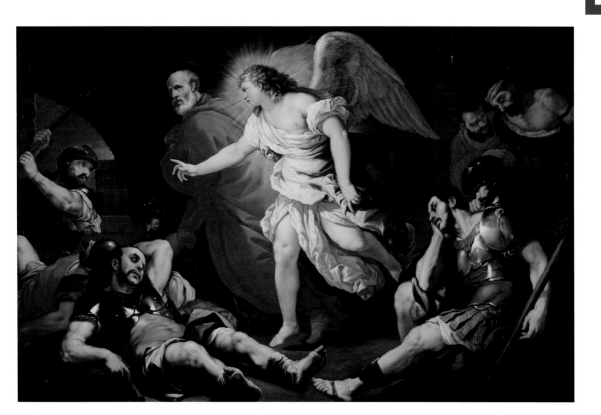

Luca Giordano (Italian, 1634–1705), **The Liberation of Saint Peter**. Oil on canvas, shortly after 1660. 78 ¾ x 120 ⅞ in. (200 x 307 cm). Gift of Arthur J. Secor, Dr. Frank W. Gunsaulus in memory of Miss Rosa Lang, and Purchased with funds from the Libbey Endowment, Gift of Edward Drummond Libbey, by exchange, 2014.44

With its resplendent levitating angel, bewildered yet obedient Saint Peter (in voluminous gold robes), sleeping guards, and shackled prisoners, Luca Giordano's composition is an operatic presentation of the power of the divine overwhelming the earthbound. The scene comes from the biblical narrative in which the Apostle Peter is freed from King Herod's prison by divine intervention: "Peter was sleeping between two soldiers, bound with two chains . . . and behold, an angel of the Lord appeared, and a light shone in the cell; and he struck Peter on the side and woke him up, saying, 'Get up quickly'" (Acts 12:5–11). This painting is a remarkable juxtaposition of two styles: rugged realism—note especially the soldiers—and classical idealism, most apparent in the angel. This dichotomy also suggests the duality of the mortal and the spiritual.

Giordano was a highly sought-after and prolific Neapolitan painter. During his long career, he earned the nickname *Luca fa presto* (Luca work quickly). He was awarded many prestigious commissions, including from the Medici courts in Italy and some he obtained when he served as official painter to King Charles II of Spain from 1692 to 1702.

Rembrandt van Rijn (Dutch, 1606–1669), **Christ Crucified between the Two Thieves (The Three Crosses)**. Drypoint and burin on laid paper, fourth state, 1660 (first state 1653). 15 ⅟₁₆ x 17 ¹¹⁄₁₆ in. (38.4 x 45 cm). William J. Hitchcock Fund in memory of Grace J. Hitchcock, 2002.1

In addition to being a master painter and lyrical draftsman, Rembrandt van Rijn was a superb printmaker. *Christ Crucified between the Two Thieves*, commonly known as *The Three Crosses*, is one of his most spectacular prints.

All five states (or versions) of this etching are filled with emotion and drama, but Rembrandt radically reworked the copper plate between the third and fourth states. In the third state the scene invites somber meditation as light floods the mourning figures at the foot of the cross. In this image, from the fourth state, the contemplative mood is shattered. Bathed in darkness and highlighted by light streaming from the heavens, the scene becomes a poignant study of despair. The figure of Christ on the cross stands out starkly from the dark shadows, evoking the biblical passage, "And about the ninth hour Jesus cried out with a loud voice . . . 'My God, my God, why hast thou forsaken me?'" (Matthew 27:46)

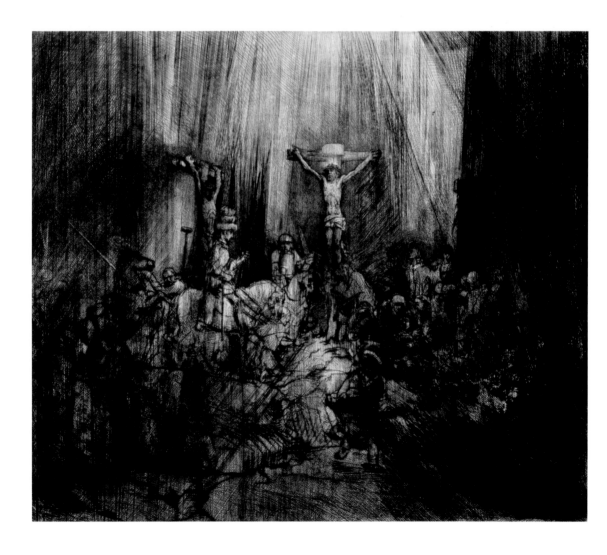

Rembrandt van Rijn (Dutch, 1606–1669), **Man in a Fur-Lined Coat**. Oil on canvas, about 1655–60. 45¼ x 34¾ in. (114.9 x 88.3 cm). Clarence Brown Fund, 1977.50

Rembrandt's reputation as a superlative artist rests largely on his uncanny ability to convey the psychological depths and nuances of the human condition. The introspection evident in the figure depicted gives him a compelling presence. The man gazes out at the viewer with his deep-set eyes, his mouth slightly open, his face framed by long reddish-brown hair. He stands dressed in exotic costume of a fur-trimmed coat over a red garment cut low at the neck to reveal a gold-embroidered collar and a pleated linen shirt. Near the hilt of a sword or dagger his right hand rests on a sash, while his left arm extends out of the frame (technical examination indicates that the canvas was probably cut down slightly at left, right, and bottom).

The man has not been identified, and it may be that Rembrandt's intent here, as with some of his other works, may have been simply to capture the likeness of a contemporary in the guise of an historical personage, perhaps an Old Testament figure, rather than a portrait of a specific person. The glowing light, the broad brushstrokes, and the rich colors combine to endow this image with both uncanny stillness and, paradoxically, palpable vitality.

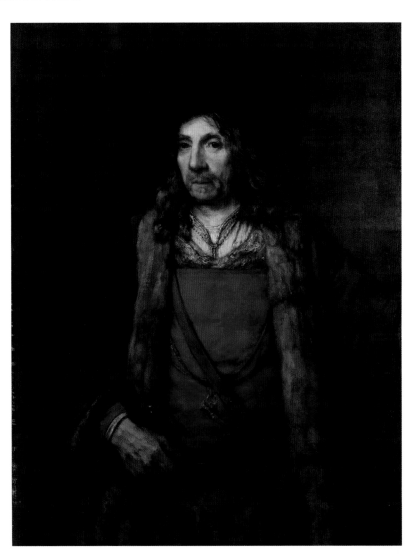

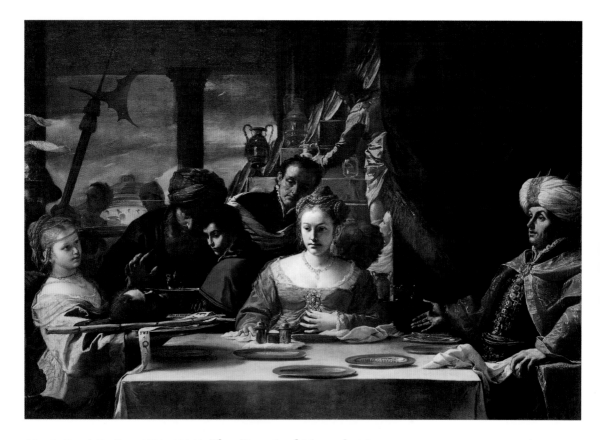

Mattia Preti (Italian, 1613–1699), **The Feast of Herod**. Oil on canvas, 1656–61. 70 x 99¼ in. (177.8 x 252.1 cm). Purchased with funds from the Libbey Endowment, Gift of Edward Drummond Libbey, 1961.30

A haunting silence pervades Mattia Preti's scene of John the Baptist's horrific end. As recounted in the Bible's Gospels of Matthew and Mark, John the Baptist was imprisoned for condemning King Herod Antipas for unlawfully marrying his brother's divorced wife, Herodias. At Herod's birthday feast, Herodias's daughter, Salome, danced to entertain the guests. Salome pleased the king so much that he promised to grant her whatever she wished. At her mother's urging, Salome asked for the head of John the Baptist, and the king reluctantly granted her wish. The deed was done—the moment imagined here by Preti.

Salome stands at the far left, presenting John's severed head on a silver charger to her mother, the sharp-pointed halberd above her a reminder of the shocking action just taken. Across from her, at the opposite end of the table, Herod recoils at the grizzly outcome of his promise. Primacy of place in this painting is reserved for Herodias, who stares at the platter and nervously fingers her garment. The whole effect is that of a magnificent, mute opera, with pathos the poignant theme.

Giuseppe Recco (Italian, 1634–1695), **Kitchen Interior with a Piglet**. Oil on canvas, about 1675. 29 x 40¼ in. (73.7 x 102.2 cm). Purchased with funds from the Libbey Endowment, Gift of Edward Drummond Libbey, 2017.37

This challenging yet visually rewarding still life of a kitchen larder reveals the scientific, artistic, and gastronomic interests of seventeenth-century Neapolitan society. The artist, Giuseppe Recco, painted many still lifes of food. In this one, he has depicted a freshly slaughtered piglet, a provolone cheese, a sausage, a plucked chicken, a bottle of olive oil, a meat pie, and two live pigeons.

The beginnings of a scientific approach to rational thought in the sixteenth and seventeenth centuries called for an objective examination of the natural world, one that relied not on theory but on the senses,

especially sight. This concept is reflected in the intense realism of Neapolitan painting, which was also inspired by the naturalism of Netherlandish still life paintings; the works of Caravaggio and his followers in Rome; and, perhaps most importantly, the robust and unforgiving qualities of Spanish still lifes. This painting showcases the intentionally flamboyant cuisine favored by the nobility in Naples. In a kind of visual recipe, Recco presents an array of some of the ingredients—meat (pork), fowl, and cheese—needed to prepare a variant of *pasticcio* (or *timballo*), the savory pie on the right.

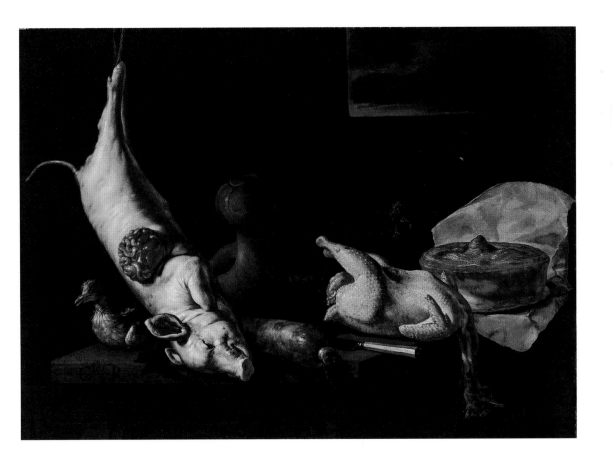

Willem van de Velde the Younger (Dutch, 1633–1707), **Ships in a Stormy Sea**. Oil on canvas, 1671–72. 52 1/16 x 75 9/16 in. (132.2 x 191.9 cm). Purchased with funds from the Libbey Endowment, Gift of Edward Drummond Libbey, 1977.62

The excitement and danger of seventeenth-century sea travel is dramatically presented in this large canvas. The emerging Dutch Republic had a close and ambivalent relationship with the sea. On the one hand, its flat land had to be constantly protected from flooding by the construction of dikes or levees; on the other hand, seafaring was essential to its economy and power. Images of ships at sea became a popular subject to celebrate Dutch prosperity.

Willem van de Velde the Younger was himself a skilled sailor, and his marine paintings were valued for their realistic depictions of ships and sailing. The ship spotlighted in the foreground of this painting is a *kaag*, a small passenger boat. Van de Velde shows it sailing close-hauled—one of the most difficult sailing maneuvers, in which the vessel sails into the strong wind as directly as it can. Van de Velde has captured both the power of the wind and waves and the confident skill of the sailors.

In 1802 the painting was in the collection of the 3rd Duke of Bridgewater, who commissioned the English artist J. M. W. Turner to paint a companion painting, which is now in the National Gallery, London.

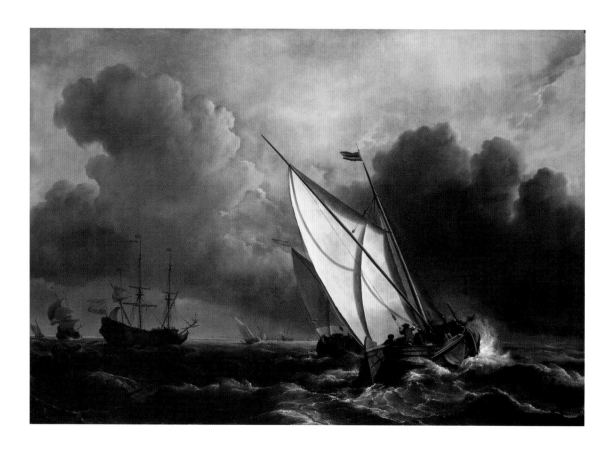

After Martin Desjardins (French, 1637–1694), **Equestrian Monument to Louis XIV**.
Bronze with gilding, modeled about 1688–91; this cast about 1700. H. (without base) 39 in. (99 cm).
Purchased with funds from the Florence Scott Libbey Bequest in Memory of her Father, Maurice A.
Scott, 1980.1330

The ruler on horseback as the ultimate image of power has a long history going back to ancient Greek and Roman monuments. Following this ancient precedent, the French King Louis XIV (ruled 1643–1715) is shown here riding without saddle or stirrups and wearing Roman military costume and the imperial cloak. On his breastplate is the Gallic rooster overcoming a lion, emblematic of Holland or Spain, two adversaries of France. The saddle blanket bears the head of Apollo, the royal symbol for Louis XIV, who was called the Sun King. The magnificent horse treads upon a sword and a barbarian shield bearing the head of an Amazon, a legendary race of female warriors, to symbolize enemies defeated.

In 1688 the city of Lyon commissioned the sculptor Martin Desjardins to make an over-life-sized bronze equestrian statue of the king. Cast in Paris shortly before Desjardins died in 1694, the statue was finally installed in 1713. It was later destroyed along with all public royal images, in the late 1700s, during the French Revolution. The original is now known only by various small-scale versions, the largest and finest of which is Toledo's bronze.

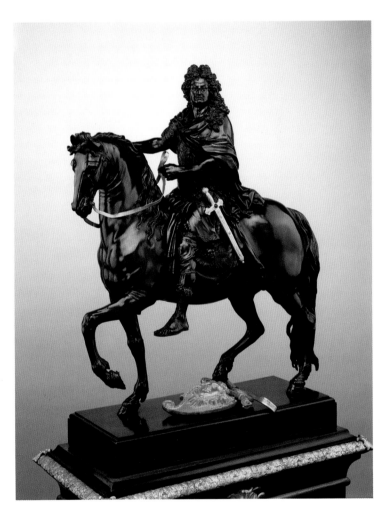

Symbols: Object Lessons

In the works of art in this group, ordinary things take on a symbolism that adds layers of meaning. Although these meanings are linked to the time, place, and culture in which each work of art was created, our understanding of them is also shaped by our own personal beliefs and societal values.

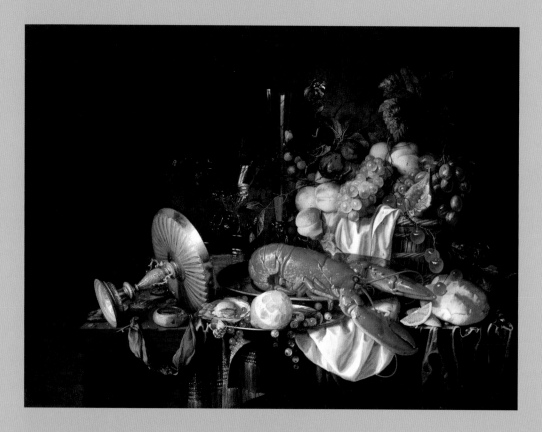

Jan Davidsz de Heem (Dutch, 1606–1684), **Still Life with a Lobster.** Oil on canvas, late 1640s. 25 x 33¼ in. (63.5 x 84.5 cm). Purchased with funds from the Libbey Endowment, Gift of Edward Drummond Libbey, 1952.25

In this sumptuous still life, the pocket watch on the front left edge of the table holds the key to the painting. The image of a clock or watch stands for the idea of the relentless passage of time. In Dutch seventeenth-century visual culture, a watch or an hourglass in a painting of such earthly abundance would have served as a *memento mori*—a reminder that pleasure is fleeting and death is inevitable.

We recognize symbols by calling on personal knowledge gained through memory and lived experience

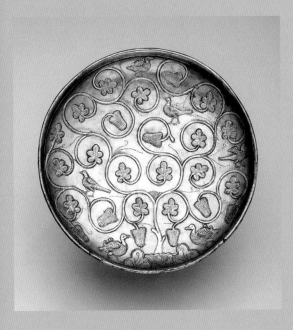

Sasanian Empire (227–651), possibly from Iran, **Plate.** Silver, 6th–7th century. Diam. 8 1/16 in. (20.5 cm). Purchased with funds from the Libbey Endowment, Gift of Edward Drummond Libbey, 1949.35

The exuberantly branching grapevine decoration punched and engraved on the interior of this bowl is a common motif in Sasanian silverwork. The vine may allude to Dionysos, the Greek god of wine, who was also celebrated in parts of the Near East. Winemaking and wine drinking played important roles in the rituals of many religions, practiced in the ancient world including Zoroastrianism in the Sasanian culture.

Lorna Simpson (American, born 1960), **Wigs.** Waterless lithographs on felt, 1994. Overall (installed): 72 x 162 1/2 in. (182.9 x 412.7 cm). Gift of Mrs. Webster Plass and of Miss Elsie C. Mershon in memory of Edward C. Mershon, by exchange 2007.7a–mm

How does your hair reflect your identity or shape people's perceptions of you? Lorna Simpson presents an array of images of wigs and hairpieces—braids, weaves, falls, Barbie Doll blonde locks, even male facial hair—to raise the issue of how hair has played a vital role in African American cultural and personal identity, especially in the context of traditional white standards of beauty.

Art of Europe and America

18th to 19th century

After a design by Nicolas Delaunay (French, 1646–1727), **Table Centerpiece**. Gilded bronze and marble veneer, about 1710. H. 22¾ in. (57.8 cm). Gift of Mr. and Mrs. Edward H. Alexander, 1971.178a-i

The fashion to combine candlelight and condiments in an elaborate table centerpiece (*surtout de table*) emerged at the French court of Louis XIV (ruled 1643–1715) in the 1690s. This complex, gilded bronze example was probably made about 1710 under the supervision of royal goldsmith Nicolas Delaunay. The central figure, Cupid riding a dolphin, tops an eight-branched candelabrum supported by four busts of nymphs and satyrs on top of mythical animals' feet. The candelabrum rests on a second, smaller platform with casters at each corner

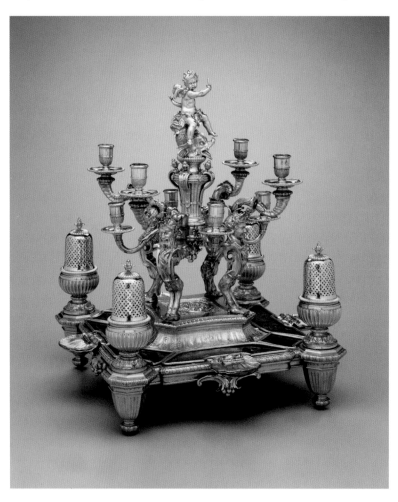

designed to hold spices, salt, and sugar. Eight glass cruets, now missing, were originally placed around the base. When using this centerpiece in the daytime, the candle cups could be replaced with decorative finials.

This gilded bronze centerpiece was made to replace a gilded silver version created by Delaunay in the late 1690s, probably for Louis XIV's son, the Grand Dauphin. The dolphin (*dauphin* in French) at the top of the centerpiece is likely a play on the heir apparent's title. The original centerpiece was probably melted down in 1709 to help finance the king's war efforts.

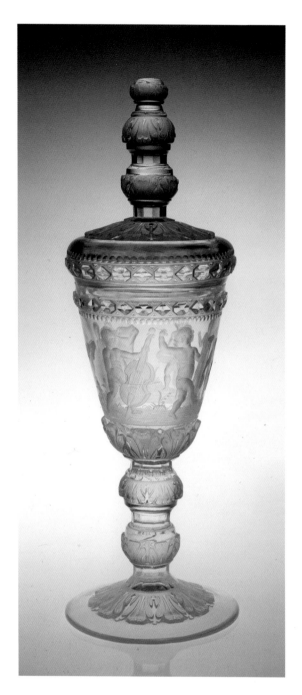

A stellar example of German Baroque glass-cutting, this covered goblet (*pokal*) was most likely engraved in the Berlin workshop of Gottfried Spiller, who trained as a gem-cutter. The jewel-like faceting of the engraved bands attests to the skill of Spiller, who excelled at large-scale, figural friezes modeled in deep relief, like the classically inspired procession of musical children on Toledo's goblet.

At the time this *pokal* was made, the social climate at the Berlin court had become more austere under the "Soldier King," Frederick William I of Prussia (ruled 1713–40), who eliminated many of the court's artistic endeavors as frivolous expenditures, including the court orchestra. In contrast, his wife, Sophia Dorothea of Hanover (1687–1757), loved music and was a patron of the arts. She established one of the most important porcelain and glass collections in Europe at her summer residence, Monbijou Palace, in central Berlin. The more light-hearted milieu of the Queen's court is reflected in Spiller's quintessential Baroque goblet with its joyous musical frieze.

Workshop of Gottfried Spiller (German, Potsdam-Berlin, 1663–1728), engraver, **Goblet with Cover**. Glass, about 1715–25. H. (with cover) 17⅛ in. (42.8 cm). Purchased with funds from the Libbey Endowment, Gift of Edward Drummond Libbey, 1950.43

Jean-Siméon Chardin (French, 1699–1779), **The Washerwoman**. Oil on canvas, about 1733–39. 15 ¾ x 12 ½ in. (40 x 31.8 cm). Purchased with funds from the Florence Scott Libbey Bequest in Memory of her Father, Maurice A. Scott, 2006.3

Painted as a pair by French artist Jean-Siméon Chardin, this canvas and *Woman Drawing Water at the Cistern* (opposite) represent his mastery of domestic scenes. Both depict servants engaged in humble activities. In *The Washerwoman* a maid scrubs laundry in a large wooden barrel. With light shining from the left, perhaps through a window or an open door, she looks away from her work as if someone or something has distracted her attention—or as if she is thinking about something else. In the companion painting, a woman stoops to fill a jug with water from a large copper urn, her face hidden by her bonnet. A glistening side

Jean-Siméon Chardin (French, 1699–1779), **Woman Drawing Water at the Cistern**. Oil on canvas, about 1733–39. 15 ⅝ x 12 ½ in. (39.7 x 31.8 cm). Purchased with funds from the Florence Scott Libbey Bequest in Memory of her Father, Maurice A. Scott, 2006.2

of meat hangs above. A second servant and a child are visible through a doorway behind her. Both paintings, with their focus on household chores and the effects of light on a variety of surfaces—fabric, ceramic, glass, copper, meat, skin, fur, and stone—owe much to seventeenth-century Dutch painting. Chardin painted several variations of these two compositions, but this pair is especially well-preserved. The paint is essentially untouched, maintaining the freshness of Chardin's vibrant brushstrokes and striking color harmonies.

Rachel Ruysch (Dutch, 1664–1750), **Flower Still Life**. Oil on canvas, about 1726. 29 ¾ x 23 ⅞ in. (75.6 x 60.6 cm). Purchased with funds from the Libbey Endowment, Gift of Edward Drummond Libbey, 1956.57

Against a dark background, in the style of flower painting from the second half of the seventeenth century, Rachel Ruysch composed a lush floral arrangement, including many flowers that would never actually bloom at the same time. Among this array of blossoming and wilting plants, a closer look reveals caterpillars crawling along the stem of a flower and browning leaves riddled with holes made by hungry insects. Such vivid details suggest the fragility of the arrangement, alluding to the fact that beauty fades and all living things must die.

Ruysch was the daughter of a professor of anatomy and botany, and likely became familiar with plants through him. By age fifteen, she was studying with the still-life artist Willem van Aelst (1627–about 1683). From this background of scientific and artistic studies, she learned to capture the essence of nature in her own flower paintings. The most famous female painter in the Golden Age of Dutch art, Ruysch enjoyed an international reputation over a career that lasted almost seven decades.

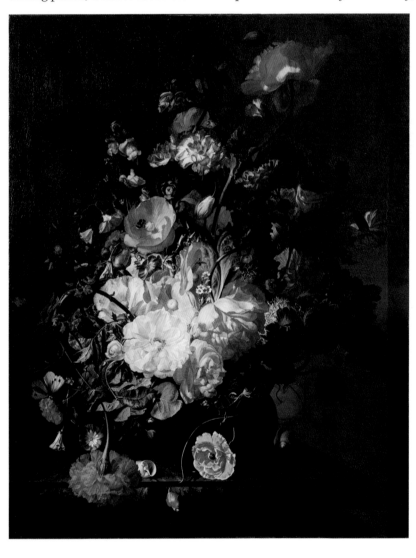

Paul Crespin (British, 1693/94–1770), **Tureen and Stand**. Sterling silver, 1740–41. L. (overall) 21⁷⁄₁₆ in. (54.5 cm). Purchased with funds from the Florence Scott Libbey Endowment in memory of her father, Maurice A. Scott, 1964.51a–d

English silver from the first half of the eighteenth century rarely achieved the artistic sophistication and technical invention of this exceptional tureen by Paul Crespin, a distinguished London goldsmith of French origin. His clients included the Prince of Wales and the nobility of Portugal and Russia.

The tureen itself—encrusted with fruits and flowers and cushioned by garlands of delicately rendered flowers—rests on the backs of two reclining goats. The goats' heads are part of the tureen, but when the vessel is placed on its stand, the neck of each goat rests on an upturned scroll. The goats probably refer to Amalthea, the mythical Greek nanny-goat who suckled the infant Zeus. When one of her horns came off, the baby Zeus returned it to her, promising that it would forever be filled with an endless supply of fruits. In this way, Amalthea's horn became the cornucopia, or "horn of plenty," the symbol of abundance and prosperity. Likewise, the tureen's bountiful array would have made a fitting statement as the centerpiece on the dining table of a wealthy family.

Bernardo Bellotto (Italian, 1721–1780), **The Tiber with the Church of San Giovanni dei Fiorentini, Rome**. Oil on canvas, about 1742–44. 33½ x 57½ in. (85 x 146 cm). Purchased with funds from the Libbey Endowment, Gift of Edward Drummond Libbey, 1977.3

As a destination on the Grand Tour—the circuit of European cultural sites considered indispensable for attaining cosmopolitan polish in the eighteenth century—Rome was rivaled only by Venice. In both cities specialist painters met the demand for souvenir views of famous sights. At about age fifteen, Bernardo Bellotto became the pupil of his uncle in Venice,

Giovanni Antonio Canal (called Canaletto, 1697–1768), the most celebrated view-painter in Europe. Bellotto would have made a spirited on-site drawing of this view along the Tiber River. In the background is the circular papal fortress Castel Sant'Angelo (originally the tomb of Roman Emperor Hadrian) and nearer to the foreground, across the river from the onlookers, is the Church of San Giovanni dei Fiorentini. It remains uncertain whether Bellotto painted this canvas in his Roman studio or a year or two later in Venice. Views such as this were often done in sets, and Toledo's painting was originally paired with a view of Castel Sant'Angelo from a different angle, now in the Detroit Institute of Arts.

Jean-Honoré Fragonard (French, 1732–1806), **Blind-Man's Buff**. Oil on canvas, about 1750–52. 46 x 36 in. (116.8 x 91.4 cm). Purchased with funds from the Libbey Endowment, Gift of Edward Drummond Libbey, 1954.43

In the sixteenth and seventeenth centuries, artists and authors used the children's game of blind-man's buff as a symbol of the folly of marriage, where one took one's chances in choosing a mate. Because only one couple plays the game in this playful scene by Jean-Honoré Fragonard, neither the ultimate partner nor the final outcome is in doubt. As the youth tickles his blindfolded beloved on the cheek with a piece of straw, a child reminiscent of a classical cupid distracts the woman by touching the palm of her hand with the end of a stick. Reaching out to locate her lover, the woman steals a glance from beneath her blindfold, leaving viewers in no doubt that she is the one in control of the situation.

Fragonard first studied with the Rococo painter and engraver François Boucher (1703–1770) and later won a scholarship to attend the French Academy in Rome. *Blind-Man's Buff* was a pendant, or companion painting, to *The See-Saw* (1750–55), now at the Thyssen-Bornemisza Museum, Madrid. Judging from eighteenth-century engravings of the two images, both paintings may have originally been as much as a foot taller at the top.

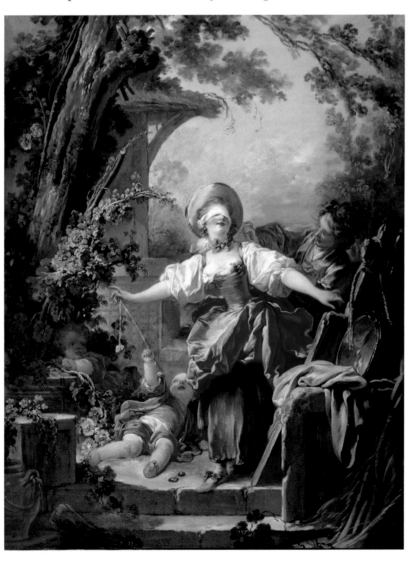

Louis-Marin Bonnet created his print *Head of Flora* after seeing a delicate, intimate pastel portrait that François Boucher (1703–1770) made of his daughter in 1757. Bonnet's virtuoso color print was achieved by preparing eight different copper plates—each inked with a shade of blue, red, brown, or white—and then printing them on paper in succession, one over the other. At a time when printmaking designs were typically printed with black ink, *Head of Flora* is considered one of the most ambitious color prints made in eighteenth-century France.

Responding to a series of recent technical innovations in printmaking, in 1767 Bonnet announced his adaption of a multiple-plate technique to produce full-color images in the pastel chalk manner. This labor-intensive but short-lived process, practiced only until the early 1800s, utilized newly adapted tools and inks designed to mimic pastel's soft, grainy texture. As the popularity of pastels and drawings grew, established engravers were encouraged to translate designs by both old masters and fashionable contemporary artists such as Boucher into luxury prints, which were eagerly acquired by collectors not only in Paris but throughout Europe.

Louis-Marin Bonnet (French, 1736–1793), **Head of Flora** (after François Boucher). Etching, engraving, and mezzotint, about 1769. 15¾ x 12¼ in (38 x 30.4 cm). Purchased with funds from the Libbey Endowment, Gift of Edward Drummond Libbey, 1929.1

John Singleton Copley (American, 1738–1815), **Young Lady with a Bird and a Dog**.
Oil on canvas, 1767. 48 x 39½ in. (122 x 101 cm). Purchased with funds from the Florence Scott
Libbey Bequest in Memory of her Father, Maurice A. Scott, 1950.306

Bostonian painter John Singleton Copley became the most distinguished American portraitist of his day through his largely self-taught mastery of drawing, color, and refined execution. Copley's restless ambition pushed him to seek fame farther afield than the colonies, however. After successfully exhibiting *Boy with a Squirrel* (now in the Museum of Fine Arts, Boston) with the Society of Artists of Great Britain in London in 1766, he sent this larger, more ambitious portrait of an unknown girl to the Society's exhibition of 1767.

The details of the elegant interior of *Young Lady with a Bird and a Dog*—columns, drapery, Chippendale chair, carpet, and exotic lovebird—were meant to speak the language of fashionable British portraiture. This painting did not garner the same praise as the earlier portrait, however, and Copley was accused of placing too much emphasis on setting and props—ironically, the very details that made him such a great success with his American patrons.

During the American colonial period of the 1700s, British trade policy ensured that British goods dominated the American market and discouraged manufacturers in the colonies. At the end of the American Revolutionary War (1775–1783), entrepreneurs such as German-born John Frederick Amelung seized the opportunity to fill the resulting manufacturing void. Based on his experience working in the Grünenplan mirror glass factory in Germany and with financial backing from promoters in Bremen and America, Amelung hired glass-workers, bought equipment, and sailed for the United States.

Upon his arrival in Maryland in 1784, Amelung purchased an existing factory and began to make glass windows and tableware. Faced with robust competition from imported British, German, and Bohemian glass, he created gifts for prominent politicians and businessmen. This goblet is engraved with a Rococo-style inscription that includes the factory's name and location and the date the goblet was made (1792), along with the name "G. F. Mauerhoff," likely a European whom Amelung hoped would invest in his enterprise. Despite his ambitious efforts, he failed to garner much-needed financial support, and his glassworks closed in 1795. Only seven known goblets and tumblers bear the name of the New Bremen Glassmanufactory, making Toledo's goblet an extraordinary and rare example of early American glass.

New Bremen Glassmanufactory, Maryland (Frederick County), John Frederick Amelung (American, 1741–1798, maker), **Mauerhoff Goblet**. Glass, 1792. H. 7 $^{15}/_{16}$ (20.1 cm). Purchased with funds from the Libbey Endowment, Gift of Edward Drummond Libbey, 1961.2

Élisabeth Louise Vigée-LeBrun (French, 1755–1842), **Comtesse de Cérès**. 36 x 29 in. (91.4 x 73.7 cm). Oil on canvas, 1784. Purchased with funds from the Libbey Endowment, Gift of Edward Drummond Libbey, 1963.33

Hints of a lively personality shine through in this portrait of Anne Marie Thérèse de Rabaudy Montoussin, la Comtesse de Cérès (1759–1834). The fashionable young countess has apparently just finished writing a letter, glancing up as if interrupted. Élisabeth Louise Vigée-LeBrun's skill at conveying a sense of naturalness and spontaneity helped secure her appointment as court painter to Queen Marie Antoinette and made her one of the most successful portraitists in eighteenth-century Europe.

Vigée-LeBrun came to regret her association with the countess, who was having an affair with Charles Alexandre de Calonne, the French Minister of Finance. The artist wrote in her memoirs, "While I was painting her portrait, she did me an atrocious disservice. In her ingratiating way she asked me to lend her my horses and carriage to take her to the theater. . . . The next morning [. . .] Coachman, horses, nothing had come back. . . ." The countess had spent the night at the finance minister's home. Because Vigée-LeBrun's coach was seen there, it fed rumors that she herself was having an affair with him, damaging the artist's reputation.

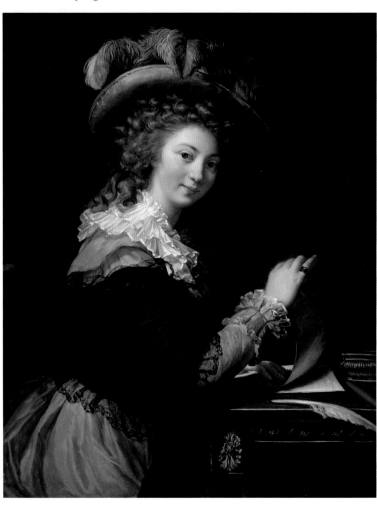

Thomas Gainsborough (British, 1727–1788), **Hester, Countess of Sussex, and her Daughter, Lady Barbara Yelverton**. Oil on canvas, 1771. 89 ¼ x 60 ¼ in. (226.7 x 153 cm). Purchased with funds from the Libbey Endowment, Gift of Edward Drummond Libbey, and with funds from the Florence Scott Libbey Bequest in Memory of her Father, Maurice A. Scott, 1984.20

First exhibited at the Royal Academy in London in 1771, this full-length portrait was painted in Bath, a popular destination resort in southwest England for members of fashionable high society. As a rare double portrait, this canvas by Thomas Gainsborough depicts the wife and the daughter of Henry Yelverton, 3rd Earl of Sussex. Hester (1728–1777) had served as Lady of the Bedchamber to King George II's three eldest daughters.

In this painting Hester sits before a tree, one hand to her cheek, the other clasping a broad-brimmed hat. She wears a billowing, cream-colored satin dress with a black lace shawl over her shoulders. Standing close by is her only child, Barbara (1760–1781), aged ten or eleven. Barbara holds a sprig in her hand and wears a white muslin dress with a blue sash. Her clothes are decorated with blue ribbons, echoed by the bow in her mother's powdered hair. With poetic grace Gainsborough deftly conveys the tender bond between mother and daughter, a bond that would be broken when Barbara, at age fifteen, eloped with a young soldier who had served in the British Army during the American Revolutionary War. Her parents later disinherited her; she died before her twenty-first birthday.

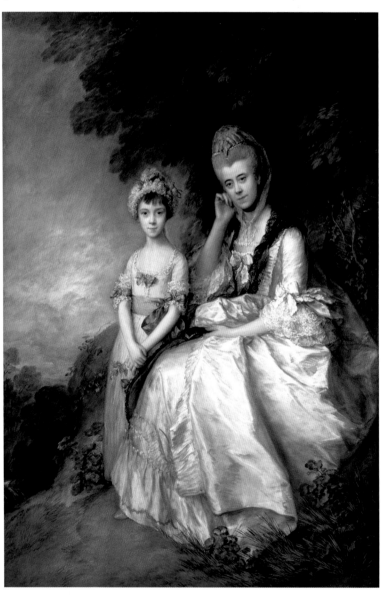

Giacomo Raffaelli (Italian, 1753–1836), **Micromosaic Box with Monkey**. Polychrome glass; copper; tortoiseshell in gold frame, 1794. Diam. (rim) 3 in. (7.9 cm). Mr. and Mrs. George M. Jones, Jr., Fund, 2004.67

Giacomo Raffaelli is credited with inventing the process of micromosaic, using tiny bits of colored glass chips (tesserae) to create decorative images. This small tortoiseshell box by Raffaelli for snuff (powdered tobacco) or sweets features a charming micromosaic of a monkey wearing a belt with a metal ring. A captive monkey was a popular symbol of humankind voluntarily shackled by sin. The monkey holds a cherry, perhaps alluding to the Sufi Arab fable of the monkey captured by a hunter because it refused to relinquish a cherry in a bottle. That reference might be a subtle reminder to use the box's tempting contents in moderation.

In 2009 the Toledo Museum of Art acquired a painting, by Dutch artist Melchior d'Hondecoeter, that bears a remarkable resemblance to Raffaelli's imagery on this box. When comparing the micromosaic to the painting, it is obvious that the monkey's pose and gaze are exactly alike, it has the same belt and loop around its waist, and it sits atop a stone wall. Raffaelli must have seen either the d'Hondecoeter painting or a print or a copy of it and used it as his compositional model.

Melchior d'Hondecoeter (Dutch, 1636–1695), **A Diana Monkey on a Chain in a Landscape**. Oil on canvas, about 1690. 24 5/16 x 19 3/19 in. (61.7 x 48.8 cm). Gift of Mrs. George M. Jones, Jr., by exchange, 2009.15

Attributed to James Cox (British, purveyor) or possibly Joseph Beloudy (British, organ builder),
Pagoda Organ Clock. Gilded bronze clock on lacquered wood stand, about 1780. H. (with stand) 40 in. (101.6 cm). Purchased with funds from the Libbey Endowment, Gift of Edward Drummond Libbey, 1968.76a-b

From the late 1500s to the late 1700s when European nations were establishing colonies in Asia, Europe became enamored of Chinese forms and designs and, consequently, a style known as *chinoiserie* permeated the decorative arts.

This large pagoda-shaped clock may have been made for James Cox, who contracted goldsmiths to make intricate clockwork curiosities (automata) for customers in China and India. This clock, festooned with tiny golden bells, is one of the most elaborate *chinoiserie* timepieces made in England. Inside its three tiers is a clock mechanism that is coupled with a tiny automated bellows organ. The central tier has an enameled dial at the front, while the panels on the other three sides have miniature Chinese land- and seascapes with mechanical moving parts. When the clock chimed every quarter hour, the ships in the tower "sailed" on the sea, and, in a curious mix of "oriental" influences, the organ plays English pseudo-Arabic melodies.

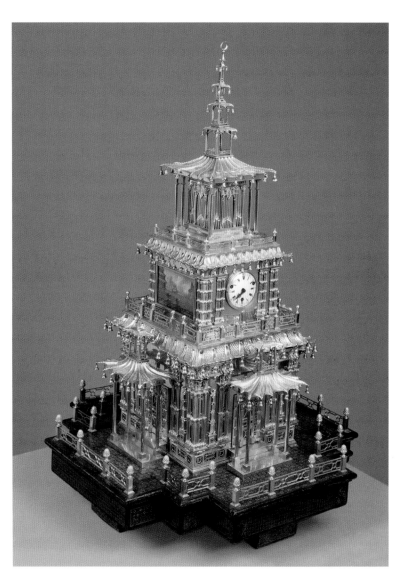

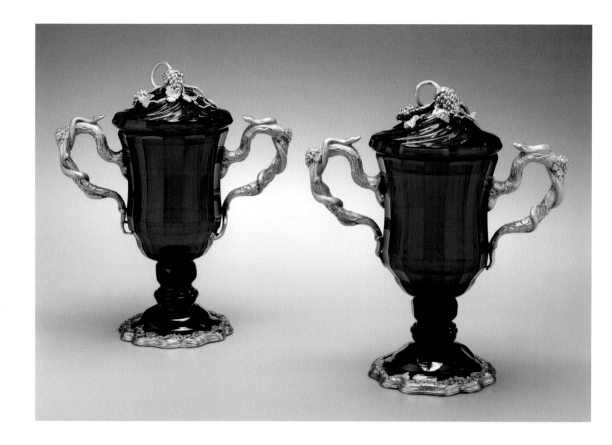

Thomas Betts (British, died 1765, glasscutter) and Thomas Heming (British, 1722/23–1801, silversmith), **Pair of Cups with Covers**. Glass, blown and cut; gilded silver mounts, about 1752–53. Each: H. (with cover) 12 ⅝ in. (32.1 cm). Purchased with Funds from the Florence Scott Libbey Bequest in memory of her Father, Maurice A. Scott, 1968.73a–b

Unique survivals, these two luxuriously mounted cups represent a collaboration between two very successful English craftsmen: Thomas Heming, Principal Goldsmith to King George III (ruled 1760–1801), and the glasscutter Thomas Betts. The cups' dramatic design contrasts richly textured, gilded silver mounts against the faceted and polished surface of thick, cobalt-blue lead glass. The combination echoes the French preference for deep blue Chinese porcelains that were fitted with gilded bronze mounts by the great Parisian *bronziers.*

Evoking luxury tableware from Venice, France, and Asia, the designer of this pair of cups applied a practical solution, using materials that were more readily available in London— cobalt-blue glass rather than Chinese porcelain, and gilded silver rather than gilded bronze.

Until the mid-1750s, Thomas Betts seems to have run a hand-cranked, glass-cutting lathe in his London shop. He later set up a successful workshop outside London, with water-driven glass-cutting machinery—a rarity in England at the time.

This jewel-like footed bowl (*tazza*) is a superb example of the type of fashionable glass objects favored by sophisticated collectors in eighteenth-century France. Commissioning such a work may have been the realm of the *marchands-merciers*, decorative arts dealers who specialized in luxury goods, arbiters of taste and inventors of stylish furnishings for the mansions and palaces of Paris. This footed bowl is an unusual glass version of hard-stone vessels with similar gilded bronze mounts, a form that became popular in France during the late 1700s. The rose color of the bowl, achieved by adding colloidal gold to the glass batch, was expensive to produce in glass.

Perhaps once part of a garniture (a matching set of decorative objects), this delicate vessel might have been placed on a sideboard or a dressing table to hold scented potpourri. This elegant tripod form references ancient Greco-Roman incense burners. Empress Marie-Louise, the second wife of Napoleon Bonaparte, had a jasper version of this bowl in her boudoir.

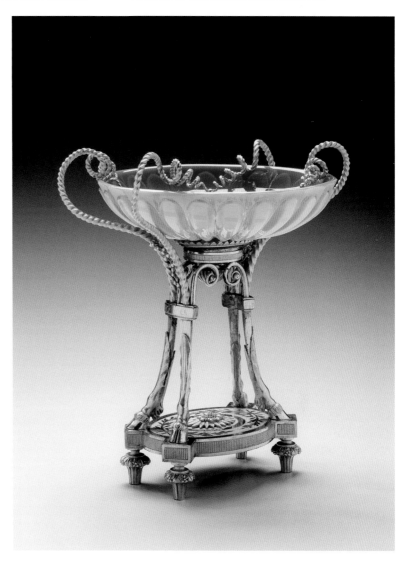

France, **Tazza**. Opacified opaline glass; gilded bronze (ormolu) mount, late 18th century. H. 9¼ in. (23.5 cm). Purchased with funds from the Libbey Endowment, Gift of Edward Drummond Libbey, 2007.48

Joseph Baumhauer (French, died 1772), **Commode**. Oak veneer with tulipwood, kingwood, casuarina, and purpleheart wood; gilded bronze mounts; breccia marble top, about 1767–72; possibly a decade earlier. L. 50 in. (127 cm). Purchased with funds from the Florence Scott Libbey Bequest in Memory of her Father, Maurice A. Scott, 1976.38

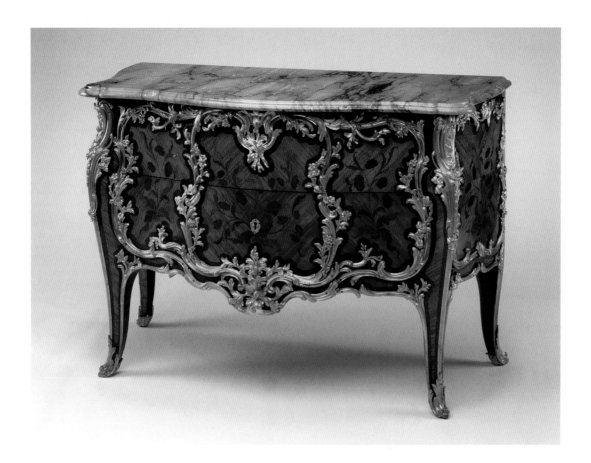

A German-born cabinetmaker working in France, Joseph Baumhauer emerged as one of the most important furniture-makers of the eighteenth century, his work sought after by a distinguished and selective international clientele. Around 1749, he was made a dealer and cabinetmaker to King Louis XV (ruled 1715–74). Baumhauer's work continues the innovative use of marquetry and gilded bronze (ormolu) fittings developed by the renowned French cabinetmaker André-Charles Boulle (1642–1742). Boulle was among the first to make furniture in the form known as the commode, or chest of drawers.

This Rococo example is remarkable for its tightly organized design, with the whole two-drawer front treated as a single decorative unit. Also notable is the exceptional craftsmanship and design of the wood marquetry. Finely chased gilded bronze garlands frame the delicate tendrils and floral clusters on the drawer fronts, while subtly curving corner mounts taper down the legs into leafy, scrolling feet known as *sabots*. A commode nearly identical to this one in the collection of the National Gallery of Art, Washington, DC, suggests that the two were probably designed as a pair.

Gaetano Gandolfi (Italian, 1734–1802), **Saint Camillus of Lellis Adoring a Crucifixion**. Oil on canvas, about 1793. 41¾ x 29⅛ in. (106 x 74 cm). Gift of Patrick Matthiesen of The Matthiesen Gallery, London, 2017.39

In this painting, Gaetano Gandolfi depicts an Italian priest, Camillus (Camillo) de Lellis (1550–1614), as he experiences a miraculous vision. As the saint was praying before a crucifix, he saw the hands of the figure of the crucified Christ reach toward him and heard a voice saying, "O faint of heart, why are you troubled? Carry on with my support, for it is my work, not yours." Camillus founded the Camillians, or the Ministers of the Sick, a congregation of male nurses who tended those who were ill, battle-wounded, or plague-stricken. The red cross on the kneeling figure's cassock (clerical robe) is a precursor of the symbols later used by the international aid movements Red Cross and Red Crescent. Camillus was canonized in 1746.

Born to a family of artists, Gandolfi worked in Bologna where he enjoyed a prolific career as a painter of private devotional pictures such as this example. He also painted monumental altarpieces and murals for churches, decorative frescoes for palaces, as well as portraits and allegorical and historical subjects.

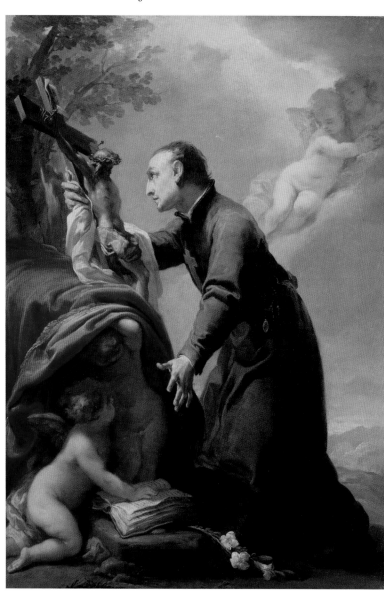

Jacques-Louis David (French, 1748–1825), **The Oath of the Horatii**. Oil on canvas, 1786. 51¼ x 65⅝ in. (130.2 x 166.7 cm). Purchased with funds from the Libbey Endowment, Gift of Edward Drummond Libbey, 1950.308

In 1784 the French king, Louis XVI (ruled 1774–92), commissioned Jacques-Louis David to paint a life-size depiction of the ancient legend of the Horatii brothers of Rome pledging to fight the Curiatii of Alba Longa, each side defending their own city-state. That painting, now in the Musée du Louvre, Paris, defined the Neoclassical style with its sense of order and classical restraint and is one of the most significant images in the history of French art. The Toledo Museum of Art's canvas, a reduced replica of the Louvre painting, was ordered from David by the comte de Vaudreuil, a high-ranking courtier. It differs from the original composition by the addition of a spindle (distaff) near the women's feet. David's pupil Anne-Louis Girodet de Roussy (1767–1824) is thought to have assisted in making this version.

David composed the scene as a shallow frieze, with three figural groups organized before three classical archways. In a dynamic, interlinked pose, the Horatii brothers swear before their father to fight to the death. Their muscular, angular bodies contrast with the fluid contours of the Horatii women, who sit slumped in grief. The woman on the far right, a Horatii sister, was engaged to marry one of the Curiatii and realizes that whichever side wins, she will lose someone she loves.

Antoine Berjon (French, 1754–1843), **Still Life with Grapes, Chestnuts, Melons, and a Marble Cube**. Oil on canvas, about 1800–10. 12 ¹⁵⁄₁₆ x 16 ⅝ in. (32.8 x 41.4 cm). Purchased with funds given by Dr. and Mrs. James G. Ravin, 2015.4

For this striking painting, Antoine Berjon organized a simple grouping of four elements: a large cube of white marble, three bunches of red grapes, two melons, and three chestnuts (one bursting from its prickly pod). All are arranged on a veined marble ledge against a dark background. Despite its seemingly straightforward composition, this still life engages the eye in subtle and complex ways.

This is a painting of contrasts and comparisons. Berjon has set small, smooth, red grapes against spiky chestnut pods and large rough-skinned melons. Unexpectedly, among these fruits and nuts of the natural world he has placed a pristine white marble cube, shaped by human hands. This curious juxtaposition is emphasized by straight lines and right angles paired with curvilinear and irregular shapes. The setting is defined by strong, bright light coming from the upper right that seems to light the grapes from within and casts shadows on the ledge and the cube. Close observation reveals that Berjon even painted the reflected color from the fruits and nuts in the luminous white of the cube.

Washington Allston (American, 1779–1843), **Italian Landscape**. Oil on canvas, 1814. 44 x 72 in. (111.8 x 183 cm). Purchased with funds from the Florence Scott Libbey Bequest, in Memory of her Father, Maurice A. Scott, 1949.113

Educated at Harvard University, Washington Allston not only painted, but also designed sculpture and architecture and wrote artistic theory, essays, poetry, and even a novel. He spent most of his career in Boston, with the exception of two extended periods in Europe. It was in England, at the height of his career, that he painted *Italian Landscape* in 1814.

Allston's sensibilities aligned him with the Romantics, who gave preference to emotion, faith, and spirituality over rational intellect.

Instead they idealized the freedom of nature in contrast to the constraints of civilization. Here, Allston depicts an imaginary Italian landscape in which civilization and nature, past and present, coexist. The rustic figures contemplating a fountain may suggest an allegory about life (the overflowing water) and death (the fountain's sarcophagus-like shape). This idyllic scene is played out against a backdrop of ancient ruins, a walled medieval city, and a Vesuvius-like mountain in the distance.

Antoine-Jean Gros (French, 1771–1835), **Napoleon on the Battlefield of Eylau**. Oil on canvas, 1807. 41¼ x 57⅛ in. (104.9 x 145.1 cm). Purchased with funds from the Libbey Endowment, Gift of Edward Drummond Libbey, 1988.54

Surrounded by his officers, the commanding figure of Emperor Napoleon Bonaparte (ruled 1804–14; 1815) surveys the carnage after the battle between French troops and the combined Russian and Prussian forces at Eylau in East Prussia (now part of Russia). Fighting in snow and bitter cold on February 7 and 8, 1807, the armies were deadlocked until the Russians retreated during the night, leaving the French as bloodied victors by default. The staggering casualties on both sides—some 50,000 out of 150,000—made this one of the most devastating battles in the Napoleonic Wars (1800–15). In this panoramic landscape, the dead and dying in the foreground contrast with seemingly endless lines of troops stretched out against fire and smoke on the dark horizon.

On March 7, 1807, possibly to boost confidence in the emperor during the Napoleonic Wars, the French government announced a competition for the best painting depicting the emperor's visit to the battlefield. Antoine-Jean Gros, a favorite student of Jacques-Louis David, entered this canvas in the competition and won the commission to execute an immense painting of the subject, now in the Musée du Louvre, Paris.

François-Honoré-Georges Jacob-Desmalter (French, 1770–1841), **Bas d'Armoire**. Burr yew wood mahogany; gilded and patinated bronze; *rouge griotte* marble top, about 1812. W. 76½ in. (194.3 cm). Purchased with funds from the Mr. and Mrs. Georges M. Jones, Jr. Fund, the Mrs. C. Lockhart McKelvy Fund, the Florence Scott Libbey Bequest in Memory of her Father, Maurice A. Scott, by exchange, and the Museum Purchase Fund, 1996.29

Commissioned about 1812 for the Château de Malmaison outside Paris, the residence of Empress Joséphine (1763–1814), this *bas d'armoire* (low wardrobe) is one of the most celebrated examples of French furniture in the Neoclassical style that was favored by Emperor Napoleon Bonaparte. Although unmarked, this work is attributed to François Honoré-Georges Jacob-Desmalter, Napoleon's preferred cabinetmaker.

The wardrobe is made of richly figured burr yew on the exterior and mahogany on the interior, and its top is a gray-toned *rouge griotte*, a mottled marble. Two secret drawers are hidden to the right and left of the center drawer. The decoration includes four female busts as supporting columns (caryatids) in gilded bronze. Their Egyptian-style headdresses reference Napoleon's Egyptian campaigns (1798–1801) and are typical of the Egyptomania that followed suit. Other gilded bronze ornaments include roundels with scenes of Roman gods and goddesses and bands of olive branches, lotus buds, and Greek palmettes. The design reflects a nostalgia for classical antiquity, all things Egyptian, and a desire for a style that embodied a sense of order, power, and grandeur.

Founded in 1792, the Berlin luxury-goods manufacturer Werner & Mieth was favored by members of the Bonaparte family, who ordered many gilded bronze and glass furnishings from them. This chandelier was purchased for the new summer palace of Jérôme Bonaparte (1784–1860), Napoleon's fashionable brother and King of Westphalia from 1807 to 1813. Werner & Mieth described it as the "most beautiful crown they can offer." The design may be attributed to the archaeologist and theoretician Hans Christian Genelli (1763–1823), particularly in reference to a drawing in which he "dissects" the volute shapes of a classical Ionic capital. Like the drawing, the chandelier is based on a logarithmic spiral with a downward movement. The concept of a column hanging upside down is a remarkable one. In this case, the coiling forms of the chandelier are especially noticeable from below.

Werner & Mieth (German, Berlin, maker), **Spiral Chandelier for Jérôme Bonaparte**. Fire-gilded bronze (ormolu); glass, 1810/11. H. 68⅞ in. (175 cm). Gift of Mrs. Henry Goldman, Mr. and Mrs. Allen Owen, Florence Scott Libbey, Angelo del Nero, and Bequest of Edward E. MacCrone, by exchange, 2014.33

Raphaelle Peale (American, 1774–1825), **Still Life with Oranges**. Oil on wood panel, about 1818. 18 ⁵⁄₈ x 22 ¹⁵⁄₁₆ in. (47.4 x 58.3 cm). Purchased with funds from the Florence Scott Libbey Bequest in Memory of her Father, Maurice A. Scott, 1951.498

Painted with such care that any single object in this simple tableau could stand on its own, the fruit and tableware depicted nevertheless form a coherent, balanced composition. The sensuous delights of the fruits and nuts, the ceramic basket, and full wine glass to the side—all rendered in precise detail—suggest abundance, though sensibly moderated. A soft direct light accents the different textures and reflective qualities of glass, ceramic, leaves, grapes, nuts, and oranges. The artist, Raphaelle Peale, enhanced their three-dimensional qualities by overlapping them against a partially lit background. Depth is suggested by the diagonal thrust of the citrus twig and its twisting, curving leaves. (The spiraling orange peel may be a visual pun on the artist's last name.) His inscription at the bottom: "Painted for the Collection of John A. Alston, Esqr. / The Patron of living American Artists" refers to John Ashe Alston of South Carolina.

A member of the renowned Peale family of Philadelphia, whose three generations of artists helped shape the history of American painting, Raphaelle Peale is considered the nation's first professional still-life artist and founder of the American still-life tradition.

Gilbert Stuart (American, 1755–1828) and Jane Stuart (American, 1812–1888), **Commodore Oliver Hazard Perry**. Oil on wood panel, 1818–28. 26 ⅝ x 21 ¾ in. (67.7 x 55.3 cm). Purchased with funds from the Florence Scott Libbey Bequest in Memory of her Father, Maurice A. Scott, 1967.140

In 1818 the Rhode Island legislature commissioned Gilbert Stuart, the noted Rhode Island portraitist, to paint a full-length portrait of one of their most famous native sons, the American naval commander Oliver Hazard Perry (1785–1819). Perry became a national hero in the War of 1812 after defeating a British squadron near Put-in-Bay, Ohio, during the Battle of Lake Erie. Perry sat for this portrait just before sailing for the West Indies, where he died of yellow fever on his thirty-fourth birthday. Stuart, who was notorious for leaving his paintings unfinished, only completed the face of this portrait. After his death in 1828, his youngest daughter, the talented sixteen-year-old, Jane, finished the head, sky, and uniform. Because the Stuarts were left penniless after Gilbert's death, Jane took it upon herself to complete, exhibit, and sell many of her father's unfinished works.

Gilbert Stuart painted portraits of many of early America's most important citizens, including the first six presidents. His distinctive style of sketchy brushstrokes and strong characterizations set the standard for American portraits for at least a generation.

Bertel Thorvaldsen (Danish, 1770–1844), **Count Artur Potocki**. Marble, modeled 1829; executed 1830–33. H. (with base) 28⅝ in. (72.6 cm). Purchased with funds from the Libbey Endowment, Gift of Edward Drummond Libbey, 1991.64

When he carved this noble portrait, the Danish sculptor Bertel Thorvaldsen was perhaps the most famous living artist of his day. A resident in Rome since winning a scholarship to study there 1797, he had become a leading exponent of Neoclassicism, the radical new interpretations of the same Greek and Roman ideals that had inspired Western art since the Renaissance. In addition to his skill with classical subjects, Thorvaldsen was also a remarkable portraitist. While this portrait bust of Count Artur Stanislaw Potocki reveals his close study of Greco-Roman sculpture, the tousled hair and sideburns reflect current fashion. The finely textured finish of the marble—"to catch the light," as Thorvaldsen said—was his personal technique, one widely emulated by younger sculptors on both sides of the Atlantic.

Count Potocki (1787–1832) was a much-admired member of international society and belonged to a great Polish aristocratic family. This bust was completed for his family estate at Łańcut, in southeast Poland, after his death in January 1832.

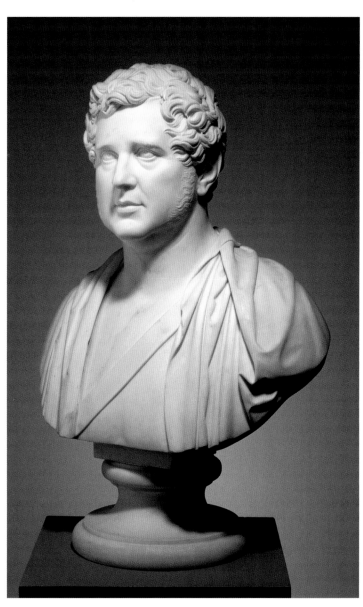

Honoré Daumier (French, 1808–1879), **Rue Transnonain, le 15 Avril 1834**. Lithograph, 1834. 11¼ x 17⅜ in. (28.6 x 44.1 cm). Gift of Albert Roullier Art Galleries, Chicago, 1923.3103

Chronicling the French government's use of excessive violence during workers' uprisings in Paris in April 1834, *Rue Transnonain, le 15 Avril 1834* departs from Honoré Daumier's famous satirical images of the French middle class. The print's title refers to the street where shots were fired from a building during a riot, prompting the French National Guard to storm in and massacre residents in retaliation. Rather than depict the dramatic moment of execution, Daumier instead focused on its terrible aftermath. Amid the disorder of a bedroom lie the corpses of three generations of a working-class family. In haloed moonlight, the bloodied father, wearing only a nightshirt and a sleeping cap, has collapsed on his back. The tiny head and arms of his dead infant protrude beneath

him, while the body of his wife and the child's grandfather lie nearby. Demonstrating his mastery of the newly developed printmaking process of lithography, Daumier used strong light and shadow and radical foreshortening to emphasize the brutality of the killings. His portrayal of the innocent victims presents them as martyrs, sacrificed to the cause of social justice and freedom.

This image was published in the journal *L'Association Mensuelle* in July 1834. But in a move that indicates the tumultuous political climate of the times, Louis-Philippe (ruled 1830–48) ordered that all impressions of the print be destroyed, though many survived his wrath.

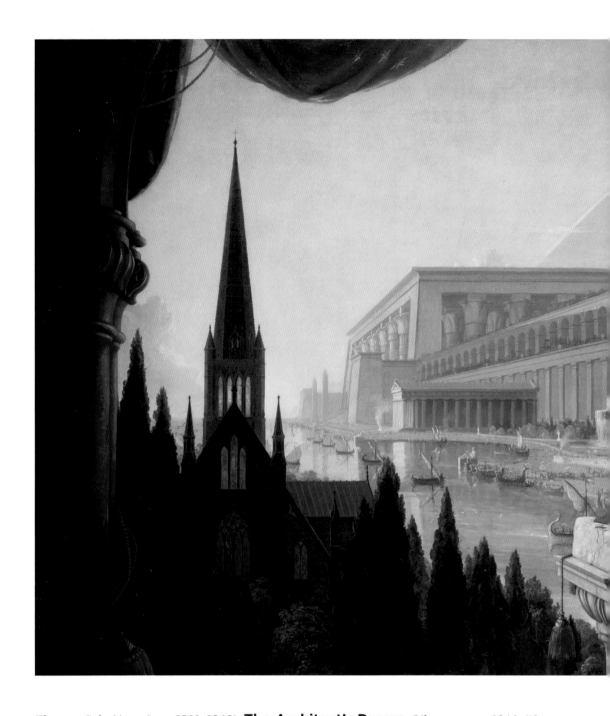

Thomas Cole (American, 1801–1848), **The Architect's Dream**. Oil on canvas, 1840. 53 x 84 1/16 in. (134.7 x 213.6 cm). Purchased with funds from the Florence Scott Libbey Bequest in Memory of her Father, Maurice A. Scott, 1949.162

The Architect's Dream **portrays** an ideal realm imagined by an architect who reclines in the foreground atop a monumental column. Arranged chronologically back to front, the Egyptian pyramid and temple in the background give way to Greek and Roman temples of the Doric, Ionic, and Corinthian orders on the right. To the left, the spire of a Gothic cathedral rises above the pines. Dozens of small figures and sailboats fill the waterfront in

the mid-ground. Thomas Cole was the premier figure in a group of American landscape artists who were later called the Hudson River School of painters. Here he has cleverly used light and setting to distinguish between the clarity of Mediterranean architecture bathed in southern sunlight and the mystery of a medieval church cast in northern shadow.

In 1839 successful American architect Ithiel Town (1784–1844) commissioned Cole to paint a view of Athens, Greece, either ancient or modern. Town had asked that the landscape dominate the architecture, so *The Architect's Dream* was not what Town had envisioned. Disappointed, he rejected Cole's painting, much to the artist's indignation. Inscribed "Painted by T. Cole / For I. Town Archt.," the painting remained in Cole's family until the Museum acquired it in 1949.

Joseph Mallord William Turner (British, 1775–1851), **The Campo Santo, Venice**. Oil on canvas, 1842. 24½ x 36½ in. (62.2 x 92.7 cm). Gift of Edward Drummond Libbey, 1926.63

Venice is splendid even in its decline in J. M. W. Turner's radiant view northward across its main lagoon. The city is to the left and the cemetery island (Campo Santo) of San Michele is in the distance, on the right. Artists did not often paint this view; it lacked impressive monuments or other reminders of the city's grand and powerful past. For Turner, however, the cemetery may have been a fitting symbol of the "death" of this once-great city. At midground is a lateen-rig sailboat, its shallow draft designed to navigate the lagoon. The reflections of its twin white sails resemble angel's wings, perhaps stressing the theme of mortality.

Such historical and poetic associations may have been clearer when Turner showed this painting in 1842 at the Royal Academy, London, alongside its companion canvas, *The Dogano, San Giorgio, Citella, from the Steps of the Europa* (now in Tate Britain, London). In contrast to *The Campo Santo*, it is a historical view of prosperous Venice, its cargo-laden boats arrayed before the Customs House.

Sanford Robinson Gifford (American, 1823–1880), **Lake Nemi**. Oil on canvas, 1856–57. 39⅝ x 60⅜ in. (101.8 x 153.3 cm). Purchased with funds from the Florence Scott Libbey Bequest in Memory of her Father, Maurice A. Scott, 1957.46

The landscape painter Sanford Robinson Gifford is considered one of the leading members of the second generation of the Hudson River School. In this painting, he masterfully recorded the subtle effects of atmosphere and light at Lake Nemi, Italy, southeast of Rome. Like many nineteenth-century American artists, Gifford traveled to Europe to study the work of European masters and to visit historic sites of the ancient world. When he visited Lake Nemi in October 1856, during his first tour of Europe, he recorded the view in a letter: "We were high up above the lake. On one side in the foreground were some picturesque houses and ruined walls—a tall dark cypress, rising out of a rich mass of foliage, cut strongly against the lake, distance, and sky."

In this painting the emphasis on radiating afternoon sunlight became a common theme, both for Gifford and for many of his fellow American landscape painters. Historians later named this style of painting "Luminism."

William Henry Fox Talbot (British, 1800–1877), **Articles of Glass**. Salt print from a calotype negative, about 1844. 7 ½ x 9 1/16 in. (19.1 x 23 cm). Gift of Harold Boeschenstein, Jr., Frederick P. and Amy McCombs Currier, William and Pamela Davis, Mary and Thomas Field, Mr. and Mrs. O. Lee Henry, Mr. and Mrs. Harry Kaminer III, The Reva and David Logan Foundation, Dr. and Mrs. James Ravin, Mark and Rubena Schaffer, and Mr. and Mrs. Spencer D. Stone in honor of the 150th anniversary of the invention of photography, 1989.32

In 1839, the "official" year of the invention of photography, both William Henry Fox Talbot in England and Louis Daguerre (1787–1851) in France announced their own revolutionary new processes for capturing an image. Though Daguerre's copper-plate-fixed daguerreotype technique was first to acquire a patent, Talbot's 1841 invention of the paper-negative calotype to create multiple copies of an image introduced the concept of reproducibility to photography.

This remarkable image was published as plate four in Talbot's *The Pencil of Nature* (1844), marketed as the first commercial manual with photographic illustrations devoted to the new medium. To promote and illustrate photography's practical, artistic, and documentary possibilities, Talbot included *Articles of Glass* and its companion, *Articles of China*, in his booklet. Here, suites of domestic items have been carefully placed in consecutive rows, as though they were scientific specimens, by size, shape, and pattern. In all, the arrangement creates a pleasing, symmetrical composition. By resourcefully placing the glass objects against a dark backdrop, Talbot found a brilliant yet simple solution to photographing transparent objects. With his firsthand knowledge of the photographic process and his skillful use of light, he masterfully recorded the multifaceted surface of cut glass and its reflective properties.

Gustave Le Gray (French, 1820–1884), **The Mediterranean with Mount Agde**. Albumen print from multiple wet-collodion negatives, 1856–59. 10 ⅝ x 15 ½ in. (27 x 39.4 cm). Purchased with funds from the John S. and Catherine Chapin-Kobacker Family and with funds from the Libbey Endowment, Gift of Edward Drummond Libbey, 1997.283

The seascapes of Gustave Le Gray remain his most admired and important photographs. Although trained as a painter, Le Gray turned to photography in the 1840s as a new, exciting medium having infinite possibilities. He explored and adapted the new techniques to create remarkable images that still astound and puzzle collectors and photographers alike. In 1856 Le Gray exhibited the earliest of his seascapes at the Photographic Society in London. The images, numbering about thirty, in which both the sea and the sky were dramatically detailed, caused a sensation.

Le Gray made two negatives to produce this dazzling atmospheric image of the Mediterranean coast with Mount Agde, France, in the distance. Keeping his camera pointed in precisely the same direction, he exposed one negative to capture the dark, reflective tones of the water and another to capture the clouds and rays of sunlight in the bright sky. He then placed both glass-plate negatives against a sheet of albumen-coated paper and exposed them to light, ultimately creating a seamless image with striking effects of light and capturing the beauty and majesty of both sea and sky.

Hiram Powers (American, 1805–1873), **The Greek Slave** (Bust Version). White marble, after 1845. H. (with base) 27½ in. (69.8 cm). Museum Purchase, 1917.128

Sculpted in white marble, this serene, bust-length rendering of a nude woman is not a portrait, but instead an idealized representation of feminine grace and beauty. The full-length, life-size version of Hiram Powers's *The Greek Slave* (1841–43) was once the most famous sculpture in nineteenth-century America. When several versions of it were sent on tour of the eastern United States from 1847 until the mid-1850s, more than 100,000 people paid to see it. Depicting a nude Greek maiden, her hands chained together as she is displayed in a Turkish slave market, this was America's first publicly exhibited nude female figure. To prevent criticism from the largely conservative audience of the day, it was accompanied by texts emphasizing its "high moral and intellectual beauty." The subject was inspired by the Greek struggle for independence from the Ottoman Empire in the 1820s and dubious reports of Christian women being sold into Turkish slavery, but, understandably, some reviewers linked it to the very real practice of slavery in the United States.

The Greek Slave proved so popular that Powers, who worked in Italy, could hardly keep up with the demand for copies. He also produced smaller tabletop and modified versions, such as this bust. It was acquired by the Museum from Charles W. Lemmi, a grandson of Hiram Powers.

The subject of this sculpture is taken from classical Greek mythology. Hebe, the daughter of Juno and Jupiter, was the goddess of youth and young brides, an attendant to Venus and, most importantly, cupbearer to the gods. As cupbearer she served ambrosia (a drink that was said to reinforce a god's immortality) at feasts on Mount Olympus. Here she is shown serving the drink to Aetos Dios—the giant golden eagle who was Jupiter's personal messenger and animal companion. He holds one of Jupiter's thunderbolts in his talons. From the beginning of the nineteenth century, the subject of Hebe offering nectar to the eagle was a popular way for artists to depict innocence and beauty with a hidden eroticism. When this silvered bronze version by Albert Ernest Carrier-Belleuse was exhibited at the Paris Salon of 1859, it was praised for its gracefulness, its seductive arrangement, and its Renaissance-inspired style.

Albert Ernest Carrier-Belleuse (French, 1824–1887), **Hebe and the Eagle of Jupiter**. Silvered bronze, 1858. H. 19½ in. (49.5 cm). Purchased with funds given by Mr. and Mrs. George M. Jones, Jr., 1992.20

Joseph Cremer (French, 1811–1878), **Cabinet**. Oak, with amboyna wood, walnut, and ebony veneer, walnut and mahogany marquetry, pearwood carving; gilded bronze, 1856. H. 104⅜ in. (285 cm). Mr. and Mrs. George M. Jones, Jr. Fund, 1990.97

Joseph Cremer was a gifted specialist in marquetry, mosaic-like inlays of exotic woods and other expensive materials. On this cabinet, made for display at the London International Exhibition of 1862, Cremer also carved some parts in high and low relief, added sculpture in the round, and applied gilded mounts to create a striking example of Second Empire style, named for the reign of Napoleon III (ruled 1852–73). Its strongly architectural form reflects the enthusiasm in France at the time for sixteenth-century Renaissance design.

The allegorical decoration is as eclectic as the techniques that were used to make this cabinet. On the upper doors are carved relief roundels of Ceres and Minerva, the ancient Roman goddesses of abundance and craft, above marquetry trophies symbolizing agriculture and good government. The caryatids (corner figures) on the base represent Flora (goddess of flowers) and Bacchus (god of wine). When the upper doors are opened, Cremer's artistry is seen at its most dramatic. The detail image illustrates the inside of one of the upper doors—a marquetry "trophy" composed of ethnographic objects from the South Pacific, including a feather lei (garland), a claw-studded mace, a split coconut, and a feathered helmet and shields.

James Abbott McNeill Whistler (American, 1834–1903), **Black Lion Wharf**. Etching and drypoint, 1859; published 1871. 5⅞ x 8⅞ in. (14.9 x 22.5 cm). Gift of an anonymous donor, 1912.1190

Among the best-known etchings by the American artist James Abbott McNeill Whistler, *Black Lion Wharf* owes its enduring appeal to its unflinching portrayal of working-class men and their surroundings. Created in 1859 when Whistler first arrived in London, this print was not published until 1871, when it was issued as part of his *Thames Set*, a series of sixteen prints chronicling London's gritty docklands and their wharfs, warehouses, and workshops. Anchoring the image is a young, unkempt, bearded man who sits before a view of ramshackle buildings along the Thames. The arresting composition—with its flattened view, cropped forms, and distinct spatial zones—fuses Whistler's knowledge of both photography and Japanese woodblock prints. By rendering the distant warehouses in greater detail than the sketchy treatment of the foreground, Whistler introduced a novel handling of pictorial space that captured his subject in a striking new manner.

This etching's importance to the artist is suggested by its inclusion, framed on the wall, in his famous painting *Arrangement in Grey and Black, No. 1*, commonly known as *Whistler's Mother* (1871; Musée d'Orsay, Paris).

Cheyenne nation, North America, **Model Tipi Cover**. Animal hide, paint, sinew, about 1860. 57 x 31½ in. (144.8 x 80 cm). Gift of The Georgia Welles Apollo Society, 2017.17

Beginning about the seventeenth century, the Cheyenne people used *tipis* for shelter when the tribe transitioned from an agricultural existence, living in earth-lodge dwellings, to becoming nomadic, bison-hunting warriors. For the next 300 years or more, tipis served as the primary dwellings for the Cheyenne, who often decorated them with pictograms of their horses and the animals they hunted. The spiritual power and social status associated with painted Cheyenne tipis was often ritually passed on for generations.

This model tipi cover, made in the mid-nineteenth century, was intended to pass down tribal history and traditions at a time when the Cheyenne's established way of life came under ever-increasing threat, from settlers moving westward, railroad expansion, and the US government. Intended as a form of remembrance, it mimics traditional full-scale tipi construction methods, in which several pieces of buffalo hide were sewn together. The dyed blue areas on the top and bottom symbolize the sky and the earth. The horses, shown in profile at mid-stride, represent power, wealth, prestige, and courage, values that the Cheyenne associated with the ownership of horses in the nineteenth century.

Jasper Francis Cropsey (American, 1823–1900), **Starrucca Viaduct, Pennsylvania**. Oil on canvas, 1865. 22⅜ x 36⅜ in. (56.8 x 92.4 cm). Purchased with funds from the Florence Scott Libbey Bequest in Memory of her Father, Maurice A. Scott, 1947.58

In a celebration of both American nature and industry, Jasper Francis Cropsey highlights the Starrucca Viaduct, a railroad bridge over Starrucca Creek in the Susquehanna River Valley near what is now the town of Lanesboro, in northeast Pennsylvania. Built by the New York and Erie Railroad in 1847–48, the viaduct was among the first great American engineering feats. In nineteenth-century landscape painting, and in the early years of railroad transportation, the new smoke-spewing invention of the steam locomotive was often seen either as a symbol of industrial progress or of human destruction and exploitation of nature.

Cropsey is from the second generation of nineteenth-century American landscape painters who were later called the Hudson River School. Their work was strongly influenced—stylistically and thematically—by the work of the first artist to focus on that region, Thomas Cole (1801–1848, see pp. 190–91). Like Cole, Cropsey sketched extensively in nature, primarily in upstate New York and New England, transforming his direct observations of nature into ideal landscapes. The emphasis on nature's tranquility and a preference for fall's brilliant colors are hallmarks of Cropsey's late landscapes.

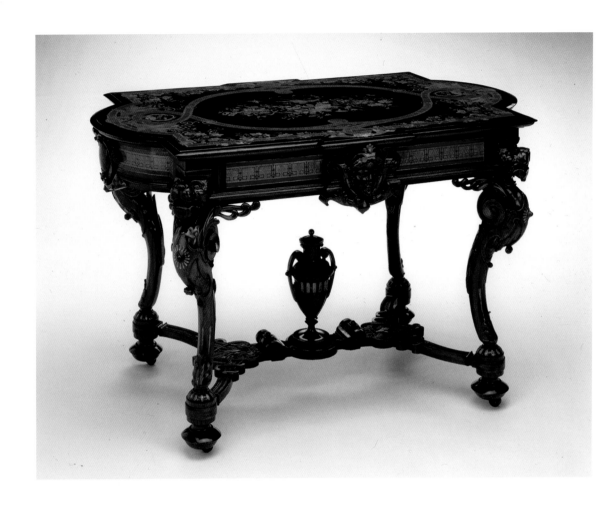

Herter Brothers (American, New York, New York), **Center Table**. Ebony, rosewood, sycamore, kingwood, tulipwood, amboyna; mother-of-pearl; lacquer, about 1865–70. L. 48 in. (121.9 cm). Gift of Dr. and Mrs. Edward A. Kern, 1986.65

America's foremost cabinetmaking and decorating firm in the late nineteenth century, Herter Brothers was founded in New York in 1864 by German immigrants Gustave Herter (1830–1898) and his half-brother Christian (1840–1883). The firm produced the structure supporting the elaborate top for this center table. The legs are topped with carved winged lions' heads and end in trumpet feet that are joined by an x-shaped stretcher of interlaced and pierced strapwork with an elaborate two-handled urn at the center. The marquetry top, inlaid with a central medallion of flowers and birds and surrounded by interlacing vines

and scrolls, is embellished with mother-of-pearl and lacquer that imitates lapis lazuli. This table may have been imported from the leading Parisian marquetry specialist, Joseph Cremer (see pp. 198–99). The tabletop's decoration, reminiscent of late-seventeenth-century Baroque furniture from the Netherlands and France, together with the classically inspired urn, and the overall Renaissance-inspired form, represents a flamboyant transition in American furniture, one that was heavily influenced by immigrant designers and craftsmen with a strong European aesthetic sense.

William Holman Hunt (British, 1827–1910), **Fanny Waugh Hunt**. Oil on canvas, 1866–68. 40 ¹⁵⁄₁₆ x 28 ¾ in. (104 x 73 cm). Purchased with funds from the Libbey Endowment, Gift of Edward Drummond Libbey, 1977.34

Personal tragedy suffuses this portrait: Fanny Waugh Hunt, the artist's wife, died before her portrait could be completed. Painted by William Holman Hunt, it epitomizes two themes of the Pre-Raphaelite Brotherhood (of which he was a founding member): moral seriousness and sincerity. In August 1866 the couple had set out for the Holy Land but were delayed in Florence, Italy, where day after day in intense heat Fanny posed for Hunt behind a chair that concealed her pregnancy. Their son, Cyril Benoni (Hebrew for "son of sorrow") was born in October but Fanny died in Florence two months later, of complications from the delivery.

After returning to London, the grieving Hunt finished Fanny's portrait from memory, with the aid of a photograph and her peacock shawl, silk dress, and cameo brooch. The rich interior evokes upper-class "artistic" taste with its Chinese porcelain vase and gold mirror frame, Venetian glass bowl and chandelier, Persian pottery dish, and elegantly framed watercolors. Many of these objects are seen through the multiple mirror reflections behind Fanny's head, which suggest observations on eternity and the dimming of receding memory.

The Aesthetic movement of the late 1800s argued that art could be enjoyed for its own sake. Its most important impact was on the decorative arts, helping to elevate their importance in order to stand alongside painting, architecture, and sculpture. The movement's broad eclecticism often embraced stylistic design sources favored for their historic distance or exotic appeal. The Whiting Manufacturing Company, which produced this vase with its dense relief decoration, was one of the three great silver firms of the American Aesthetic movement, along with Tiffany & Company and the Gorham Manufacturing Company. The naturalistic repoussé lilies, irises, ferns, and other flowers embellishing the body of the vase appear as though in conversation with the extremely stylized, Egyptian-influenced flowers and plants around the vase's neck. The contrast between these two stylistic choices reflects the aesthetic discourse during this period.

Whiting Manufacturing Company (American, North Attleboro, Massachusetts, maker), **Vase**. Sterling silver, about 1880–85. H. 7½ in. (19.1 cm). Purchased with funds from the Florence Scott Libbey Bequest in Memory of her Father, Maurice A. Scott, 1987.70

Gustave Courbet (French, 1819–1877), **The Trellis**, or **Young Girl Arranging Flowers**. Oil on canvas, 1862. 43¼ x 53¼ in. (109.9 x 135.3 cm). Purchased with funds from the Libbey Endowment, Gift of Edward Drummond Libbey, 1950.309

Gustave Courbet, who became famous for his confrontational images of peasant life and his dramatic landscapes, led a personal campaign to reform art. He declared brashly that artists must represent contemporary life, not imitate the past. This painting of a woman arranging cut flowers on an outdoor trellis reflects Courbet's Realist manifesto, because it presents the young woman not as a classical nymph or allegorical figure, but as an ordinary woman in contemporary dress.

In 1862 Courbet was invited for a two-week stay at the estate of Etienne Baudry, a wealthy young art patron, in southwest France. Delighted by the hospitality of his host, the charming gardens, and the surrounding forests (and an alluring female neighbor), Courbet stayed on for almost a year. During that time he completed nearly one hundred canvases, including two dozen flower paintings, among them *The Trellis*. These paintings were inspired in part by Baudry, whose passion was botany, and by another neighbor, the lawyer Phoedora Gaudin, who was fascinated by the history of floral symbolism.

European Jewelry, 19th–20th century

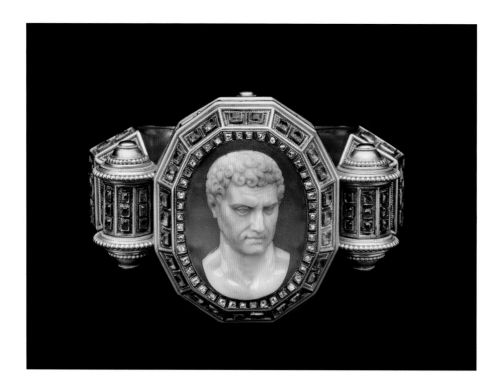

Ernesto Pierret (Italian, 1824–1898?), **Bracelet in "Archaeological Style."** Gold, rubies, emeralds, diamonds, agate cameo, about 1865. H. (pendant) 1⅜ in. (3.5 cm). Mr. and Mrs. George M. Jones, Jr., Fund, 1999.11 a–b

The Toledo Museum of Art has a significant collection of fine jewelry from the nineteenth and twentieth centuries, a period of great vitality in jewelry design. Despite sweeping industrial and social changes in the 1800s, many jewelers continued to focus on the past. French-born jeweler Ernesto Pierret, for example, mounted an exquisitely carved agate cameo, inspired by ancient Roman cameo portraiture, in an architectural hinged cuff. The cuff recalls Byzantine designs and is embellished with fine grains of gold (called granulation), rubies, emeralds, and diamonds. The cameo pendant can be removed and worn as a brooch.

By contrast, the flowing curves and expressive naturalism of the poppy pendant by René Lalique define it as a quintessential jewel of the Art Nouveau style. Lalique's innovative designs attracted an elite clientele with modern, esoteric tastes. Art Nouveau jewelers used precious gold and diamonds alongside baked enamel and glass, keeping all elements in sync with the unifying aesthetic idea.

London designer Edward Spencer's Arts and Crafts-style *Phoenix Necklace* is a tour-de-force of exquisite craftsmanship and layers of meaning. Seven opals hang like fruit from the Tree of Knowledge. At the foot of the tree the Phoenix rises from its fiery nest, an emblem of Eternal Life. The World Serpent of Norse mythology, Jormungund, binds together the earthly and heavenly systems.

René Lalique (French, 1860–1945), **Poppy Necklace**. Patinated glass, enamel, gold, rose-cut diamonds, about 1900–1903. H. (pendant) 2⅞ in. (7.3 cm). Mr. and Mrs. George Jones, Jr. Fund, 1995.13

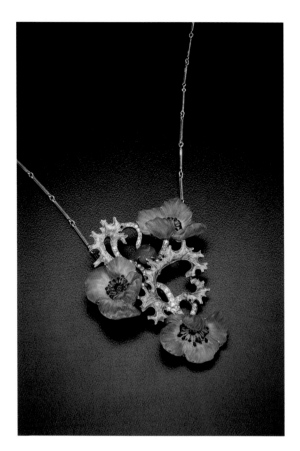

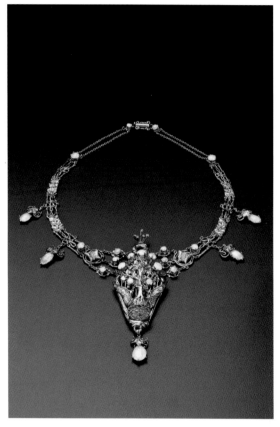

Edward Spencer (British, 1873–1938) for The Artificers' Guild (London), **The Phoenix Necklace**. Gold, diamonds, opals, about 1904. H. (pendant) 3⅞ in (10 cm). Purchased with funds given by Helen W. Korman and Barbara Goldberg and with funds from the Libbey Endowment, Gift of Edward Drummond Libbey, 2004.66

James Tissot (French, 1836–1902), **London Visitors**. Oil on canvas, about 1874. 63 x 45 in. (160 x 114.2 cm). Purchased with funds from the Libbey Endowment, Gift of Edward Drummond Libbey, 1951.409

Standing on the steps outside the National Gallery, London, a fashionable couple has stopped to decide what to see or do next. The woman points her umbrella imperiously to the right, in the direction of Trafalgar Square, while her male companion ignores her to consult a guidebook. Meanwhile, several steps down, a young guide from Christ's Hospital School (identified by his distinctive uniform), stands by, bored, his services unengaged. The painting seems a straightforward but somewhat humorous look at sightseers in London.

The well-dressed woman has broken two important Victorian social rules: her dress is too ostentatious for a day spent touring the city, and her forthright gaze—looking directly either at someone in the foreground or at the viewer of the painting—is a breach of feminine propriety. A proper lady would never make eye contact with strangers. The abandoned cigar on the steps provocatively suggests an unseen male presence.

French artist James Tissot moved to London in 1872. A keen observer of fashion and manners among the newly wealthy British middle class, many of his paintings suggest narratives of "social mistakes," both unintended and deliberate.

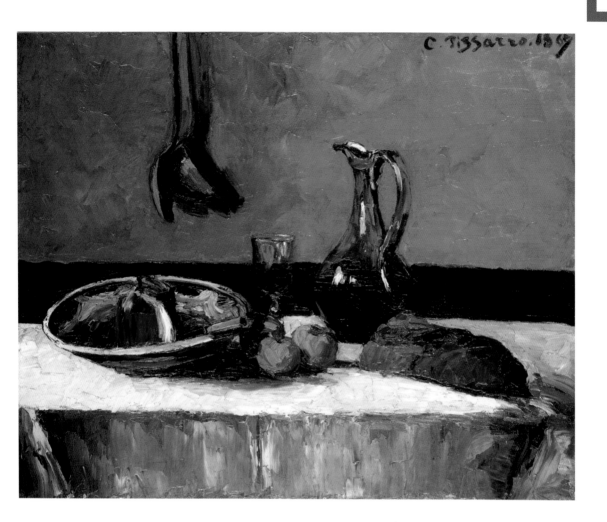

Camille Pissarro (French, 1830–1903), **Still Life**. Oil on canvas, 1867. 31 ⅞ x 39 ¼ in. (81 x 99.7 cm). Purchased with funds from the Libbey Endowment, Gift of Edward Drummond Libbey, 1949.6

"The Louvre will burn," wrote the artist Antoine Guillemet (1843–1918) in 1866, using incendiary language to describe and endorse the artistic revolution that Camille Pissarro and Paul Cézanne (1839–1906) were unleashing with the shocking canvases they painted in the mid- to late 1860s. It was their goal to breathe into their art an audacity that reflected individuality, which they termed "sincerity." Pissarro's still life of 1867, the first of only twenty-two that he would paint, is a monumental testament to this theoretical and practical approach to artmaking.

The subject of this painting is as much the insistent display of *how* it was created, as it is *what* is represented. Pissarro not only worked the canvas with broad brushstrokes, he also used a palette knife to apply the paint boldly in smooth, flat surfaces, interrupted by sculpted areas of thick impasto. His deliberate juxtaposition of these techniques results in a vibrant surface that not only vividly renders the different texture of each object, but also conveys great visual energy and emotional power.

Charles-François Daubigny (French, 1817–1878), **Auvers, Landscape with Plough**. Oil on canvas, about 1877. 18 ⁵⁄₁₆ x 32 ¹⁄₁₆ in. (46.5 x 81.5 cm). Purchased with funds from the Florence Scott Libbey Bequest in Memory of her Father, Maurice A. Scott, 2015.18

Initially trained as an engraver, Charles-François Daubigny took up a career as a landscape painter in the 1830s. Early on, as a Barbizon School painter—a group of artists who traveled to the Forest of Fontainebleau near Paris to sketch and paint landscapes out-of-doors—he championed humble scenes of nature sketched from life rather than grandiose, classically composed canvases. Daubigny was particularly interested in transitory light effects. He developed his technique increasingly toward a spontaneous application of paint, resulting in one critic lambasting him for "heading up the school of the impression." In fact, Daubigny's work did influence the Impressionists.

From 1860 Daubigny lived at Auvers-sur-Oise, northwest of Paris (the same town where Vincent van Gogh, 1853–1890, who was profoundly influenced by Daubigny's work, later spent the last month of his life). The vast fields outside the village captured Daubigny's attention. In this canvas, which he painted not long before he died, Daubigny chose a scene laden with nature's fleeting qualities. Equally dividing the sky and the earth, the horizon line gently slopes downward to the right. The dynamism of the turbulent clouds, barely pierced by the sun, is matched by the riot of greens and browns of the rolling fields below.

Gustave Doré (French, 1832–1883), **The Scottish Highlands**. Oil on canvas, 1875. 42¾ x 72⅛ in. (108.6 x 183.2 cm). Gift of Arthur J. Secor, 1922.108

In this sweeping view of the Scottish Highlands, rugged, cloud-wreathed mountains dwarf the hunter and his dogs in the foreground, conveying the sense of awe that many nineteenth-century travelers felt in this land romanticized as one of the last "unspoiled" corners of the British Isles.

Both majestic and severe, the beauty of the Scottish Highlands enchanted Gustave Doré so much that he wrote upon returning to Paris from Scotland in 1873, "Henceforth, when I paint landscapes, I believe that five out of every six will be reminiscences of the Highlands. . . . I hope to go back there again and again." Doré sketched incessantly on that initial trip, returning the following year. The series of paintings of the Highlands that he produced from 1874 to 1881 were based in part on these sketches, but also on his "reminiscences." As a result, *The Scottish Highlands* captures a romantic ideal of a timeless, wild land untamed by human civilization rather than recording a topographical description of a specific landscape.

Édouard Manet (French, 1832–1883), **Antonin Proust**. Oil on canvas, 1880. 51 x 37¾ in. (129.5 x 95.9 cm). Gift of Edward Drummond Libbey, 1925.108

Posed in an attitude of carefully studied relaxation, the elegantly urbane and impeccably dressed Antonin Proust (1832–1905) embodies something of the essential traits of the modern Parisian dandy. When Édouard Manet painted this likeness of his childhood friend, the artist had already challenged the tenets of academic art and would later be considered the "father of Modernism." Proust was a rapidly rising leftist legislator in Paris, as well as a journalist and politician, art critic, collector, and curator, later to be named France's Minister of Fine Arts. In 1879, as Proust later recounted in his biography of the artist, Manet was fixed on a plan "to paint my portrait on unprepared white canvas, in a single sitting."

Traces of the artist's struggle with spontaneity are still evident in the canvas's extensive surface crackle, a sign of considerable reworking. Manet generally developed his compositions directly on the canvas. He would revise, scrape away, repaint, and sometimes even discard a canvas to begin afresh. Of his portrait session, Proust recalled, "After using up seven or eight canvases, the portrait came all at once."

Aimé-Jules Dalou (French, 1838–1902), **Maquette for the Delacroix Monument**. Bronze, modeled 1885; this cast about 1902–1905. H. 34 ¾ in. (88.3 cm). Purchased with funds from the Libbey Endowment, Gift of Edward Drummond Libbey, 1964.61

The Third Republic in France began in 1870 after public turmoil that led to the collapse of Napoleon III's Second Empire regime. Seeking to establish calm after a public uprising in September 1870, French leaders sought to commemorate great men who epitomized the nation's glory. In 1885, a group that included well-known politicians, critics, artists, and writers proposed the creation of a monument to honor the artist Eugène Delacroix (1798–1863). Delacroix was the undisputed leader of the French Romantic style, and one of France's greatest painters. To create the monument, the group chose Aimé-Jules Dalou, who was considered among the greatest French sculptors of the day. This sculpture is a later cast from the original scale model in plaster. The full-size monument in bronze and marble stands in the Luxembourg Gardens in Paris.

This sculpture is full of Baroque movement and complexity. Set against a square-sided stele (vertical architectural form), three figures rise in a dynamic upward thrust. Apollo applauds at the base, while Time supports Fame, who offers a wreath of everlasting glory to the bust of Delacroix.

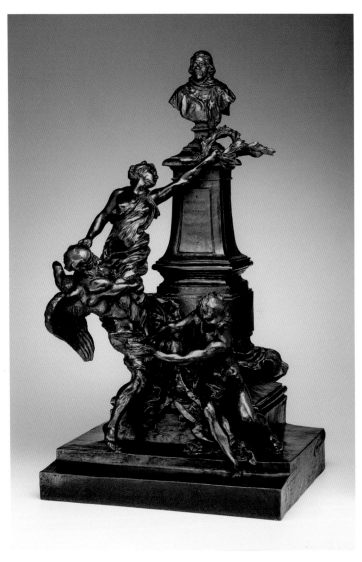

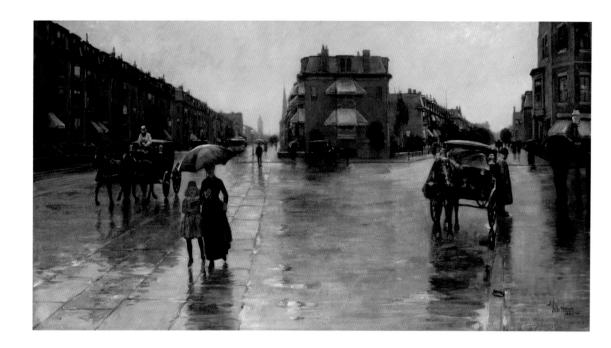

Childe Hassam (American, 1859–1935), **Rainy Day, Boston**. Oil on canvas, 1885. 26 ⅛ x 48 in. (66.3 x 122 cm). Purchased with funds from the Florence Scott Libbey Bequest in Memory of her Father, Maurice A. Scott, 1956.53

Painted during a time when urban landscapes were still a novel subject in the United States, *Rainy Day, Boston* depicts the intersection of Columbus Avenue and Appleton Street in the city's South End. According to the artist, Childe Hassam, "The street was all paved in asphalt, and I used to think it very pretty when it was wet and shining and caught the reflections of passing people and vehicles." In this view, seen through the atmospheric filter of rain, Hassam made the most of the pictorial effects produced by the conditions of light and weather.

Rainy Day, Boston also celebrates Boston's fashionable, clean, and spacious cityscape. Hassam had been to Europe in 1883 and had seen Paris following the completion of a vast public works program to rebuild the city as a modern capital, with its wide boulevards and broad vistas. In this, his first major oil painting, Hassam was also attempting to show American audiences the modern urban theme so thoroughly embraced by the French Impressionists, whose work he had seen in Paris.

William Michael Harnett (American, 1848–1892), **Still Life with the Toledo Blade**. Oil on canvas, 1886. 22 ⅛ x 26 ³⁄₁₆ in. (56.1 x 66.5 cm). Gift of Mr. and Mrs. Roy Rike, 1962.2

Painted for Isaac N. Reed, a prominent Toledo pharmacist, this still life features domestic bric-a-brac—books, pipe, violin, and folded newspaper—that William Harnett often used to evoke the modest pleasures of leisure activities and gentlemanly commerce. The folded newspaper is the September 17, 1886 edition of the *Toledo Blade*. Now renamed *The Blade*, it is still the main daily newspaper of Toledo, Ohio. Reed may have asked Harnett to include the paper to indicate his hometown.

Although enormously popular and widely known for his super-realist fool-the-eye

(*trompe l'oeil*) compositions, Harnett remained outside established art circles, where anecdotal scenes and landscapes were regarded more highly than still lifes. Most of his supporters were middle-class businessmen, self-made, recently wealthy, and unconcerned with fashionable taste. In this painting, the pyramidal arrangement of tilted and leaning objects, the dark, earth-toned palette, and the thinly applied, uniform brushwork are all characteristic of Harnett's late work.

Asher B. Durand (American, 1796–1886), **Rocks and Trees, Forest Hillside**. Oil on paper, 1855?. 26 ¾ x 39 ¾ in. (67.9 x 101 cm). Partial purchase from the Dorothy Chandler Fund for 19th-century American Art, and partial gift in honor of William Hutton, TMA curator (1952–1965, 1971–1992), by his children, 2016.212

Painted on a large sheet of paper, likely done on the spot somewhere in the Catskill Mountains of New York, this intense oil study offered Asher B. Durand the opportunity to capture a specific locale in all its precise detail. In this painting, moss-covered boulders and an uprooted tree stump commanded the artist's attention. Backlit trees on the horizon give way to a glimpse of azure sky, but Durand focuses the viewer on the textures, colors, and shapes of a close-up, "photographic" experience of nature.

Durand was drawn to what he called "simple truth and naturalness" in landscape painting. In 1840–41, when Durand was on a European tour, he wrote home: "When all this looking and studying and admiring shall have an end, I am free to confess that . . . for real unalloyed enjoyment of scenery, the rocks, trees, and green meadows of Hoboken [New Jersey] will have a charm that all Switzerland cannot boast."

Winslow Homer (American, 1836–1910), **Sunlight on the Coast**. Oil on canvas, 1890. 30¼ x 48½ in. (76.9 x 123.3 cm). Gift of Edward Drummond Libbey, 1912.507

The sight of waves crashing against the rocky coast intrigued Winslow Homer from the time he moved to the rugged peninsula of Prout's Neck, Maine, in 1883. Only in 1890, beginning with *Sunlight on the Coast*, did Homer shift away from his essentially narrative compositions of figural subjects to focus instead on the pure seascape elements of rocks, light, water, and sky.

The subject of *Sunlight on the Coast* is the never-ending battle between the sea and the shore, captured under specific conditions of light and weather. Homer's title for his painting seems curious. Sunlight barely pierces the dark sky, although its chilly glow transforms the backwash of one wave into a glittering surface and illuminates a portion of the sea and a steamship far on the distant horizon. As in the paintings that were to follow *Sunlight on the Coast*, Homer's depiction of the forceful interplay between sea and shore is an image that contemplates our relationship with the overwhelming powers of nature.

William Merritt Chase (American, 1849–1916), **The Open Air Breakfast**. Oil on canvas, about 1888. 37 ⁷⁄₁₆ x 56 ¾ in. (95.1 x 144.1 cm). Purchased with funds from the Florence Scott Libbey Bequest in Memory of her Father, Maurice A. Scott, 1953.136

Capturing a moment of domestic pleasure in the life of a contented family, *The Open Air Breakfast* depicts family members of the American Impressionist artist William Merritt Chase, his favorite models for many of his pictures. His young wife, Alice Gerson, is seated at the table next to their first child, also named Alice, in the high chair. Chase's sister Hattie stands behind them wearing a seventeenth-century-Dutch-style hat and holding a paddle used in the game of battledore and shuttlecock, an early form of badminton. Chase's sister-in-law, Virginia Gerson, reclines in a hammock while one of his favorite Russian wolfhounds sleeps in the grass near the fence. The scene is set in the backyard of his parents' house in a fashionable section of Brooklyn, where William and Alice lived when baby Alice was born.

Chase was the first American artist to paint in the Impressionist style in the United States. Although at first the figures in this composition seem to be the focal point of the painting, they are really just part of the decorative array of unrelated subjects that Chase assembled to create a pleasing effect.

Claude Monet (French, 1840–1926), **Antibes Seen from La Salis**. Oil on canvas, 1888. 28⅞ x 36¼ in. (73.3 x 92 cm). Purchased with funds from the Libbey Endowment, Gift of Edward Drummond Libbey, 1929.51

Shimmering mid-afternoon light infuses Claude Monet's painting of the fortified town of Antibes in southeast France, on the Côte d'Azur. When Monet arrived there in January 1888, he was dazzled by the Mediterranean light and the striking seaside scenery, but apparently struggled with how to represent it on canvas. As a founding member of the Impressionist movement of the mid- to late 1800s, Monet focused on painting the very act of seeing nature. As he wrote to his friend, the sculptor Auguste Rodin (1840–1917), in February: "I'm fencing and wrestling with the sun. And what a sun it is! In order to paint here, one would need gold and precious stones."

For this painting, Monet chose the vantage point of the La Salis Gardens across the cape from Antibes. (He painted three other views of the town from this same garden, captured at different times of day.) Here he set up his easel in the garden's lower area, near the water. The leaves of a tall, twisting olive tree sparkle in the foreground, while Antibes glistens in the distance, with the tower of the medieval Château Grimaldi (now the Musée Picasso) prominent in the center.

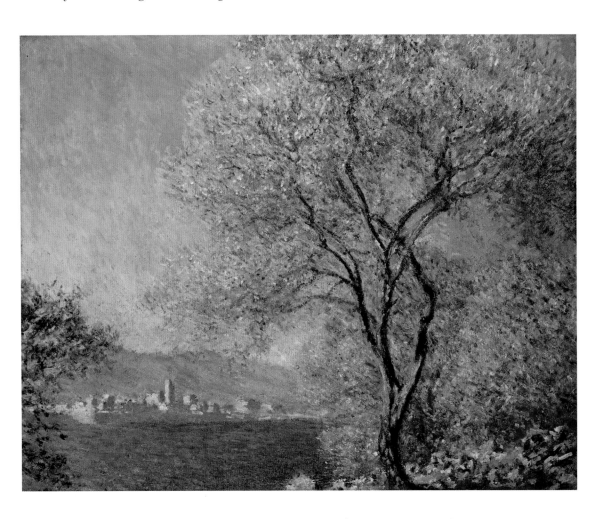

Paul Cézanne (French, 1839–1906), **Avenue at Chantilly**. Oil on canvas, 1888. 32 x 25 ½ in. (81.3 x 64.8 cm). Gift of Mr. and Mrs. William E. Levis, 1959.13

In 1888 Paul Cézanne worked for several months at Chantilly, near Paris, where he explored the tree-lined avenues of the park surrounding its château. *Avenue at Chantilly* is one of three canvases he painted of these shady paths. His symmetrical composition features a many-gabled château in bright sunlight, carefully framed by the trees along the path leading up to it. Cézanne's energetic brushwork and architectural structure help to integrate the scene's natural and man-made elements.

In his work as a Post-Impressionist painter, Cézanne combined classical structural stability with a new sense of respect for the inherent two-dimensionality of painting. In so doing, he established tension between the illusion of spatial depth and the flatness of the canvas. In *Avenue at Chantilly* he used several techniques to avoid depicting a deep, tunneling plunge toward the house. He flattened out the image by painting dense blue shadows across the path beneath the trees; bringing the distant building forward with bright, clear colors; and blending the edges of the path with the grasses alongside it. He also strategically repeated colors throughout the canvas with short, distinct brushstrokes.

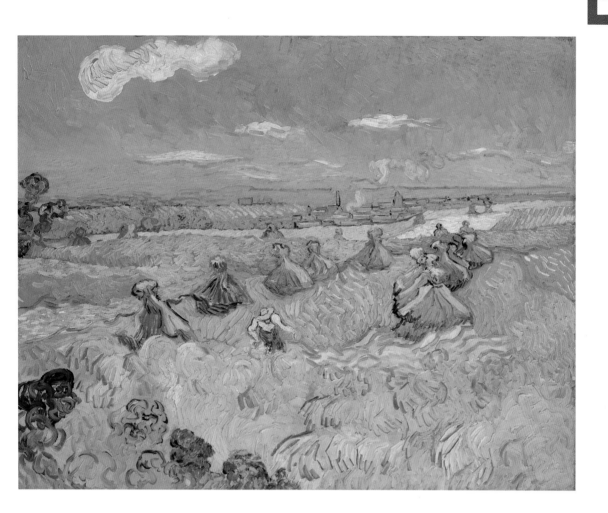

Vincent van Gogh (Dutch, 1853–1890), **Wheat Fields with Reaper, Auvers**. Oil on canvas, 1890. 29 x 36⅝ in. (73.6 x 93 cm). Purchased with funds from the Libbey Endowment, Gift of Edward Drummond Libbey, 1935.4

Vincent van Gogh was fascinated by the vast fields of wheat that stretched above Auvers-sur-Oise, a town north of Paris where he lived during the summer of 1890, the last two months of his life. Applying bright colors with his characteristic staccato brushstrokes, he painted many views of these fields in his final days, including this landscape with a man reaping the golden grains, while the stacked sheaves recede toward a village and the blue hills in the distance. Van Gogh often painted outdoors, seeking to express what was for him the essential character of the landscape. But his work pursued a singular goal: to evoke "a more exalting and consoling nature," he wrote, "than a single brief glance at reality. . . can let us perceive."

In the wheat fields and in the figure of the reaper, Van Gogh saw symbolic meanings and sublime, almost religious, emotions. "I see in him the image of death," he wrote to his brother Theo, "in the sense that humanity might be the wheat he is reaping . . . it is an image of death as the great book of nature speaks of it. . . ."

Paul Gauguin (French, 1848–1903), **Street in Tahiti**. Oil on canvas, 1891. 45½ x 34⅞ in. (115.5 x 88.5 cm). Purchased with funds from the Libbey Endowment, Gift of Edward Drummond Libbey, 1939.82

Paul Gauguin began his career as an amateur artist after first working as a merchant marine and then as a stockbroker. After a stock market crash in 1882, he decided to become a full-time painter. Dissatisfied with the values of modern European culture, he left France in search of a more "primitive" way of life, one where he could live in intimate association with nature. His goal was to renew his art through contact with a non-European, pre-industrial culture. In 1891 he traveled to Tahiti in the South Pacific and found what he was seeking: a "new Eden."

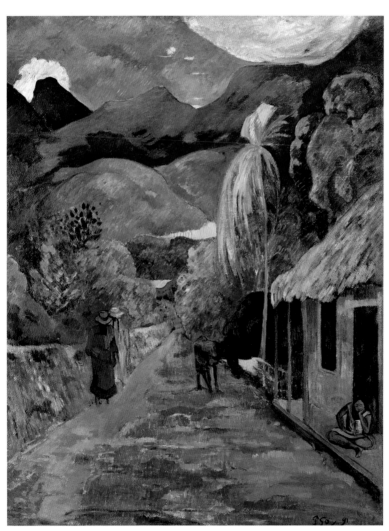

Gauguin lived for about three months on the outskirts of Papeete, the capital of French Polynesia. *Street in Tahiti* was among the first paintings he produced during his initial two-year stay in Tahiti. The overall effect of the scene is sumptuous and majestic, but minor notes—such as the brooding woman sitting in the doorway to the lower right and the heavy clouds pressing down against the mountaintops—introduce undertones of sadness and unrest into this luxurious fiction of a tropical paradise.

Henri de Toulouse-Lautrec (French, 1864–1901), **The Englishman at the Moulin Rouge**.
Color lithograph, 1892. Publisher: Edward Ancourt, Paris. 18½ x 14⅝ in. (47 x 37.1 cm).
Winthrop H. Perry Fund, 1938.2

In this exuberant scene of fin-de-siècle Parisian nightlife, Henri de Toulouse-Lautrec captures a moment of intrigue at the Moulin Rouge, Montmartre's most popular cabaret. The Englishman of the title is Toulouse-Lautrec's friend, the portrait painter William Tom Warrener (1861–1934) who is shown flirting with two fashionably dressed young women. As the debonair, top-hatted gentleman leans in, both women draw back, one with a raised eyebrow and one with an upturned nose. Through suggestive gesture and abbreviated facial expressions, Toulouse-Lautrec instantly communicates the lascivious nature of the man's conversation.

Here Toulouse-Lautrec boldly incorporates the style and compositional elements of Japanese woodblock prints—its oblique angles, bold contours, vibrant colors, and flattened, sinuous shapes—into his portrayal of Belle Époque (1871–1914) social customs. Also innovative is his use of the newly developed lithographic technique called *crachis* to create a splatter effect and to add luminosity to his delicate color palette. In applying his brilliant understanding of surface design and an economy of means to color lithography, Toulouse-Lautrec is largely credited for its newfound recognition as a fine-art medium.

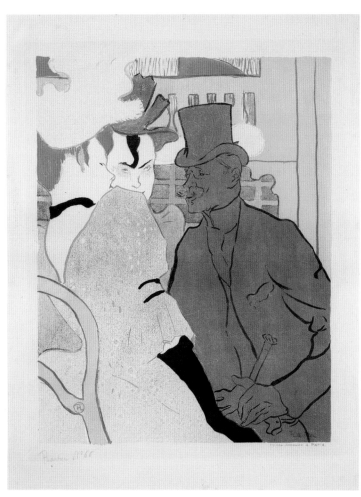

Thomas Webb & Sons (British, Amblecote, maker) Thomas Woodall (British, 1849–1926, engraver), and George Woodall (British, 1850–1925, engraver), **Pair of Vases with Girls Dancing**. Glass, cameo-carved, about 1895. Each: H. 12¾ in. (32.5 cm). Purchased with funds from the Libbey Endowment, Gift of Edward Drummond Libbey, 1970.442, 1970.443

Cameo glass, one of the oldest and most complex decorating techniques for luxury glass, had an unprecedented revival in England in the late nineteenth century. Brothers Thomas and George Woodall produced much of the finest cameo glass for the firm Thomas Webb &

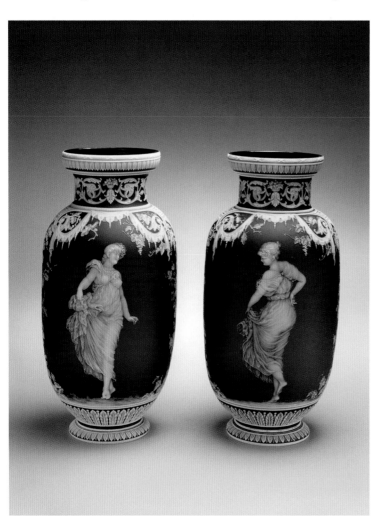

Sons, including this pair of vases with dancing young women wearing classically inspired costumes. The cameo technique, adapted from a centuries-old skill of carving a portrait head from a hardstone or a seashell, involves casing white glass over an opaque colored glass, then painstakingly carving the white layer back to create the raised design. The Woodalls contributed two important innovations to cameo-glass technology: extensive use of the cutting wheel, which accelerated the time-consuming carving process, and overlaying bluish-tinted white glass on the dark base color, which, when carved away, resulted in a greater range of tonal shading. The figures— one facing forward, the other back—are posed in motion, clasping their diaphanous dresses. Their contrasting poses show that they were designed to face each other when the vessels are placed together on a shelf or mantel. The coat-of-arms on the reverse of each vase identifies the original owner, a member of the Cure family of London.

A famous beauty and fashion leader, Sophie Ilarinovna (1871–1953) married the Russian diplomat Prince Demidoff in 1893. The noted American artist John Singer Sargent painted her portrait in London a few years later, where her husband worked for the Russian Embassy. Sargent highlights her stylishness by painting her standing before a fashionable Chinese lacquer screen (a prop from his studio). Princess Demidoff's deep pink velvet wrap with brown fur trim adds bright color to the mostly neutral palette, while her gold and jeweled bracelets and gleaming pearls underscore her status and wealth.

Born in Florence, Italy, to wealthy American parents, Sargent established himself in London as the leading society portraitist of his day. His elegant, glamorous paintings of the rich and famous of late-nineteenth-century England and the United States are characterized by his free handling of paint— broad, loose brushstrokes are visible throughout this portrait—and by his sensitivity to the individuality of each of his subjects.

John Singer Sargent (American, 1856–1925), **Princess Demidoff**. Oil on canvas, about 1895–96. 65 ¾ x 38 ³⁄₁₆ in. (167 x 97 cm). Gift of Florence Scott Libbey, 1925.109

Jules Breton (French, 1827–1906), **The Shepherd's Star**. Oil on canvas, 1887. 40½ x 31 in. (102.8 x 78.7 cm). Gift of Arthur J. Secor, 1922.41

Walking barefoot and carrying a large sack of potatoes on her head, a young peasant woman returns from the fields at dusk as Capella, the "shepherd's star," rises in the sky over her shoulder. This canvas by the French realist painter Jules Breton presents an idealized image of the peasant, despite the physical demands of their endless toil. Breton's depiction romanticized the traditional rural and idyllic way of life—one that was rapidly disappearing in the nineteenth century under the pressures of mechanization during the Industrial Revolution.

Breton's work not only brought him widespread acceptance at the Paris Salons of the 1800s, it also made him immensely popular in the United States. His American art dealers commissioned him to paint *The Shepherd's Star*, which was exhibited at the 1888 Paris Salon and the 1889 Paris World's Exposition Universelle.

Light and lines are the focus of *Interior of Courtyard, Strandgade 30*, but this painting goes beyond the straightforward representation of architectural space. Vilhelm Hammershøi's intense, personal vision uncannily conveys a pervasive quietness and emptiness.

In December 1898 Hammershøi moved into a seventeenth-century merchant's house at Strandgade 30, Copenhagen. For the decade that he and his wife lived there in a second-story apartment, he painted more than sixty views of its rooms. Reflecting the influence of Dutch seventeenth-century painting, particularly the muted, softly lit interiors of Johannes Vermeer (1632–1675) and Pieter de Hooch (1629–1684), Hammershøi's meditations on the interior spaces of his apartment look quiet and mysterious, making them psychologically enigmatic. In this canvas, he renders the walls, stairway, and windows of the building's interior courtyard in muted tones of black, white and brown. Though the courtyard is dim, an area of bright light falls inexplicably on an open second-story window, suggesting human presence, but the overall effect is one of profound absence.

Vilhelm Hammershøi (Danish, 1864–1916), **Interior of Courtyard, Strandgade 30**. Oil on canvas, 1899. 25⅞ x 18⅝ in. (66 x 47 cm). Gift of The Georgia Welles Apollo Society, 2000.30

Edgar Degas (French, 1834–1917), **The Dancers**. Pastel on paper, about 1899. 24 ½ x 25 ½ in. (62.2 x 64.8 cm). Purchased with funds from the Libbey Endowment, Gift of Edward Drummond Libbey, 1928.198

The incandescent, expressive colors of Edgar Degas's pastel *The Dancers* seem to vibrate off the paper. Applied in layered webs of rhythmic strokes, they achieve remarkable effects of translucency, depth, and texture. After about 1895, Degas turned more and more to pastel as his eyesight grew worse. Unlike oil painting, working in pastels required little preparation, no drying time, and could be easily reworked. Over the course of his career, Degas produced almost 700 works in pastels, many of them focusing on ballet dancers, whose movements required discipline, flexibility, and strength.

In this and other later works, memory and imagination—"freed from nature's tyranny," as Degas remarked—played a more dominant role than anything he observed directly. As his work evolved, Degas repeated a shrinking repertory of poses and compositions, obsessively recycling, rephrasing, and regrouping the same few figures studied either from the model or from his own photographs or sketches. Considering the high point of view, the tightly cropped figures, and the asymmetrical composition of *The Dancers*, Degas also drew inspiration from Japanese prints. Like many of his fellow Impressionists, his late works became more passionate and subjective, with artifice ultimately dominating nature.

Ideas: Telling Tales

How do we understand a narrative or "story" in an image if we're unfamiliar with the story being told? Artists use details of gesture, expression, or a significant object or action to tell us what is happening in a scene. Despite differences in time period or culture, we are often able to understand these details because they represent shared human experiences.

Kangra School, India, Punjab Hills, Mughal Period (1528–1858), **The Death of Bali**. Opaque watercolor and gold on paper, about 1780–1800. 9 x 12 ¾ in. (22.9 x 32.4 cm). Purchased with funds from the Libbey Endowment, Gift of Edward Drummond Libbey, 2007.102

Judging from the emotional reactions of the monkeys and the woman crouching near the fallen monkey's head, we can recognize this as a scene of grief and pathos. This painting illustrates a passage from the Indian epic poem *The Ramayana*. The hero Rama—recognizable by his blue skin, his prominent placement in the composition, and his bow—has fatally shot Bali with an arrow for usurping the throne of the monkey king Sugriva, who sits grimly at the left.

Arthur Hughes (British, 1832–1915), **Ophelia (And He Will Not Come Back Again)**. Oil on canvas, about 1865. 37 ⁵⁄₁₆ x 23 ³⁄₁₆ in. (94.8 x 58.9 cm). Purchased with funds from the Libbey Endowment, Gift of Edward Drummond Libbey, 1952.87

In this painting, Arthur Hughes provides the clues needed to identify the subject as Ophelia from Shakespeare's *Hamlet*: an armful of flowers, a willow tree, and a stream. In the play, she gathers flowers by a willow before accidentally slipping into a stream and drowning. Even without knowing the story, we might suspect impending tragedy from her melancholy demeanor and the bright red poppies she holds, a common symbol of death.

Does this painting tell a tale of an illicit affair interrupted? Important details include the woman's fearful expression and her state of undress, the rumpled bed, the dog greeting someone (the woman's husband?) "off stage," and—perhaps most damning—the overturned chair and the hot chocolate service for two.

Jean-Baptiste Le Prince (French, 1734–1781), **Fear**. Oil on canvas, 1769. 19 ³⁄₄ x 25 ¹⁄₄ in. (50 x 64 cm). Purchased with funds from the Libbey Endowment, Gift of Edward Drummond Libbey, 1970.444

Culture and history influence how and what we see

World Art

20th to 21st century

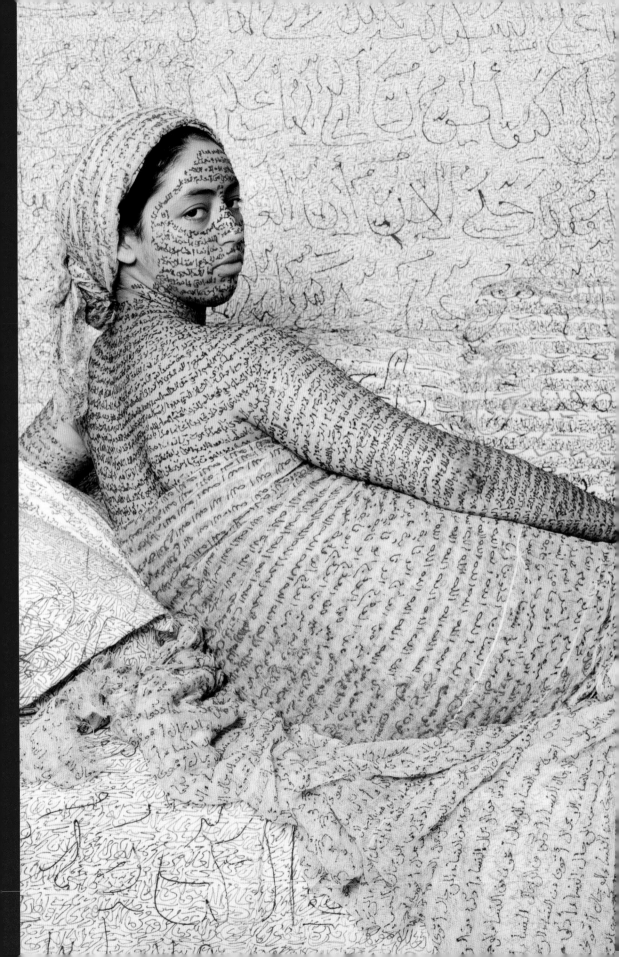

André Fernand Thesmar (French, 1843–1912), **Bowl with Anemones**. Gold, transcluent enamel, 1900. Diam. 3⅝ in. (9.1 cm). Mr. and Mrs. George M. Jones, Jr. Fund, 2005.43

André Fernand Thesmar made this jewel-like bowl using the demanding enameling technique known as *plique-à-jour*. French for "braid letting in daylight," *plique-à-jour* looks like miniature stained glass. It is a technical tour de force that requires glass enamels to be suspended within a filigree framework of gold or silver without a metal backing. Painterly effects are created by applying shades and tones in each color field, and the modulated colors are built up in layers by intermittent firings. The entire process requires great delicacy, skill, and expertise.

Thesmar's exquisite anemone bowl was inspired by Chinese and Japanese enamelwork. Initially known as a painter of flowers, Thesmar displayed his exceptional *plique-à-jour* works in the jewelry and metalwork section of the Exposition Universelle of 1900, held in Paris, where they received much praise. The year

"1900" is embedded in the base with fine gold wire, suggesting this bowl may have been made for display at that important World's Fair.

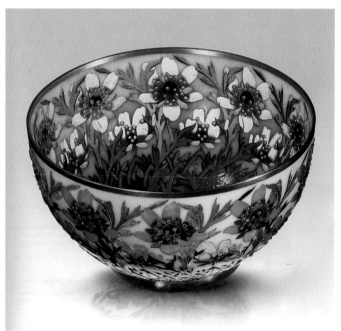

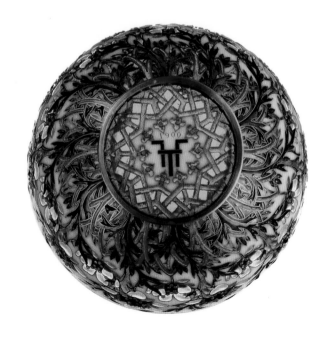

Louis Majorelle (French, 1859–1926), **Pair of Gates**. Wrought iron, copper, 1906.
Each: W. 59⅛ in. (150.2 cm). Mr. and Mrs. George Jones, Jr., Fund, 1997.302a–b

The city of Nancy, in northeastern France, became a leading center of European Art Nouveau in the late nineteenth century, a movement influenced by an alliance of young artists known as the School of Nancy. One of the leaders of this group, Louis Majorelle, had established his reputation as the preeminent French furniture-maker at the Exposition Universelle of 1900 in Paris. The artists whose work was featured in that exhibition established Art Nouveau (new art) as a significant new force in design and architecture. The name of the movement was derived from La

Maison de l'Art Nouveau, the gallery owned by Siegfried Bing, a prominent Parisian art dealer.

Reacting against the predominant classical style, Art Nouveau drew much of its inspiration from nature, especially local. The Museum's wrought-iron gates incorporate a native plant, satinpod or annual honesty (*Lunaria annua*). While attenuated wrought-iron tendrils form the framework, silvery seed pods in copper and tin add shimmering accents. These gates were displayed at the Salon des Artistes Décorateurs (also called the Salon d'Automne) in 1906.

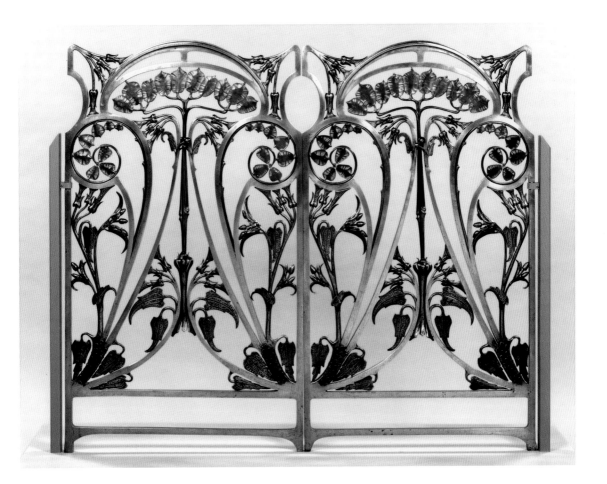

Libbey Glass Company (American, Toledo, Ohio, maker), John Rufus Denman (American, 1876–1956, cutter), and Patrick W. Walker (American, cutter), **Punch Bowl and Stand with Cups**. Glass, 1903–1904. Diam. 24 in. (61 cm). Gift of Libbey Glass Company, division of Owens-Illinois Glass Company, 1946.27a, c–y

Created for the Louisiana Purchase Exposition of 1904 (also known as the St. Louis World's Fair), this show-stopping punch bowl and stand with twenty-four cups required the skill and artistry of the finest glassmakers of the Libbey Glass Company—the firm headed by Edward Drummond Libbey, founder of the Toledo Museum of Art. The largest cut-glass factory in the world at the turn of the century, Libbey displayed some 1,800 cut-glass objects at the 1904 Fair, marking the pinnacle of taste for this form of extravagant tableware. The punch bowl alone weighs 134 pounds and can hold 60 quarts.

Elaborately decorated by two of Libbey's premier glasscutters, J. Rufus Denman and Patrick W. Walker, the dazzling ensemble won the Grand Prize Medal for cut glass at the Fair. Its status as a luxury object was due in large part to the Libbey Company's marketing of "brilliant" cut glass (echoing the name of a special cut of diamond) as the most socially appropriate gift for weddings and other important occasions.

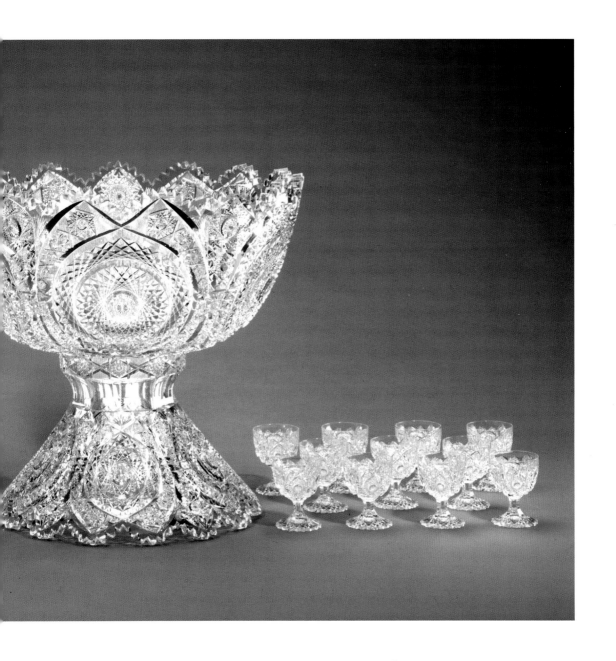

Tiffany Furnaces, Inc. (American, Corona, New York, maker), Louis Comfort Tiffany (American, 1848–1933, designer), **Vase**. Iridescent glass, blown, about 1913. H. 20 1/32 in. (50.9 cm). Gift of Helen and Harold McMaster, 1986.62

As artist, designer, and tastemaker, Louis Comfort Tiffany altered the course of American decorative arts in many fields. He began to experiment with materials for stained-glass windows in the 1870s, eventually patenting an opalescent glass that revolutionized the art form. Tiffany's chapel installation at the 1893 World's Columbian Exposition in Chicago—filled with elaborate mosaic work—brought him international recognition. That same year he turned his attention to blown glass and founded the Stourbridge Glass Company in Corona, Long Island. Under the direction of English glassmaker Arthur J. Nash (1849–1934), the glassblowers created organically inspired vessels with lustrous surfaces. The iridescent glass was produced by putting metal oxides on or in the glass and then putting the glass through an oxygen reduction process. The variation in color is the result of different thicknesses of the metallic layer. Tiffany trademarked the name "Favrile" for all of its glass. Louis Comfort Tiffany called it, "a new word. . . derived from the same root as the Latin words *faber*, *fabrico*, and *fabrilis*," and therefore related to the concept of making or fabricating by hand.

Tiffany's love for the natural world is evoked in this pansy-inspired vase. The undulating surface of the trumpet shape maximizes the effects of light on this colorful iridescent glass.

Considered the foremost American sculptor of his generation, Augustus Saint-Gaudens set the standard in portraits on coins, medals, and public sculptures. His last major monument was the gilded equestrian portrait of a Union Army hero of the American Civil War, General William Tecumseh Sherman (1820–1891). The steadfast soldier on horseback, his cape flowing in the breeze, is led by winged Victory, which Saint-Gaudens intended "to express victory and peace at the same time."

Saint-Gaudens began the Sherman Monument in 1892, unveiling it in 1903 in New York City in Grand Army Plaza, at the south corner of Central Park and Fifth Avenue. The carefully studied portrait, based on a bust Saint-Gaudens had made during Sherman's lifetime, contrasts with the idealized beauty of the allegorical Winged Victory. Crowned with a laurel wreath, a palm branch in her left hand, and an American eagle emblazoned across the front of her garment, she strides confidently forward, radiating power and exaltation.

Saint-Gaudens often cast smaller versions, with slight variations, of his most popular large figures. From a series of nine reductions of *Victory*, the Museum's sculpture was cast posthumously for Saint-Gaudens's widow in about 1908.

Augustus Saint-Gaudens (American, 1848–1907), **Victory (from the Sherman Monument)**. Gilded bronze, modeled 1902; cast about 1908. H. 42 ½ in. (108 cm). Purchased with funds from the Florence Scott Libbey Bequest in Memory of her Father, Maurice A. Scott, 1986.34

Alfred Stieglitz (American, 1864–1946, publisher), **Camera Work**. 50 bound volumes containing photogravures, photomechanical reproductions, and letterpress, 1903–17. 12 ⅝ x 8 ¹³⁄₁₆ in. (32 x 22.4 cm). Gift of The Georgia Welles Apollo Society, 2015.12a–xx

A pioneering photographer, gallery owner, writer, and publisher, Alfred Stieglitz founded the Photo-Secession in 1902, an exhibition society and photographic movement established to promote photography as a fine art. Initially this small group included such like-minded photographers as Edward Steichen (1879–1973), Alvin L. Coburn (1882–1966), Clarence H. White (1871–1925), and Gertrude Käsebier, who shared with Stieglitz an adherence to labor-intensive processes to produce painterly, atmospheric effects and to highlight the photographer's technical skill. The following year Stieglitz began publishing the quarterly *Camera Work* to champion American

Gertrude Käsebier (American, 1852–1934), **Blessed Art Thou among Women,** from **Camera Work, No. 1, 1903.** Photogravure, original photograph taken 1899, 2015.12a

Paul Strand (American, 1890–1976), **Wall Street,** from **Camera Work, No. 48, 1916.** Photogravure, 1915. 2015.12ww

photography as an artistic expression equal to painting.

Throughout its fifty issues, *Camera Work* (1903–17) charted photography's transition from early nineteenth-century Pictorialism— which portrayed intimate scenes through lush, tonal effects (see image by Gertrude Käsebier)—to Modernist photographers' sharp-focus approach that favored crisp, abstracted compositional designs (see image by Paul Strand). Reflecting Stieglitz's own evolving interests, *Camera Work* began to review avant-garde European artists, along with photographers whose work corresponded to the new, revolutionary Modern aesthetic. The last two issues in 1917 returned exclusively to photography and prominently featured the work of Paul Strand, who rejected the Pictorialists' use of soft focus and symbolic content. Instead, as evident in his iconic *Wall Street,* he turned to a pure and direct style called "straight photography" to document forms found in everyday life through an attention to clean lines, strong contrasts, and repeating, geometric patterns.

Käthe Kollwitz (German, 1867–1945), **Working Woman with a Blue Shawl**. Lithograph, 1903. 13 ⅞ x 9 ⅝ in. (35.2 x 24.4 cm). Frederick B. and Kate L. Shoemaker Fund, 1950.293

The German sculptor and printmaker Käthe Kollwitz devoted her artistic career to championing social reform and labor rights for Germany's impoverished working class, especially its women and children. Because Kollwitz's physician husband, Karl Kollwitz, ministered to Berlin's urban poor, she witnessed firsthand their struggles and pain.

In *Working Woman with a Blue Shawl*, Kollwitz brings the same emotional intensity and empathy toward the downtrodden and the oppressed as she conveyed in her powerful graphic series "The German Peasants' War" (1902–1908), based on the popular uprisings of 1524–26 in which some 100,000 peasants were killed. Kollwitz here poignantly captures the essence of the anonymous woman's fortitude in the face of hardship. Through her use of color—in muted blues and browns—Kollwitz evokes her subject's introspective mood and somber surroundings while applying her skillful draftsmanship to portray the woman's careworn face, downward gaze, tilted head, and tranquil expression.

As one of only two color lithographs that Kollwitz created, this image was printed in an edition of approximately 100 impressions. It was published in 1906 in a special portfolio for *Gesellschaft für vervielfältigende Kunst* (Society of Reproducible Art) in Vienna.

Painted the year Pablo Picasso moved from his native Spain to Paris. *Woman with a Crow* is a portrait of Marguerite Luc, stepdaughter of the owner of Le Lapin Agile, a café Picasso often visited in Montmartre. Set against a solid cobalt-blue background, Marguerite seems removed from everyday life as she leans over to caress her pet crow. Her sunken features, her wide shoulders hunched over an extended neck, and her attenuated limbs—especially her fingers—suggest her resemblance to the bird she embraces.

Woman with a Crow was drawn during a transitional moment between Picasso's so-called Blue and Rose Periods. Between 1901 and early 1904, when he traveled from Barcelona to Paris and back again, he often sketched and painted the poor and the downtrodden in pale tones, with blue as the dominant color. Created when he was in his early twenties, these compelling works also show how rapidly Picasso attained artistic maturity, always pushing new ideas and styles—like Cubism—into new artistic realms.

Pablo Picasso (Spanish, 1881–1973), **Woman with a Crow**. Charcoal, pastel, and watercolor on paper mounted on pressboard, 1904. 25 ½ x 19 ½ in. (64.8 x 49.5 cm). Purchased with funds from the Libbey Endowment, Gift of Edward Drummond Libbey, 1936.4

George Wesley Bellows (American, 1882–1925), **The Bridge, Blackwell's Island**. Oil on canvas, 1909. 34 1/16 x 44 1/16 in. (86.5 x 112 cm). Gift of Edward Drummond Libbey, 1912.506

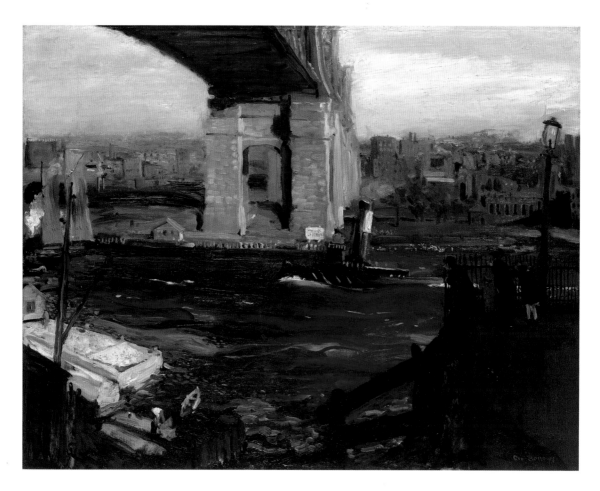

The Queensboro Bridge in New York City spans the East River to link Manhattan with Long Island City in Queens. Midway across, its massive piers rest on Blackwell's Island (now Roosevelt Island). Painted from the Manhattan side in December 1909, shortly after the bridge was completed, this canvas reflects the spirit and energy of urban life. The tugboat fighting the strong current, the gritty cityscape in the distance, and the onlookers in the foreground are all overshadowed by the engineering feat: when it was built, this was the longest cantilever bridge in North America and the fourth longest bridge in the world. New York was expanding rapidly in the twentieth century. Its metropolitan grit and new technology enthralled Bellows, who celebrated in this painting the achievements of modern construction.

Bellows, a native of Columbus, Ohio, identified with a group of American realist artists called the Ash Can school, who had begun their careers in journalism, illustrating newspapers in Philadelphia and New York. Their social consciousness and spirited brushwork are reflected in Bellows' own vigorous style and subjects—portraits, the boxing ring, the waterfront, and New York City's streets and tenements.

Frederic Remington (American, 1861–1909), **Indians Simulating Buffalo**. Oil on canvas, 1908. 26¹⁵⁄₁₆ x 40⅛ in. (68.4 x 101.9 cm). Gift of Florence Scott Libbey, 1912.1

An exchange of glances is the focal point of Frederic Remington's intriguing homage to the American West. Bent over their grazing ponies with buffalo skins thrown over them, two American Indians of the Great Plains have disguised themselves as bison. Although Remington often portrayed Native Americans as antagonists, a wagon train barely visible in the distance suggests these men are scouts.

More than any other artist, Remington shaped our view (and misconceptions) of the Old West. Fascinated with its vast panoramas and raw drama, he vividly recorded the lives and adventures of Plains Indians, US cavalrymen, cowboys, and settlers in paintings, magazine illustrations, and sculptures. As Remington wrote in *Collier's Weekly* magazine (March 18, 1905): "I knew the wild riders and the vacant land were about to vanish forever, and the more I considered the subject the bigger the Forever loomed. . . ." This painting, completed a year before his death, was commissioned by publishers P. F. Collier and Son and became the cover image of the September 18, 1909, issue of *Collier's Weekly*.

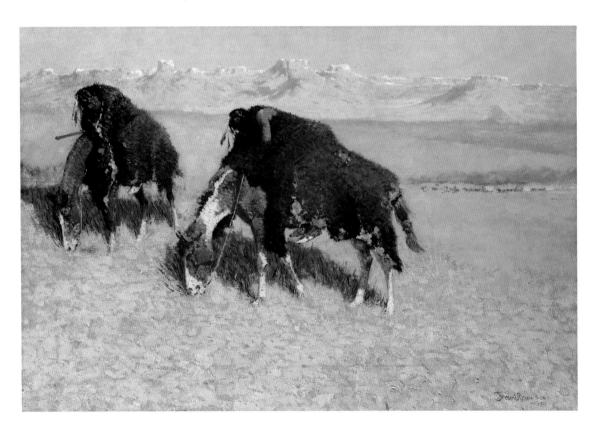

Ernst Ludwig Kirchner (German, 1880–1938), **Young Girls of Fehmarn**. Woodcut, 1913. 19 ¹³⁄₁₆ x 16 ½ in. (50.4 x 41.9 cm). Purchased with funds from the Libbey Endowment, Gift of Edward Drummond Libbey, 1986.21

This exceedingly rare woodcut exemplifies Ernst Ludwig Kirchner's newly forged German Expressionist style, created shortly after he discovered the art and cultures of people living in Africa and the South Pacific. During the summers of 1908 and 1912–14 Kirchner and his close friends resided on the remote island of Fehmarn in the Baltic Sea. Regarding it as a restorative retreat from the frenetic tempo of city life, the artist described it as where he "experienced the ultimate unity of man and nature."

With this print Kirchner masterfully manipulates the inherent properties of the woodcut to celebrate two young girls in harmony with nature. By incorporating the coarsely gouged out areas and the wood grain into the overall design, the artist integrates the two female forms into the surrounding landscape. In a style reminiscent of African tribal and Oceanic art, he depicts the girls with oversized heads and mask-like facial features to make a formal connection between his rural subject matter and the art of preexisting, non-industrialized societies. Here, Kirchner has merged the woodcut medium's directness, linearity, and simplicity with the power and immediacy of so-called primitive stylistic elements—reduction of form and crudely angular and disproportionate bodies—to evoke his concept of a sensuous, natural existence not found in modern urban life.

Amedeo Modigliani (Italian, 1884–1920), **Paul Guillaume**. Oil on board, 1915. 29 ½ x 20 ½ in. (74.9 x 52.1 cm). Gift of Mrs. C. Lockhart McKelvy, 1951.382

In this striking portrait, the twenty-three-year-old Parisian writer and art dealer Paul Guillaume (1891–1934) sits in his library by a bookcase, with an upright piano in the background. A champion of African art and of the avant-garde, Guillaume was one of Italian Modernist Amedeo Modigliani's earliest supporters, exhibiting his works along with those by Pablo Picasso and Henri Matisse. From 1914 to 1916, when Guillaume was his dealer, Modigliani painted four portraits and made several drawings of him.

In this portrait, Modigliani painted Guillaume with characteristic aloofness, concentrating on his features rather than his character. By carefully selecting and emphasizing a few details, such as his pursed lips and tightly trimmed mustache, Modigliani provided clues to Guillaume's personality. His almond-shaped eyes, painted solid black, show no pupils or irises. Guillaume's face has been reduced to the stark stylization of a mask, like the African masks he so admired. As in most of Modigliani's portraits, the subject remains distant.

Marsden Hartley (American, 1877–1943), **Abstraction (Military Symbols)**. Oil on canvas, 1914–15. 39¼ x 32 in. (99.7 x 81.3 cm). Purchased with funds from the Libbey Endowment, Gift of Edward Drummond Libbey, 1980.1013

Abstraction (Military Symbols) captures the militaristic pageantry and visual dynamism of Berlin during the early days of World War I (1914–18). While living in Berlin during that time, the American artist Marsden Hartley created "War Motifs," a series of paintings that reflected his fascination with the elaborate displays and medals of German military life. Spiritual by nature and influenced by mystical writings, he expressed his own emotions by using a personal vocabulary of symbols based on his immediate visual experience. Hartley painted the series, in part, as a tribute to his lover, Karl von Freyburg, a young German lieutenant who was killed in the war.

After returning to America in December 1915, perhaps responding to the anti-German sentiment already rampant in America at the time, Hartley denied that the symbols in these paintings had any specific meaning: "The forms are only those which I have observed casually from day to day. There is no hidden symbolism whatsoever in them; there is no slight intention of that anywhere. . . . I have expressed only what I have seen."

Before producing his groundbreaking mural-size version of *The City (La Ville)*, now in the collection of the Philadelphia Museum of Art, Fernand Léger worked out his composition in several smaller canvases. His related works in the series, each called a "study" or "fragment," focused on different areas of the final composition. In this oil sketch, however, the painting appears complete rather than simply a preliminary sketch.

Views of Paris became a primary subject for Léger when he returned to the city after serving in the French army during World War I. The image, as Léger described the final version, was "composed . . . with pure, flat colors" and achieves "depth and dynamism without modeling or chiaroscuro." With its Cubist fragmentation and glimpses of scaffolding, smokestacks, and billboards, this painting captures the height of the modern Machine Age and vibrant postwar development in Paris.

Fernand Léger (French, 1881–1955), **Sketch for The City**. Oil on canvas, 1919. 25⅝ x 21¼ in. (65.1 x 54 cm). Purchased with funds from the Libbey Endowment, Gift of Edward Drummond Libbey, 2000.9

Stanton MacDonald-Wright (American, 1890–1973), **Synchromy, Blue-Green**. Oil on canvas, 1916. 36 1/16 in. x 28 1/16 in. (91.6 x 71.3 cm). Purchased with funds from the Libbey Endowment, Gift of Edward Drummond Libbey, 1996.19

Synchromy Blue-Green encapsulates Stanton MacDonald-Wright's interest in color theory and pure abstraction. MacDonald-Wright and a fellow American artist, Morgan Russell (1886–1953), founded an art movement they called Synchromism in 1913, while the two men were living in Paris. They based their new concept on color theories and proposed that it was the next logical stylistic progression after Cubism. MacDonald-Wright and Russell strove to move beyond mere abstraction of their subjects to arrive at a purified expression of ideas through color. Though the two founding artists were later joined in their efforts by other American painters, including Thomas Hart Benton (1889–1975) and Patrick Henry Bruce (1881–1936), they abandoned Syncromism about 1919 and returned to representational painting. MacDonald-Wright and Russell were the first American artists to develop an abstract art movement.

This painting's burst of warm orange and red near the top of the canvas seems to represent a beacon of light or a musical crescendo rising from the shadows of the surrounding planes of cool blues and greens. As MacDonald-Wright explained in 1916, the year he made this painting, "I strive to divest my art of all anecdote and illustrations and to purify it so that the emotions of the spectator can become entirely 'aesthetic,' as in listening to music."

Joseph Stella (American, 1877–1946), **Nocturne**. Pastel and watercolor on paper, about 1918. 23¼ x 17 ¹⁵⁄₁₆ in. (59 x 45.5 cm). Museum Purchase, 1953.51

Joseph Stella is widely known for his abstract images of industrial America. For *Nocturne* he chose a quieter subject. In music, a nocturne is a composition with a dreamy or pensive mood, suggesting nighttime. Stella, like many artists in the late nineteenth and early twentieth centuries, translated that definition into visual form in this simple pastel and watercolor drawing of a receding road.

Stella's choice of medium for this image is important, allowing for a softness of line and form and a depth of color so integral to the time of day and the mood he was attempting to express. *Nocturne*'s composition is unusual: as the perspective lines of the road and sidewalk recede into the background, the vertical space is anchored by a lamp post or telephone pole, while a formless black shape suggests heavy smoke or a passing vehicle. The pole not only divides the space vertically, but also reinforces the awareness of foreground/background and suggests that the viewer is walking along the road.

Paul Manship (American, 1885–1966), **Dancer and Gazelles**. Bronze, modeled 1916; cast about 1922. W. 73½ in. (186.7 cm). Purchased with funds from the Frederick B. and Kate L. Shoemaker Fund, 1923.24

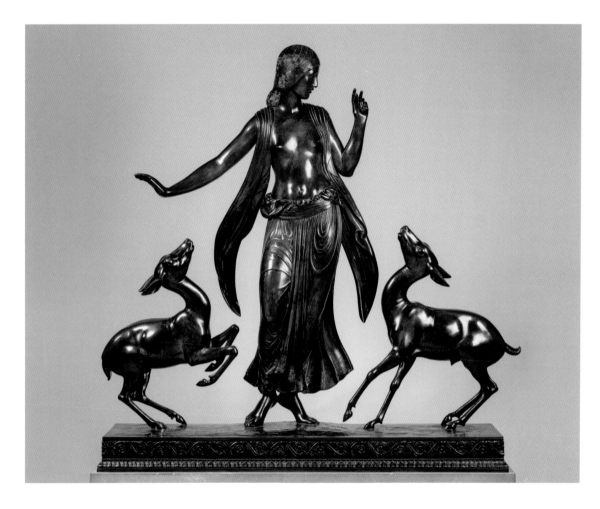

Fluid, graceful motion defines Paul Manship's *Dancer and Gazelles*, its sinuous contours and abstract elegance reflecting his free interpretation of artistic sources. The dancing female figure recalls elements found in ancient Greek art, while the rhythmic grace of the group, the decorative detail, and the curving forms recall painting and sculpture from India. With its streamlined forms and suggestion of classical subjects, Manship's sculpture was an important precursor to the Art Deco style that developed in the mid-1920s and that Manship helped to popularize with works like his famous sculpture *Prometheus* (1934), a focal point of Rockefeller Center in New York City.

Manship deftly straddled the traditional taste for decorative beauty and the Modernist appreciation of simplified forms, bringing fame and honor to himself as an artist of great talent and unique vision. His popularity was due in part to his ability to fuse into his works elements from a wide range of cultures and eras, bringing new freshness to American sculpture. He wrote about sculpture, "more important than formalities and geometrical considerations is the feeling for human qualities and harmony and movement of life."

Steuben Glass, Inc. (American, Corning, New York, maker), Sidney Biehler Waugh (American, 1904–1963, designer), **Gazelle Bowl and Stand**. Glass, designed 1935. H. (bowl only) 7 in. (17.8 cm). Gift of William E. Levis, 1936.36

Steuben Glass was a distinguished American glassworks that was founded in Corning, New York, in 1904 (the factory closed in 2011, but Corning Inc. re-purchased the brand and continues to produce Steuben glass today). When Steuben introduced the *Gazelle Bowl* in 1935, it marked a turning point in the firm's history. Sales of Steuben glassware had dropped precipitously during the Great Depression that began in 1929, and to boost sales the firm charted a new course, in terms of both material and design. Their original output was colorful glass tableware and decorative objects in the Art Nouveau style. Now, Steuben glassmakers would use almost exclusively a flawless, colorless crystal that had first been developed for commercial applications. Steuben's president, Arthur A. Houghton, Jr., proclaimed that they will now focus on making "the finest glass the world has ever seen." New designs, meant to exploit the brilliance and clarity of this glass, would often come from artists working in other mediums. The young sculptor Sidney Biehler Waugh, for example, was named the firm's principal designer. The *Gazelle Bowl* was his first notable design in glass. Compact and robust, with elegant, prancing gazelles engraved around the circumference of the bowl, this sculptural vessel exemplifies the geometric lines and stylized forms of the new Art Deco style.

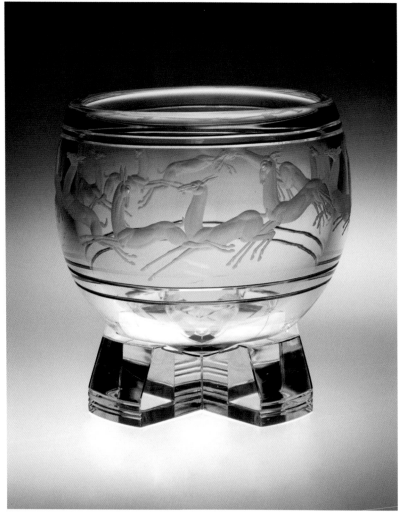

René Lalique et Cie (French, Nancy, maker), René Lalique (French, 1860–1945, designer), **Serpent Vase**. Glass, designed 1924. H. 9¾ in. (24.8 cm). Purchased with Funds from the Florence Scott Libbey Bequest in Memory of her Father, Maurice A. Scott, 1976.47

By the early 1920s, the French designer René Lalique had established a reputation as a leader in Art Deco glass design. At the landmark exhibition l'Exposition Internationale des Arts Décoratifs et Industriels Modernes in Paris, Lalique presented his *Serpent Vase* of vibrant amber-colored mold-blown glass. The vase's daring shape, resembling a curled viper with its jaws wide open and every scale defined, caused a sensation at the Exposition and remains one of the firm's most popular designs. The snake was a recurring theme in Lalique's glass production, just as it had been in his earlier designs for jewelry in the Art Nouveau style.

Trained as a jeweler in London and Paris, Lalique first established his reputation designing colorful jewelry that featured enameled glass and precious gemstones. His work also caught the attention of leading French perfume manufacturers, who commissioned him to create a signature line of glass perfume bottles. Lalique later worked entirely in glass, renting and finally purchasing a glass factory to produce high quality glass art that appealed to a broader market.

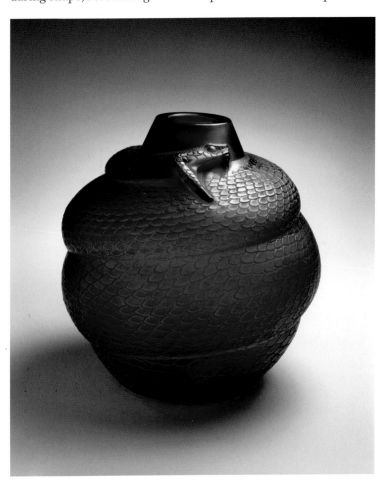

Jean Fouquet's bold, architectural brooch is considered a quintessential example of jewelry in the Art Deco style, evoking the rhythm of a modern cityscape of skyscrapers. Fouquet's grandfather, Alphonse Fouquet, had founded the famed Maison Fouquet jewelry firm in Paris in 1860. His father, Georges (1862–1957), who ran Maison Fouquet from 1895 until it closed in 1936, resolved to rejuvenate the firm's style after World War I by hiring talented contemporary artists and designers. Jean, an early champion of the streamlined Art Deco style that emerged in postwar France, joined his father's firm in 1919 and soon conceived the most striking and celebrated European jewelry designs produced in the 1920s and '30s.

Fouquet's designs aligned with the aesthetic currents of the time, drawing on Cubism and geometric abstraction. Above all, they also complied with his own requirement, that jewelry must be designed "with volumes readable from afar."

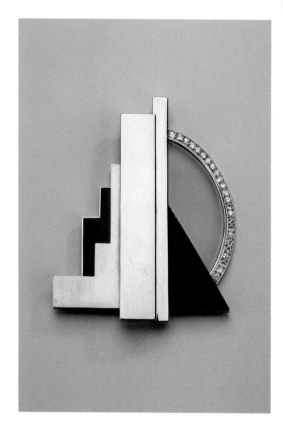

Maison Fouquet (French, Paris, maker), Jean Fouquet (French, 1899–1984, designer), **Brooch**. White gold, yellow gold, onyx, lacquer, rock crystal, diamonds, 1925. H. 3 1⁄16 in. (7.8 cm). Mr. and Mrs. George M. Jones, Jr. Fund, 1999.4

Édouard Vuillard (French, 1868–1940), **La Salle Clarac**. Oil paint with distemper on canvas, 1922. 38⅝ x 45⅝ in. (98.1 x 115.9 cm). Purchased with funds from the Libbey Endowment, Gift of Edward Drummond Libbey, 1999.2

One of a series of four paintings by Édouard Vuillard representing rooms in the Musée du Louvre, Paris, *La Salle Clarac* (The Clarac Gallery) was painted on commission for a private home in Switzerland. Remembered most for his intimate interior scenes, here Vuillard depicts one of his favorite galleries, decorated in 1826 with gilded paneling and paintings and showcasing ancient Greek vases and artifacts. The artist has included four figures, a man and three women (one barely visible beside the man), looking at, reading about, and contemplating Greek antiquities presented in display cases. By rendering the scene from a low vantage point, Vuillard encourages the viewer of his painting to identify with the gallery visitors in the scene, who, in turn, are engrossed in the act of viewing art.

Vuillard's style interpreted scenes of everyday Parisian life with flat patches of color and pattern. He achieved the unusual surface appearance of this painting by applying distemper—a water-based medium that dries quickly—in addition to slower-drying oil paint. The painting challenges perception with its complex spatial arrangements, overlapping figures and objects, and rendering of glass as both clear and reflective.

Giorgio de Chirico (Italian, 1888–1978), **Self-Portrait**. Oil on canvas, about 1922. 15⅛ x 20⅛ in. (38.4 cm x 51.1 cm). Purchased with funds from the Libbey Endowment, Gift of Edward Drummond Libbey, 1930.204.

Two faces—one painted as marble bust, the other as flesh and blood—face each other on this canvas, presenting the viewer with their profiles. Both bear the features of the Surrealist artist Giorgio de Chirico. While the marble bust seems to stare directly at its human counterpart, the figure on the right instead gazes intently at the viewer. The Latin inscription, *se ipsum*, in the lower right corner translates as "himself" or "itself," emphasizing both the intimacy of the naturalistic self-portrait and the cold "otherness" of the marble persona.

The bust references the classical past, which De Chirico found endlessly inspiring. However, De Chirico's decision to present himself as if chiseled in marble departs from his earlier work, as does the tightly cropped composition. The imposing, empty cityscape just visible through the window in the background is an element common to De Chirico's style, one that he described as "metaphysical" to indicate that his works express meaning beyond their outward physical appearances.

Constantin Brancusi (Romanian, 1876–1957), **Blond Negress I**. Bronze, marble, and limestone, 1926. H. (with base) 26 in. (66 cm). Partial gift of Thomas T. Solley and partial purchase with funds from the Libbey Endowment, Gift of Edward Drummond Libbey, and with funds from the Florence Scott Libbey Bequest in Memory of her Father, Maurice A. Scott, 1991.108

One of the most innovative sculptors of the early twentieth century, Constantin Brancusi simplified outward appearances to express inner, universal beauty. This highly refined and abstracted sculpture of a woman's head is said to have been inspired by a young African woman, whom he saw in Marseilles.

The polished surface of this head features only three details: lips, an elegant chignon, and an ornament at the lower back of the head. Brancusi poised the head on the front edge of a white marble cylinder, which in turn is mounted on a cross-shaped limestone base. Brancusi deliberately chose materials that ignore skin color and focused on revealing the subject's inner radiance.

Brancusi's mature work was profoundly influenced by the ancient Greek philosopher Plato's concept of ideal form. Rather than imitate nature, he simplified his images to the essential, ideal forms that he believed lay beneath surface appearances.

Piet Mondrian (Dutch, 1872–1944), **Composition with Red, Blue, Yellow, Black, and Gray**. Oil on canvas, 1922. 16½ x 19⅛ in. (41.9 x 48.6 cm). Purchased with funds from the Libbey Endowment, Gift of Edward Drummond Libbey, 1978.44.

Dominated by a large white square surrounded by small color planes that extend to the edges of the canvas, this painting expresses Piet Mondrian's desire to balance opposing forces by concentrating on the subtle relationships between lines, shapes, and colors. Mondrian developed his distinct, radical painting style in the 1920s, eliminating recognizable objects in favor of a visual language of vertical and horizontal lines and rectangles restricted to black, white, gray, and the three primary colors (red, yellow, and blue).

Mondrian believed his nonrepresentational style, which he called Neoplasticism, expressed the unity and order possible in nature when the forces of opposition are in balance. He hoped that his images of absolute harmony, clarity, and order would point the way toward a future universal utopia. This goal was first formulated in the Netherlands around 1916–17 by Mondrian and a small group of like-minded artists and architects known as De Stijl (the Style). Their ideas profoundly influenced not only later painting but also many aspects of modern design.

Max Beckmann (German, 1884–1950), **The Trapeze**. Oil on canvas, 1923. 77⅜ x 33⅛ in. (196.5 x 84 cm). Purchased with funds from the Libbey Endowment, Gift of Edward Drummond Libbey, 1983.20

Crowded against one another into a narrow vertical space, seven acrobats perform their routines onstage. Masked, eyes closed, or self-absorbed, they are psychologically distant from one another despite the fact that their bodies are so uncomfortably crowded. Max Beckmann often depicted performers from the circus and the cabaret—who hide behind masks and greasepaint—to express the absurdity and the meaninglessness of human behavior. The face of the man in brown stripes, hanging upside-down and the only one who directly engages the viewer, is probably a self-portrait.

Beckmann was professionally trained, first as a classical idealist painter, later becoming a German Impressionist, and finally as a German Expressionist. At the outbreak of World War I in 1914 he volunteered for medical duty and was assigned to working in field hospitals, where he was exposed to horrific battlefield injuries. Beckmann's outlook on life was influenced by those experiences. In 1918, the year the war ended, he wrote of his desire to "capture the more unspeakable aspects of life." Beckmann described his role as a painter as a societal necessity: "We should first do what there is to be done, and our work is painting."

The Bareiss Collection of Modern Illustrated Books

The Toledo Museum of Art began collecting rare and illustrated books in the first decade after it was founded in 1901. This longstanding commitment to the art of the book strongly contributed to the decision of Connecticut-based collectors Molly and Walter Bareiss to donate their expansive collection of more than 1,400 limited-edition, Modern illustrated books to the Museum in 1984. Among them are seventy-three volumes containing original prints by Pablo Picasso, including his first illustrated book (and the first to include his Cubist prints), *Saint Matorel*. The Bareiss Collection contains not only fine press productions with original prints by prominent artists, but also more experimental works, like *Dlia Golosa* (*For the Voice*). This small volume features Constructivist typographical designs by El Lissitzky and an ingenious thumb-index with symbols on separate tabs to locate thirteen read-aloud poems by Vladimir Mayakovsky.

Pablo Picasso (Spanish, 1881–1971, artist), Max Jacob (French, 1876–1944, author), **Saint Matorel**. Book with etchings and drypoint, 1911. Publisher: (Daniel) Henry Kahnweiler, Paris. Page: 10 ½ x 8 ¹³⁄₁₆ in. (26.7 x 22.4 cm). Gift of Molly and Walter Bareiss in honor of Barbara K. Sutherland, 1984.873

El Lissitsky (Russian, 1890–1941, artist), Vladimir Mayakovsky (Russian, 1893–1930, author), **Dlia Golosa (For the Voice).** Book with typographic designs, 1923. Publisher: Gosudarstvennoe izdatel'stvo, Moscow-Berlin. Page: 7 ⅜ x 5 ³⁄₁₆ in. (18.7 x 13.1 cm). Gift of Molly and Walter Bareiss, 1984.681

Henri Laurens (French, 1885–1954, artist), Theocritus (Greek, about 300–260 BCE, author) **Les Idylls.** Book with wood engravings, 1945. Publisher: Éditions de la revue Verve, Paris. Page: 13 ⅛ x 9 ¹⁵⁄₁₆ in. (33.2 x 25.2 cm). Gift of Molly and Walter Bareiss, 1984.655

Le Corbusier (French, 1887–1965, artist and author), **Le Poème de l'angle droit (Poem of the Right Angle).** Book with lithographs, 1955. Publisher: Éditions Tériade, Paris. Page: 16 ¹³⁄₁₆ x 12 ¹¹⁄₁₆ in. (42.7 x 32.2 cm). Gift of Molly and Walter Bareiss, 1984.662

Edward Weston (American, 1886–1958), **Diego Rivera, Mexico**. Platinum print, 1924. 7½ x 9½ in. (19.1 x 24.2 cm). Purchased with funds given by anonymous donor, 1971.143

Edward Weston is celebrated today for his highly accomplished photographs of landscapes, nudes, and natural objects that he depicted in rich detail and with sharp clarity. Though well known for his role in establishing photography as a Modern artistic medium, he first gained success working in California as a Pictorialist portrait photographer, relying upon an approach that imitated painting and its artistic manipulations.

This striking, closely cropped image portrays the revolutionary Mexican artist Diego Rivera (1886–1957) before one of his murals. It was taken while Weston lived in Mexico from 1923 to 1926 and shortly after becoming acquainted with the avant-garde photographer and gallery owner Alfred Stieglitz (see p. 242). Created during a transitional period, it exemplifies the time when Weston began to redefine his aesthetic approach through Stieglitz's influence and his own study of Modern art. Though *Diego Rivera, Mexico* retains the soft focus of the Pictorialist style, Weston's innovative placement of his subject on a diagonal slant within a flattened space anticipates his eventual break with Pictorialism. With this portrait Weston takes advantage of photography's own technical visual language—its high contrast lighting, rich detail, range of tonality, and adherence to documentary truthfulness—to vividly record the sitter's defiant attitude and forceful personality.

Isamu Noguchi (American, 1904–1988), **Miss Expanding Universe**. Aluminum, 1932. H. 40⅞ in. (103.8 cm). Museum Purchase, 1948.12

Modern dancer Ruth Page (1899–1991), the artist Isamu Noguchi's lover at the time, was the inspiration behind this sculpture, which hovers both literally and figuratively between form and abstraction. The simplified shapes make it as evocative of a butterfly or a bird as it is of the human form. Though born in the United States, Noguchi spent his early years in Japan. Throughout his career he sought to merge Asian traditions with Western Modernism, an aesthetic that is clearly apparent in the spare simplicity of *Miss Expanding Universe*.

This cast aluminum sculpture, which Noguchi described as "full of hope," is light enough to hang from the ceiling. Its apparent weightlessness gives it the same sense of graceful movement that can be seen in Modern dance. Noguchi's choice of aluminum and his emphasis on sinuous lines reflects his ongoing association with the visionary American architect and theorist R. Buckminster Fuller (1895–1983), who shared Noguchi's interest in translating complex scientific and philosophical ideas into physical reality.

Shin hanga: New Prints for a New Era

Oda Kazuma (Japanese, 1882–1956), **Catching Whitebait at Nakaumi, Izumo,** from **Scenes of San'in.** Publisher: Watanabe Shōzaburō (Japanese, 1885–1962). Color woodblock print, 1924. Image: 9½ x 14⅝ in. (24.1 x 37.1 cm). Gift of Hubert D. Bennett, 1939.252

Japanese woodblock prints with images of beautiful women, leisure activities, famous sites, and popular Kabuki actors rose to prominence as an art form during the early Edo Period (1615–1868). By the late 1800s, however, that art form had become stagnant. But a few decades later, in the 1910s and '20s, a new generation of artists and print publishers, trained in Western art techniques and inspired by Japan's own artistic traditions, revived Japanese woodblock printmaking for the modern era. This resurgence was known as the *shin hanga* (new prints) movement. Mining many of the same subjects as their Edo Period predecessors, *shin hanga* artists used a broader, often more vibrant palette for their prints.

In 1930, with the help of artist Hiroshi Yoshida, the Toledo Museum of Art helped to popularize *shin hanga* in America with a landmark exhibition of 343 modern Japanese woodblock prints. All but five of these were purchased at the time of the exhibition by local businessman Hubert D. Bennett, who graciously donated them to the Museum in 1939. His gift of these and other prints by *shin hanga* artists is characterized by the exceptional condition of the prints and the sharpness of their colors. Today, these prints form the core of one of the finest collections of *shin hanga* in any American museum.

Itō Shinsui (Japanese, 1898–1972), **Painting the Eyebrows.** Publisher: Watanabe Shōzaburō (Japanese, 1885–1962). Color woodblock print, 1928. Image: 10 ⅝ x 15 in. (27.0 x 38.1 cm). Gift of Hubert D. Bennett, 1939.105

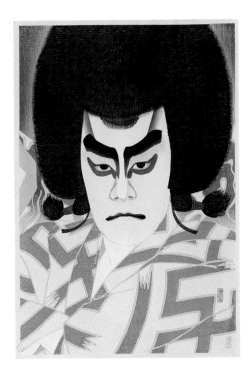

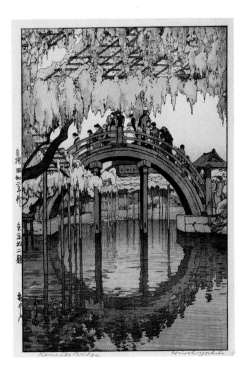

Natori Shunsen (Japanese, 1886–1960), **Ichikawa Sadanji II as Priest Narukami,** from **Creative Prints, Collection of Portraits by Shunsen.** Publisher: Watanabe Shōzaburō (Japanese, 1885–1962). Color woodblock print, 1926. Image: 15 x 10 ³⁄₁₆ in. (38.1 x 25.9 cm). Gift of Hubert D. Bennett, 1939.220

Hiroshi Yoshida (Japanese, 1876–1950), **Kameido Bridge,** from **Twelve Subjects of Tokyo.** Color woodblock print, 1927. Image: 14 ¾ x 9 ¾ in. (37.5 x 24.8 cm). Gift of Hubert D. Bennett, 1939.355

Paul Cadmus (American, 1904–1999), **Jerry**. Oil on canvas, 1931. 20 x 24 in. (50.8 x 60.9 cm). Purchased with funds from the Libbey Endowment, Gift of Edward Drummond Libbey, by exchange, 2008.140

In this frank and intimate portrait, the artist Jared French (1905–1988) gazes candidly out at the viewer. Painted while Paul Cadmus and French, who were lovers at the time, were traveling together in Europe, this image reveals an emotional depth that can appear startling in its unequivocal directness. Although *Jerry* does not include the social or political commentary typical of Cadmus's best-known paintings, he considered it his first mature work as an artist. Despite the painting's importance in Cadmus's body of work, it was rarely exhibited and remained in the private collection of French and his heirs until acquired by the Museum in 2008.

Although this painting may lack overt social commentary, the inclusion of a copy of James Joyce's *Ulysses*, which French holds, his finger marking his place, resonates with meaning. From the book's first publication in 1922 it aroused controversy, drawing intense scrutiny, from early obscenity trials to protracted textual battles. Now considered one of the most important works of Modernist literature, by 1931 *Ulysses* would have symbolized everything these two young Americans believed desirably European and avant-garde.

Edward Hopper (American, 1882–1967), **Two on the Aisle**. Oil on canvas, 1927. 40⅛ x 48¼ in. (102 x 122.5 cm). Purchased with funds from the Libbey Endowment, Gift of Edward Drummond Libbey, 1935.49

A master of the quiet narrative, the American realist artist Edward Hopper imbued ordinary moments of everyday life with psychological intensity and complexity. Viewers inevitably find themselves drawn into his carefully composed scenes, identifying with or speculating about the often isolated characters. *Two on the Aisle* is a seemingly simple composition: three figures in an otherwise empty theater. It is Hopper's first significant painting of a theater scene, a theme to which he subsequently returned many times. Instead of capturing the drama on stage or the bustle of the audience, Hopper focuses on a quiet, anticipatory moment before the play begins, even before most playgoers have arrived or taken their seats.

As is typical of Hopper's compositions, each of the three figures seems alone in his or her own separate emotional space, even though two of them are clearly a couple. (The models, in fact, are Hopper himself and his wife and former fellow art student, Josephine Verstille Nivison, or as Hopper called her, Jo).

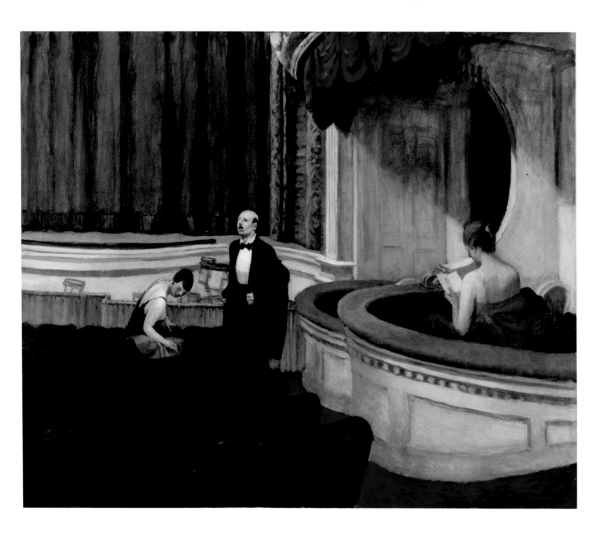

Pablo Picasso (Spanish, 1881–1973), **Faun Uncovering a Sleeping Woman**. Etching and aquatint, 1936. 12 ⅜ x 16 ⅜ in. (31.4 x 41.5 cm). Purchased with funds from the Libbey Endowment, Gift of Edward Drummond Libbey, 1982.133

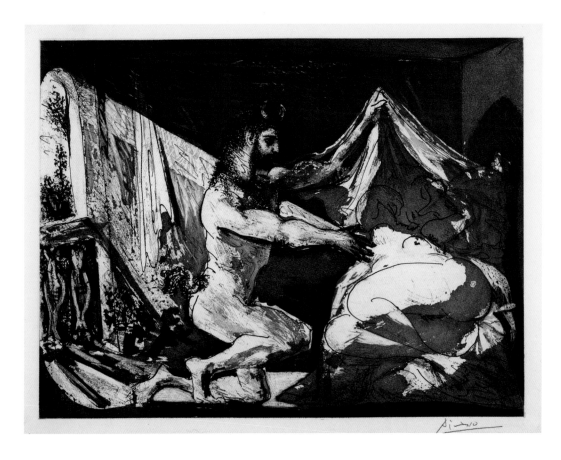

Faun Uncovering a Sleeping Woman is a striking example of Picasso's frequent use of classical myths and motifs to explore his personal sexual passions, identity, and creativity. In this print, he substitutes a gentler creature, a faun (a mythological forest spirit with both human and goat-like attributes) for the Minotaur, or bull-headed man, that he often used to represent himself. Here the faun looks fondly on a sleeping nude, who represents Marie-Thérèse Walter (1909–1977), his lover of nearly ten years. For his composition, Picasso borrowed from Rembrandt's etching *Jupiter and Antiope* (1659), in which Jupiter (Zeus) in the guise of a

playful, ugly faun, watches a woman in peaceful slumber. Picasso has reworked the subject of a god's lustful pursuit of a mortal woman to allude instead to the transformation of his personal feelings toward his lover, from lust to tender affection.

In this dramatic and expressive image, the last in the series known as the "Suite Vollard" after Picasso's art dealer, Ambroise Vollard (1866–1939), Picasso introduces painterly effects, such as changes in tone and shading with subtle shifts of light. *Faun* is among Picasso's most beautiful and successfully executed etchings.

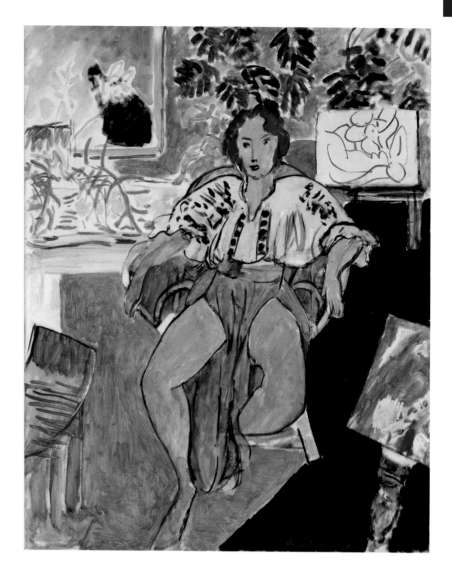

Dancer Resting draws in the viewer with its subject's direct gaze and unselfconscious pose. This canvas is an outstanding example of Henri Matisse's final oil paintings, before he turned almost exclusively to making cut-paper designs, or *gouaches découpés*. Long interested in pattern and color, Matisse filled the upper half of the painting with houseplants, a window, and a sketch for another of his paintings, all of which create a rich, decorative backdrop for the figure. The peasant-style blouse the model is wearing, white with black trim, appears in several other of Matisse's paintings from this period. Given its simplified lines and shapes, *Dancer Resting* conveys an astounding amount of information, personality, and detail.

The model for this theatrical and engaging composition is likely Matisse's companion and assistant of many years, Lydia Delectorskaya (1910–1998). Though 40 years his junior, Delectorskaya remained with Matisse as a studio manager, model, and secretary until his death in 1954. Enigmatically known only as "Madame Lydia" to studio visitors, she was pivotal in helping to produce his late work when his health was in rapid decline.

Henri Matisse (French, 1869–1954), **Dancer Resting**. Oil on canvas, 1940. 32 x 25 ½ in. (81.3 x 64.8 cm). Gift of Mrs. C. Lockhart McKelvy, 1947.54

Joan Miró (Spanish, 1893–1983), **Woman Haunted by the Passage of the Bird-Dragonfly Omen of Bad News**. Oil on canvas, 1938. 31½ x 124 in. (80 x 315 cm). Purchased with funds from the Libbey Endowment, Gift of Edward Drummond Libbey, 1986.25

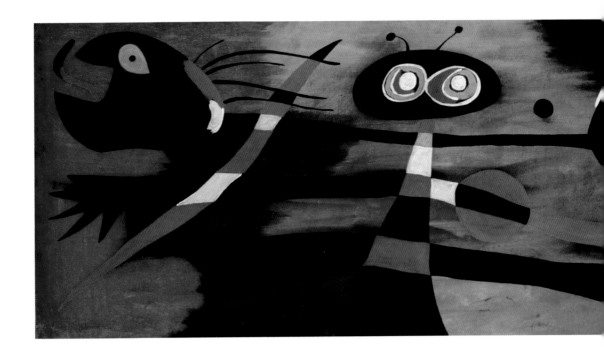

Although Joan Miró insisted that every element in his art represented something that existed in nature, his fanciful images were actually expressions of his subconscious rather than his perceptions of the objective world. Like other Surrealist artists, his aim was to free the viewer's imagination by creating a multilayered, pictorial sign language.

This panoramic painting, from a group of canvases Miró painted between 1934 and 1939 (known as his "savage period"), may have been influenced by the tensions felt throughout Europe on the eve of World War II (1939–45). Incredibly, Miró painted *Woman Haunted* for the nursery of the children of his dealer, Pierre Matisse (son of artist Henri Matisse), and inscribed on the back of the canvas in French, "for Jacky, Peter and Pauley Matisse." The painting's title, *Nursery Decoration*, was changed to its current, more fanciful and descriptive title when Miró saw the painting again in 1959, twenty years after he had finished it.

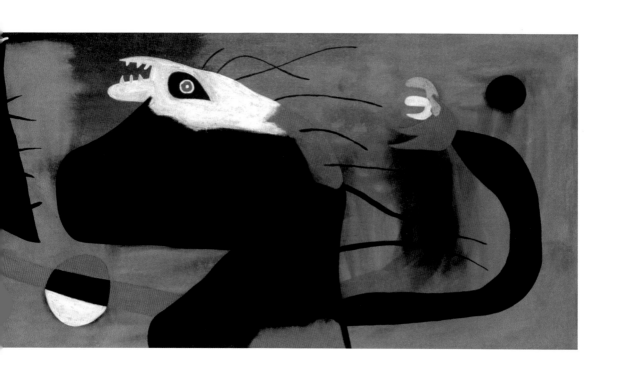

Joan Miró (Spanish, 1893–1983), **Sunrise at Varengeville** from **Constellations**. Gouache and oil on paper, 1940. 14 ⅞ x 17 ¹⁵⁄₁₆ in. (37.8 x 45.6 cm). Gift of Thomas T. Solley, 1996.16

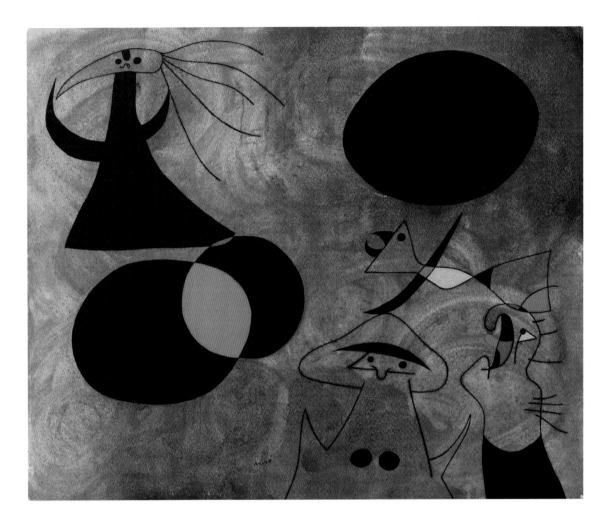

Sunrise at Varengeville and *Passage of the Divine Bird* both belong to Joan Miró's Constellations series, created from 1940 to 1941 in response to the havoc produced by World War II. As the first and last works of this nocturnal sequence comprising twenty-three paintings in gouache (opaque watercolor) and oil on paper, they provide a lens into the artist's creative process that sustained him throughout his self-imposed exile in France between 1939 and 1940, where he went to escape the military dictatorship of General Francisco Franco in Spain. In *Sunrise*, the simplest composition of the series, four savage creatures—three humanoid and one

bird-like—float across a nocturnal, phospho-rescent ground. The ferocious, open-jawed profile figure in the lower right, often read as a caricature of Franco, underscores the composition's foreboding and aggressive mood.

By contrast, *Passage of the Divine Bird* illustrates the role "the night, music, and the stars" played as Miró's turbulent imagery gradually gave way to more lyrical compositions. Miró painted this final work—a teeming, interconnected "constellation" of fantastic figures, floating eyes, and abstract shapes—in 1941, shortly after he returned to his family farm in Mont-Roig del Camp, Spain. Here, stars and other celestial motifs, strung like beads, dance across a brilliant chromatic space. As an image of balance and harmony on a cosmic scale, this painting expresses Miró's renewed faith in humanity's place in the universe.

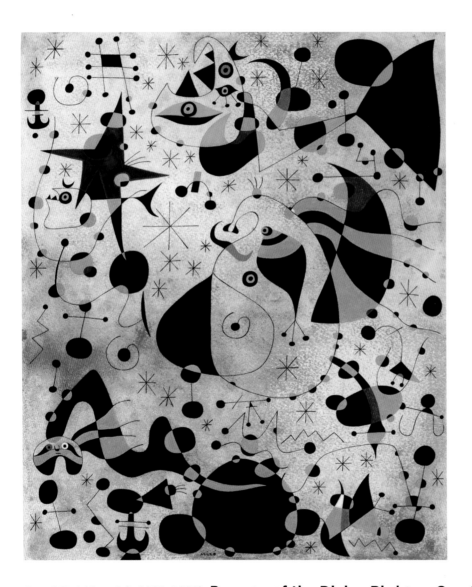

Joan Miró (Spanish, 1893–1983), **Passage of the Divine Bird** from **Constellations**. Gouache and oil on paper, 1941. 18 x 14 ⅞ in. (45.7 x 37.8 cm). Purchased with funds from the Libbey Endowment, Gift of Edward Drummond Libbey, 1996.21

Staunchly independent, Georgia O'Keeffe was a pioneer of Modernism and abstraction in America, forging her own artistic path across seven decades, from the 1910s to the 1980s. By the mid-1920s she had transitioned from purely abstract to representational paintings, though even these were often rendered in extreme close-up, featured surrealistic juxtapositions, or were done in saturated, vivid colors.

This canvas, which O'Keeffe painted while on vacation in the Bahamas, exhibits her signature crisp lines and strong color. The mainsail and jib, "sailing wing and wing" (downwind), take on an organic, almost dorsal fin-like shape that reflects O'Keeffe's signature style of focusing attention on and exaggerating natural forms.

This painting is an anomaly in relation to her iconic close-ups of flowers or spare scenes of the American Southwest, yet the composition has many qualities that are also characteristic of her work. Here she has combined realistic representation with abstract forms. While the cloud-covered sky and lighthouse are rendered naturalistically, the cropped brown sails assume an abstract shape that slices through the composition. Only the seams in the sails suggest three-dimensionality.

Georgia O'Keeffe (American, 1887–1986), **Brown Sail, Wing and Wing, Nassau**. Oil on canvas, 1940. 38 x 30 1⁄16 in. (96.6 x 76.4 cm). Museum Purchase, 1949.106

Andrew Wyeth (American, 1917–2009), **The Hunter**. Tempera on Masonite, 1943. 33 x 33⅞ in. (83.8 x 86 cm). Elizabeth C. Mau Bequest Fund, 1946.25

The Hunter, painted as an illustration for the cover of the popular weekly magazine *The Saturday Evening Post*, brought Andrew Wyeth to national attention. His startling and unusual point of view gives a heightened sense of drama to this otherwise ordinary scene of a hunter walking across the fields in an autumn landscape. The viewpoint is from high above in a majestic sycamore tree, peering down through the branches and the sparse dry leaves at the red-capped hunter moving through the tall grasses below, as if the prey is tracking the pursuer.

Wyeth's compositions are always closely observed and highly detailed, and his decision to use the centuries-old but difficult technique of tempera (a paint made by mixing pigment with an egg medium) adds to the intensity and subtlety of his colors. Because tempera quickly dries very hard, the artist must use the smallest brushstrokes to build the composition. Wyeth's brushstrokes are almost invisible, heightening the sensory experience of looking at the painting and feeling as if one were actually there.

Gordon Parks (American, 1912–2006), **American Gothic (Ella Watson).** Gelatin-silver print, 1942. 13 $^{15}/_{16}$ x 10 $^{7}/_{8}$ in. (35 x 28 cm). Purchased with funds given by the Toledo Friends of Photography and with funds from the Libbey Endowment, Gift of Edward Drummond Libbey, 2010.21

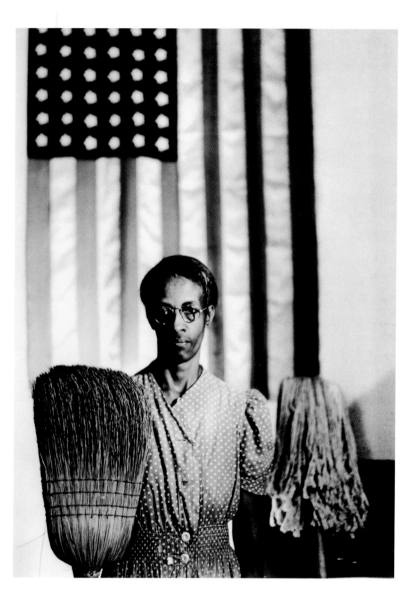

A powerful image from the pre-Civil Rights era, *American Gothic (Ella Watson)* was photographed during Gordon Parks's fellowship at the Farm Security Administration (FSA) in Washington, DC. For his ironic commentary on social inequality, Parks appropriated the title and modeled his composition after the famous Depression-era painting by Grant Wood, *American Gothic* (1930; Art Institute of Chicago). Wood's portrayal of a hard-working, rural father and daughter standing before their sturdy American Gothic-style farmhouse was celebrated for its evocation of quintessential American values and as a reassuring affirmation of economic well-being. Here, substituting Wood's unsentimental farm family, Parks presents an equally unsentimental subject, Ella Watson, a cleaning woman at the FSA office building, standing somberly before an American flag. A mop and a broom replace the farmer's pitchfork. Through dramatic lighting and selective focus, Parks carefully composed an image that calls attention to his subject's perseverance, but also to her unequal status in the capital of the nation known for its ideals of freedom, equality, and financial advancement.

As the son of black sharecroppers in Kansas, Parks became a keen observer of the pervasive racism that he encountered throughout American culture. In 1948 Parks became the first African American photojournalist at *LIFE* magazine, where he focused on issues of civil rights and poverty.

Elizabeth Catlett (American, 1915–2012), **Head of a Young Woman**. Grit-tempered clay, about 1947. H. 10.5 in. (26.7 cm). Gift of Florence Scott Libbey, by exchange, 2006.145

In 1946, with a grant from the Rosenwald Foundation, Elizabeth Catlett moved from her home in Washington, DC, to Mexico City, where she spent most of her career. *Head of a Young Woman* elegantly expresses her abiding interest in representing the figure in a straightforward, powerful manner. This sculpture's stylization and simplification reflect both the prevailing Modernist aesthetic and Catlett's own interest in the human figure in African art and the pre-Columbian art of Mexico.

Throughout her long career Catlett, the granddaughter of former slaves, used her art to address injustices, tackling controversial issues, such as lynching and racially motivated violence, the CIA's involvement in Central America, and Mexico's discrimination against its indigenous peoples. In both sculpture and printmaking, she

also celebrated famous forebears in African American history and unsung people of color— her family and friends, laborers, the poor, and the oppressed. It is these ordinary people and their struggles and dreams in whom she found the most beauty and inspiration, as revealed in this striking portrait that is at once personal and universal.

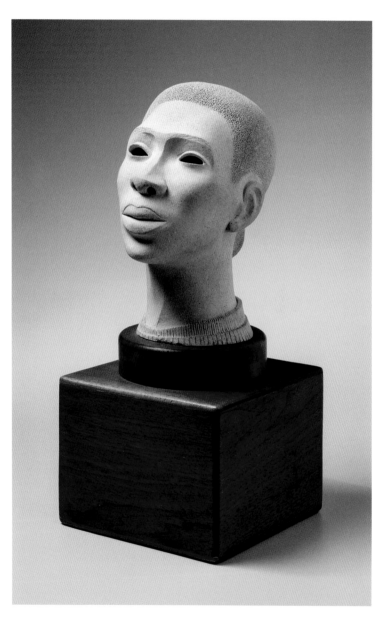

Gertrude Glass Greene (American, 1904–1956), **Composition**. Oil on wood panel, 1940. 48 x 32 in. (121.9 x 81.3 cm). Gift of the Woodward Foundation, by exchange, 2005.104

In 1937 a small group of artists, including Gertrude Greene and her husband Balcomb, founded the American Abstract Artists (AAA), whose goal was to promote abstraction. At that time in the United States, abstract art was considered too connected to European traditions, too inaccessible to the viewer, and neither socially relevant nor American enough. These pioneering AAA artists laid the foundation for those who pursued and expanded on their thesis: the Abstract Expressionists and the so-called American action painters a generation later.

Always intellectually energetic, Gertrude Greene began creating low-relief abstractions in 1935. In her work she almost always referenced her interest in reconciling hard-edge, geometric abstraction with the organic abstract forms of other artists, such as Joan Miró. *Composition* is a definitive example of her work during this period. The hard lines and rectilinear forms in both positive and negative space are offset and softened by the single curving shape that anchors the shapes. While the composition is strictly abstract, Greene does provide one easily recognizable element: the arrow, which points the way for the eye to move around the painting.

Jacob Lawrence (American, 1917–2000), **Barber Shop**. Gouache on paper, 1946. 21⅛ x 29⅜ in. (53.6 x 74.6 cm). Purchased with funds from the Libbey Endowment, Gift of Edward Drummond Libbey, 1975.15

After a stint in the Coast Guard during World War II, the young Jacob Lawrence turned his attention to documenting life in Harlem, New York—a city within a city, with its own distinctive African American culture. *Barber Shop* encompasses all three themes. Lawrence imbues the scene, with its simplified figures, expressive gestures, bold color and form, and dynamic composition, with the distinctive character of 1940s Harlem, its occupations, gathering places, and social interactions. *Barber Shop* is rich in detail: the openwork in the metal footrests, one customer's fancy high-top shoes, the hats and coats hanging in the background. Anchoring the composition, against a bright red shawl, is a tiny white

rectangle—a cigarette dangling between a customer's fingers.

In his youth, Lawrence faced many upheavals, including interstate moves, separated parents, and foster care. He discovered art through his teacher, Charles Alston, and later met many of those involved in the Harlem Renaissance. The purpose of his social realist art, he explained, was to show black Americans the stories of their history, which were too often absent from mainstream cultural narratives. While Lawrence painted figurative subjects throughout his career, he also absorbed Modernism's tendency toward abstraction.

Henri Matisse (French, 1869–1954, artist and author), **Jazz**. Book with pochoir prints, 1947. Edition, 215/270. Publisher: Éditions Tériade, Paris. Page: 16 ⅝ x 12 ¹³⁄₁₆ in. (42.2 x 32.5 cm). Purchased with funds from the Libbey Endowment, Gift of Edward Drummond Libbey, 1985.85.a–v

Finding it difficult to paint while recovering from surgery in 1941, Henri Matisse found a new way to channel his drive to create: he used scissors to cut shapes from colored papers that had been painted with gouache. He pinned the shapes to his studio wall, rearranging them until he was satisfied with the composition. Matisse used this technique, which he called "drawing with scissors," to create the original collages for his circus-themed book *Jazz*, which he began in 1943 and finished in 1946. In order to publish the collages, he decided against reproducing them as lithographs (which at that time could not capture the vivid colors of the gouache). Instead, he decided to have the book printed using the pochoir technique,

whereby custom-mixed ink could be directly applied to the paper through stencils that were cut by the *découpeur* to match the shapes in his designs. The stencils would then be used by the *coloristes* to produce the different shapes in ink on paper. Although pochoir is a labor-intensive process, because so so much has to be done by hand, the eye-popping result for *Jazz* is today recognized as one of the most important—and most beautiful—artist's books ever produced.

The title *Jazz* likely comes from the improvisational and "syncopated" nature of Matisse's handwritten text (reproduced in facsimile), which explores the artist's thoughts on art and life in an intensely intimate, though often rambling, way.

This intimate and vibrant scene of a wooded landscape belongs to Zao Wou-ki's first foray into printmaking, an important means of expression for the artist and one to which he devoted himself throughout the rest of his career. Created at the lithography studio l'Atelier Desjobert shortly after he arrived in Paris from China, this print provides a charming early example of Zao's unique pictorial language, which was built on East-West artistic influences.

Comprising a brilliant red sun encircled by delicate, willowy trees and matchstick human and animal figures, Zao's ethereal composition incorporates motifs and symbols that recall Chinese calligraphy and scroll painting. Its brightly colored, luminous backdrop, filled with atmospheric light, stems from his experimental approach to printmaking, in which he re-created the spontaneous and fluid effects found in Chinese watercolor and ink paintings. Zao's *The Red Sun* attests to his exploration of new visual and technical possibilities. While it retains the lyrical essence of Chinese artistic traditions, and signals his discovery of the printmaking medium, it also marks a significant turning point in his career.

Zao Wou-ki (Chinese-French, 1920–2013), **The Red Sun**. Five-color lithograph, 1950. 19 x 13½ in. (48 x 34 cm). Frederick B. and Kate L. Shoemaker Fund, 1952.19

David Smith (American, 1906–1965), **2 Circle IV**. Painted steel, 1962. H. (with base) 119 in. (302.6 cm). Purchased with funds from the Libbey Endowment, Gift of Edward Drummond Libbey, 2001.3

David Smith was the most prominent American sculptor of the twentieth-century, in an era dominated by painting. *2 Circle IV* is one of a series of sculptures in which he explored the interaction between shape, color, and gesture. Seen from afar, it seems to be simply a round field of yellow over another circular blue field—creating a beautiful interaction between color and form. Coming closer reveals a surprise: Smith was as much a painter as a sculptor. He experimented with automotive paint, but deliberately avoided the smooth finish characteristic of spray application. Instead, he applied the paint with a brush, treating the steel form almost as a shaped canvas.

Smith took an unusual path to becoming a sculptor. After leaving home in Indiana at age sixteen, he found work as a welder and riveter in an automotive plant. He moved to New York City in 1926 and studied at the Art Students League, applying his skills to welding metal scraps into sculptures. Smith secured his reputation through his unorthodox approach, his successful integration of color and sculpture, two-dimensional pictorial construction, and three-dimensional form.

Wayne Thiebaud (American, born 1920), **Roast Beef Dinner (Trucker's Supper)**. Oil on canvas, 1963. 20 x 24 in. (50.8 x 61 cm). Purchased with funds from the Libbey Endowment, Gift of Edward Drummond Libbey, by exchange, 2009.65

The quintessential truck-stop meal of an open-faced roast beef sandwich and French fries (plus bread and butter on the side) is here laid out as a still life of simplified formal elements—circular plates, cylindrical glass of milk, rectangular sandwich, square slices of bread—to present a complex and seductive painted surface. The viewpoint is such that the viewer seems invited to pull up a chair and sit down to enjoy this hearty fare.

Wayne Thiebaud's paintings of food and consumer goods (cakes and pies, gumball machines and lipsticks) first emerged in mature form in 1961–62. His inclination to depict commonplace objects from middle-class America—decidedly "blue collar" subjects—manifested itself in the mid-1950s, before the Pop Art movement of the 1960s both romanticized and satirized similar consumer subjects. Unlike the Pop artists, Thiebaud treated the everyday trappings of ordinary America, particularly diner culture, with affection rather than cynicism.

Luisa Parisi (Italian, 1914–1990, designer), and Domenico (Ico) Parisi (Italian, 1916–1996, designer), **Sideboard**. Mahogany with lacquered brass mounts, about 1955. L. 81½ in. (207 cm). Purchased with funds from the Florence Scott Libbey Bequest in Memory of her Father, Maurice A. Scott, 1984.79

In this sleek Italian sideboard, post-World War II design is expressed in elegantly arranged, meticulously matched wood grains. The angular, horizontal case is cantilevered on slender legs and a gracefully carved stretcher along the back. The two front legs, set on an angle front-to-back, taper into gleaming protective brass sheaths. Postwar design emerged in Italy as a European style phenomenon in the early 1950s, gradually evolving into distinctly Italian *chic*. As Italian consumers became obsessed with interior design, the country's industrial designers satisfied their demands with creative energy and fervor. Avant-garde furniture and accessories burst with drama and movement—even more than their leading contemporaries who were designing so-called Mid-century Modern in the US and Scandinavia.

The influential portfolio of two Italian architects and designers—Luisa Parisi and her husband, Ico Parisi—included projects that ranged from office buildings to airplanes, including their famous *Uovo* (egg) chair for Cassina. In this mahogany sideboard, the grace and fluidity of modern sculpture is imbued with a refined structural dynamic indebted to the plywood models the Parisis made as design prototypes for airplanes.

Marisol (Marisol Escobar; Venezuelan-French, 1930–2016), **The Party**. Assemblage of fifteen life-size figures and three wall panels, with painted and carved wood, mirrors, plastic, television set, clothes, shoes, glasses, and other accessories, 1965–66. Dimensions variable. Museum Purchase Fund, by exchange, 2005.42a–n

Fifteen boxy, life-size wooden figures and three wall panels comprise Marisol's largest sculptural installation. The figures are formally dressed for a cocktail party. Some have real gowns and accessories, others have painted or glued-on clothes. Each figure displays the details of costume, hairstyle, pose, or props that convey personality and social class, as well as tongue-in-cheek irony. Marisol Escobar was the toast of the New York art world at the time she constructed *The Party*. She was also the only woman and person of color consistently associated with the Pop Art movement of the 1960s.

Though she often attended fashionable New York parties, Marisol later claimed, "I never wanted to be a part of society. I have always had a horror of the schematic, of conventional behavior. All my life I have wanted to be distinct, not to be like anyone else. I feel uncomfortable with the established codes of conduct." The tension between conformity and self-expression is evident in *The Party*, in which Marisol's own face—photographed or cast in plaster or rubber—animates each of the figures.

Ideas: Isolation and Anxiety

Have the technological and social advances of modern life made us less connected to one another? These three images explore degrees of isolation, both social and psychological, as experienced in the twentieth and twenty-first centuries.

Yinka Shonibare (British-Nigerian, born 1962), **Homeless Child 3.** Mannequin, Dutch wax–printed cotton textile, fiberglass, globe head, steel base plate, leather suitcases, 2012. H. 106 1/16 in (269.4 cm). Gift of The Georgia Welles Apollo Society, 2013.32

This sculpture directly confronts the modern crisis of displaced migrants, reminding us that not all people are connected in this new, global age. The child figure—bent under the weight of a tall stack of suitcases—conveys an overall sense of instability and precariousness—of a refugee in a hostile world.

Alberto Giacometti (Swiss, 1901–1966), **Standing Woman.** Bronze, about 1958. H. 30 5/8 in. (77.8 cm). Gift of Thomas T. Solley, 1996.14

Giacometti's elongated sculpture seems to dissolve form, suggesting the fragility of the physical world. It is like seeing someone at a great distance, especially on a sunny day, when we can just barely tell that it is a person, and individuality is reduced to generic sameness.

Ronald B. Kitaj (American, 1932–2007), **Notes Toward a Definition of Nobody—A Reverie**. Oil on canvas, 1961. 48 x 88 in. (122 x 223.5 cm). Gift of Dr. and Mrs. Joseph A. Gosman, 1973.42

The subject of this painting draws on a German legend about a scapegoat, Nobody, who takes the blame for disharmony in the home. Here, Kitaj transforms Nobody into a universal symbol personifying the human condition of frustration and helplessness. Significantly, Kitaj has envisioned Nobody as an African American man. The work was painted in 1961, during the height of the Civil Rights movement.

Culture and history influence how and what we see

Hans Hofmann (American, 1880–1966), **Night Spell**. Oil on canvas, 1965. 72 x 60 in. (182.9 x 152.4 cm). Purchased with funds from the Libbey Endowment, Gift of Edward Drummond Libbey, 1970.50

In *Night Spell*, large areas of color that optically advance and recede demonstrate Hans Hofmann's belief that form, color, and space create interdependencies in what he called "push and pull." The different colors, as well as their value (light or dark), saturation (bright or muted), gloss, size, texture, and placement, enliven the space of a painting without depicting recognizable objects.

In the 1930s Hofmann, already a successful painter, was among many European artists who came to America to escape Nazi oppression. After establishing himself in the United States, he developed a reputation as an acclaimed teacher, playing a decisive role in the development of Abstract Expressionism.

Throughout his career, he was recognized as an advocate for combining color and shape in dynamic ways. Less well known is the variety of techniques he used to put paint on canvas: everything from liquid washes, to flat brushwork, to thick impasto—paint applied heavily with a brush or a palette knife. Hofmann completed *Night Spell* at the age of eighty-five, after he retired from teaching, a time that has been characterized as the richest decade of his artistic life.

Frank Stella (American, born 1936), **Conway I**. Fluorescent alkyd and epoxy paints on canvas, 1966. 80 x 122 in. (203.2 x 309.9 cm). Purchased with funds from the Florence Scott Libbey Bequest in Memory of her Father, Maurice A. Scott and Purchased with funds from the Libbey Endowment, Gift of Edward Drummond Libbey, by exchange, 2012.99

On childhood vacations to the White Mountains of New Hampshire, Frank Stella and his father found a favorite fishing spot at an eroded cliff in Conway. This painting—part of Stella's groundbreaking shaped-canvas series Irregular Polygons (1965–66)—is named for that location. In this painting, a horizontal red rectangle is interlocked with an equal-sided aqua blue parallelogram that extends beyond the lower edge. The placement of the eight-inch-wide border stripes gives the impression that the parallelogram is swiveling. In fact, Stella said he was inspired by a swiveling mirror in his mother's bedroom.

Stella made four versions of each of the eleven compositions in his Irregular Polygons series, using different color combinations. Like much of Stella's work, *Conway I* disrupts our expectations of space and volume. As he explained of his canvases, "I work by moving away from the flat surface, but I don't want to be three-dimensional, at least literally . . . more than two dimensions, but less than three."

In *Guardian*, Robert Rauschenberg applied his collage aesthetic—mixing techniques, subjects, and processes—to lithography. He made this print at Universal Limited Art Editions (ULAE) in Bay Shore, New York, during the summer of 1968, one of the most consequential years in recent American history. The images, selected from magazines and newspapers, allude to many of the year's momentous cultural and political events: the summer Olympics in Mexico City, when African American sprinters Tommie Smith and John Carlos made the Black Power salute at the medal ceremony; the presidential campaign of Richard Nixon; and the escalating war in Vietnam. Rauschenberg, however, masks celebrity personalities and specific dramatic moments to avoid the emotional and inflammatory responses usually triggered by such incidents. Incorporating layered, duplicated, and inverted imagery, his deliberately fragmented design suggests the deluge of images found in modern media culture.

Rauschenberg took to lithography reluctantly, famously stating that "the second half of the 20th century was no time to start writing on rocks." Nevertheless, he became an important figure in revitalizing American printmaking during the 1960s, steering it in new directions. Discovering that its properties were ideally suited to his signature method of combining mechanically reproduced imagery with painterly techniques, he made nearly one thousand prints.

Robert Rauschenberg (American, 1925–2008), **Guardian**. Color lithograph and intaglio on German copperplate paper, 1968. Edition, 14/44. Publisher: Universal Limited Art Editions (ULAE), New York. 42 ½ x 30 ¼ in. (108 x 77 cm). Winthrop H. Perry Fund, 1970.61

Dominick Labino (American, 1910–1987), **Vitrana.** Polychrome glass, 1969. 96¼ x 108⅜ in. (244.5 x 275.3 cm). Gift of Mr. and Mrs. Dominick Labino, 1970.449

Dominick Labino was one of the first artists to combine technological innovation and aesthetics successfully in studio-made glass. Labino observed the connection between science and art as early as the 1930s when—as part of his job at an Owens-Illinois Glass Co. container plant—he set up a small laboratory to formulate new glass batches and to fabricate small glass objects. After moving to the Toledo area to work at Johns Manville Fiberglass, he built a glassblowing furnace at his home. In 1962 he provided technical assistance for the Toledo Workshops, two experimental but highly successful seminars held on Toledo Museum of Art grounds that explored glassblowing with a small studio furnace. These two workshops are widely considered as marking the birth of the American Studio Glass movement. Labino retired in 1965 to pursue a full-time career as a glass artist.

Labino's interest in expanding the range and variety of colors and their effects in glass resulted in his monumental installation, *Vitrana*, commissioned for the opening of a new glass gallery at the Toledo Museum in 1969. The chemical compositions required to create the colors were a technical challenge, and Labino had to develop a special annealing oven to allow for the slow cooling of the cast glass panels. Held in place by metal pins and a steel frame, the thirty-three glass panels of the wall piece appear to float in space.

Romare Bearden (American, 1911–1988), **Family Dinner**. Collage on Masonite, 1968. 30 1/16 x 39 15/16 in. (76.4 x 101.5 cm). Purchased with funds from the Libbey Endowment, Gift of Edward Drummond Libbey, 1992.17

In his dynamic and distinctive collages, Romare Bearden combined his academic training as a mathematician, his knowledge of music, his study of art history, and his personal experiences of life in the twentieth century as an African American man. He had grown up in New York, where, at his parents' apartment, he was present for gatherings of such Harlem Renaissance luminaries as W. E. B. Du Bois (1868–1963), Duke Ellington (1899–1974), Aaron Douglas (1899–1979), and Paul Robeson (1898–1976). While visually inspired by Cubism's approach to form and the brilliant colors of Henri Matisse's cut-out compositions, Bearden remained emotionally rooted in social justice. In the turbulent 1960s he turned to collage as his medium of choice, using it to express the rhythms and rituals of family life and the African American community.

Family Dinner is a masterful assemblage of fragmented and powerfully evocative images. Bits and pieces of color and form are layered and locked together in a scene that conveys the universal human experience. Bearden's unexpected juxtaposition of photographic details and flat cut-out or torn shapes convey both the physical and the emotional interactions of an extended family sharing a meal.

Alice Neel (American, (1900–1984), **Nancy and the Rubber Plant**. Oil on canvas, 1975. 79 ⅞ x 36 in. (203 x 91.3 cm). Purchased with funds from the Libbey Endowment, Gift of Edward Drummond Libbey, 2016.8

Alice Neel's portraits of friends, family, and acquaintances simultaneously capture physical likeness and insight into the psychology of the sitters. She provocatively referred to herself as "a collector of souls." *Nancy and the Rubber Plant* features Neel's daughter-in-law and studio assistant, a frequent subject for the artist. In a composition of bright colors and simplified forms, Neel's signature thin blue contour line traces the edges of the figure, the chair, and the rubber plant that the fills the top half of the canvas. Peeking out from behind the large leaves is the sour countenance of a portrait-within-a-portrait. The almost cartoonish figure, her hand to her face mirroring Nancy's pose, represents Audrey McMahon, Neel's former supervisor when she worked for the Works Progress Administration in the 1930s and '40s. It is taken from a satirical portrait of McMahon—who fired Neel twice—that Neel painted in 1940.

Alice Neel's work was not widely known until late in her career, when the feminist movement of the 1960s and '70s helped spark renewed interest in her art. Having struggled in near poverty for most of her career, she finally found recognition and acclaim in the last decades of her life.

Helen Frankenthaler (American, 1928–2011), **East and Beyond with Orange**. Color woodcut with acrylic on handmade Nepalese paper, 1973–74. Edition, 7/12. Publisher: Universal Limited Art Editions (ULAE), New York. 32¼ x 22⅛ in. (81.9 x 56.2 cm). Frederick B. and Kate L. Shoemaker Fund, 1974.25

When influential abstract artist Helen Frankenthaler made her first woodcut, *East and Beyond*, in 1973, she withheld several impressions from the original edition because of her dissatisfaction with the registration of the woodblock used to print the orange ink. This print, *East and Beyond with Orange*, belongs to a subsequent edition released a year later in which the artist added a fleck of cadmium orange acrylic paint to resolve this imperfection. Her masterful approach to printmaking was widely hailed as groundbreaking, and Frankenthaler is credited with launching a renewed interest in the woodcut, the oldest graphic technique.

In this print, as in her paintings, Frankenthaler created uninterrupted fields of luminous color by using an experimental approach that combined traditional Japanese woodblock techniques with recent stylistic developments in abstract art. Printed from eight jigsaw-cut blocks, each used to print a different color, the design is reminiscent of the same misty veils of color that the artist achieved in her signature "soak-stain" technique, in which she poured washes of thinned paint onto an unprimed canvas. However, the rustic beauty of the woodcut technique is retained and enhanced in *East and Beyond with Orange* by the woodgrain left visible through the controlled application of ink to the blocks. The resulting ethereal image has the appearance of thin, color-glazed wood.

Anselm Kiefer (German, born 1945), **Athanor**. Oil, acrylic, emulsion, shellac, and straw on photograph, mounted on canvas, 1983–84. 88½ x 149⅝ in. (225 x 380 cm). Purchased with funds from the Libbey Endowment, Gift of Edward Drummond Libbey, 1994.22

Evil redeemed and human cruelty purified are the themes of this powerful mural-sized image. Much of Anselm Kiefer's art explores German history and nationalism; this painting belongs to a series inspired by Nazi architecture.

Athanor is based on the courtyard of the massive Reich Chancellery, the seat of Adolf Hitler's government in Berlin.

Kiefer inscribed the painting's title on the canvas twice: on the lintel above the center

columns and in the sky, on the upper left. The name Athanor refers to a furnace that provides constant heat and was supposedly used by medieval alchemists to transform base metals into gold. Here, the partly obliterated word over the doors at the end of the courtyard alludes to the doors of the ovens where millions of corpses, most of them Jewish prisoners, were incinerated at the rate of 8,000 bodies a day at Auschwitz during World War II.

Kiefer actually scorched sections of this painting with a torch to symbolize redemptive suffering and purification through fire. *Athanor* epitomizes his intense belief that by acknowledging the tragedies of history, learning from them, and transforming images associated with them into symbols of hope, humanity can achieve a better future.

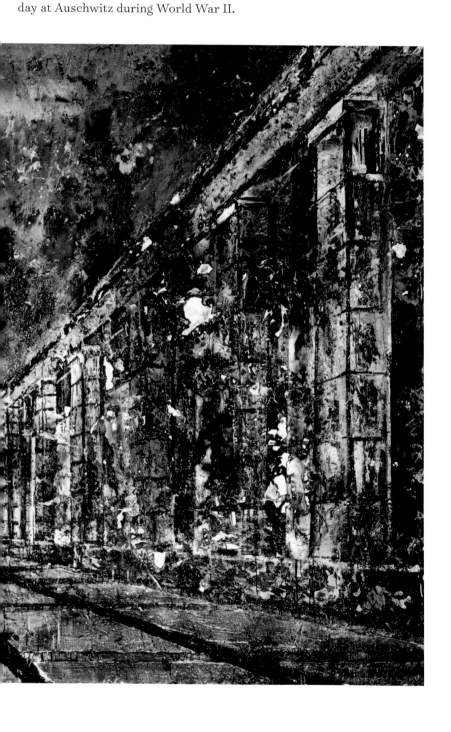

Nam June Paik (Korean-American, 1932–2006), **Beuys Voice**. Two-channel color video, television cabinets, felt, mixed media, 1990. H. 104⅜ in. (265.1 cm). Purchased with funds from the Libbey Endowment, Gift of Edward Drummond Libbey, 2015.16

Korean-American artist Nam June Paik is often hailed as the father of new media art and is renowned for his early explorations into the overlap between music, video, performance, and emerging technology. During his career spanning more than four decades, Paik created a body of work that foresaw the technological revolution of the late twentieth century and drew attention to electronic technology's increasing omnipresence in our daily lives.

Demonstrating Paik's sense of humor and playfulness, *Beuys Voice* is an example of the artist's "robot portraits"—sculptural assemblages composed primarily of stacked television consoles. It is an homage to the avant-garde artist Joseph Beuys (German, 1921–1986), a close friend of Paik's and an important influence on his development as a young artist. This mixed-media sculpture features some of the objects particular to Beuys's "mythical persona," such as felt, a sled, and a hare. On its many television screens, the "robot" also includes video footage of Beuys in some of his performance art.

Stanislav Libenský (Czech, 1921–2002) and Jaroslava Brychtová (Czech, 1924–2002), **Gray Table**. Glass, 1987, this cast 1988. W. 30¼ in. (77.5 cm). Gift of Dorothy and George Saxe, 1991.98

The artistic collaboration between the husband-and-wife team of Stanislav Libenský and Jaroslava Brychtová has significantly shaped the landscape of contemporary glass art, redefining glass's use as a sculptural medium through their investigation of light, color, and, form. Their accomplishments are especially remarkable given the oppressive political conditions of the Communist government of what was then Czechoslovakia, where they spent much of their career. Libenský and Brychtová were among the artists who supported a rebirth of Czech art as a form of political protest.

Though from a region of the Czech Republic historically known for its decorative and utilitarian glassware, Libenský and Brychtová challenged traditional concepts of glassmaking, pioneering the making of large-scale glass objects by casting the molten glass in molds. Their volumetric, light-filled works, which stretch the physical limits of the material to achieve mass and scale, are both impressive and technically difficult.

Gray Table belongs to a body of work from the 1980s that took the form of tables and thrones. While much of the couple's work is geometric and abstract, this more representational expression is perhaps a quietly subversive symbol of the power and control exerted by the government over their personal and artistic lives until the 1990s.

Chuck Close (American, born 1940), **Alex**. Oil on canvas, 1987. 100¼ x 84 in. (254.6 x 213 cm). Gift of The Georgia Welles Apollo Society, 1987.218

Inspiring at first awe, then intense scrutiny, Chuck Close's large-scale portraits draw attention to process as well as image. Working from photographs, Close imposes a grid—which he leaves visible—to enlarge and transfer the

image onto canvas (the Museum also owns Close's original 24-by-20-inch Polaroid for *Alex*, with the grid overlaid in felt-tip pen). When this painting is viewed from a distance, like others he has made, the thousands of small, painted squares optically blend into an illusionistic portrait of the American artist Alex Katz. At close range, however, the painted squares separate into abstract markings. The artist is fully aware of this dissolution of form. While painting, he says, he is not "conscious of making a nose or an eye, but only of distributing pigment on a flat surface." Close not only uses photographs as the basis of his work, he also replicates the camera's imperfect process of capturing three-dimensional reality as he retains the same variations in focus and distortions of form caused by the camera's shallow depth of field.

Aminah Brenda Lynn Robinson (American, 1940–2015), **The Ragmud Collection of Folkquilt Stories**. 10 books with mixed media, 1987–2008. Museum purchase with funds given by Rita B. Kern and Dorothy M. Price, with additional support from the artist and Hammond Harkins Gallery, and Gift of Mr. and Mrs. William E. Levis, by exchange, 2007.99a–k, 2008.18a–d, 2008.132a–g, 2008.133a–r, 2008.134a–i, 2008.135, 2008.173a–c, 2008.174a–d, 2009.5a–c, 2009.6a–h

Aminah Robinson's *Ragmud Collection of Folkquilt Stories*, a ten-volume set of unique, handmade books, is rooted in the senses. In this series, the artist harnessed an explosion of intricate visual details; the creak of vellum pages and the clink of buttons and beads; and the tactile sensations of cloth, shells, thread, hand-made paper, leather, and needlework. The books also contain sculptural elements, hidden mini-books, removable figures, music boxes, and other unexpected and delightful discoveries.

The Ragmud Collection (Volume 2): Growin' up on Thorn, 2008.18

Aminah Robinson learned to take in the details of her surroundings with what she called "observational penetrations," a skill her father taught her when she was only a toddler. "It's a way of seeing inside a particular view of things," she said, "and keeping it in your head like a computer so it's always there."

Created over two decades, *The Ragmud Collection* was inspired by the West African Akan people's concept of Sankofa—going back to one's roots in order to move forward. In these books Robinson has preserved the stories of her family, the neighborhood of her birth, Columbus, Ohio, and African American history.

The Ragmud Collection (Volume 1): Folklife in Poindexter Village 1940–1957, 2007.99

The Ragmud Collection (Volume 5): I Just Take Walks, 2008.134

Sean Scully (Irish-American, 1945), **Ookbar**. Oil on linen, 1993–94. 96 x 114 in. (243.8 x 289.6 cm). Gift of Edward Drummond Libbey, Dr. and Mrs. Joseph A. Gosman, Felix Wildenstein, and Paul Reinhardt, in memory of his father, Henry Reinhardt, by exchange, 2012.101a–c

Sean Scully began exploring the stripe in his work in 1969 after a trip to Morocco, where he was captivated by patterned and patchwork textiles that seemed to support his belief that abstraction is a universal language. In this painting, Scully has referred to the narrow vertical rectangle of gray-and-black horizontal stripes that interrupts the black-striped yellow-orange background as an "uninvited guest" and as a "visitation." He further explains, "something is entering the painting and breaking the field from the top edge; breaking the harmony of the painting."

When he painted *Ookbar*, Scully had been reading the short story "Tlön, Uqbar, Orbis Tertius" (1940) by the Argentine author Jorje Louis Borges (1899–1986). The story involves a place that may or may not exist—no one can quite remember where it is, or how to spell its name. Scully made two paintings around this idea of a forgotten place—*Ookbar* and *Ukbar* (1994; now in the Museo Reina Sofia in Madrid). The titles of both paintings are variations of the spellings that Borges suggested for the mysterious land.

Bill Viola (American, born 1951), **Still image from *Ascension* (Edition 1 of 3)**. Single-channel color video projection on white wall in an entirely darkened room, two channels amplified sound, 10 min, 2000. Approx. dimensions of projection wall: 108 x 120 in. (274.3 x 304.8 cm). Purchased with funds from the Libbey Endowment, Gift of Edward Drummond Libbey, Gift of Arthur J. Secor, and Gift of Dr. and Mrs. Alfred Bader, by exchange, 2013.180

As a pioneer of new media art, Bill Viola has created video installations that are immersive and sensory experiences and that tend to be lush, slow-motion, and cinematic. In his own words, Viola aims to create "total environments that envelop the viewer in image and sound." Calling himself a sculptor of time, Viola slows the normal rate of viewing in his videos to deepen the viewer's experience of observation and of self-examination.

Ascension opens with a tranquil, dark underwater view lit by blue shafts of light from above. A fully clothed man plunges in, accompanied by an explosion of bubbles; the whole sequence is captured in hypnotic slow-motion. Over the course of the video, the man's body sinks before floating toward the surface again. The title refers to the religious belief that certain individuals can rise to heaven without first dying on Earth. In this context, the man's outstretched arms recall those of Christ crucified. The Christian imagery—as well as the act of looking closely—is informed by Viola's interest in Renaissance paintings of the fifteenth and sixteenth centuries. When watching Viola's *Ascension* video, the viewer is invited to feel both the physical and emotional impact of this transformational experience.

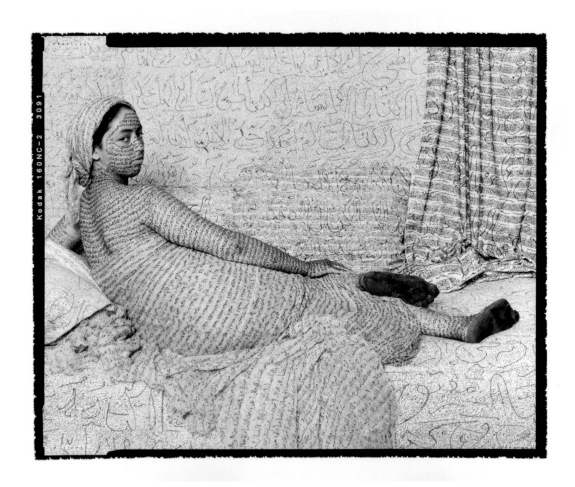

Lalla Essaydi (Moroccan, born 1956), **Women of Morocco: The Grand Odalisque**.
Chromogenic print mounted on aluminum, 2008. Edition, 5/10. 50 x 60 in. (127 x 152.4 cm). Gift of
The Georgia Welles Apollo Society, 2011.8

Lalla Essaydi's photographic series Les Femmes
du Maroc (Women of Morocco) responds to the
West's perception of Muslim women through
the lens of nineteenth-century Orientalism, a
European movement in which artists treated
Near Eastern and North African cultures as
colorful, exotic, and sensual. In such paintings
as *La Grande Odalisque* (1814) by Jean Auguste
Dominique Ingres (1780–1867)—from which
Essaydi adapted the pose for this photograph—
Orientalist artists depicted Muslim women as
sexually passive members of harems.

Essaydi's "Grand Odalisque" (concubine)
is draped in white mourning fabric rather than
nude, as in Ingres's painting, and her gaze
appears more suspicious than inviting. Every
surface of this image, including the model's skin,
is scrawled in henna with writings in Arabic—
excerpts of musings on personal freedom, iden-
tity, and memory from Essaydi's own journals.
Essaydi's use of Arabic calligraphy, seen as a
religiously charged Islamic art form typically
reserved for men, creates a powerful statement
because the silent woman is clad in words and
thoughts that her society does not traditionally
permit her to express.

Kehinde Wiley (American, born 1977), **Saint Francis of Paola**. Oil on canvas, 2003. 82 x 70 in. (208.3 x 177.8 cm). Gift of Charles L. Borgmeyer, Mrs. Webster Plass, and C. W. Kraushaar, by exchange, 2005.290

Though Kehinde Wiley sometimes paints well-known figures, such as his portrait of Barack Obama (2018), he still practices the collaborative method he calls "street casting" that he developed early in his career, the period when he painted *Saint Francis of Paola*. In that process, Wiley chooses as his portrait subjects people of color whom he has seen passing by on the street. Wiley asks his chosen model to select a pose by leafing through images in art history books that show portraits of monarchs or saints by Renaissance or Baroque masters. He then paints his model, usually wearing everyday street clothes, like the backwards ballcap,

baggy jeans, and white Nike sneakers on the young man in *Saint Francis of Paola*, standing in the pose that matches the chosen historical painting. Finally, he adds vivid all-over patterns as a luxurious, and often symbolic, backdrop to the realistic portrait of his modern subject. By this method, Wiley elevates the image of a contemporary person of color within the grandiose traditions of Old-Master painting, where, traditionally, black men and women were either absent or relegated to the margins.

Kara Walker (American, born 1969), **Harper's Pictorial History of the Civil War (Annotated)**. Portfolio of 15 offset lithographs with silkscreen, 2005. Edition, AP 2/10, from an edition of 35. Publisher: LeRoy Neiman Center for Print Studies, New York. 53 x 39 in. (135 x 99 cm). Purchased with funds from the Libbey Endowment, Gift of Edward Drummond Libbey, 2016.75a–p

In her print portfolio *Harper's Pictorial History of the Civil War (Annotated)*, Kara Walker superimposed her signature black silhouette figures over landscape and military scenes taken from the original two-volume anthology *Harper's Pictorial History of the Civil War* (1866). Walker chose fifteen illustrations from more than one thousand images in the *Harper's Weekly* publication that documented the American Civil War (1861–65), then reproduced and enlarged them before silkscreening her own distinctive images over those selections. In this powerful graphic series, she has re-imagined historical events from an African American perspective, a point of view that stands in dramatic contrast to *Harper's* account.

Unlike *Harper's* chronological history, Walker's series unfolds in no special order, as if to suggest that chronology is unimportant when the racial tensions inherent in the historical conflict continue today. The physical presence of her interventions—which loom over, obscure, or interact with the historical scenes—call attention to the title's ironic inclusion of the word "annotated," a term that refers to explanatory comments placed near a given text. In this portfolio, by making central the African Americans who had been marginalized, Walker creates an evocative visual statement that both challenges and complicates *Harper's* textbook version of the Civil War and the abolition of slavery.

Exodus of Confederates from Atlanta, 2016.75c

Dale Chihuly (American, born 1941), **Campiello del Remer Chandelier #2**. Glass, steel armature, original 1996; this configuration 2006. H. 108 ft (270 cm). Purchased with funds given by Anne and Carl Hirsch, 2006.54

In 1996 Seattle glassmaker Dale Chihuly embarked on an ambitious and audacious installation of monumental, multi-piece "chandeliers" throughout the city of Venice, Italy. The *Campiello del Remer* chandelier (named for its installation location) was one of fourteen that he designed for his project, *Chihuly Over Venice*. For this chandelier, Chihuly and his team collaborated with glassworkers at the Waterford Crystal Factory in Ireland, famous for its fine cut lead crystal.

When the installation was dismantled, Chihuly split the chandelier in two, one part going to the Kemper Museum in Kansas City, Missouri, and the other to the Toledo Museum of Art. These clear glass chandeliers are unusual works for Chihuly, who is better known for his expressive use of vibrant colors in his glass installations. Here, the irregular hollow shapes of the colorless, highly refractive Irish lead glass are enhanced by the deep, random lines and patterns engraved onto each piece by the Waterford glasscutters. Because Chihuly's chandeliers are site-specific, his team installed the Toledo sculpture so that it echoes the undulating curves prevalent in the Museum's Glass Pavilion.

Karen LaMonte (American, born 1967), **Dress Impression with Train**. Glass, designed 2005; this cast 2007. H. 58¼ in. (148 cm). Purchased with funds from the Libbey Endowment, Gift of Edward Drummond Libbey, by exchange, 2008.148

Karen LaMonte creates life-size, cast-glass sculptures that simultaneously evoke the human figure and highlight its absence. Her "empty dresses" bear both the internal impression of the wearer's body and an exterior that is defined by her clothing. For LaMonte, apparel is "our second skin, our social skin." This glass "skin" carries messages about notions of ideal beauty, social status, and the body-controlling and body-distorting aspects of fashion—particularly for women. "We use clothing," LaMonte says, "to conceal our bodies in a practical manner but also to obscure and protect our individual personalities. We also use it to project a public personality, and that is where my interest is; in this interplay between the inner layer of the body, the individual, and the exterior layer of the clothing, which is the society."

Haunting and evocative, *Dress Impression with Train* is also a technical tour de force. LaMonte used a series of positive and negative molds taken first from the nude model and then from the dress arranged

on the mold of that body. She then casts the inner and outer molds together in glass. The transparency of the material allows the viewer to look through the evening gown, revealing the human shape beneath.

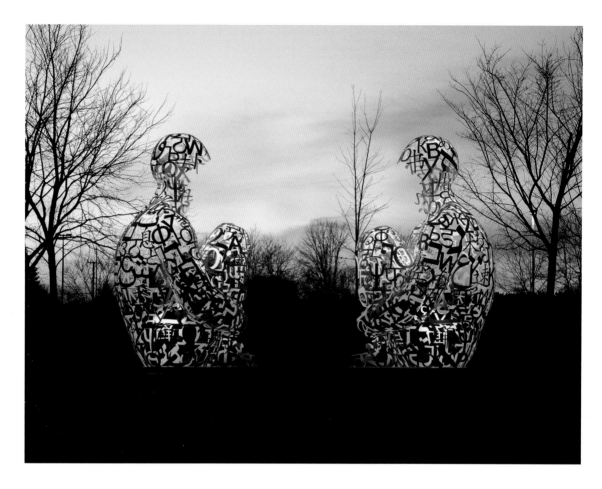

Jaume Plensa (Spanish, born 1955), **Spiegel**. Stainless steel, painted, 2010. Each: H. 148½ (377 cm). Purchased with funds given by Rita Barbour Kern and Gift of Mrs. George M. Jones, Jr., by exchange, 2012.84a–b

Spiegel **(German for "mirror")** shows two identical seated figures, tightly hugging their knees and facing one another, though they are technically faceless. They are also nearly bodiless—instead of the solid, opaque bodies of classical marble sculpture, these figures are hollow screens given shape by a painted steel latticework made of letters and characters from eight alphabets: Latin, Greek, Hebrew, Russian, Arabic, Hindi, Japanese, and Chinese. The pair seems to be communing with rather than confronting one another, symbolic of the open-ended dialogue that artist Jaume Plensa hopes that his works will encourage. As he has explained, "We are each a country, an island . . . linked and separated by an ocean. As far as we are so different and unique, we can collaborate, we can exchange information, but never compete."

Because of their inherent transparency, these two hollow sculptures interact with light and landscape, sometimes standing out starkly (especially with bright light shining from inside them at night); at other times almost disappearing against the sky. They also invite interaction with the viewer to walk inside them and look out through a "cage" of jumbled language.

Silvia Levenson (Argentine, born 1957), **Strange Little Girl #7 (Nena Cuervo).** Kilncast Bullseye® glass and mixed media, 2014. H. 41¼ in. (104.7 cm). Purchased with funds from the Libbey Endowment, Gift of Edward Drummond Libbey, 2015.41

Although she was born in Argentina, Silvia Levenson immigrated to Italy in 1981 with her family to escape the oppressive regime of military dictator Jorge Rafaél Videla, during which members of her extended family were "disappeared." Her experiences during this intense and frightening time continue to inform her work.

In *Strange Little Girl #7*, a small child stands, arms at her sides, wearing a black dress and black, cast-glass rain boots. On her head is a crow mask made of cast glass, and she wears black feathered wings. Her blue-tinted glass hands are the only note of color. This sculpture addresses issues of personal identity during childhood. As Levenson explains, "The world of children is still far from adults until they accept their social rules: what is good and what is evil. Those years to me delineate an era where the edge between reality and dreams is very evanescent." For her "Strange Little Girl" series of works in glass and mixed media, Levenson began by making collages with photos from her youth, mixing these with animals' heads and children's bodies, emphasizing the dreamlike and unreal—and the sometimes unsettling—world of childhood.

Tjungkara Ken (Aboriginal Australian, Pitjantjatjara language group, born 1969), **Seven Sisters**. Acrylic on linen, 2013. 78 x 60 in. (198.1 x 152.4 cm). Gift of Georgia E. Welles, 2013.182

Tjungkara Ken is one of the key members of Tjala Arts, an artist-run cooperative that has been recognized as one of the strongest and most coherent sources of contemporary Aboriginal Australian art. In *Seven Sisters* she employs a rich palette and meticulous dotting arranged in sections of parallel lines to suggest the patchwork of land forms that make up the vast and changing topography of her ancestral country, the Anangu Pitjantjatjara Yankunytjatjara Lands in South Australia.

The subject of the painting is a Dreaming, a story of the creation of the world by ancestral beings in which the Seven Sisters (the Pleiades star cluster) are forever chased by Nyiru (a star in the Orion constellation), who wants to marry the eldest sister. The sisters travel to Earth to escape Nyiru's unwanted attention and assume

human form. Ken's painting depicts their journey across the desert. Circles and ovals represent important sites, and traveling lines join them to mark the flight of the Seven Sisters. Like many Aboriginal Australian artists, Ken paints works like *Seven Sisters* to preserve and to pass on to others her religion and her culture.

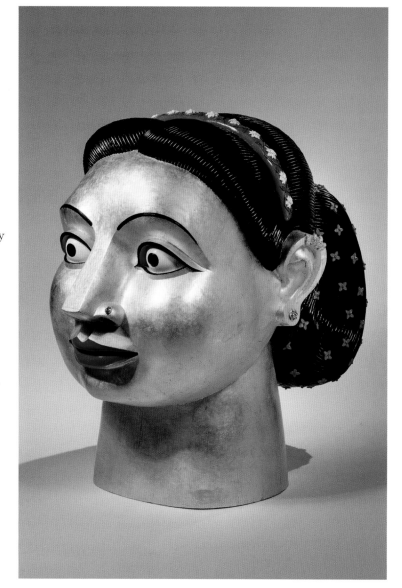

Contemporary Indian sculptor Ravinder Reddy creates monumental female heads that draw upon two divergent sources: India's sacred traditions and everyday contemporary culture. The heads' wide-open, staring eyes and severe frontality and symmetry are arresting, even confrontational. Born in Suryapet, in the Andhra Pradesh region of India, Reddy was influenced by sensuous folk-art forms, particularly brass *gauri* (goddess heads used in Hindu rituals) and the brightly painted sculptures that decorate *gopuram* (towers) on Southern Indian temples. The facial features and bold colors of his sculptures also emulate the ordinary people and the objects in his immediate environment and daily life. With his fusion of Pop Art, popular culture, and Hindu sculptural forms, Reddy fuses the ideal goddess with the ordinary Indian woman. "When I have this rich culture around me," he has said, "why should I discard it and look to the West?"

Ravinder Reddy (Indian, born 1956), **Untitled (Head–Gold)**. Fiberglass, resin, and gold gilt, 2003. H. 44 in. (111.8 cm). Gift of The Georgia Welles Apollo Society, 2014.20

Mary Sibande (South African, born 1982), **Rubber Soul, Monument of Aspiration**. Cast resin, fiberglass, cotton, tulle, and rubber, 2011. H. 101½ in. (257.8 cm). Gift of The Georgia Welles Apollo Society, 2013.160

Mary Sibande investigates issues of race, class, and power in post-Apartheid South Africa in her work. *Rubber Soul* is the last in her series depicting a semi-autobiographical character, Sophie, a colonial South African maid who serves as Sibande's alter ego. Sophie is usually rendered as a matte black resin mannequin with eyes closed, dressed incongruously both as a maid and as a Victorian lady. This ambiguity of costume is a way for Sibande to question the overly simplistic dichotomies of servant versus mistress and black versus white, while asserting the power of fantasy and self-fashioned identity.

In this sculpture, she also questions gender distinctions: the khaki fabric and brass buttons of Sophie's voluminous dress are associated with the suits usually worn by men who belong to the South African Zion Christian Church (ZCC). The men also wear white, hand-made rubber-soled shoes, which represent masculinity and identify power. Likewise, Sophie's jumping action imitates a male-only praise ritual practiced at the church. By wearing these clothes and engaging in this forbidden action, Sophie/Sibande directly challenges gender and power norms in her South African homeland.

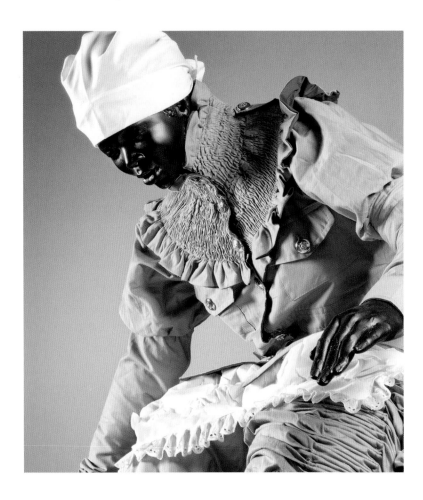

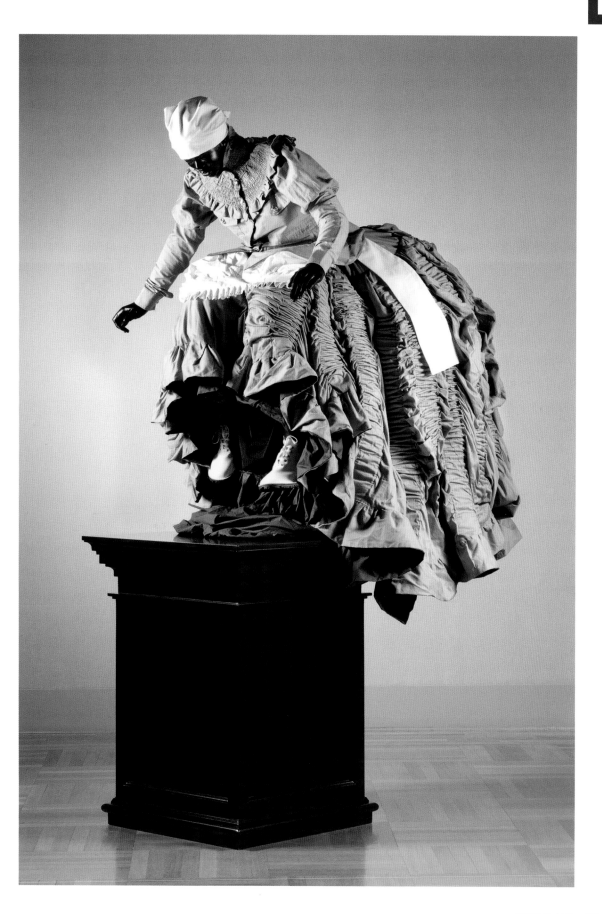

Alfredo Jaar (Chilean, born 1956), **Be Afraid of the Enormity of the Possible**. Neon gas and glass tubing, 2015. W. 72 in. (182.9 cm). Museum Purchase and Gift of Florence Scott Libbey, by exchange, 2016.9

Unapologetically political, Chilean artist Alfredo Jaar addresses globalism and its negative outcomes in his art, particularly issues of social and economic inequality, humanitarian crises, and political divisions. He believes his art can affect change, informing and engaging his audience and illuminating his message, both figuratively and sometimes—as in Toledo's neon work—literally.

Jaar has recently begun to explore neon text as a medium to provoke deep connections and thoughtful discourse. His neon works often quote or are inspired by the words of poets and philosophers. He has explained that he approaches his work as a kind of haiku—a form of poetry in which very few words, only seventeen, are used to express often profound ideas. "I strongly believe in the power of a single idea," he explains, "so the most difficult thing for me is to arrive at the essence of what you want to say." The phrase "Be afraid of the enormity of the possible" is based on the writings of the Romanian Emil Cioran (1911–1995), one of Jaar's favorite authors. Here color, light, and scale transform the quote into a form of visual poetry.

David Hockney (British, born 1937), **A Bigger Card Players**. Photographic drawing printed on paper, mounted on Dibond®, 2015. 72 x 69¾ in. (182.9 x 177.2 cm). Museum Purchase, by exchange, 2015.47

One of the most influential British artists of the twentieth and twenty-first centuries, David Hockney has created a body of work that is characterized by continual evolution and experimentation in different mediums. He is greatly interested in human perception, the nature of perspective, and the fluid relationships among drawing, painting, photography, and digital art. *A Bigger Card Players* touches on all of these themes.

Hockney made this so-called photographic drawing in 2015, along with several paintings depicting variations of the same scene, all based on Paul Cézanne's series of paintings of men around a table playing a card game.

Hockney took multiple photographs of his friends around a card table to create a digital "collage" for this work. "Each photograph," he explained, "has a vanishing point, so instead of just one, I get many vanishing points." The multiple vanishing points are especially noticeable in the trapezoidal shape of the table and the position of the three men—a visual playfulness echoed in one of his own paintings with a similar composition, visible on the wall behind the card players. The multiple perspectives in this work give the image, according to Hockney, "an almost 3D effect without the glasses."

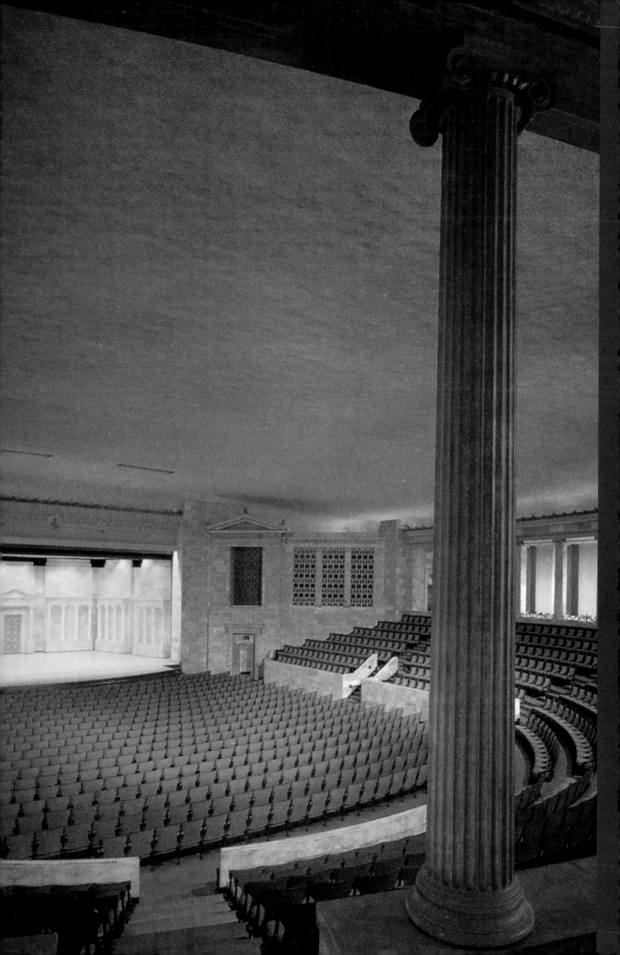

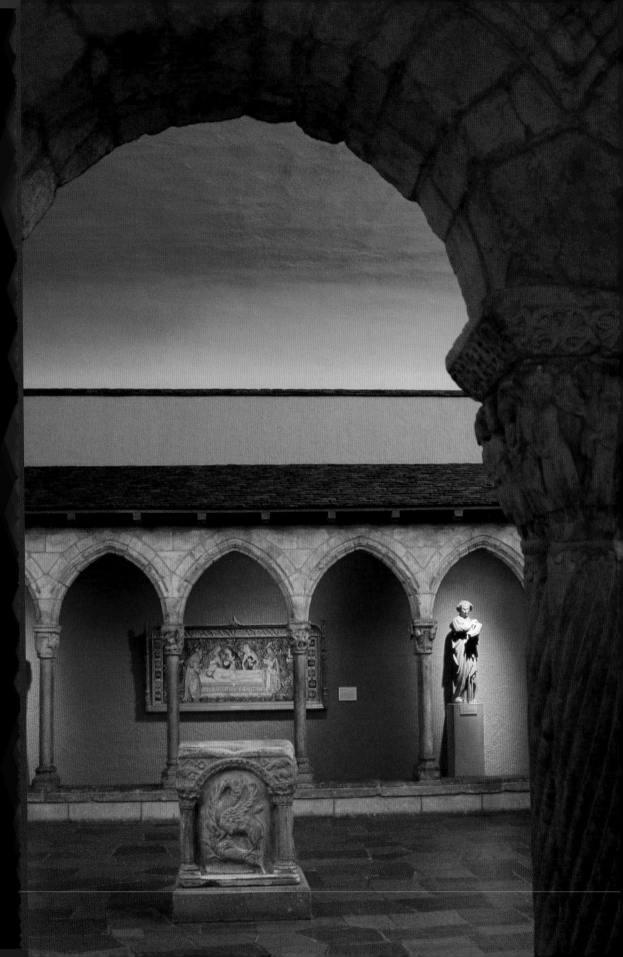

Contributors

Brian P. Kennedy, President, Director, and CEO

Tami Landis, Research and Editing Assistant

Adam Levine, Associate Director and Associate Curator of Ancient Art

Courtney Macklin, Works on Paper Curatorial Assistant

Lawrence W. Nichols, William Hutton Senior Curator of European and American Painting and Sculpture before 1900

Halona Norton–Westbrook, Director of Curatorial Affairs and Curator of Modern and Contemporary Art

Paula Reich, Head of Interpretive Projects and Managing Editor

Robin Reisenfeld, Curator, Works on Paper

Diane C. Wright, Curator of Glass and Decorative Arts

We are grateful to the following colleagues and Toledo Museum of Art staff, past and present, whose research and writing shaped many entries.

Ellenor Alcorn, Don Bacigalupi, Roger M. Berkowitz, Kate Blake, Mark Bockrath, Stefano Carboni, Clifford Craine[†], Mike Deetsch, Laura Deiger, Maggie Dethloff, Emily Floyd, Andrea M. Gardner, Marc S. Gerstein, Amy Gilman, Sidney M. Goldstein, David Frederick Grose[†], David Guip, Elaine D. Gustafson, Suzanne Hargrove, James A. Harrell, Edward T. Hill, Alison Huftalen, William Hutton[†], Sandra E. Knudsen, Christina Larson, Thomas Loeffler, Kurt T. Luckner[†], Martha Drexler Lynn, Lance Mayer, Julie McMaster, Carol C. Mattusch, Julie M. Mellby, Laura J. Mueller, Gay Myers, Jutta–Annette Page, Arlene Palmer, William H. Peck, Robert F. Phillips[†], Carolyn M. Putney, Richard H. Putney, Mary Nooter Roberts, David W. Steadman[†], E. Marianne Stern, Mark S. Tucker, Terry Wilfong, and Kenneth M. Wilson[†].

[†] denotes deceased

Credits

Index

W9-BBM-532

Purchase only authorized editions.
Library of Congress Cataloging-in-Publication Data • Rubin, Adam, date.
Secret pizza party / by Adam Rubin ; illustrated by Daniel Salmieri. p. cm.
Summary: While Raccoon is eating pizza at his secret pizza party, he sees a masquerade
party going on in the house next door to him and joins the fun.
ISBN 978-0-8037-3947-5 (hardcover) [1. Raccoon—Fiction. 2. Parties—Fiction.
3. Pizza—Fiction. 4. Secrets—Fiction. 5. Humorous stories.]
I. Salmieri, Daniel, date. ill. II. Title.
PZ7.R83116Sec 2013 [E]—dc23 2012025360
Manufactured in China on acid-free paper
Designed by Jennifer Kelly
Text set in Octone
The artwork was created with watercolor, gouache, and color pencil.

The publisher does not have any control over and does not assume any
responsibility for author or third-party websites or their content.

ALWAYS LEARNING PEARSON

1 3 5 7 9 10 8 6 4 2

SECRET PIZZA PARTY

BY Adam Rubin

ILLUSTRATED BY Daniel Salmieri

Dial Books for Young Readers an imprint of Penguin Group (USA) Inc.

SILVERMAN'S BEARD STORE

Uncle Mark's PIZZA

USE MIT

Poor Raccoon.
All he wants in life is some pizza.

If only he knew how to ask politely.

Ah, pizza . . .
So beautiful, you could hang it on the wall of a museum.

So convenient, you could eat it in the bathtub.

Of course, the best part about pizza is the gooey cheesy-ness, salty pepperoni-ness, sweet, sweet tomato-ness, and crispity, crunchity crust.

Yum!

Sorry, Raccoon. I didn't mean to rub it in.

Hey, cheer up. I just had a great idea! Let's throw a pizza party at your house tonight.

Shhh, don't tell anyone. This will be a secret pizza party.

I know what you're thinking. Why would we keep such a delicious, delicious party a secret?

Okay, sure. It's so folks don't show up to bonk you with brooms, but that's not the only reason. When you make something secret, you make it special.

Regular handshake: Boring.

Secret handshake: *Booyah!*

Regular staircase: Tiring.

Secret staircase: Terrific!

Regular pizza party: Get that raccoon off the table!!!

Secret pizza party: Get that raccoon another slice of pizza, he's the guest of honor.

Hot diggity dog, our pizza party is going to be so much fun!
Call the pizza man and tell him to bring over his absolute finest pizza pie.

Hang on a minute, you don't want the
delivery guy to know where you live.
He might recognize you from the
posters and chase you off
with a broom.

Think, Raccoon. **Think!**

Okay now, play it cool. You're just an honest pizza-buying citizen who left his wallet in the car. The pizza man thinks you'll be right back . . .

Let's go!

I've planned the perfect getaway route:

Around the broom factory.

Over the broom enthusiasts club.

Run, Raccoon.

Run like the wind!

Phew! We made it.

Let's barricade the doors and pop open that pizza box.

Mmmmm . . .

SECRET PIZZA PARTY!

Oops, I said that kind of loud.

Sorry, pizza smell gives me the happy screams.

Try not to crunch too loud.
Definitely no high-fiving.
Or music.
Or dancing.
In fact, we'd better turn off the lights and whisper,
just to be safe . . .
secret pizza party!

What's the matter?

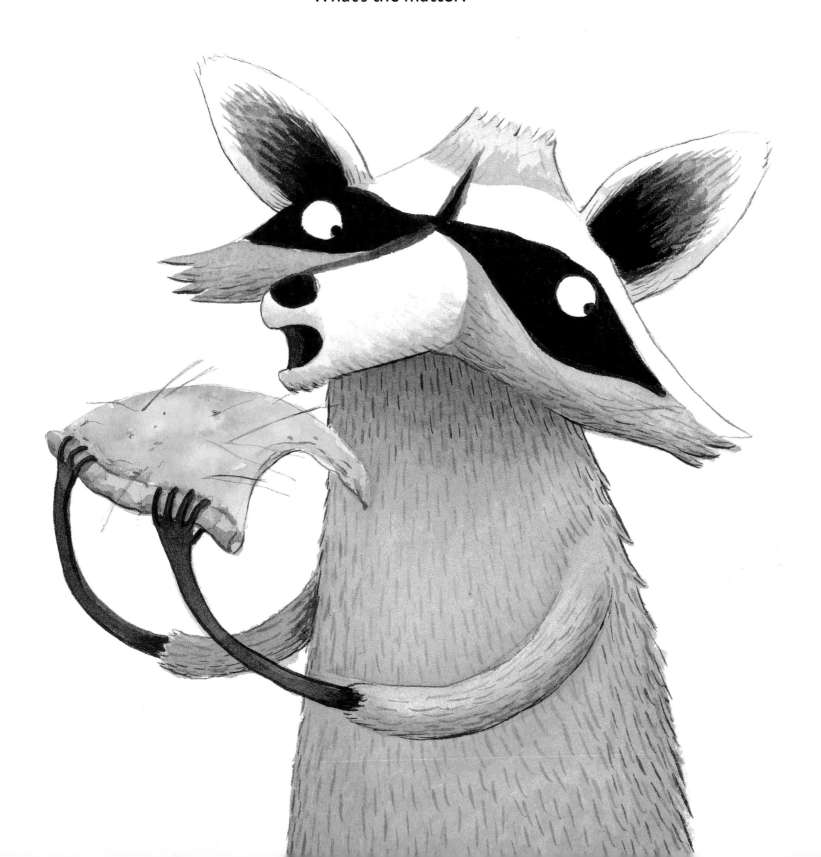

Sweet sassy molassy, look at all that pizza!

Clearly, these people are much better at throwing parties than they are at keeping secrets.

Are you thinking what I'm thinking?

Okay, you're in.
Just play it cool.
No one suspects a thing.